Printmaking

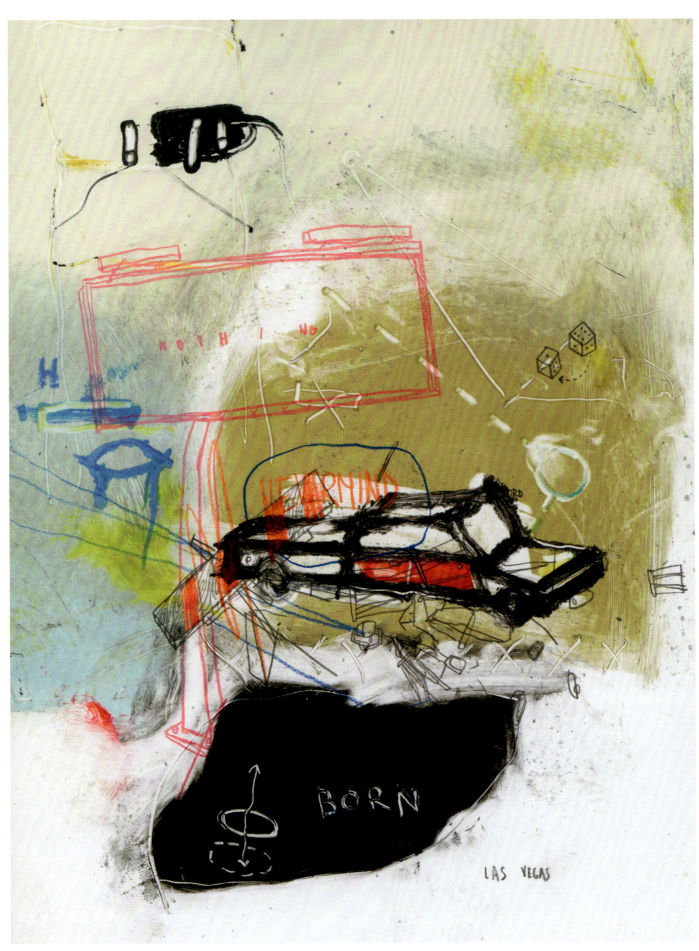

Marcin Kuligowski, *The Great Nothing*, 2006. Monoprint with gumprint, 19 × 15 in (48 × 38 cm).
Published by Atelier Tom Blaess. Courtesy of the artist.

Printmaking

A Complete Guide to Materials & Processes

Beth Grabowski & Bill Fick

Prentice Hall

Upper Saddle River Toronto Sydney
Tokyo Singapore Mexico City Hong Kong

For Jim, Zoë and Gray
Beth Grabowski

For Kristin and Josie
Bill Fick

Cataloging-in-Publication Data is available from the Library of Congress

Editor in Chief: Sarah Touborg
Senior Editor: Amber Mackey
Editorial Assistant: Theresa Graziano
Executive Marketing Manager: Wendy Gordon
Senior Marketing Manager: Kate Mitchell
Marketing Assistant: Jennifer Lang

Pearson Education Ltd.
Pearson Education Australia PTY, Limited
Pearson Education Singapore, Pte. Ltd
Pearson Education North Asia Ltd
Pearson Education, Canada, Ltd
Pearson Educación de Mexico, S.A. de C.V.
Pearson Education—Japan
Pearson Education Malaysia, Pte. Ltd

This book was designed and produced by Laurence King Publishing Ltd, London www.laurenceking.com

Front cover: *Country Croc* by Sean Star Wars (© Sean Star Wars/photo by Bill Fick).
Editor: Zoe Antoniou
Designed by Andrew Lindesay

Prentice Hall
is an imprint of

10 9 8 7 6 5 4 3 2 1
ISBN 978-0-20566-453-5

www.pearsonhighered.com

Contents

Preface

The impetus for this book began with an exploratory visit to North Carolina from Lee Ripley Greenfield of Laurence King Publishing. She was seeking a potential author for a book on printmaking and, unbeknownst to each of us, Lee had parallel conversations with both authors. Well, the print world is not huge, and academia is even smaller. Add to that the fact that the authors live in the same area and had other professional connections; it was not long before we discovered our corresponding conversations with Lee. While we both were intrigued, the task of writing a book on contemporary printmaking practices was daunting. We quickly agreed that it might be a good idea to take this on as a collaborative effort. Many times during the two years of this book's production we have affirmed the serendipity of that initial impulse. Our own backgrounds and professional connections in printmaking as well as our own talents and areas of expertise have complemented each other quite nicely. The book is far better for our collaboration than if it had been done by either of us alone.

The intention of the book is to provide a survey of contemporary printmaking practice. While the emphasis is on technical information, we believe that technique serves a broader goal of art-making. Accordingly, we strove to frame technical discussion within the broader context of artistic practice that includes conceptual issues of concern to artists working in print media. Some of these ideas are specific to print and some are ideas relevant to any art-making enterprise. To that end, we made an effort to show the best of contemporary printmaking, covering a range of aesthetic approaches, from abstract to representational, narrative comic book style to the ethereal. We have included works from artists who work independently as well as images made in collaboration with master printers in contract ateliers. Artworks represented exist within the mainstream art world, but also exist outside of the gallery or studio in non-traditional contexts. This diversity of approach confirms the idea that printmaking is a dynamic and ever-changing field. One of the benefits of the process is that we have met many fantastic artists who we had not known before. Artists included herein represent a multitude of diversities and international origins.

The technical information in this book includes both time-honored practices and contemporary innovations. We give special attention to safe practices, addressing the important concern for health and safety. The many step-by-step illustrations provide an enhanced visual reference for the beginning printmaker. When photographic information was insufficient, our brilliant illustrator, Brittain Peck, created exquisite diagrams for increased clarity.

In gathering the information for this book, we relied on our many colleagues in the discipline. It continues to be a source of pride and appreciation to recognize the amazing community of printmakers out there who willingly and graciously share their tips and techniques. The spirit of generosity is unparalleled and we are so fortunate to benefit from it. Most of the technical demonstrations were shot in the print lab at the University of North Carolina in Chapel Hill. In addition to providing facilities, we are grateful for additional funding from the UNC Art Department and the University that supported many aspects of the work.

The production of the book with Laurence King has been a rewarding experience. We are deeply grateful to our editors, Anne Townley and Zoe Antoniou, for their keen eye, spot-on advice, supportive guidance, and considerable patience through this process. Also we send much appreciation to the book's designer, Andrew Lindesay, for his superb work juggling so many variables. We are, of course, most profoundly indebted to our families for their forbearance as we have spent countless hours at the computer. We owe you big time.

Beth Grabowski and Bill Fick

Introduction

We deal with printed images every day. Anything that is made in a reproducible format is a print. Photocopies, rubber stamps, newspapers, photographs, posters, your favorite band T-shirt, and the page from your desktop inkjet printer… these are just a few examples of prints in our everyday world. In practical contexts, prints and print processes often signify important information. For example, the post office cancellation mark verifies the time and location origin of a letter and a hand-stamp distinguishes minors attending a concert at the local hip-hop bar from those of legal drinking age. But whether these things can be classified as "art" depends on the intention of the maker. They demonstrate prints and print processes that serve particular, non-artistic functions. But the line between printmaking art and other printed forms has been blurred as artists re-examine the traits that define print practice and look to such moments and their cultural contexts as fair game for artistic intervention.

Fine art printmaking has been traditionally defined through the technical process of relief, intaglio, lithography, and screen printing. With the addition of digital processes, these technical approaches continue to define the field. As with any artistic enterprise, the medium or process exists as the means to realize an idea. But, demanding and important as they are, it is limiting to reduce the concept of printmaking down to a set of technical procedures. For many practitioners, the processes and functions[1] intrinsic to print media inform the

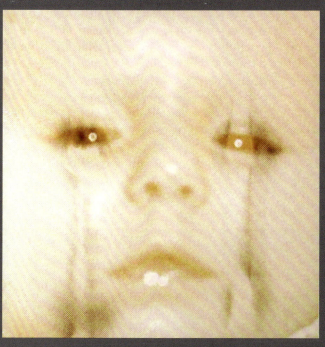

Beth Grabowski, *Cryogenic Self Portrait (fork and knife)*, 2005. Screen print with milk, scorched, 11 × 11 in (27.9 × 27.9 cm). Courtesy of the artist.

This print was made by screenprinting a thickened mixture of breast milk and cornstarch. The initial screen print was essentially invisible; the white milk mixture was the same color as the paper. The image only became visible when the milk was browned using a heat gun. The cryogenic aspect of the title refers to the fact that the milk used in the print was the artist's own breast milk salvaged from a vial that had been left in the artist's freezer almost 12 years prior from the time that she was still nursing her own child. The image is of the artist herself as a baby.

very strategy of art-making. Considered from such structural and conceptual perspectives, the "how" and the "why" of printmaking can hold many creative opportunities. Just which moments along the path of making provide inspiration reside with each individual artist. Ultimately, understanding the authority and, in turn, any qualitative evaluation of the resulting artwork, must include awareness of the artist's intent. So what are the core ideas of printmaking? The following are some of the significant concepts that have emerged as central to the discipline.

The Generative Matrix

Fundamental to the "how" of printmaking is the concept of the generative matrix. A matrix is the plate, block, stone, stencil, screen, or other means of carrying image information that is ultimately printed onto another surface, typically paper. The process of creating the matrix is sometimes a very time-consuming procedure and often the locus of the artistic authority of the work. In most traditional practice, the artist establishes the matrix by directly drawing or carving onto the matrix material. In such instances, much of the quality of the resulting print rests in the virtuosity of the artist's hand. Alongside the importance of the narrative or concept within the subject matter, it is the artist's skill, demonstrated in such visual pleasures as the exquisite drawing in a lithograph, or the unique translation of the mark in linoleum carving, that conventionally provide distinction and establish authority in a work of art.

Sometimes, though, the matrix is not generated through conventional art-making practices. Matrices can be made from found materials, as is the case with some collagraphs, or can be found themselves. Under these circumstances, a print can function like a photograph in its capacity to refer to the object printed. Like a photographic souvenir, the print taken from a physical surface stands as empirical evidence of the existence of that surface. All of the associations contained in the original are transferred to the printed form. Conversely, certain aspects of the original can be highlighted or reframed in the printed form. The latter also introduces a portability that continues to announce its linkage to the original, "reactivat(ing) the object reproduced,"[2] and concurrently amplifying the physical and/or temporal distance that separates the print from its source.

Another advantage of the matrix is the benefit it has for serial and sequential thinking. Individual works within a series can share information contained in a common matrix. Sequentiality is literally pictured in the printed states of a matrix as it is developed. Adopting this idea with intentionality, the artist creates a visual narrative that is closely connected to the documentation of the working process. The visual traces between states are a direct consequence of repeatedly reworking the same matrix.

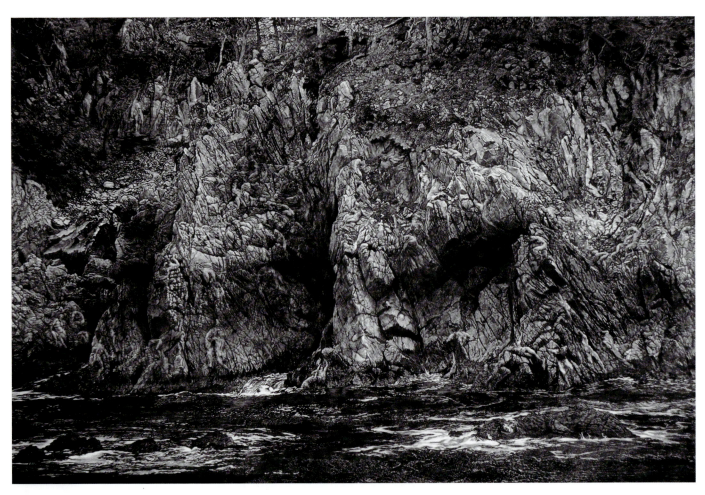

Art Werger, *Requiem*, 2007. Mezzotint, 24 × 36 in (60.9 × 91.4 cm). Courtesy of the artist.

Any print medium can be used in a variety of ways, from abstraction to realism. Art Werger brings his exemplary drawing skills to the mezzotint technique. Here, he rewards viewers who spend time studying the exquisite detail portrayed in this rocky coastline.

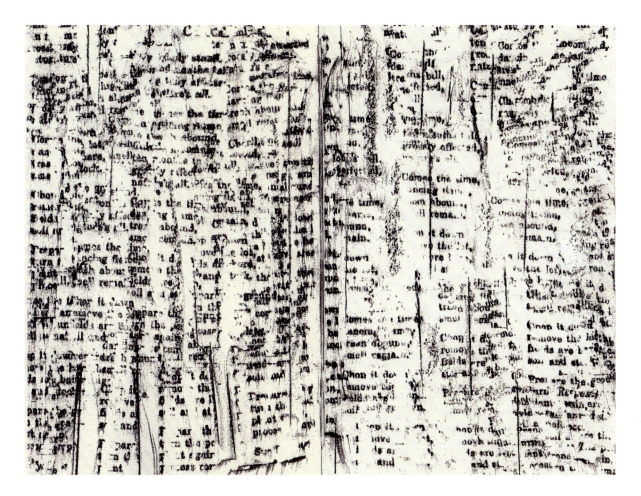

Marshall Weber, Shon Schooler, and Alice Yeates, *Cycle*, 2006. Facsimile pages from a 28-page artists' book, digital color-laser prints on Hahnemühle Ingres paper, scanned from the original artwork, 7½ × 11½ × 1 in (19 × 29.2 × 2.5 cm). Courtesy of the artist.

The original frottage (rubbings) for this book exist as a suggested portrait of Australia via the matrix of the country's monuments, plaques, architectural motifs and organic surfaces.

Tara Donovan, *Untitled*, 2007. Relief print from rubber band matrix, 37 × 29 in (93.9 × 73.6 cm). Edition of 38, printed by Pace Editions Ink., published by Pace Editions Inc. Courtesy of the artist.

The matrix for this print was made by arranging and securing thousands of rubber bands onto a board. The delight of this print is contained in the knowledge (linkage) of the image to the lowly rubber band module of the matrix. The print reframes the module by removing it from its intended function and by highlighting the formal characteristic of "loopiness" and flexibility, a clever demonstration of beauty in the mundane. Some of the work's authority is derived from a consciousness of the obsessive labor required to construct the matrix.

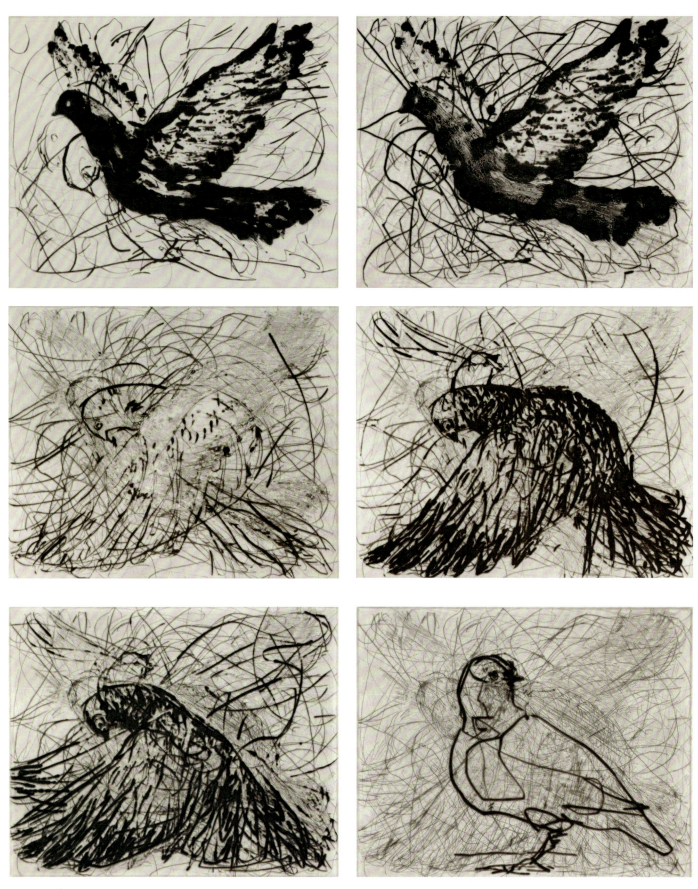

William Kentridge, (from top, left to right) *The Magic Flute: Doves* (States IV, V, VII, VIII, IX and X), 2006. Drypoint or drypoint with carborundum, 8 × 10 in (19.6 × 24.9 cm) each. Editions of 15, printed by Jillian Ross, published by David Krut Fine Art. Courtesy of the artist.

South African artist William Kentridge is renowned for his animated films. The process of making a series of prints as state prints parallels the process for his animated films in which the activity is a repeated cycle of drawing, shooting, erasing, and filming again. In both cases, the results reveal the process and the intimate presence of the artist's hand.

The Delay

In usual practice, the development of the matrix exists as an intermediate step between the idea and ultimate manifestation of the artist's labor in the printed image. Process steps contained within this delay between the mark made and the expression of the mark hold considerable creative opportunity. Most decisions reside in formal concerns; the artist must choose the colors to print, the sequence of printing, and what to print on, all of which have the potential to interpret the matrix differently. For many, the creative process in printmaking is inextricably linked to the technical process. As proofs are pulled, the printmaker becomes the choreographer on the stage of the press bed—moving, ordering, combining, amplifying, subduing, reconsidering, responding. The dialogue between the idea and the process becomes intrinsic to the conceptual development of an image.

This space of the delay also offers conceptual opportunities. How the matrix is used and under what conditions it is printed can be questions that exploit print strategies in a performative manner. If the matrix essentially leaves a trace of its existence, then such things as the impression of a body in a mattress, latent fingerprints, or lipstick smudges on a collar are prints that imply narratives without conventional visual representation. Furthermore, materials or processes used to print may themselves contain temporal performative connotations. For instance, printing with invisible ink would require viewers to be implicit collaborators in the work's completion by doing what it takes to reveal the image.

Layers

Also inherent in the printing process is the aspect of layering. When working with several matrices, the task of registration—aligning the printing of one matrix to the next—is typically done in service to creating a particular illusion. At the same time, the capacity of multiple matrices to print in various arrangements invites a consideration of relationship and hierarchy; which layer is dominant? How might changes in color, printing order, or even placement affect the image and its meaning? Conceptualizing layering as a strategy of conversation or comparison, layers can (re)define information by editing or bringing new images to juxtapose with previously printed information. Even the decision about the bottom layer—what substrate to print *on*—can impact the idea. Is paper always the optimal choice?

The Multiple

By its very existence, the matrix suggests the concept of the multiple. The capacity of the matrix to generate copies has been a persistent component of the critical discourse of prints, contributing to both affirmation and denigration of print artworks. On the one hand, the multiple suggests the inherently democratic nature of the print. By existing in multiples, printed images can be distributed widely at a

Adriane Herman, *Gum Care: Spit It Out*, 2003. Woodcut embossed on handmade slab of chewing gum, approximately 11 × 6 × ⅛ in (27.9 × 15.2 × 0.3 cm).

The surface that accepts printed information carries its own codes and references and can contribute to an idea. Herman routinely pushes the boundaries of print disciplines in her work. In this piece, a quintessentially iconic image of a schoolteacher demanding the removal of a wad of gum is reflexively impressed in that selfsame wad.

modest cost. Conversely, from an investment perspective, reproducibility can be considered a liability in that the potential for an unlimited number of identical copies to exist in effect devalues any single print.

These parallel and sometimes conflicting attitudes toward the reproducibility of the printed image find their origins in the evolution of the stature of the print in the art world. The forms of the print that we understand today as fine-art prints historically were vehicles for illustration or mass distribution of religious or political propaganda. As prints entered the fine-art realm, they came into competition with other forms of art, particularly painting and drawing, and it was difficult to escape the association with commercial and functional uses.

In his famous 1936 essay, "The Work of Art in the Age of Mechanical Reproduction", Walter Benjamin used the term "aura" to describe a condition of originality, uniqueness, and permanence that prevailed as a measure of the integrity and authority of a work of art. He noted that "…the presence of the

Israel, by British graffiti artist Banksy, Bethlehem.

The elusive Banksy has painted new works in the West Bank town of Bethlehem, including this peace dove in a flak jacket at the moment a sniper takes aim at its heart. Here, a Palestinian woman passes and looks at the work on a street corner. Banksy does not sign his works, and no one knows the identity of the artist. These new works are being dubbed "West Banksy," and some are painted on the controversial "separation barrier," or wall, that surrounds the city and cuts off its residents from nearby Jerusalem.

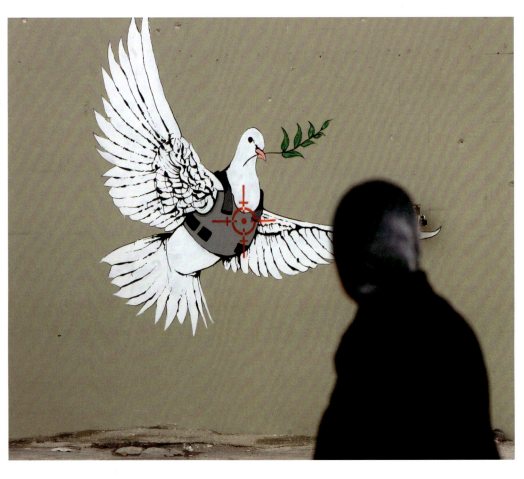

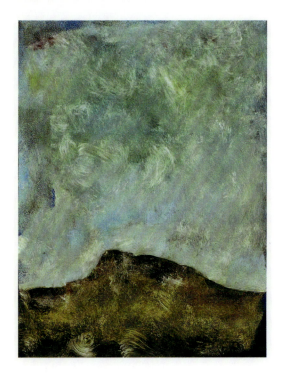

Puck and Company
cordially invites you to attend a reception for

GEORGE FLOYD

celebrating the opening of his exhibition

HILLS AND VALLEYS
MONOTYPE LANDSCAPE PRINTS
OF THE NORTH CAROLINA PIEDMONT

Friday, November 17, 2000
Six to nine in the evening.

The exhibition will continue at
Hampton House Gallery
through December.

Puck and Company
390 Mountainview Road
King, North Carolina 27021
(336) 983-8326

Hampton House Gallery
514 South Stratford Road
Winston-Salem, North Carolina 27103
(336) 983-8869

Bill Fick, *Announcement Card for George Floyd*, 2000. 8½ × 5¾ in (21.5 × 14.6 cm). Courtesy of the artist.

Co-author Bill Fick has created an alter-ego, George Floyd, to produce work for sale to corporate contexts. Under the guise of this alter ego, Bill indulges in the pure pleasure of the decorative qualities of image-making—but with a calculated purpose to sell the work in volume. The mass-produced invitation cards that announce the "publication" of the most recent edition exist as a device to suggest authority in the promotion of the work, while simultaneously satirizing the elitist hierarchy of the art world.

original is the pre-requisite to the concept of authenticity....".[3] Prints, by their very definition, exist in multiples; how could they find validity within the critical and economic realm? To compete, they had to accommodate this notion of authority and find a way to assume some aspect of aura. Among other things, the concept of the multiple evolved to include the idea of the "limited edition." An edition is the total number of prints made of one image. To put a finite cap on the number of prints pulled from any printing matrix provided a compromise of sorts between the concept of the unique and the infinitely reproducible: While it may not be unique, it is still only one of a select few.

This concept of the limited edition, born out of an economic context, remains as a standard, ritualized practice of signing and numbering prints and destroying printing matrices so that only a specified and documented number of copies of an image can exist. For the print artist, publisher and, perhaps more importantly, the print collector, these conventions can give some measure of value (even if artificially produced).

But, like other defining characteristics of the print, the reproducibility of the matrix can also be employed with other aims in mind. Letting go of the idea of an *exact* copy, the printing matrix also contains the idea of the infinitely variable. *Resemblance* then becomes a filial relationship between prints made from the same set of parent matrices.

Used in a modular way, the matrix can also generate a larger image or form through repeated printings. The module might build on a single sheet or multiple printings might be organized into a larger whole. The relationship of the information contained in the print module and the larger constructed image is ripe for artistic exploration.

Function

In addition to the inspiration that the process itself can bring to the print, there are the possibilities inherent in its function. In other words, looking at how prints are involved in the culture at large becomes fair game for artistic commentary. Culturally contextualized function as motivation for making works of art, including prints, derives its legacy from the conceptual art movements beginning in the 1960s. Artists questioned the commodification of the art object and rejected conventional and elitist modes of art consumption. Instead, they embraced artistic strategies of performative intervention which subverted the hierarchical status quo and interrupted preconceptions of elite ownership. With conceptual works, the authority of art shifted from the virtuosity of craft to the capacity of the idea to interrupt and call attention to a range of ideas or issues stemming from political and social motivations to epistemological conditions. Often the art object was ephemeral and the virtuosity of the hand was secondary to the intellectual or political impact—art as an intervention.

From this perspective, the print enjoys a culturally rich position, ripe with possibilities for subversive intervention. With so many diverse purposes, mixing traditional aesthetics and qualities from mass media, an epistemological questioning of the various modes of making, distributing, and acquiring information through the printed image seems a natural source of conceptual motivation. Just think of the potential commentary made possible by a reinterpretation of the myriad common contemporary printed elements—money, official "seals of approval," any kind of counting/stamping, books, posters, leaflets, signs, not to mention mass-distributed form of printed communication such as announcements or advertising. By referencing or parodying these other printed forms, the art print can function in a subversive manner, calling into question truths of political propaganda or other information granted authority through the printed form. The artist's role becomes that of a dissident, a progenitor of facsimile, forgery, propaganda, or satirical commentary. Artworks made with this kind of motivation tend to exist outside the traditional routes of dissemination, existing—often subversively—in the public eye, so to speak.

Certainly, this kind of work, with its built-in obsolescence, operates in a much different manner from the precious and unique art object.

Originality, Authorship, Authority

Walter Benjamin was not a defender of the notion that quality rested in the rarefied object. In the aforementioned essay, he suggested that standards of authority in artworks must change as a response to a world where modes of reproduction were ubiquitous to everyday life. He saw the tools of mechanical reproduction as liberating "the work of art from its parasitical dependence on ritual... [allowing it] to be based on another practice—politics."[4] He further argued "... that the whole sphere of authenticity was outside technical, of course not only technical reproducibility."[5] In other words, it was not craft that particularly mattered but the ability of any artwork to affect social change. Because reproducibility enables dissemination, it became an asset for works with a social or political agenda.

William Ivins, writing in his 1953 book *Prints and Visual Communication,* echoed this sentiment when he said "... what makes a medium artistically important is not any quality of the medium itself but the qualities of the mind and hand that users bring to it."[6]

Yet, throughout the recent history of the print, there has been an ongoing conversation about prints and their claim to status in the art world. Because of the multiple and the fact that prints are associated with non-artistic functions, there continues to be suspicion of printed works and their claims of originality. The case is confused further by other modes of reproduction, which use the indicators of fine art prints, specifically the conventions of the limited edition. Print artists and publishers take great pains to distinguish the "multiple original" from photomechanical reproduction of artworks made in another medium. In addition to printing with archival materials (the permanence dimension of Benjamin's aura), they cite the artist's direct participation and engagement in print media as an important and necessary condition of authenticity.

Anish Kapoor, *Untitled 10*, 1991. Color woodcut, 27½ × 23½ in (69.9 × 59.7 cm). Printed by Tadashi Toda, published by Crown Point Press, collection of Ackland Art Museum, University of North Carolina at Chapel Hill, Ackland Fund. Courtesy of the artist.

Kapoor's works evoke mystery with dark voids, and simple beauty in color, form, and tactility. Their inviting surfaces elicit fascination and contemplation. The artist collaborated with Japanese master printmakers Shunzo Matsuda and Tadashi Toda.

But even this definition is complicated. For those who locate artistic genius in the virtuosity of the hand, the collaborative conditions for the production of many print works that remove this hand from the process of making can be problematic. For such artists, the direct involvement of the hand is a non-negotiable condition of authenticity and originality. However, if we disassociate the idea of originality from the hand alone and locate it with the idea, then we can see that collaborative practices enable a transcendence of the limitations of any individual; originality, then, depends on a a collaborative venture, where relationship is integral to the artistic enterprise. Such is the case with the beautiful relief print by Anish Kapoor illustrated here. Done as part of Crown Point Press' woodcut program in Kyoto, Japan, it followed the divisions of labor traditional to Japanese *Ukiyo-e* printing. In this case, artisans Shunzo Matsuda and Tadashi Toda were the technical collaborators who cut and printed the 24 blocks used to make the print. The intention of the Crown Point program was to bring artists and artisans together to provide Western artists the opportunity to work with Japanese craftsmen, using skills not readily available to them. Kapoor traveled to Japan to work with Toda to refine color and form in the blocks. The success of the work ultimately relies on the relationship between the artist and the craftsmen.

Of course, artistic collaboration is nothing new. Artists have worked with assistants and fabricators or in artistic partnerships for hundreds of years. In many cultures, the divisions of labor, such as that for Kapoor's print, are uncontested. From this point of view, it is curious that such collaborative relationships are questioned. Consider the issue of originality from another point of view—that of the artist's creative intent. To be original also means to be creative. It is with this notion that most artists approach their image-making in any media. From this perspective, "original" is not synonymous with unique. The key to originality in print forms lies in the intent of the artist to exploit the intrinsic quality of the print medium in which he or she has chosen to work. This includes all of the unique, expressive qualities of any print medium or—as has been discussed—any myriad attributes or conditions prompted by the process or function of the print.

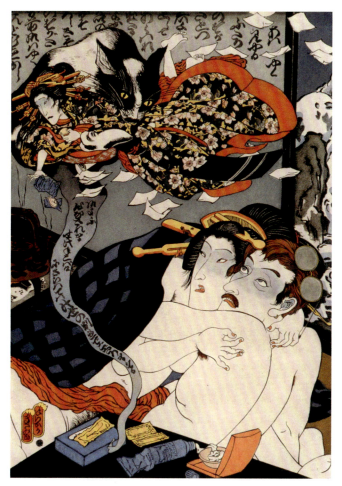

Masami Teraoka, *AIDS* series: *Geisha and Ghost Cat*, 1989–2002. Aquatint and sugar-lift etching with spit-bite and direct gravure, 27½ × 20 in (69.9 × 50.8 cm). Collection of Ackland Art Museum, Ackland Fund. Courtesy of Catharine Clark Gallery, San Francisco, California and Tokugenji Press, Ouda, Nara, Japan.

An example of a print with a social agenda, Teraoka's image employs a juxtaposition of historical style and contemporary narrative to highlight changing attitudes toward sex. Ostensibly celebrating dalliance and delicious decadence, historical *Ukiyo-e* prints came with a melancholic undercurrent—the good times must end some day. In Teraoka's print that day has come with the specter of AIDS.

Yet even this concept of the original has its limitations, and deserves to be pushed and challenged. The idea of originality can be accommodated on a conceptual level or even called into question as a necessary component for art. In fact, from a postmodern critical perspective, any tradition can and should serve as a point of reference for reinvestigation. Many print-making processes that heretofore have served as a means to the limited edition end can, and are, being explored in their own right. Adopting an attitude of "print strategy" can help to redefine and expand traditional uses of any print process.

Of course, these expansions of the print as an art form are just that—expansions. For many artists working within the tradition's discipline, there are limitless qualities intrinsic to printmaking that legitimize work in print media as fine art. It is the aesthetic that celebrates the beauty of ink on paper, the embossment of a woodcut, the seductive lithographic wash,

the essential intimacy of an image on paper, or the joy of the process itself. But at whatever point along that continuum between tradition and innovation an artist chooses to work, it should be arrived at from an informed sense of the various contexts. Standards for criticism in one context might be wholly inappropriate in another. To develop depth in one's own personal artistic voice, it is important to understand the point of view that is appropriate both from the perspective of the maker and of the viewer.

Print Classification

There are four general categories of traditional printmaking: relief printing, intaglio, planographic, and stencil processes. Leaving aside the more recent addition of digital means for the moment (we will return to the discussion in Chapter 2), we can speak of a print belonging to one of these categories from a couple of different angles. Identification of print type is made using several indicators, most commonly through the association between the materials used to make the matrix and the manner in which it is printed. A brief overview of these main characteristics follows.

Stencil

With stencil printing, images are made by forcing ink through a shaped opening. The term *pochoir*, French for stencil print-ing, refers to the most direct process whereby the stencil is hand-cut from paper or thin plastic. Ink is applied to the paper through the stencil openings with a stiff brush. Contemporary versions of the hand-cut stencil are almost ubiquitous in spray-painted graffiti.

Screen printing makes the stencil slightly more stable by creating one that is attached to a fine screen, traditionally made with silk. The screen-mounted stencil allows for very intricate information to be printed.

Relief

In fine-art printmaking, the relief print is associated with the woodcut, wood engraving, and linocut. The materials are carved and the printed image is made of what is left of the original surface. The result tends to be high-contrast, although some wood engravings can have quite subtle tonal ranges pro-duced through textural cutting, such as cross-hatching. The ink surface of the print is generally smooth, with an embossment of the block. This embossment is traditionally minimal, but can be exaggerated for enhanced relief effect of the printed surface.

Intaglio

Intaglio prints are traditionally associated with metal-plate matrices which are engraved or chemically etched to establish the image. Traditional platemaking processes can be further divided into two basic categories. Direct processes include engraving and drypoint. Etching involves the use of acids

to create the image. Within the sub-category of etching are designations that refer to how the plate was made. These include line etching, an essentially linear approach, and soft-ground, which allows for textural effects. Aquatint is a term often used independently to refer to a specialized etching process that results in a tonal image.

An intaglio print records the opposite of the relief. Instead of inking the top surface, ink is added to the depressions and recesses of the matrix. An impression is made by pushing dampened paper into these areas to pull the ink out. In the finished print, the ink layer sits up on the surface. This almost sculptural quality of the mark is often one of the most coveted attributes of the intaglio print. Another telltale sign of the intaglio print is the evidence of the plate embossed into the paper. This is called the platemark. It is not visible in bleed prints, which are prints made with paper that is smaller than the printing element causing the image to "bleed" over the edge of the paper.

Crossovers

The word collagraph comes from the union of two words, collage and graphic, implying a connection between the method of construction and the subsequent printing of an image. A traditional collagraph matrix is made in the manner of collage; cutting and pasting paper and other textural elements. Rather than existing as an end in itself, the plate is then printed in intaglio and/or relief methods. The visual characteristics of the inked surface are similar to intaglio and relief qualities, but the fact that the plate is constructed in this collage manner is usually easily discernible.

As print artists have explored a variety of material possibilities, the category of collagraph has expanded to include printing matrices that are made with a combination of techniques. Photo-collagraphs employ light-sensitive films or emulsions to establish information.

Other recently developed material technologies, such as photo-sensitive plastics, are often used in either intaglio or relief manners. In such cases, the resulting print is identified by the manner of printing.

Embossings are essentially inkless images produced by impressing dampened paper into the surface of any relief or intaglio plate. The result is essentially a low-relief sculpture. A strong, raking light is necessary to see the image.

Planographic Process

Lithography is the planographic process. What prints in a lithograph is what is drawn on the surface of the stone or plate. Lithography is a chemical process based on the principle that oil and water don't mix. The artist draws on a specially prepared flat stone or metal plate with a greasy substance. The stone or plate is then chemically processed to create mutually exclusive printing and non-printing areas.

The surface of a lithograph is smooth. Ideally, the ink is absorbed into the paper. It can be difficult to discern the order of printed color.

Mixed Processes

Many contemporary printmakers employ a mixture of different processes. Their interest is less in the purity of a particular medium than in the appropriateness or efficiency of an approach to realize an idea. Sometimes, processes are used as modifying agents in other processes. This is especially true of stencils, which are regularly employed in relief, intaglio, and lithography practices.

Combining processes has some technical implications which will be addressed in the mixed media chapter (see pages 205–219). In this regard, the classification of process is useful in that the differentiated language helps to communicate ideas, and practical suggestions for realizing work. William Ivins raised a concern surrounding such labeling, though, when he expressed his frustration at the tendency for prints and print artists to be "hamstrung by arbitrary definitions." We hope to heed that caution in the rest of this book as we introduce the technical aspects of printmaking. We believe that the practices and procedures described in this book can contribute to an intellectual and practical "toolkit" that enhances and informs individual approaches to printmaking. But in the end, the point is to make good art.

NOTES

1. Weisberg, Ruth, *The Syntax of the Print; In Search of an Aesthetic Context*, *Tamarind Papers* Vol. 9, pages 52–60, 1984. In this seminal work of print theory, Weisberg advocates a theoretical framework for print practice, arguing that analysis of printworks based simply on technical virtuosity was reductionist. This work expanded critical dialogue within the US and global print communities that continues to evolve to this day.
2. Benjamin, Walter. "The Work in the Art in the Age of Mechanical Reproduction, Illuminations: Essays and Reflections", edited by Hannah Arendt, Schocken Books, New York, page 221.
3. Benjamin, Walter. "The Work in the Art in the Age of Mechanical Reproduction", page 230.
4. ibid.
5. ibid.
6. Ivins, M. William, Jr, *Prints and Visual Communciation*, Harvard University Press (MIT Press paperback edition, 1978), page 114.

Chapter 1
Practical Matters

Most of the processes described in this book assume access to a workshop outfitted for printmaking. That being said, there are many processes that require only a minimal setup to enable you to have a productive printmaking experience. In this chapter we look at some practical ideas to help you set up and to explain some common printmaking issues and routines.

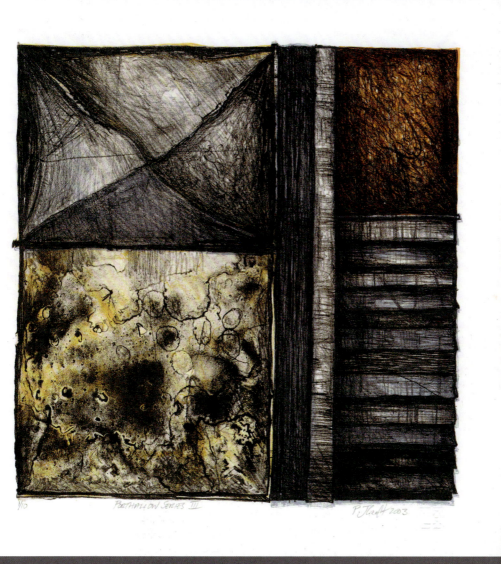

Paul Croft, *Porthallow Series II*, 2003. Waterless lithograph, 8 × 8 in (20 × 20 cm).

This piece is part of a series of eight or nine prints that were made from drawings of fishermen's huts in the small hamlet of Porthallow on the Lizard Peninsula in Cornwall, in the very southwest of England. The artist was attracted by the age of the huts, probably at least 100 years old, and their construction of whitewashed walls and bitumen-covered wood—with an accumulation of detritus, layers of salt, rust, and fish guts. Croft comments, "they were quite sculptural—and wouldn't have been out of place in the Tate Modern."

Setting Up Shop

A basic print studio needs to adapt to a variety of procedures. It is ideal if separate areas can be maintained for clean work, such as paper preparation, and messy procedures, such as mixing ink. At the very least, dedicated spaces are needed for inking, as well as a ventilated station for toxic processes, sinks for washing out and cleaning up, a darkroom for photo processes, and spaces that can be used for print drying and storage of materials and finished work.

Printing Equipment

While in some cases the objective of transferring ink to paper can be accomplished by hand, the use of the printing press is essential for several forms of printmaking. The way that pressure is applied distinguishes presses from each other.

The action of an etching press is like that of an old-fashioned clothes wringer. With the matrix and paper situated on the press bed, printing blankets—also called felts—are placed on top. The assembly is cranked between two cylinders, which

CLEAN | DIRTY

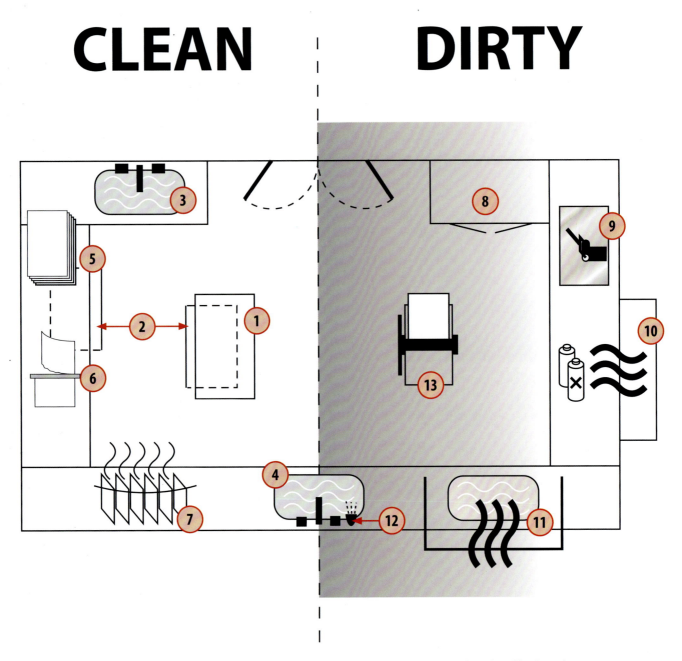

An efficient shop setup locates clean operations away from messy ones. Efficiency is also enhanced if workstations are sequenced more or less to the workflow. Start with a centralized work surface (1). Smaller studios can make good use of spaces below for storage (2). It is ideal to have two sinks, one for paper-soaking (3) only and the other for general cleanup (4). Paper handling takes place in the clean areas: a blotting station sits next to the paper-soaking sink (5), paper tearing (6), and print-drying station (7). On the "dirty" side, use under-counter space to store solvents in a metal fire-safety cabinet (8). The inking station (9) has a glass slab for rolling ink. A spray booth with fume exhaust (10) is important for maintaining air quality safety in the shop. Similarly, acid baths (11) should be situated in an enclosed, vented station or in a separate room with good exhaust ventilation. This diagram locates the acid bath next to a sink with an emergency eye-wash attached (12). Finally, the press (13) sits in the center, near the central work surface.

apply sufficient pressure to transfer the ink from the matrix to the paper.

Lithographic presses work by having a directly mounted scraper bar positioned over the press bed. When the scraper bar is lowered onto the printing element, it exerts a great deal of pressure as the bed travels under the scraper bar.

From the earliest days of movable type, iron hand presses were the production presses for printing type and relief imagery. As the technology for mass production moved to lithographic (and now digital) technologies, these presses found their way into the fine art printmaking studio. Known by their trade names of Albion, Washington, or Columbia,

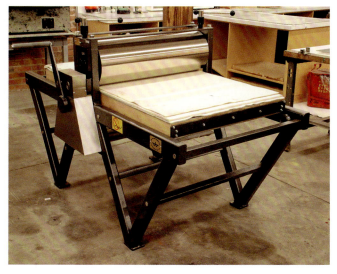

● The etching press is perhaps the most versatile of all kinds of presses. In addition to printing intaglio plates, it can be adapted for printing relief blocks and lithographic plates.

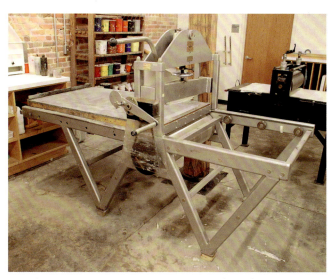

● Litho presses can be adapted for printing some relief and monotype work.

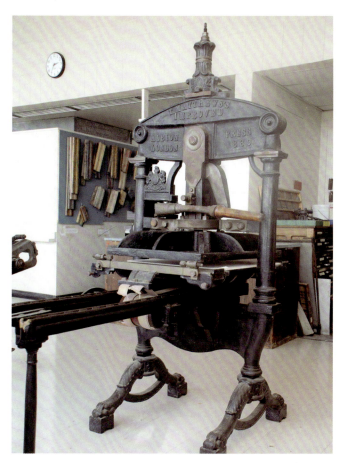

● Originally designed for letterpress printing, the iron hand press is a fine choice for all types of relief printing.

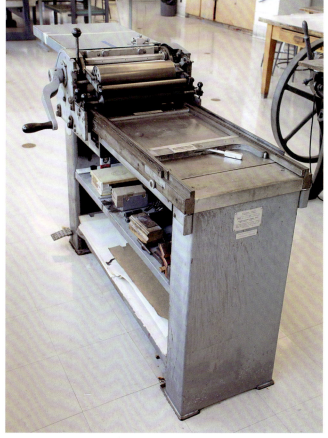

● The cylinder proof press is another favorite press for relief artists. Relief blocks must match the height of the type being printed—the standard type measurement is 0.918 in (2.3 cm).

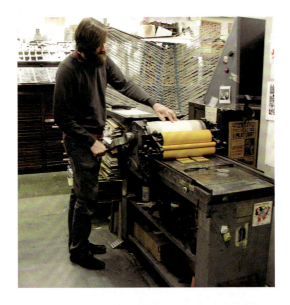

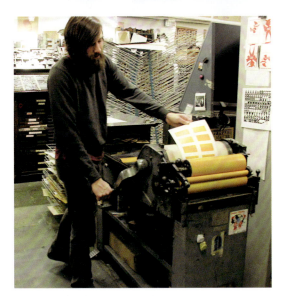

these antique presses have become favorites for relief and letterpress printmakers.

The iron hand press works with a vertical motion. The pressure is controlled by building up packing underneath the relief matrix until the pressure is firm. The amount of embossment of the print can be controlled by adding soft packing on top of the printing paper.

Screen printing requires a flat, smooth surface to which a screen is hinged. Ideally, this is a smooth table with permanent hinge clamps mounted on it. Alternatively, clamps can be mounted on a portable board, which can be stored when not in use.

⌃ Adam Ewing from Yee-Haw Industries of Knoxville, Tennessee, works at a Vandercook proof press. Yee-Haw specializes in original art-like products, from letterpress posters promoting special events, music acts, and theater shows to handmade, woodcut, fine art prints.

⌃ Screen printing must be done on a very smooth surface. Specialty clamps can be mounted directly onto a table or a smooth board if portability is desired.

Standard Tools and Equipment

The following is a basic list of standard tools and equipment:

- First aid kit
- Brayers and rollers
- Ink knives
- Razor scrapers
- Inking slabs—a piece of plate glass that is big enough to accommodate the largest roller
- Scrap paper (newsprint)
- Drying system: for dry-printing paper, an open-air system of racks or hanging paper; for dampened paper, smooth boards or drying stacks.
- Hair dryer and heat gun
- Rags and rag bins

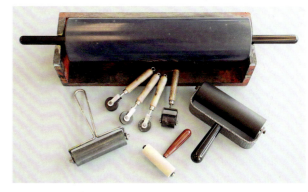

⌃ Brayers have one handle, rollers have two (both tools are called rollers outside the US).

Drying systems

◦ To dry prints made on dampened paper, tape wet prints to a board so that, as the paper dries and shrinks, the print will become very flat. Sometimes prints are taped face down, so that when the tape is removed it will not show on the face of the print.

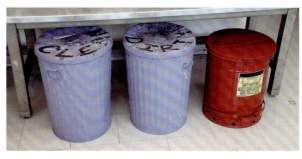

⌃ At the University of North Carolina in Chapel Hill, a container system cycles rags from "clean" to "usable dirty rags" to "soiled rags." Closed containers keep any solvent fumes out of the shop environment. Soiled rags are picked up by a rag service for cleaning.

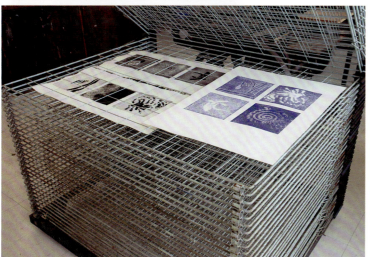

⌃ A drying rack is a simple way to air-dry prints made on dry paper, such as lithographic, relief, or screen prints.

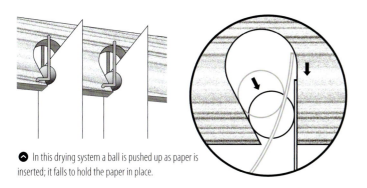

⌃ In this drying system a ball is pushed up as paper is inserted; it falls to hold the paper in place.

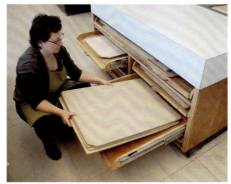

⌃ Drying stacks made with insulation board. Wet prints are covered with clean newsprint and placed between boards. The fibrous board wicks away moisture, yielding a flat, dry print within a couple of days. At the University of North Carolina, drying stacks are stored on convenient roll-out shelves for easy access.

Solvents

Many printmaking practices require the use of solvents. These can range from simple, non-toxic solvents such as water or vegetable oil, to substances that are more dangerous. Fortunately, many print practices have evolved so that the use of highly toxic solvents can be avoided or at least kept to a minimum. With proper precautions, most operations can be undertaken safely.

The cardinal rule is to use the least toxic solvent needed for the job at hand. Material Safety Data Sheets (MSDS) contain information on health, flammability and stability of solvents. Use this information to label all containers clearly with the solvent's name and hazard ratings. When using more toxic solvents, protect hands by wearing nitrile gloves and avoid inhalation exposure by working with local exhaust ventilation or wearing a respirator. Minimize fire hazard by storing stock supplies of flammable solvents in fire-safe metal cabinets.

It is very important to label all solvents accurately. A color-coded system helps to identify solvents quickly.

Common Solvents and their Uses

Solvent	Use
Water	Dampens paper, cleans gum arabic.
Vegetable oil	Dissolves oil-based inks, used for cleanup and to oil photocopies for photo-printmaking transparencies.
Biodegradable degreaser/cleaner	Used as general cleaner for water-based materials and to degrease and remove haze from ink slabs and mixing knives after using oil or solvents.

More Toxic Solvents (use only in adherence to proper safety guidelines*)

Solvent	Toxicity rating	Fire hazard	Use
Acetone	1–2	3	Removes spray paint. Used for photocopy transfer and in the solvent chamber to fuse toner powder to plastic sheets (Mylar or polyester plates).
Denatured alcohol (ethyl alcohol)	1–2	3	Degreaser for cleaning ink slabs. Removes rosin-based aquatint and shellac. Removes some acrylic-based grounds.
Lithotine	1–2	2	Specific to lithographic processes for image processing. Press stations should have adequate local ventilation.
Mineral spirits	2	3	Removes asphaltum-based etching grounds. Used as a general conditioning cleaner for brayers and rollers.

*Ratings based on 0=no hazard to 4=deadly.

Inks and Additives

Success in printing often depends on the quality of ink used to make the print. Not only do the different printmaking processes require different properties of ink, but different applications within the processes may require modification to yield desired results. It is important to know about the general properties of ink and additives to be able to adjust inks for each purpose. Some processes rely on very specific inks—for example, screen printing employs a specialized water-based ink. With relief and intaglio processes, artists can choose traditional oil-based inks, water-based acrylic or water-washable oil, or soy-based alternatives. All inks, regard-less of whether they are oil-, rubber-, soy-, or water-based, are made by suspending a pigment in a binding medium, known as a vehicle.

Oil-based Inks

Used for relief, intaglio, and lithography, oil-based inks use polymerized linseed oil as a vehicle. The process of polym-erization changes the chemical structure of the oil, essentially beginning to convert the oil to a solid. Depending on the length of time that the oil is processed, the resulting medium ranges from runnier burnt plate oils to more viscous litho-graphic varnishes. Another consequence of polymerization

is that the resulting vehicle does not cause organic material to deteriorate, as the original oil would. This means that oil-based inks can be printed directly onto rag paper without having to prime the surface first, as in oil painting.

After printing, polymerization continues as the ink dries or cures. This can affect how well the ink layers can be printed on top of each other. Too wet or too dry an ink can cause a subsequent layer to be rejected.

The other main difference in the manufacture of oil-based inks is the particle size of the pigment. Inks formulated for lithography and relief are made with a small particle size to ensure the greatest color strength. This is especially important in lithographic inks, since layers are printed quite thinly. Intaglio inks are made with a larger particle, facilitating the wiping process of printing intaglio plates. Different pigments also bring their own unique attributes to any ink mixture and may require specialized handling of individual colors.

Other additives in an ink mixture can include driers and waxes. These basic components are varied according to the ink being made and their proportions can affect the working properties of the inks. The most important working properties of inks include viscosity, tack, the thixotropic nature, and, in the case of lithography, the grease content of inks.

Viscosity refers to an ink's ability to flow. It can be measured both by the rate of flow and length of an ink. Viscosity also relates to the relative oiliness of an ink. Stiffer inks are short, more viscous, and less oily; looser inks are long, less viscous, and oilier.

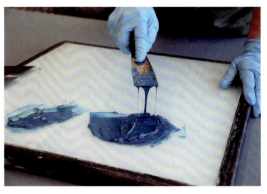

To determine the length and flow of an ink, lift the ink from the slab with the broad side of the knife. A stiff, dry ink will break quickly, while a long ink will string out.

Tack refers to the stickiness of an ink and can affect its ability to adhere to the paper.

The term thixotropic describes the tendency for most printing inks to loosen up as they are worked. Work ink initially in order to determine and adjust its properties according to how it will be used.

Oil-based inks for relief, intaglio, and lithography

Inks formulated for different processes consider the manner in which the ink is applied to the printing matrix. Intaglio inks are designed for wiping a plate. Relief and lithographic inks must be rolled into a thin film and applied to a matrix.

Modifiers for Oil-based Inks

Modifier	Purpose
#000 Burnt plate oil (reducing oils)	Thin-bodied oil that reduces tack and length without increasing greasiness. Reducing oils and varnish are numbered from #000 (light) to #8 (thick).
#3 Burnt plate oil	Medium-bodied oil used to increase adhesion, particularly when broken traces are experienced in intaglio printing.
#3 Litho varnish	Reduces body, tack, and length. Increases greasiness.
#5 Litho varnish	Increases tack and length. Reduces body.
#7, #8 Litho varnish (body gum)	Increases body, tack, and length.
Magnesium carbonate (known as "mag")	Stiffens and shortens ink. Reduces tack and grease content, so sometimes used in combination with a heavy varnish or body gum to retain sufficient tack for litho or relief inks.
Easy Wipe	A reducing compound. Shortens ink and reduces tack without affecting the body of the ink. Aids wiping intaglio plates—important for collagraph printing.
Miracle Gel	Similar to Easy Wipe, reduces body and tack. Add 5–10 percent by volume for most applications. In litho inks, decreases tack without increasing greasiness (helpful when printing large flats that tend to show roller marks). When added to relief inks, reduces the tendency of soft papers, such as traditional Asian papers, to stick to the wood or linoleum.
Reducers (Sureset, Setswell Compound)	Reduces tack and assists adhesion or "trapping" of ink into the paper, preventing a build-up of ink and inhibiting rejection of subsequent ink layers. Most often used in lithographic ink mixtures.
Clove oil/eugenol (synthetic clove oil)	Retards drying. Use one to two drops for about a walnut-sized quantity of ink.
Cobalt drier	A viscous, purple liquid that speeds up ink drying by attracting oxygen more quickly to the ink. Use only a small amount.
Tu-Way drier	Promotes drying from the inside out.

Intaglio inks are made with a burnt plate oil vehicle and have a large pigment particle. Ideally, this creates a looser ink with a short, low-tack, buttery consistency that is perfect for wiping. In actuality, some manufacturers have considerable variety in consistency between colors. Some pigments (Thalo colors, for instance) tend to be more difficult to wipe, requiring modification to reduce tack.

Lithographic inks use a more viscous varnish as a vehicle with a very finely ground pigment. Generally, they are short and have a higher tack, which allows subtle details to print clearly. These properties of length and tack are adjusted depending on the amount of detail and the particular qualities of the lithographic printing matrix. The grease content is important to the stability of the lithographic printing element.

Relief inks, made especially for this type of printing, are similar to lithographic ink in their manufacture. The vehicle is a heavier burnt plate oil or a lighter varnish. They have sufficient tack to help inhibit paper movement during hand-printing, but not so much that the paper will "pick," causing it to tear. In most cases, relief inks also need to be short, so that the edges of relief shapes can print sharp and clear.

Inks formulated especially for relief or lithography are more likely to be ready to use direct from the can. Intaglio inks can be modified for relief purposes, but some intaglio inks can be too runny for relief printing. In general, dedicated relief or modified lithographic inks are best suited for relief work.

Modifiers for oil-based inks

No matter what kind of print you are making, there will be requirements unique to the situation at hand that may require some modification of ink properties. In reality, all properties are interrelated, so that modifying one will also affect another. In general, the best ink is the one that is modified the least, but appropriately for optimal printing. In most cases only small amounts of modifier are required. Let moderation be your guide. See the table on page 23, which lists common modifiers and their respective purposes.

Water-based and Water-washable Inks for Intaglio and Relief

In recent years, manufacturers of printmaking inks have responded to government regulation and the general interest in lowering toxicity by introducing ranges of water-based and water-washable inks. The main benefit of these inks is that they do not require the use of any solvent for cleanup. If reduced toxicity is the primary reason for choosing such inks, it remains important to be sure that the pigments used also conform to nontoxic standards (see discussion in the safety section in this chapter about product labeling, page 32).

Water-based and water-washable inks are two somewhat different products. Typically, water-based types are acrylic products, while water-washable inks are oil-based and have been designed to clean up safely with just liquid hand soap and water. It is this latter category that holds most promise for the contemporary printmaker, in that the working properties are basically the same as the familiar traditional oil-based inks. In situations where oil-based products are discouraged or banned, these products are the best alternative.

Water-based Screen-printing Inks

When screen printing first became popular with artists in the early twentieth century, oil-based inks were standard. Unfortunately, because of the high solvent content, using these inks rendered screen printing perhaps the most toxic of all printing processes. Thankfully, the development of water-based acrylic inks has supplanted oil/solvent-based inks and is now the norm, and there are few instances where an oil-based product would be necessary.

Water-based inks are available from several suppliers in varying grades. The best ones are made with finely grained pigment particles so that the ink can pass through very fine mesh screens. Products range from heavily pigmented, more opaque professional-grade inks to less densely pigmented cheaper student-grade inks. Specialty inks made for printing on fabric contain an additive that allows ink to be heat-set into the fabric once dry. Different brands also have varying product lines of additives and thinners, such as transparent base (for changing the opacity of inks) or gels and varnishes (for changing inks from mat to glossy.) When first considering inks, try several brands to compare their working properties.

Mixing Inks

Mixing colored inks for printmaking is a simple matter of understanding basic color theory if the print is a single color. But when printing multiple color layers, it is also important to understand the relative opacity or transparency of your ink mixtures. Opaque inks will cover previously printed information while transparent inks yield a mixed color where colors over-

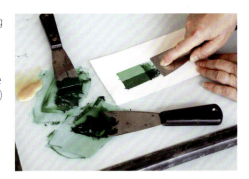

❯ Test colors by making a "draw-down" and "tap-out" to see what the ink looks like, both as a thick deposit (what it looks like in the mound on the slab) and in the variations that it might have in the print (a thin solid layer or a dispersed layer). To check opacity and simulate the effect of layered color mixtures, draw the ink mixture across a previously printed scrap of paper.

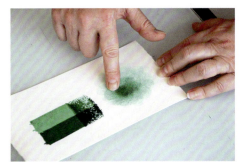

lap. Some colors are inherently more opaque than others. The degree of transparency can be determined by a "draw-down," a method by which a dab on ink is placed on paper and scraped clean to make a thin film that mimics a printed layer of ink.

If desired, inks can be made more transparent by adding transparent base, sometimes called transparent white. Quite subtle colors can be made using only a very small proportion of this base to pigmented ink. When planned efficiently, a print using a few transparent colors can create the appearance of many more colors with the overlapped mixtures.

When mixing inks, always add darker colors to lighter colors, including transparent base, which falls into the "light" color category. Start by combining small quantities until satisfied with the mixture. Keep track of general proportions so that a larger quantity can be mixed later. Printmaking inks are generally more saturated than their painting medium counterparts. This fact can be key to a color-mixing strategy. Test colors to get a sense of the varying densities that might print. Isolate the color with a window viewer to see the color in context. Once satisfied with the color, mix a larger batch. When modifying (adding retarders, oils, or driers), first adjust only a small amount of the ink mixture. Modify the rest after testing.

Paper

Making the various printing matrices described in this book usually seems the lion's portion of the work involved in printmaking. But, all too often, the consideration of what to print that information on is left to the last minute. Certainly, there are many occasions when a variety of papers will suffice. But it is a shame to overlook the potential of available alternatives that can actually enhance the work or, in some cases, contribute to and inform the content of the work. Get into the habit of considering these options as part of your image-making strategy.

An artist should be concerned with several factors when choosing a paper. For nearly all print processes, a paper needs to be strong, have some longevity and, for most applications, have little or no sizing. Most printmaking papers of any quality have low acidity and contain some cotton or linen fibers. This is called the rag content. The best papers have a neutral pH and are 100 percent rag. Many acceptable papers, however, are 30–50 percent rag combined with a buffered high-alpha wood pulp.

The weight of a paper can be another important factor. Generally, papers in the 200 to 300 grams per square meter (gm^2) are good for most printmaking purposes. Lighter-weight Asian papers are traditional for woodcut and wood engraving. Embossing and collagraph printing tend to require much more substantial papers.

The surface texture of a paper can be an enhancement or a limitation depending on the technical requirements of the various printing procedures and your aesthetic requirements for the image at hand. Surface texture is a function of how the paper is made. All paper is made on some kind of screen, then transferred to a felt, or in the case of Asian papers, to a smooth surface, for drying. Consequently, the surface of the paper will retain some of the characteristic of the material that it has touched. In traditional papermaking, sheets of paper are made using a mould and deckle. The mould is a frame covered with a screen. The deckle is a second, removable frame that sits on top of the screen to keep the pulp from flowing off the screen during the papermaking process. The feathery edge of a piece of paper is also called a deckle and is a byproduct of the process of forming a sheet of paper.

The kind of screen most often used is a wove screen, imposing a very even, regular texture in the paper. A laid screen, on the other hand, imposes a definite pattern that is visible when the sheet is held up to the light. In the same way, a watermark

◬ The beautiful laid lines in sheets of Roma and Nideggen papers.

◬ The Arches 88 watermark is a clear example of this paper feature. When looking at the face of the paper, the watermark should read correctly. This can be helpful when trying to determine the "front" of smooth papers.

Choosing Papers

Job	Qualities to look for	Some common paper choices
Screen printing (water-based inks)	Paper with sufficient sizing to withstand the moisture content of the inks. Smooth surfaces.	Rives BFK, Stonehenge, Lokta, Aquaprint, Hahnemuhle silkscreen, Pescia, Somerset Satin, Somerset Velvet
Relief (hand-printing)	Softer, thinner papers that handle more easily. As the print is burnished, the image can be seen through the back side of the paper, offering a gauge to the quality of printing. Asian papers are traditional for woodcut.	Arches text, Hosho, Kitikata, Okawara, Rives Lightweight, Sekishu
Relief (press printing, dry)	Soft, smooth paper for dry printing.	Arches 88, Arches Text, Domestic Etch, Stonehenge, Hosho, Kitikata, Okawara, Pescia, Rives Lightweight, Rives Heavyweight, Rives BFK, Rives de Lin, Somerset Velvet, Sekishu
Relief (press printing, damp)	Requires heavier paper that will withstand dampening and embossment from relief printing elements. Can handle more texture.	Arches Cover, Copperplate, German Etch, Johannot, Rives Heavyweight, Rives de Lin, Somerset, Stonehenge
Intaglio (etching and photo collagraph)	Soft, flexible paper. Use heavier papers for deeply embossed plates. Waterleaf papers must be prepared in a damp box rather than soaked and therefore require a one-day advance preparation.	Arches Cover, Copperplate, Domestic Etch, German Etch, Johannot, Rives Heavyweight, Rives de Lin, Lennox, Pescia
Collagraph	A soft but strong, heavier paper that can withstand the more dimensional embossment of collagraph plates.	Arches Cover, Copperplate, German Etch, Johannot, Rives de Lin, Pescia
Lithography	Paper with a relatively smooth surface. Better if not sized. Some soft but textured papers can be printed successfully after calendaring or dampening slightly.	Arches Cover, Arches 88, Mohawk Superfine, German Etch, Japanese Etch, Magnani Incisioni, Pescia, Rives BFK, Rives Lightweight, Rives Heavyweight, smooth Asian papers
Monoprint	Smooth waterleaf papers are best for dry printing from smooth surfaces.	Arches 88, Pescia, Rives BFK, Somerset Velvet
Chine Collé	A wide variety of papers will work, but thinner, Asian papers are traditional. Those made with gampi or kozo fibers are very strong.	Kitikata, Sekishu, Mulberry, Moriki, Okawara, Silk Tissue
Inkjet printing	Smooth, sized papers or papers coated especially for inkjet printing.	Somerset Velvet, Somerset Satin, Hahnemuhle digital, Arches Infinity, Concorde Rag

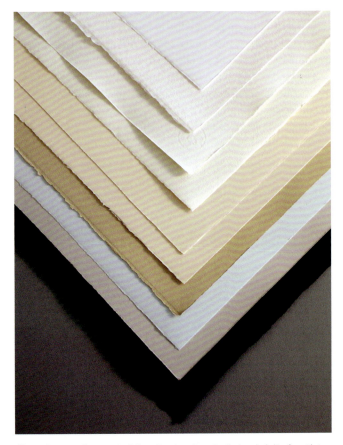

⌄ A wide variety of papers is available to the printmaker today. Get into the habit of considering paper choices as part of the conceptualization of the image.

⌄ Asian papers are traditionally used for handprinting relief images. The term "rice paper" is a common misnomer as there are no papers actually made from rice. Papers can range from very thin silk tissues to strong, sturdy papers made from kozo, bamboo, abaca, and other plant fibers. Papermaking enterprises are strong in Japan, China, Thailand, and the Philippines.

may also be visible. The screen side of the paper is usually considered to be the back of the sheet. Printing is ordinarily done on the face of the paper, although the printer should print on the side most suited to the job at hand.

Other surfaces can be given to a paper by pressing it against various smooth or rough surfaces. A rough paper is the paper as it exists when it has only been pressed between the original felts used to form the sheets. Cold pressed refers to paper that has been made smoother by pressing between fine weave felts or cold metal cylinders. Hot pressed papers have a very smooth surface from being pressed between hot metal cylinders. The degree of roughness and smoothness that these processes give depends somewhat on the makeup of the paper, its additives, and its thickness.

Common additives in paper are sizing, dyes, and bleaches. Most paper contains some sizing, which aids in the binding of the fibers and stiffens the paper. It affects the absorptive properties and sometimes the tactile qualities. Sizing can also affect the longevity of a paper if it is too acidic. Paper without size is called waterleaf. Dyes are the least predictable additive to papers. Some dye colors are fugitive, and can fade when exposed to light. Inclusions are bits of fiber, bark, or other materials added to papers to create enhanced textures or decorative effects.

Papers for Print Processes

Each print process has considerations that make certain choices more or less effective. See the "Choosing Papers" table on page 26, which lists the qualities needed for different processes, and some of the commonly available papers suitable for each type of job.

Registration

Printmaking is a process of layering. The task of aligning information is part of both the matrix-making process and printing. When printed, all elements must align precisely on the paper. The goal of registration is to align layers of printed information.

The following basic approaches to registration are used for most print processes, sometimes with adaptations. Guide patterns can be useful in many applications but are the most common for printing on an etching press. T and bar and punch systems are typically used with dry paper.

Mylar

Polyester film, known in the United States by the trade name Mylar®, is perhaps the most helpful material for achieving correct registration when developing multiple matrices. Due to its dimensional stability, polyester film is preferable to other materials, such as acetate. It is almost always a component of other registration systems, especially punch and T and bar.

"Pulling a Mylar" refers to printing the matrix onto a sheet of Mylar. When using T and bar or punch registration, be sure to record those marks on the Mylar. Once printed, dust the wet ink with talc to keep it from smearing. The Mylar is then used to develop other transparencies for use in photographic processes, or to lay out subsequent matrices in register to the first. Because Mylar is transparent, it can be positioned by eye until elements align. Once in position, registration marks (T and bar or punch) can be set. During the printing process, the Mylar is used to position the paper and/or matrix relative to the press, table, or each other.

Mylar

A key image printed in red lies underneath a second Mylar. Black India ink is used to create a solid shape. This second Mylar is then exposed to a photosensitive matrix, which will eventually print a solid color underneath the key image.

Layers drawn on translucent drafting film are aligned on a set of punched Mylar sheets.

In this example, the Mylar serves as a carrier for a collage of photocopied elements that will ultimately become a transparency for a screen-printed stencil, to print on the top of the existing image.

A key image printed on Mylar can be used to locate information on to other matrices. In this case, a chalk paper placed between the image Mylar and a litho plate enables information to transfer by tracing.

The Jig

A registration jig is used for developing multiple matrices. A key drawing or Mylar proof is taped in a fixed position. A plate or block sits underneath, positioned against a fixed corner. Information can be traced from the key image onto multiple matrices or vice versa. This system can be made temporarily, just using tape to affix the paper and mark the position of plates. A cardboard jig is easily made by affixing an L-shaped board to a base and hinging a second L-shaped board at the edge.

⌃ A cardboard jig is most useful when working with intaglio plates or unmounted linoleum.

Guide Pattern

A printing guide or pattern is most often used on an etching press. It has precise markings to locate relative placement of plate and paper. To make one, take a sheet of newsprint and mark the boundaries of the paper. Mark the center axis on the outside of this boundary so that it can be used with T and bar marks. Position the printing matrix relative to the paper position and trace its shape. Place the pattern on the press bed and cover it with Mylar.

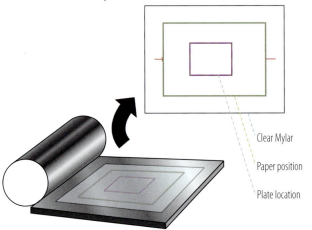

Clear Mylar

Paper position

Plate location

⌃ A guide pattern placed under a plastic sheet records the relative position of the paper and plates. Colored markers can help to code the placement of different elements.

Punch

Punch registration is very accurate. It is most commonly used for screen printing and lithography. A punch system requires a multiple hole punching tool and pins designed to fit the punched hole. A paper punch from an office supply store can do the job, although heavy-duty versions made especially for this purpose are available from specialty printmaking suppliers.

To use this system, start by tearing or cutting the paper to be printed at least 3 in (7.5 cm) longer than the final intended sheet size. This extra length is where holes will be punched and is removed once the printing is complete. Mark the center of the paper and transparencies and, in the case of lithography, the plates. Next, align these center marks at the same point on the punching device and punch a set of holes in everything. Be sure to punch all materials in the same orientation in which they will be ultimately be printed; for screen printing place everything face up; for lithography place plates face up and all papers and Mylars face down. In addition, punch a thin strip of cardboard or aluminum plate to hold a set of registration pins. Use a Mylar to position the strip with its pins in place and attach it to the screen printing table or stone. Printing commences by simply laying the end of each sheet of paper on the pins and lowering it into place.

⌃ Here, a set of Mylars is being punched in preparation for a silk screen print. Pins can be set into a pre-punched strip or set individually to the printing matrix (lithography plate or stone) or onto a table (screen printing and trace monoprint).

T and Bar

T and bar is perhaps the easiest system and can be quite accurate. Unlike a punch system, it does not involve having a margin that is later trimmed away. With a sharp pencil, mark the back of each sheet of paper at the midpoints, with a T at one end and a bar at the other end. These T and bar marks are lined up against corresponding T and bar marks on the matrix or registration pattern. T and bar is mostly used with dry paper for relief, lithography, and monoprint.

❯ T and bar marks scratched into the matrix or drawn on a registration guide align with corresponding marks on the printing paper.

Kentō

Kentō is a Japanese registration system specific to woodcut. Similar in concept to T and bar, registration guides exist in fixed positions right on the matrix. A corner stop, or *kag*—an L-shaped cut—is made in the lower right-hand corner of the block. A second alignment stop, or *hikitsuke*, is cut about two-thirds of the way down the long side of the block. The paper is positioned so that it rests in the corner, and is then aligned to rest against the side stop.

⌄ Kentō stops are cut directly into the woodblock.

Proofing and Editioning

Conventional printmaking practices usually involve making a series of proofs to fine-tune an image toward its final state. When that point is reached, the artist or printer can make copies of that image. The total number of those copies is called an edition. Sometimes a matrix will be editioned at various states along the way. If the images are similar, the titles might include an indication of the state, such as "Great Print (State I)" and "Great Print (State II)." But if the image is sufficiently changed, an artist might decide to title the later work independently.

Proofing

There are several designations for proofs made in developing an image. A trial or working proof is one taken while the matrix is being developed. These proofs are pulled so that the artist can see what work still needs to be done to the matrix. Once a printed image meets the artist's expectations, it can either

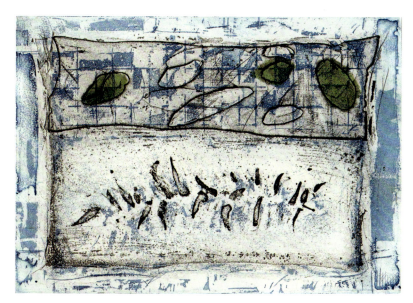

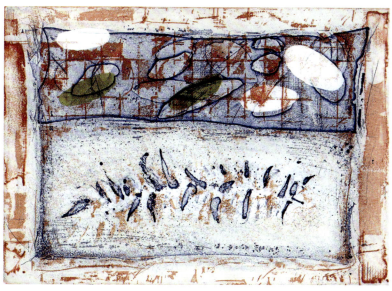

◄ A set of plates can be inked in an infinite number of ways. Proofing allows exploration of such possibilities. It can be an end in itself, creating unique images, or can lead to a *bon à tirer* proof (see page 31) as a guide for an edition.

This is an example of a working proof—notice the commentary and markings
made on the print to guide further development of the image.

be accepted as a unique image and signed as a state proof or, if copies of the image will be made, it can becomes a *bon à tirer* ("good to pull" in French) proof. The *bon à tirer* is also signed by the artist and in the place of the edition number, the words *bon à tirer* or the initials BAT are written. This designation indicates the artist's approval and is used for comparison purposes when printing the edition.

Editioning

Creating the plate through various techniques and developing and adjusting the image through proof printing is the art of printmaking. Pulling an edition comes under the heading of the business of printmaking.

There are a few "rules" to follow when editioning. Of course, rules are made to be broken, but if there is no good reason for doing so, use these conventions:

- Paper is commonly torn rather than cut.
- Paper deckles go to the right or bottom of the print.

- Borders on prints are equal on the top and sides and larger on the bottom, by about 1/16–1/2 in (6–10 mm).
- Prints should be free of smudges and fingerprints—both front and back!
- Prints are signed with the proof designation or edition number, title, and artist's signature.

In addition to BAT, there are some other notations that are commonly used to designate specific prints or aspects of the printing:

- In lieu of edition numbers, TP (for trial proof) or CTP (for color trial proof) is written to denote single state proofs.
- Artist's proof or AP is used to indicate copies of the image, identical to the edition, which the artist keeps for personal use. Artist's proofs should make up no more than 10 percent of the edition size. Some artists erroneously use this designation for copies that vary from the edition. Properly, variant impressions should be called trial proofs or state proofs.

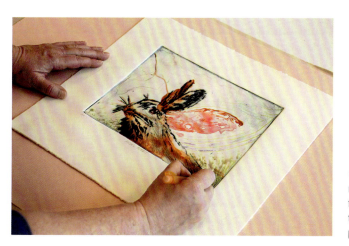

◀ A tearing bar is a stainless steel straight edge with a beveled side. To streamline tearing paper for an edition use a tearing guide. Set the paper in place, face down, and align the tearing bar to the tear guide. Hold the bar firmly and tear the paper by pulling across the bar.

◀ Notation on prints with borders traditionally occurs at the bottom of the plate mark or at the base of the printing paper. Signatures on bleed prints can be on the face or on the back of the print. Placement of notation is certainly one convention that is routinely disregarded. Some artists prefer to sign all work on the back of the print, while others place the signature aesthetically inside the work.

Safety in the Print Shop

Before discussing any technical process, it is important to understand and develop a healthy respect for the materials and processes of printmaking. It is a foolish or naive artist who adopts a cavalier attitude when working with toxic materials. Safety in the print shop falls into two interdependent categories: material toxicity and safe procedures. While it is best to seek products that minimize or eliminate toxicity, some processes may require the use of hazardous materials. In these instances, it is important to understand how to use them safely.

Government safety standards, technical advancement, and consumer demand have prompted the replacement or removal of many toxic substances used in the arts. One way to know whether products are safe is simply to read labels and to seek products that have been certified for safety. The Art & Creative Materials Institute, Inc. (ACMI) is a US-based international association that tests art materials for both youth and adult populations. ACMI retains medical experts to evaluate artist materials in two ways. It designates products that are found to contain no materials in sufficient quantities to be toxic or injurous to humans, or to cause acute or chronic health problems, as "approved products" (AP). When hazardous ingredients exist in desirable products, these medical experts also require appropriate labeling of these products. The ACMI CL seal certifies that such products are properly labeled for any known health risks and with information on the safe and proper use of these materials.

In the print studio, this kind of labeling is particularly important for oil-based or water-washable inks. It is a common misconception that oil-based inks are hazardous because they are oil-based. In actuality, it is the kind of pigment used that makes an ink dangerous. Many traditional ink colors, such as cadmiums, used pigments that are now known to be carcinogenic. Contemporary ink products that carry the ACMI AP labeling identifies safer products which use pigments that are less toxic for several reasons, one of which is that the pigments have tested as not bioavailable. Some products have been reformulated with less toxic versions of ingredients, such as the case of replacing ethylene glycol with propylene glycol. ACMI evaluations are formula-specific for every color in every product line or type, so reading individual labels is critical.

What has traditionally made oil-based inks less desirable is the use of volatile solvents for cleanup. By switching to vegetable oil and biodegradable detergents for cleanup, oil-based inks are a reasonably safe option for printmaking.

If you are ever in doubt about the health or safety implications of a product or process, do not attempt to use the material or attempt the process until you find out the safe way to proceed. It is good practice to keep Material Safety Data Sheets (MSDS) available for reference for all toxic substances used in a public shop. It is also a good idea to keep up-to-date reference material on safe practices in the studio. In the event of a toxic exposure, this information will be invaluable in emergency treatment. Most materials can be used in a safe manner, but it is ultimately up to the individual to exercise safe habits. Follow these simple rules to foster and maintain a safe working environment.

Harmful symbol

Highly flammable symbol

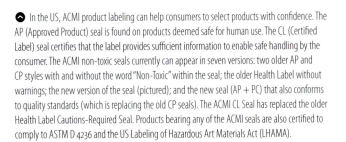
Dangerous for the environment symbol

⊙ In the US, ACMI product labeling can help consumers to select products with confidence. The AP (Approved Product) seal is found on products deemed safe for human use. The CL (Certified Label) seal certifies that the label provides sufficient information to enable safe handling by the consumer. The ACMI non-toxic seals currently can appear in seven versions: two older AP and CP styles with and without the word "Non-Toxic" within the seal; the older Health Label without warnings; the new version of the seal (pictured); and the new seal (AP + PC) that also conforms to quality standards (which is replacing the old CP seals). The ACMI CL Seal has replaced the older Health Label Cautions-Required Seal. Products bearing any of the ACMI seals are also certified to comply to ASTM D 4236 and the US Labeling of Hazardous Art Materials Act (LHAMA).

⊙ In Europe, dangerous substances are labeled according to the following classifications, which have additional levels within them: TOXIC, HARMFUL, CORROSIVE, IRRITANT, OXIDISING, EXPLOSIVE, FLAMMABLE or DANGEROUS FOR THE ENVIRONMENT. The most common classifications in artists' materials are the three as illustrated.

Safety Rules

1. **Protect yourself from toxic substances and dangerous procedures.**

 Inhalation, ingestion, and skin contact are the three routes by which the body is exposed to toxic substances. Inhalation of airborne chemicals can affect the nose, upper respiratory tract, and lungs. Upon entering the bloodstream, they affect the blood, bone, heart, brain, and liver. Ingestion can affect most of the internal organs or even cause local action on the stomach wall. Some materials are absorbed through the skin into the bloodstream, thus affecting some of the most sensitive areas of the body. Skin contact can also produce allergic reactions and dermatitis caused by loss of protective skin oils.

 The body reacts to toxic exposures in a variety of ways. Materials that adversely affect the nasal passages, the respiratory tract, and lungs will irritate these parts. Lung sensitization from inhaling irritant gases, vapors, or dusts results in an asthmatic type of reaction. Skin contact can lead to a type of dermatitis that is visible as a blister, rash, or scar. Sometimes skin contact results in an allergic dermatitis that is irreversible and often spreads to other parts of the body. Central nervous system depression or narcosis is caused by a variety of chemicals entering the body from any route. Overexposure symptoms progress from headache, dizziness, blurred vision, loss of coordination, mental confusion, weakness, and fatigue to eventual loss of consciousness.

 Most acute effects of overexposure are short-term and the body can recover. However, chronic unsafe practices can create long-term health problems, such as cancer and reproductive system damage. Pregnant women and young children are especially susceptible to long-term effects.

2. **Do not smoke or eat in the print shop.**

 Most public institutions ban smoking outright, both for reasons of fire safety and the health risks of secondhand smoke. Smoking reduces the efficiency of the lungs and makes a person more vulnerable to inhalation exposure. Foods absorb toxic substances from the air and dirty hands can carry particles into your system. Be sure to wash your hands well before eating.

3. **Take care of your skin.**

 Use hand lotion regularly to replace lost oils and prevent cracking and chafing. Cover cuts with band aids. Use a barrier cream to protect hands from chemicals and to facilitate cleaning. Wear nitrile gloves when working with solvents.

4. **Wear proper protective clothing and use protective equipment when working.**

 Aprons or cover-alls are essential. Tie back long hair. Wear eye protection when working with motor tools and acids. Wear nitrile gloves when working with acids, inks, and solvents. Dust masks should be worn when working with rosin aquatints or any other dusty procedure. Wear a respirator if a local exhaust is not available or is inadequate. Do not work barefoot or when wearing open-toed shoes.

5. **Practice safe use of solvents.**

 Keep the work area well ventilated. Turn on any supplemental exhaust system that is available. Use solvents sparingly and only at the fume hoods. Use the least toxic solvent in the smallest quantity that will do the job at hand. Dispose of any solvent-soaked rags in the covered cans. Know the materials that you are working with in case of emergency. Keep MSDS information readily available.

6. **Know your physical limitations.**

 Do not try to do something by yourself that is really a two-person job. Do not work when you are too tired.

7. **Do not use any tools or equipment without having received proper instruction.**

 Keep tools in good condition. Properly sharpened tools perform better and reduce the risk of accidents. Never use electrical tools with damaged cords.

8. **Know where the first aid kit is.**

9. **Know where the fire extinguisher is.**

10. **Know where the eye wash and emergency shower are.**

11. **Know where a telephone is.**

 Most areas have a simple telephone system to reach emergency personnel. Post the main emergency number in a visible location—preferably next to a telephone—as well as other emergency numbers, such as those for poison control, campus police, or local police.

12. **Avoid working alone.**

 If you must work alone, make sure someone else knows where you are. If you are in the shop alone after hours follow established security measures.

In this book, special health and safety cautions appear in boxed notices, like this:

> **⊗ Safety Watch!**
> For more information, consult MSDS and the health and safety manuals in the shop.

Safe Cleanup

Health, efficiency, and common courtesy are just some of the reasons for understanding proper cleanup procedures. Following these guidelines is especially important when working in a communal shop. The general rule is to start with the least toxic means possible and employ hazardous materials only when absolutely necessary—and then only with proper skin protection and ventilation.

Cleanup procedure for oil-based processes

With the exception of leather rollers used in lithography, use vegetable oil to clean tools and inking slabs used with oil-based inks, followed by a degreasing wipe with a biodegradable spray cleanser. The use of vegetable oil rather than traditional petroleum-based solvents is a much safer practice. Follow these steps for an efficient cleanup experience.

1. Any remaining ink that has not been rolled out can be wrapped in aluminum foil and saved.
2. To begin cleaning, first remove excess ink from the inking slab and mixing knives with a razor scraper. Removing excess ink in this way further reduces the need for cleanup oils or solvents of any kind. Wipe the scraped-up ink onto scrap paper (old telephone books work well for this) and discard safely.
3. Strip excess ink from rollers and brayers by rolling on the freshly scraped glass slab. If a lot of ink comes off, scrape this up with the razor scraper.
4. Now pour vegetable oil on the slab and spin the roller or brayer in oil. Remove excess oil from the roller by rolling onto newsprint. Wipe the oily residue off the roller with a clean rag. It is clean when the rag shows no sign of ink. Remember to clean the handles of the tool as well!
5. At this point, there willl still be a puddle of oil on the inking slab. Use this to remove ink from mixing knives and the razor scraper.
6. Blot up the excess vegetable oil with newsprint and then wipe down the slab with clean rags.
7. Finish cleaning the ink knives and inking slab with a biodegradable degreasing spray cleanser. Remember that an ink knife has five sides—front, back, and three edges! It is important to clean all surfaces to keep ink from being contaminated.

Storing unused inks

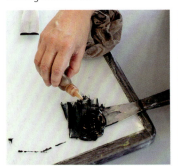

1. Add a couple drops of clove oil to the ink to retard drying.

2. Place the ink in the middle of the foil.

3. Fold in the sides so that it is easy to open the packet again.

4. Label the ink packet with a draw-down color swatch and a dated note as to how it was modified. Inks saved in this way will remain good for a few months.

Cleanup

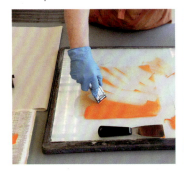

1. Remove excess ink from the inking slab and mixing knives using a razor scraper. Wipe up and discard.

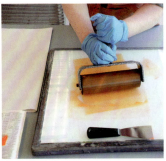

2. Pour vegetable oil onto the slab and spin the roller or brayer in oil.

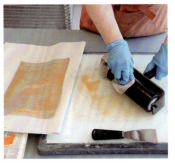

3. Wipe off the excess oil on old paper and then wipe with a clean rag.

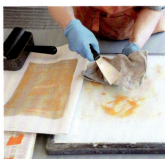

4. Use the remaining oil to remove ink from mixing knives and razor scraper. Clean with rags.

Chapter 2
Digital Processes

Artists, and especially printmakers, have always been "scavengers" of technology. Print history is replete with examples of artistic adaptation of technologies originally developed for commercial or other purposes. Utilizing digital means and approaches represents the most recent manifestation of this opportunistic attitude. But employing digital processes differs from past adaptive practices in that their impact extends far beyond the realm of artistic strategies. In an amazingly short period of time—within the space of one generation—the technological web of influence has encompassed the very routines of everyday life, and this ubiquity has had a significant impact on artistic practices. Artists engage with computing on a variety of levels, using it as a tool, as a medium, as iconography, and as a source of new perceptual, cognitive, and communica-

tion skills and habits. All of these uses may find their way into the domain of printmaking.

This chapter has been placed at this point in the book for several reasons. First, it is an acknowledgment that for many artists—especially a younger generation of students—digital modes of investigation and communication are routine. We will highlight some of these digital purposes as they join a host of traditional options in the creative workflow for imagining printed images. Secondly, on a simple, practical level, we recognize that technology has had a transformative impact on many traditional procedures in the print studio, especially those involving photographic processes. Finally, given the relative accessibility of digital inkjet printers, the entirely digital print medium has established a substantial position in the field of printmaking.

Wolfgang Beyer, *Mandelbrot Set with Continuously Colored Environment*, uploaded to Internet 2006. Digital file, variable size.

The Mandelbrot set, named after Benoît B. Mandelbrot, is a fractal image. Fractal structures are "self-similar," meaning that any part of the image approximates or duplicates the whole. The concept of self-similarity has been applied outside mathematics to describe other complex systems with repeating internal structures. The aesthetic appeal of the Mandelbrot set has contributed to its popularity outside mathematics.

History

Digital art is a large field with permeable, overlapping, and rapidly changing boundaries. As a visual tool and approach, it is relevant to many artistic disciplines. Early artistic forays into the digital realm required technological collaboration in order to take advantage of computing power. One such collaborative effort came from a group called Experiments in Art and Technology (EAT). Organized by engineer Billy Klüver, the group saw the potential benefits of technological and artistic collaboration for both disciplinary realms. The first EAT event, in October 1966, brought together over 40 engineers and ten contemporary artists, including Robert Rauschenberg, to collaborate on technology-enhanced performance artworks.

Digital artwork was also made by individuals who worked with computers in other fields. Computer art that linked to the visual articulation of mathematical or scientific data, such as the imaging of fractals developed by Benoit Mandelbrot in 1975, continues to generate fascination both with aesthetic and practical application.

For many, the rapidly evolving computer technology raised questions about the very nature of human creativity. As a tool, the computer had the potential to make "decisions" that were outside the artist's direct control, sometimes purposefully. No longer was the artist's hand the primary determinant of an aesthetic virtuosity. If the computer makes decisions, what is the role of the artist? Where does creativity exist if the artist is just "pushing a button?"

A possible answer to this question lay in relocating artistic virtuosity in a conceptual realm. This is especially evident in works where the technology becomes the subject as well as the means of the art being made. Early forays into computer-mediated art were driven by a simple curiosity to "see what could be done." If nothing else, these works called attention to our very humanity by making visible a distinction between machine-made and human-made, sometimes amplifying human limitations. Once programmed, a computer-driven machine could produce thousands of unique images that would have taken much longer if produced by hand. The creative experience then, ceased to be about a subjective call and response between artist and product, but the ability to program the computer to drive the art-making. This required the artist to either command technical proficiency or to collaborate with someone who could. Digital imaging only became viable for the average artist when proprietary software developed to the point that individuals could utilize it without unusual accommodation.

The 1989 introduction of the imaging software Photoshop is a particularly relevant moment in the development of digital technology for the field of printmaking. As the name implies, Photoshop was originally targeted at photography. It was quickly embraced as a tool by graphic designers, who added it to emerging text-editing, page layout, and illustration programs. As a consequence of these commercial applications, digital tools quickly became more powerful and more accessible to individual artists. It was not long before artists of all kinds gravitated toward the imaging software. For printmakers, Photoshop's system of layers was a familiar approach to image-making. The challenge was to find a way to print these digitally created images in a manner that offered high standards of archival quality.

Randy Bolton, *The Missing Hand*, 2000. Four-color screen print, 20 × 16 in (50.8 × 40.6 cm). Courtesy of the artist.

Bolton describes this print as "a satirical look at the apparent divide between two opposing aesthetics in artmaking today—the handmade versus the machine-made. Many may fear digital technology as a dehumanizing trend that will remove all trace of the artist's hand. Others see digital processes as a relevant tool for making art in an already depersonalized postmodern culture, where notions of originality and individual identity are seemingly old-fashioned concepts. When I speak about my work, I am usually asked if I miss using my hands, now that I have switched from screen printing to digital output. I really don't think that one way of working precludes the other, so I answer the question by saying that I use my hands as much as ever, and my brain is free to work twice as fast."

Kumar's work rhetorically raises concerns regarding methods of digital archiving of cultural and historical artifacts. Kumar manipulates the image's digitally stored code carried on magnetic or optical devices behind the façade of the image interface itself. This mostly random change constructs, destructs, breaks, and distorts the data, imitating the unpredictability and change that it would undergo with age or in the case of disaster.

David Tinapple, *Bill*, 2006. Archival inkjet print, variable size.

Pittsburgh engineers submit to being "scanned" while standing in front of their cubicles. This portrait was made using a high resolution digital camera mounted on a custom robotic motion rig. A single scan took 60 seconds, and generated 100 photos as the point of view shifted slowly from head to toe. Custom software then stitched the photos, taking advantage of the parallax errors between photos.

By many accounts, the use of inkjet printers to create fine art began in 1990, in Venice Beach, California, where musician Graham Nash, in collaboration with his printer Jack Duganne, began experimenting with methods of outputting his computer-enhanced black-and-white photographs. After much experimentation, they succeeded in producing the first fine art inkjet prints. Intending to distinguish these fine art digital prints made with archival inks from other inkjet prints, Duganne coined the term *giclée*, from the French *glicer*, meaning to squirt or spray. The term has not been adopted universally as some find it pretentious and prefer the more humble designation of inkjet or digital print.

Other early technical pioneers include David Adamson and Jon Cone, who invested in expensive equipment and research to enable collaborative production of high-quality digital prints. By the late 1990s, lower costs and improvements in printer technology enabled the home digital studio to be a viable reality. Today, digital printing serves two purposes for the printmaker: It generates transparencies for use with conventional photo-printmaking processes and enables all-digital printing as an end product.

In 1994, the introduction of the Mosaic browser (later known as Netscape) brought the worldwide web to personal computers and began a profound transformation of the cultural exchange of information. The distribution and acquisition of visual information has become increasingly disconnected from the printed element, allowing artists access to visual information in ways almost unimagined a generation ago. At the very least, the convenience of the internet has had an impact on visual research and the strategy of cultural "sampling" that is prevalent in many contemporary printworks. Similarly, digital means have changed practices of distribution. Printmakers have long embraced the idea of the "democratic multiple"; the mass distribution afforded by the paper print. With digital works, this concept has a new dimension, since dissemination is potentially limitless.

The assessment of technology's impact on the discipline of printmaking is an ongoing conversation within the field. Pedagogically, it is important to recognize that the changed technological landscape offers a new dimension to the teaching of and learning about print media. As part of artmaking, it is important to make technology visible and subject to critical questions. Of course, this holds true for any approach. It is important to ask whether a method is efficient, appropriate, and relevant, or unquestioned and merely expedient. The key to assessing quality lies in the appropriateness of the process to the the intention of the artist's concept. For some ideas, digital processes are the "right" approach, whereas for other ideas they would be wholly inappropriate. Many times both hand and digital approaches come together. In the words of artist and colleague Kevin Haas, "High tech and handmade are not intrinsically at odds with one another… rather than divide and reinforce territorial boundaries, digital technologies allow for interconnections and broadening dialogues."[1] In the end, it is interesting to view technology as an opportunity for enabling new art.

Digital Purposes

So what are the various reasons that printmakers choose to use digital media? For most, it is a simple practical matter of incorporating digital means in a standard workflow. A typical digital routine includes image input, image manipulation, and image output. The workflow may include using the computer for various operations and purposes, such as searching the internet as a research tool, as a sketchbook to preview ideas, or as a replacement for operations rendered obsolete by changing technology, especially those once relegated to the photographic darkroom. Sometimes, digital technology *is* the medium, where all operations remain in a digital mode, culminating most often in a digital print.

One image-making strategy where digital technology excels is that of image appropriation. An ever-increasing databank of ready-made images is available for artists and designers to work with. This facilitates a collage aesthetic, where images can be gathered in whole or part and juxtaposed in visual conversation. Yet the relative ease and ubiquity of this task makes it one of the most problematic concerns in the use of digital technology. On a practical level, utilizing the internet as an image-gathering resource brings up the matter of image quality in relation to resolution. Perhaps more significantly, though, are questions that appropriation raises with regard to originality, plagiarism, and copyright.

Arguably, appropriation is a concept that lends itself especially well to the digital realm. The term is often misunderstood as simply "taking" an image from another source and using it. Problems arise when the resulting work essentially "duplicates the objective of the original," resulting in potential copyright infringement. But when an artist "uses [other's work] as raw material in a novel way to create new information, new esthetics and new insights, such use, whether successful or not artistically, is transformative."[2] Borrowed elements—including images, forms, or styles from art history or from popular culture, or materials and techniques from non-art contexts—become part of the artistic

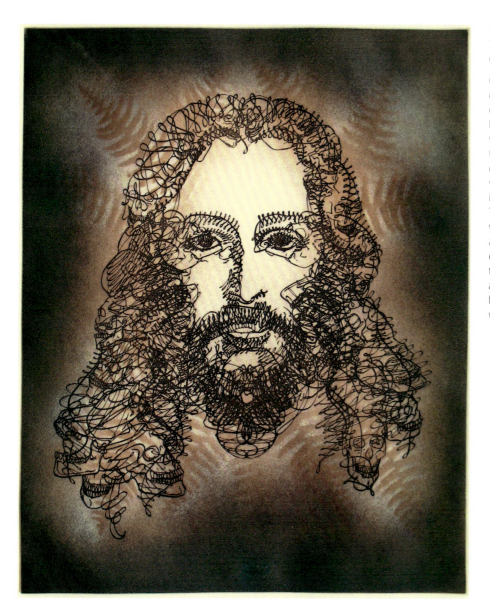

Tim Dooley and Aaron Wilson, *Slayer/Stryper*, 2007. Two-plate color etching, 22 × 18 in (56 × 46 cm). Courtesy of the artists.

Colleagues Tim Dooley and Aaron Wilson work collaboratively, using the computer to bring together elements generated by each of them. In this piece, Dooley made a variety of line drawings of skulls, which were scanned into Photoshop, then collaged to make the Jesus face. Wilson made a series of calligraphic line drawings and similarly generated a face. The two faces were then layered together and converted to a vector image to give them a commercial, illustrative feel. The image was then output to a transparency, which was used to make a silkscreen, which in turn generated an etching plate. The plate was developed with conventional etching processes. According to the artists, the suite of images generated by these plates are "all about colliding sensibilities, tattoo with renaissance, hipster illustration with fine art etching, heavy metal with elbow-patch academics."

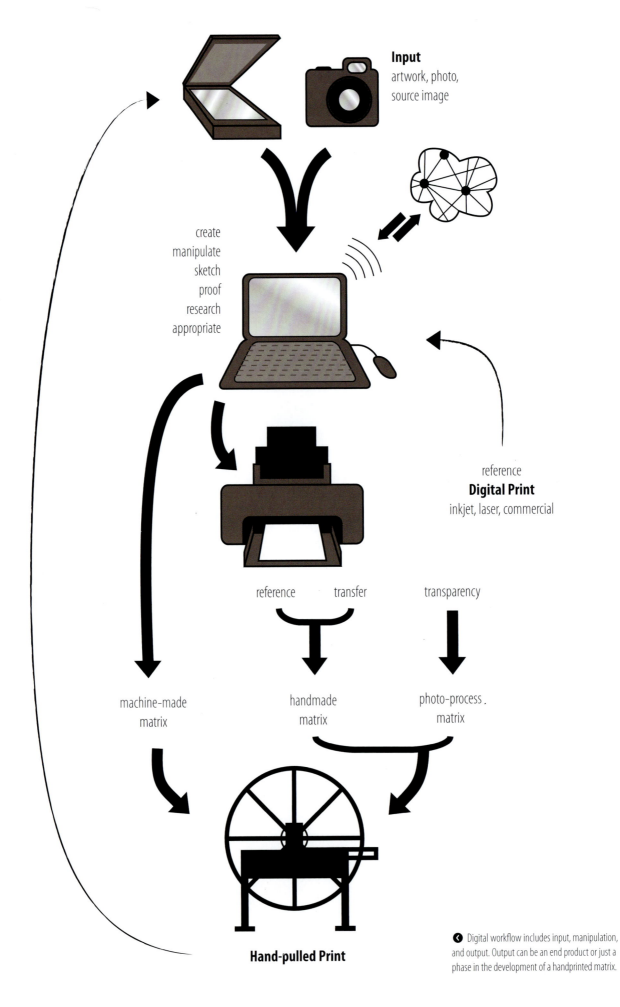

Input
artwork, photo,
source image

create
manipulate
sketch
proof
research
appropriate

reference
Digital Print
inkjet, laser, commercial

reference transfer transparency

machine-made handmade photo-process
matrix matrix matrix

Hand-pulled Print

◀ Digital workflow includes input, manipulation, and output. Output can be an end product or just a phase in the development of a handprinted matrix.

concept and serve to comment on the the original elements or their context. While the success of individual cases of appropriation is subject to debate, the distinction between legitimate appropriation and plagiarism lies in the intention of the artist.

For many, the conceptual implications of digital technology inspire ideas. As the technological landscape evolves and becomes further enmeshed in our daily lives, questions arise about its influence on issues such as human interaction and how we experience the world.

As processes, printmaking and digital means have many affiliations. Some of the features that intrinsically define printmaking—such as the idea of the multiple, of mass distribution, and the generative matrix—are also germane to digital

Michael Krueger combines digital and traditional processes

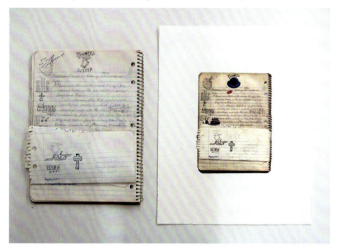

⌃ Notebook and scan.

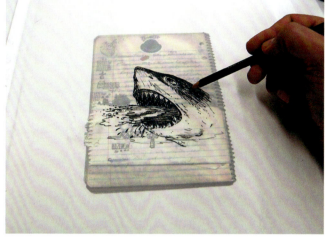

⌃ Hand-drawn overlay.

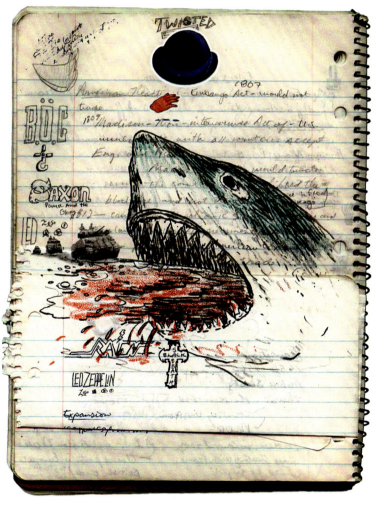

⌃ The completed image.

Michael Krueger, *Shark Sabbath*, from the "Full Metal Journals" series, 2005. Archival inkjet and lithography, 7 × 5½ in (18 × 14 cm). Courtesy of the artist.

Krueger combines subtly manipulated digital facsimiles of his original high-school notebooks with hand-drawn lithographic images printed over them. The act of creation is a cathartic one for the artist, who reexamines the references of his past in an effort to better understand the events that helped shape it: themes of death, nihilism in the post-Vietnam War adorn his notebooks, as well as a reference to the popular film *Jaws*, which conveyed the post-war mantra of self-defeat in the face of big government and corporate interests.

Bill Fick, *Bull*, 2000–6. (Left to right) linocut, rotary knife plotter-cut stencil, and white spray-painted stencil on black board, 21 × 16½ in (53.3 × 41.9 cm) each. Courtesy of the artist.

Here, a stenciled version of a linocut image was generated by scanning the original and manipulating the image so that a laser-cut stencil could be made. While the stencil could be used in many ways, this simple translation also allows the image to exist as graffiti outside the traditions of the fine art print. This parallels Fick's frequent use of his lino-heads to print T-shirts, underscoring an anti-elitist, democratic distribution of the art image.

Adriane Herman and Brian Reeves, *Slop Art Circular #4*, 2003. Commercially printed 24-page circular, 10½ × 10½ in (26.7 × 26.7 cm). Courtesy of the artists.

Slop Art is the alias used by collaborative artists Adriane Herman and Brian Reeves. Printed as newspaper inserts, their Slop Art circulars parody Wal-Mart advertising circulars and raise such issues as commodification, originality, and cultural and aesthetic elitism. The means of production extends the performative dimension of the artwork as the artist-team take on the roles of graphic designer, model, and featured artist. Beyond merely condemning materialism, the pair go on to sell the advertised works, thus positioning themselves squarely within capitalist structures. Ultimately, the desire to sell or own these works raises thorny questions of complicity and privilege.

Al Souza, *Orlando City Map*, 2005. Laser-cut multiple, 14 × 10 in (36 × 25 cm). Published by Flying Horse Editions. Courtesy of the artist and Moody Gallery, Houston, Texas.

Using laser-cutting technology on commercial maps, Souza creates an intricate metaphor for dislocation and transience.

Jennifer Yorke, *Bombshell*, 2005. Inkjet print, 40 panels, 110 × 35 in (279 × 89 cm) each.

Yorke utilizes the digital multiple to make a wall of hair. Digital means allow access to scale and quantity that would have been prohibitively difficult and expensive to produce with conventional print media.

⊘ The computer-controlled router is just one example of a machine that can easily expedite the translation of an artist's idea to a printing matrix.

processes. Some extremely interesting work in digital print-making exploits the conceptual potential of these essential characteristics For instance, the parallel between computer code and the matrix itself is often cited. What is computer code if not essentially a matrix? The matrix functions as a translator of artist-generated or defined information, whether it is drawing, photographic images, or data sets. The artist establishes rules for the use of this matrix (such as color choices, scale, limitations, and distribution). Works that interpret data sets are certainly conceptual prints and may be literally so if they are output on paper.

Sometimes digital methods "announce" themselves and the visual characteristics become iconographic, making the process visible and part of the content of the work. This effect is amplified if a contrasting "voice" is also part of the work. For instance, a hand-drawn element juxtaposed with a photographic element carries a different connotation than if the image was all rendered by hand.

Other applications of digital means include using computer software to drive machines that create a printing matrix. Precision laser-cutters or routers replace hours of hand-cutting. Assessing where the authority lies in such work becomes a more complicated question. Is it in the idea, the skill of the artist, or both? When does acknowledgment of the technical facilitation or collaboration become essential? This is a familiar question in conventional collaborative relationships.

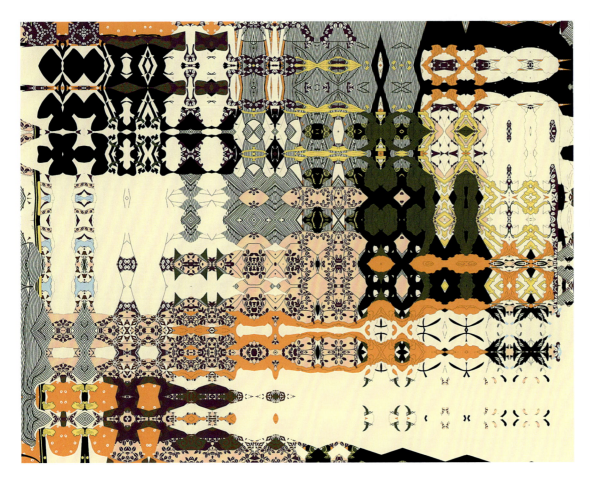

Carl Fudge, *Everyone Had a Theory As To Why III*, 2002. Iris print, 20 × 26 in (51 × 66 cm). Edition of 30, printed by Pamplemousse Press, published by Pace Editions Inc. Courtesy Ronald Feldman Fine Arts, New York.

Many of Fudge's prints are complex digital reworkings of Japanese seventeenth-century woodcuts and contemporary popular images. In this case, the digital appropriation of the source imagery is part of the concept.

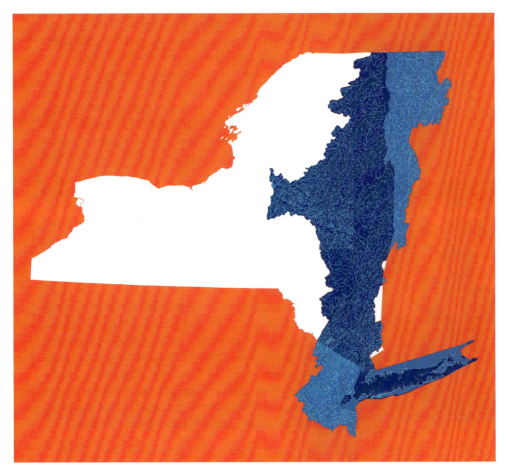

Lauren Rosenthal, *New York/Richelieu, Upper Hudson, Lower Hudson-Long Island*, from the series "Political/Hydropolitical: A Watershed Remapping of the Contiguous United States", 2005 to present. Digital print, 16 × 20 in (40.6 × 50.8 cm). Courtesy of the artist.

The artist used global positioning system data to re-imagine the political boundaries of the US based on watershed districts.

Inkjet Basics

Making a digital print involves three basic stages: input, image manipulation, and output. It is important to know how these stages are interrelated.

There are two basic kinds of digital image, raster images and vector images. Raster images are made of a grid of squares (pixels), each carrying color or tonal information. Raster images are resolution-dependent, meaning that the greater the resolution, the more pixels per inch (ppi) there are to build the image and, consequently, the more detail available in an image. The size of these images is recorded in three ways; the file size, measured in (mega)bytes; the resolution, measured in pixels per inch; and the scale, given in a unit measure such as 8 × 12 in (20 × 30 cm). These variables are interdependent, each affecting the other. For instance, an image that measures 22 × 25 in (56 × 64 cm) in scale with a resolution of 72 ppi is the same as an image measuring 5 × 6 in (13 × 15 cm) with a 300 ppi resolution. Both are approximately 8 megabyte files.

High-resolution raster formats are good for images that have a lot of tonal information and detail. In contrast, a vector graphic is made with mathematical formulas that describe shapes, line weight, color fill, and location. Consequently, they are resolution-independent and can be scaled to any size and printed without any loss of edge quality. Vector images are graphic—hard-edged and flat. They are made with drawing programs, such as Adobe Illustrator.

Raster images are by far the more common form of digital image; most input devices record information in pixels. Working with raster images is a bit more complicated, though. A more specific understanding of the relationship of input to output is essential. It helps to have some idea of the intended end product, especially with regard to scale. This may impact how the various input devices might be used or which imaging software to choose.

The quality of the final product is dependent on several variables, namely, the resolution of the image itself and the capacity of the printing device to print at high resolution. At the input stage, devices such as scanners, digital cameras, or video cameras are the primary capture tools. The original resolution of this capture presents the first restriction on the output scale. For optimal print quality, the image resolution should correspond to the capacity of the output device. For inkjet printing, the resolution of the image *at the scale that it will be printed* (not necessarily the original size in the case of scanning) should be at least 150 ppi, up to about 300 ppi. Most of the time, it is a good idea to input images at a relatively high resolution so that options for output remain flexible. With digital cameras, set the image quality high. This will create the largest image. As the final output is determined, image size and resolution can be adjusted for the specific output decisions or device. Regardless of the way that images come into the software (as jpg or native file formats), save raster files in the tagged-image file format, or .tiff. This is the most generic file format, enabling cross-

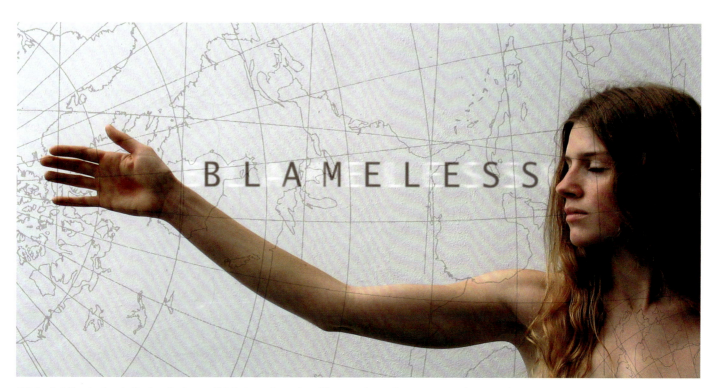

Alicia Candiani, *Blameless*, from the "Continents" series, 2007. Digital print on micro-perforated film mounted on windowpanes, 48 × 67 in (123 × 170 cm). Falun Print Triennial, Sweden.

Candiani also utilizes the capacity of the digital print to record photographic information. Many of her prints adopt a strategy of appropriation and layering, setting up metaphoric juxtapositions between the various images. Here, she uses digital and traditional techniques on commercial polyester sign material. Candiani's works are a reflection on women's role in a global world in which the effects of globalization and internal migrations have produced displacement, uprooting, and new relationships toward empowerment that women must negotiate.

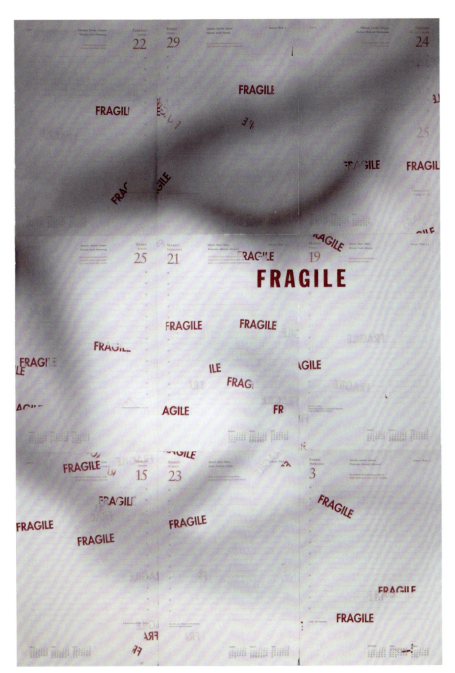

Manuel Castro Cobos, *Fragile_05*, 2004. Screen print and digital print (pigmented inks), 27½ × 18¾ in (70 × 47.5 cm). Courtesy of the artist.

Castro Cobos utilizes photographic images with text to create a "conversation of voices" in the digital image. This strategy of layering is common to both digital and conventional printmaking, but because photographic images are produced more easily and with greater detail using digital technology, it is fast becoming a preferred mode for works that incorporate photographic images. In this piece, the word "fragile" is printed over a child's picture. The multiple printings insist and fervently plead that we attend to the well-being of our world for the sake of the youngest and future generations.

platform use. Unlike file formats meant for online distribution, such as jpg, it does not compress the digital information, thus maintaining the image quality.

It is beyond the scope of this book to cover all of the possibilities for image manipulation in image-processing programs. Operations fall into the realm of design or composition through arranging, cropping, and adjusting color. Images can be changed in whole or in part with various filters, or transformed by scaling, skewing, or other distortion. Information can be added or created from scratch with digital painting and drawing tools. A feature of most imaging software is the construction of images in layers that can be adjusted independently and made in varying degrees of opacity. Layers can be re-ordered to explore the changing hierarchy of elements. If you are starting to experiment with digital imaging, try working with a guidebook dedicated to the software that you are using.

Once the image has been processed digitally, the artist has many choices for inkjet output. There are several commercial digital photo papers available in glossy or mat finishes. Most printmakers prefer papers similar to those used for traditional printmaking. Some of these fine art papers can be used for inkjet printing without further preparation. Choose smooth papers with sufficient sizing. Papers can also be prepared with a receptive coating, which helps to keep the ink from absorbing and bleeding into the paper. The result is generally a sharper, more saturated color. Several fine art papers are made especially for inkjet printing and come with a coating.

In addition to paper, prints can be output onto specialty films for transparency. Some large-scale printers can also print onto thicker substrates such as board, metal plate, or ceramic. Refer to the owner's manual to determine the capacity of your printing equipment.

The longevity of digital prints is dependent on the light-fastness of the printing inks used. Most professional printing inks are made with this feature in mind. Inks can be either pigment-based or dye-based. Sometimes the ink type is device-dependent. This may be a determining feature when selecting a personal printer.

Digital prints can exist as a final output or be combined with other print media. Typically, digital elements are printed first, followed by traditional processes. If so, the paper may have to be dampened, so it is important to use a printer with inks that, when dry, are water-insoluble. The sequence can also be reversed, with ink-jet printing taking place on top of conventional printing. This is an experimental practice and results can vary, depending on the kind of ink and physicality of the surface to be printed; keep the paper flat (run through an etching press first if necessary). The initial layer must be dry before sending printed papers through the inkjet printer.

Photo-printmaking Basics

This section is dedicated to digital processes associated with photo-based printmaking processes. It is important to note that photo-printmaking does not necessarily imply the use of a photographic image. Rather, the term refers to processes that utilize light-sensitive materials to create conventional printing matrices. To make a photo-matrix, an image in transparency form is positioned on top of a matrix that has been coated with a light-sensitive emulsion. When exposed to light and processed, the image is established in the matrix so that it can be printed. The role of digital tools is to create the transparency used for the exposure. Before the advent of digital technology, these processes were performed in the photographic darkroom. Following the lead from commercial printers, they have largely been replaced by digital means in the print studio. The following concepts are important to maximizing our understanding of the digital process.

To begin, an image must exist in digital form, either by having been created originally in a program such as Adobe Photoshop or by having been captured by an image capture mechanism such as scanning or digital photography.

Bitmap

To generate transparencies suitable for photo-printmaking, images must be converted to a binary form, meaning that they print only in black or white. This is not a problem when dealing with linear or high-contrast imagery, but images containing tonal gradations must be converted to a form that allows many levels of value to be printed with a single ink color. The ability to simulate this tonal range relies on translating value gradients into an arrangement of dots that essentially creates an optical illusion, which the brain blends into a smooth tone. In digital terminology, this is known as a bitmap.

Diffusion dither

The most basic form of the bitmap is called a diffusion dither. Tonal variances are created by changing dot frequency—fewer dots in lighter areas and more dots in darker areas. In this case, the dot itself is the actual pixel, so the amount of detail and subtlety possible in an image is based on image resolution. A diffusion dither's resolution is measured in pixels per inch (ppi), which determins the number and size of the pixels. A high resolution creates more smaller ppi, yielding finer detail.

Halftones

The conventional form of the bitmap is called a halftone. In this case, tonal variance is created by changing the size or amplitude of the dot. In light areas, dots will be very small, increasing in size as the tone gets darker. Usually, even the largest dot is sufficiently small so that the eye does not distinguish individual ones.

The halftone process involves setting two variables—the size of the pixel (ppi), which makes up the dot, and the size of the dot itself. This second measurement determines the frequency or linescreen of the image and is expressed as lines per inch (lpi) or lines per centimeter. The pixel size is important in that a smaller pixel makes the halftone dot smoother, allowing a finer halftone linescreen for more detail and subtlety in the image.

Two kinds of bitmap

⊙ The human eye perceives a continuous tone based on an optical illusion. The diffusion dither interprets gray tones in a random pattern of dots (the pixels themselves). The pixels are distributed by frequency—more pixels in the darker areas, fewer in the lighter areas.

⊙ The halftone dot also relies on an optical illusion. In this case the illusion of light and dark is based on the size (amplitude) of the dot. The dots are smaller in light areas and larger in dark areas. Look closely at any picture in a newspaper. Halftone dots used to create an image are clearly visible.

Resolution Concerns

There are many types of resolution working simultaneously in a digital image. Not only does the term describe the amount of information an image holds in digital form, but it also measures the capacity of output devices to express that information. Printer resolution is measured in dots per inch (dpi) and is device-specific. Laser printers are set to print at 600, 800, or a maximum of 1200 dpi. Ink-jet printers generally print at 360, 720, 1440, or 2880 dpi. Due to this limitation, dpi is the one of the most important factors in determining proper ppi and lpi.

Additionally, the various print processes which will ultimately realize these bitmap images have an upper practical resolution limit. This is far lower than what is possible with a direct digital inkjet output, which, these days, can rival photographic printing. In fact, most print processes perform more predictably with coarser linescreens (lpi).

Another concern is the interaction of various grid systems represented by the pixel resolution, the linescreen, the printer resolution and, in the case of screen printing, the printing mode. Sometimes these intersecting grid structures create an interference pattern called moiré.

Avoiding moiré patterns is a matter of synchronizing the relationship of the various grids and understanding the limitation of the printing method.

The table on page 49 gives practical formulas for determining the relationship of the various resolutions at work.

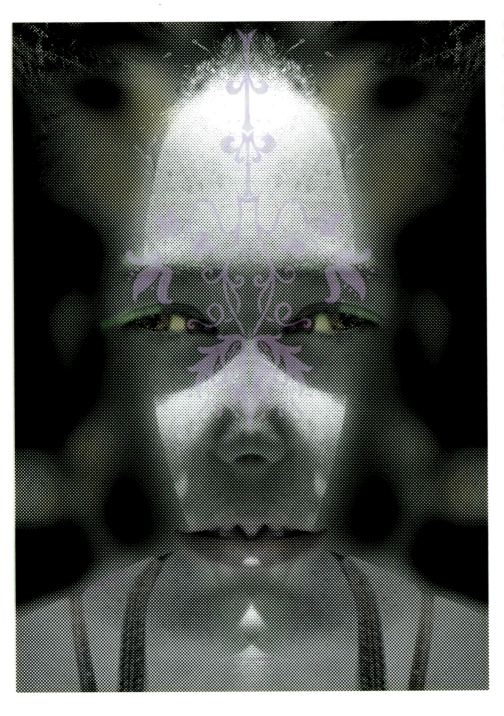

Beth Grabowski, *Nostomanic: Snake Eyes*, 2006. Digital print, 29 × 20 in (74 × 51 cm). Courtesy of the artist.

This digital print by one of the authors utilizes the halftone dot functionally and symbolically. By creating a halftone of the original, mirror-imaged layers were positioned to create new images. The halftone dot is clearly visible as a conceptual nod to the blending of old and new technology.

⏷ Relationship of pixel resolution to halftone dots. A halftone dot is made up of pixels. This example shows two different ppi resolutions with the same halftone lpi. Here, the dots are the same size, but when the resolution is low (55 ppi on the left), the halftone dot is jaggedy. When the resolution is high (1200 ppi on the right) the halftone dot is smooth.

⏷ Comparison of halftone linescreen frequency of the same image. When the ppi resolution is set to make a smooth halftone dot, linescreen frequency is the second resolution setting for a halftone. A lower linescreen frequency results in a larger halftone dot, and an obvious loss of fine detail. Greater linescreen frequency (higher lpi) gives finer detail because the dots are smaller and closer together.

◀ Moiré patterns like these are created by an overlay of screen patterns. Avoiding moiré patterns is a matter of synchronizing the relationship of the various grids and understanding the limitations of the printing method used.

Recommended resolutions for printing*

Formula	Example
ppi = 2 × lpi	A photolitho will print easily at 75 lpi, so the ppi should be set to 150. Anything above 150 will be wasting space on the disk.
optimal lpi = dpi ÷ 16	A laser printer set to 1200 dpi will print 75 lpi most accurately.
optimal halftone lpi for screen-printing = screen mesh ÷ 3.5	A 195 mesh screen cannot print above 55 lpi regardless of higher dpi or ppi.
optimal dpi for screen-printed diffusion dither = screen mesh ÷ 1.5	A 130–150 dpi bitmap will be printed most accurately on a 200 mesh screen.
Maximum lpi for photo intaglio = 65–85 lpi	If the halftone dots are too small, they may have difficulty adhering to a plate.
Optimal lpi for photo collagraph: 35–65 lpi	Photo collagraph uses liquid silkscreen emulsion. The size of halftone dot may also depend on the texture of a support board.
optimal lpi for hand-printed photolitho = 65–85 lpi	If the lpi is above 85, you may have trouble with darker areas filling in or maintaining a full tonal range.

*Remember, these guidelines are suggestions. Experiment with the specific equipment being used to fine-tune individual projects.

Randy Bolton

Randy Bolton's works evoke the historic tradition of printmaking as a democratic voice. Incorporating images from early children's texts, his work reaches out to a wide audience while addressing important social issues and the more personal themes of the human heart: loss, suffering, regret, and the possibility of redemption.

>> *Tell us about your creative process.*

I work in a collage-like manner, using both traditional and digital printmaking, to construct new images that are based on small fragments of illustrations borrowed from vintage children's textbooks. Before the advent of digital technology, I used hand-drawn and photomechanical processes to make screen prints. Since the early 1990s, many of my hand and darkroom practices migrated to Photoshop and I began to experiment with new digital printing and output possibilities. I've always tried to be innovative, to push or expand traditional approaches, utilizing new methods or using old tools and techniques in different ways.

For me now, process and content are inextricably linked. My advisor in grad school used the metaphor that "a bird needs two wings to fly," meaning that a print works through equilibrium or a kind of back and forth flow between process and idea. A good print doesn't "fly" without the two things—process and idea—working together in balance. As a student, I recall being initially attracted to printmaking, especially the practice and patience needed to master the craft of making a print. Printmaking just seemed to suit my personality—I was able to find meaning and purpose in the kind of cool, indirect, and mediated way of communicating that the printmaking process offers.

My ideas spring from everyday experiences based on what I see, think, feel, read, and collect. Ideas come in a flash of visualization, which I then begin to research and develop into a finalized image. I really "work" my ideas, and push them through a slower, "cooler" process of thinking and making to achieve a more precise visual statement. I also think in terms of serialized or sequential ideas, a kind of "if this, then that" process in which one idea generates another.

>> *What are your thoughts on the field of printmaking and its future?*

In general, I see a positive trend toward a more expansive definition of what a print can be. It is based on a more open-ended philosophy that questions basic principles of printmaking, such as originality, multiples, repetition, and the democratic voice. If a print can be described as a matrix or process that can be reproduced or repeated, then maybe it is not too far-fetched to consider something like a sneeze, an echo, or a ripple in a pond as a "print." My point here is to suggest that printmaking is undergoing a move toward a subtle redefinition and a conceptual expansion that affects how traditional media and newer technologies are utilized or combined. I think printmaking will continue to have strong connections between its old and its new, or a kind of concurrent sense of time where the past is always present.

Born Dallas, Texas

Education/training BFA from the University of North Texas and MFA from Ohio State University

Current position Artist-in-residence and head of the Print Media Department at the Cranbrook Academy of Art in Bloomfield Hills Michigan, USA

Awards and Exhibitions Bolton has exhibited widely since 1982. His prints are in many corporate and museum collections, including the Philadelphia Museum of Art and the Art Institute of Chicago. He received an Art Matters Fellowship (NYC) in 1996 and a National Endowment of the Arts Fellowship in 1989. He is represented by Littlejohn Contemporary in New York City.

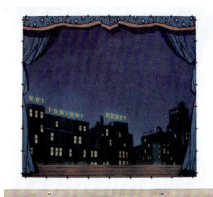

Not Tonight, Honey, 2004. Digital print on canvas, 154 × 168 in (3.9 × 4.2 m). Courtesy of the artist.

In this large-scale digital banner, the viewer is a participant looking through a window at a rooftop cityscape. A large sign, "Not tonight, honey," illuminates the night sky. It is a tranquil scene; everyone has withdrawn into his or her apartment, and the message broadcasts a collective feeling of anticipation and ennui that has settled on the town. A darkly ambiguous mood of resignation has descended for the night, but maybe things will be different tomorrow?

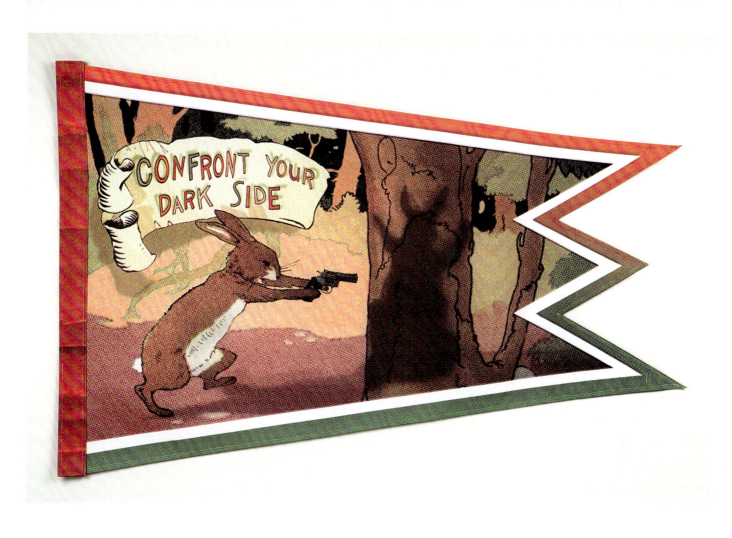

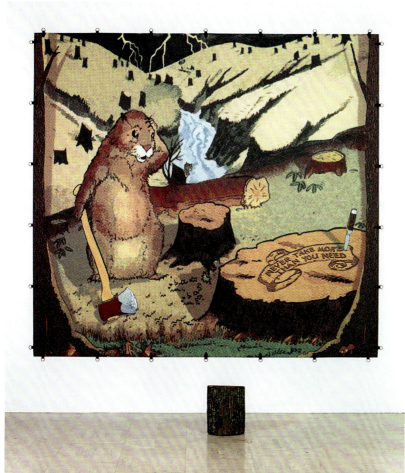

● *Confront Your Dark Side*, 2004. Digital print on canvas, 35 × 55 in (88.9 × 139.7 cm). Courtesy of the artist.

In this digital pennant, a cartoon rabbit points a gun and threatens its own shadow. The shadow raises its arms in a pose of surrender. The scrolled message, "Confront your dark side," is a rephrasing of the Platonic command, "Know thyself," for the good, the bad, and the ugly.

◀ *Never Take More Than You Need*, 2004. Digital print on canvas, tree stump with carved and burned images, 123 × 124 in (3.12 × 3.14 m). Courtesy of the artist.

Bolton takes familiar childhood images and morals and adds a modern, subversive wink to classic kids' book illustrations that often offer darkly humorous lessons. Here the message "Never take more than you need" is expressed metaphorically through a cartoon beaver who discovers he has chopped down every tree in the forest, to address ecological issues as well as issues of shortsightedness and greed. The tree stump contains further imagery to encourage viewers to rest there and contemplate further at their leisure.

Creating Bitmaps with Photoshop

Adobe Photoshop is the most widely used software for image processing. Follow these steps to create diffusion dither or halftone bitmap images.

1. Begin with a color image. This can be a photograph or scanned capture, or something created directly on the computer, such as text. It is good practice to work with a copy of the original image so that the original is available as a point of origin for variations, or to start over if necessary. The image should be sized to its intended final output size and all layers flattened (Layer/Flatten Image). Determine the optimal resolution for the image at the scale at which it will be reproduced. If you are not sure, start with a higher resolution, around 300 ppi, for flexibility.

2. Convert the image to a grayscale mode (Image–Mode–Grayscale). Save this new image as a Gray version of the file (preserving the original color file). Give it a filename such as "Myimage–Gray version.tif." If the image has not been flattened, it might try to save the file as a native Photoshop format (.psd extension). Because it is compatible across imaging software, TIF is the preferable file format.

3. Make any adjustments to the image in this new grayscale version. The Adjust Levels (Image–Adjustment–Levels) option allows contrast adjustment by moving the three sliders until the image looks good. If making a halftone for photo intaglio, move the slider on the output bar so that it is in the dark gray area instead of black. This puts a halftone dot in the darkest areas of the image which is necessary to hold ink in the intaglio process.

4. Convert to a Bitmap Mode (Image–Mode–Bitmap). This is where the image converts the grays into a texture made up of solid black or white dots. At this point the image can be made into the diffusion dither or halftone.

Diffusion dither

1. Choose Diffusion Dither from the methods list.

2. Set the ppi/output resolution anywhere between 35 and 150, depending on the size of the image and the process you will be using (see chart on page 49). Silkscreen and photo collagraph tend to do better with a coarser translation of the image, between 25 and 65. Photolithography can be quite fine, up to 100 ppi. If intending to enlarge the image after the initial printing, it is possible to start with a finer resolution at this point. That way, when the image is enlarged the dots will still be relatively small. Success can be somewhat device-dependent, though. To work, the initial print must be sharp and clear. If a fine resolution generates a mushy output, the enlargement will also be unacceptable. Use good quality coated paper and optimal print settings for the best quality output.

3. Click OK.

4. Once the image is converted, it becomes impossible to see on the computer screen because the screen pixels are at odds with the newly defined image pixels. The computer makes an approximation of the image at the existing screen size of the image. To see the configuration of the actual pixels on the computer monitor, choose "actual pixels" from the View menu. Most of the time, it is simply easier to print a test image to see the results. Print on good-quality coated stock to get the best quality output. If the output is not good, simply undo the bitmap (Edit–Undo) or Revert to the saved grayscale (File–Revert) and try again.

5. Save a copy of this new file as a bitmap version (Myimage–Bitmap res 45.tif).

6. If desired, return to the Gray image and try several varieties of the resolution for options.

Halftone

This method involves two sets of dialog boxes, first to set the ppi resolution and second to set the lpi resolution of the halftone itself. This is where it gets a bit tricky. In electronic publishing, pixels are all the same size. To create a halftone, there is the additional problem of creating the illusion of different sized dots. To do this, the dots are grouped into halftone cells. Turning on fewer dots in a given cell gives the illusion of a smaller dot; turning on more dots in a given cell gives the illusion of a larger dot.

1. Using your grayscale image, convert to bitmap mode (Image–Mode–Bitmap) and then choose Halftone from the Methods list.

2. When using an inkjet printer, set the Output Resolution high—300 to 450 ppi.

3. Click OK.

4. A second dialog box sets Frequency, Angle, and Shape. The most anonymous standard is a round shape at a 45-degree angle. Other settings offer aesthetic variety. An elliptical shape for screen printing helps minimize moiré patterns. The frequency setting determines the lpi. Set this in accordance with the formulas for output dpi and intended application as described above. If setting angles of halftones that will be printed on top of each other (color separations, for instance) set them at 30-degree intervals to avoid moiré patterns.

5. Click OK.

6. Save this as a separate file (Myimage–Halftone.tif).

Output

When it comes to output, the image must ultimately serve as a transparency to expose to a photo-printmaking matrix. To function in this way, the image must be light-opaque. For this reason, laser printers or pigment-based inkjet printers are the preferred output devices because the output has sufficient opacity. An advantage of inkjet printers is the availability of wide-format models for larger output. Preferably, the print is made onto a clear film. Alternatively, if inkjet film is not available, print onto regular paper, then photocopy onto a thin bond paper. The photocopy toner is sufficiently stable that the copy can be wiped with vegetable oil to make it translucent for exposure. With desktop inkjet printers containing dye-based inks, print at the "best" setting onto high quality imaging paper for the crispest output possible. Then, photocopy the image to make it light-opaque.

Some processes can utilize a transparency printed directly to inkjet film, but this can be device and process specific. Make a test exposure to determine whether this is possible in specific circumstances.

If the initial output was on paper, the print must be made translucent to work as a transparency to expose to a printing plate. Laser prints or photocopies on paper can be made into useable positives simply by wiping vegetable oil on the paper to make it translucent. Alternately, you can photocopy onto transparency film. If the output device is limited to 8½ in (22 cm) wide, you can enlarge the output by photocopying. Many service bureaus have very large copy machines that can make prints up to 4ft (1.2m) in width. However, this enlargement also enlarges the halftone dot. You can avoid this with a larger output device. Some service bureaus will print large output from the digital file, enabling a fine resolution at a larger scale.

Color separations

Halftones are also the conventional structure for making color separations, which converts color images into cyan, magenta, yellow, and black (CMYK). Each channel is made into a separate halftone image with a precise angle according to color. When these align correctly, moiré patterns are eliminated allowing an optical mixture that creates an illusion of infinite color variation.

1. Start with a color image and convert it to CMYK: Image–Mode–CMYK. Make any color or other adjustments to the color image. Size the image—both scale and resolution for output (you may enlarge later). Save this file as Myimage–CMYK.tif.
2. Save four copies of this, naming them Myimage–C.tif, Myimage–M,tif, Myimage–Y.tif, Myimage–K.tif.
3. Open each image separately and look at the Channels palette (Windows–Channels).

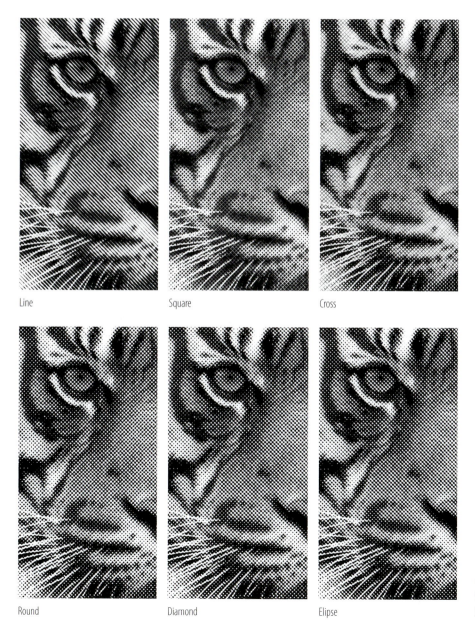

Line

Square

Cross

Round

Diamond

Elipse

◀ Different screen patterns give aesthetic variety to the halftone image. Original image 3 × 1½ in (7.6 × 3.8 cm) 300 dpi; halftone output: 600 dpi, 35 lpi, 45°.

4. Delete all channels except the target one by dragging them into the little trashcan at the bottom of that palette window. For instance, delete black, yellow, and magenta for the Myimage–C.tif file.

5. Once left with the one channel, it will appear as a grayscale image, but it really still thinks it is a color image. Convert to grayscale (Image–Mode–Grayscale). Now it is ready to convert into a halftone bitmap (Image–Mode–Bitmap).

6. Follow the normal steps for making a halftone, choosing lpi frequency appropriate for the intended print process. The standard shape for color separation is round. Color separation angles are Cyan 15°, Magenta 75°, Yellow 0°, Black 45°.

7. A further option, to assist alignment, is to print output with registration marks (File–Print) and check the registration marks box at the bottom. It can also be helpful to choose the captions and labels that will print file names and information on the output.

8. When the files are printed, they will be black and white. These will be used to make transparencies, which can be exposed to a variety of printing matrices that, when registered and printed in color, will combine to recreate the original color image in ink.

NOTES

1. Haas, Kevin, "Embedded Practices", paper presented at the 2008 College Art Association annual conference in Dallas, Texas.

2. Judge Louis L. Stanton of the U.S. District Court establishes the parameters of fair use in a decision regarding American artist Jeff Koons' use of part of a photograph by Andrea Blanch, titled *Silk Sandals by Gucci*, published in the August 2000 issue of *Allure* magazine, in his painting "Niagara."

C M

Y K

⌃ These images represent the color separations used to create the corresponding lithographic image by Melissa Harshman.

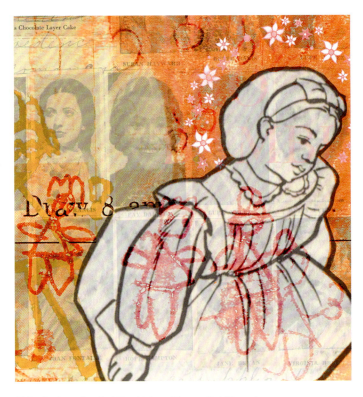

Melissa Harshman, *Bette Davis Chocolate Layer Cake*, 2001. Photolithograph, 17 × 16 in (43 × 41 cm).

The color separation enables Harshman to retain the look of the appropriated source material, while allowing her to create the image entirely in lithography.

Chapter 3
Screen Printing

Screen printing, while having a relatively recent history as a fine art process, has its origins in perhaps the oldest form of printing, the stencil. The directly applied relief handprint in prehistoric caves is perhaps the only rival to the stenciled handprint for the privileged designation of "first print."

Ultimately, the stencil is perhaps one of the most ubiquitous printing processes. Not only does it exist in various forms in its own right, but it is regularly used as a modifying procedure within other print processes.

Stencil printing was widely utilized for artistic and commercial purposes in China and Japan as early as 500 AD. During the Sung dynasty, Japanese stencil printing, known as *kappazuri-e*, employed intricate paper stencils in which small, isolated stencil pieces were joined to the rest of a complex stencil with fine silk threads or human hair. These stencil forms were used to print starch-resists onto fabrics that were then dyed, establishing a pattern. Stencils were also sometimes used in conjunction with woodblock prints as a method for printing color layers.

Stencil processes ultimately found their way to Europe via trade routes. In the late nineteenth century and into the early twentieth,

complex paper stencil printing called *pochoir* (literally, stencil printing) was widely used in Europe and the US for commercial purposes, especially in the fields of book illustration and textile printing.

In commercial applications, the need for more durable stencils capable of printing hundreds of copies led to the use of paper stencils affixed to frames stretched with a fine-weave silk. The first patent for the silkscreen process

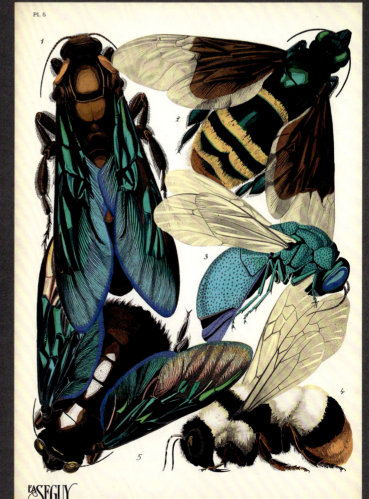

Eugene Alain Séguy, *Insectes*, plate 5, c. 1920. *Pochoir*, 17¹³⁄₁₆ × 12¹³⁄₁₆in (45 × 32.4 cm). Special Collections Research Center, North Carolina State University Libraries, Raleigh, North Carolina.

This image is from a rare portfolio produced with the *pochoir* technique, which entails handprinting each color through a large number of stencils. A close-up reveals the incredible complexity needed in the stencil for such a detailed image.

was issued in 1887 to Charles Nelson Jones in Michigan. Initially, inks were still applied through these silkscreen stencils with stiff brushes. The development of the squeegee to push ink through the screen further advanced the capability of production printing.

Initially screen printing was predominantly used for commercial applications. In the early twentieth century, the European textile industry created inspiring opportunities for artistic collaboration with the screen-printing process. It was in the 1930s that screen printing began to be used for fine art printing on paper. In 1936, artist Anthony Velonis adapted the commercial screen-printing process for printing posters for the Works Progress Administration (WPA), the largest of the US New Deal programs during the Great Depression. With support from the WPA, Velonis set up a screen-printing workshop that allowed artists to work collaboratively with designers and technicians. These exchanges spawned an expanded interest in screen printing as a fine art process. The term serigraph (from the Latin "seri"—silk—and Greek "graphein"—to write or draw)

was later coined by the influential critic and print curator, Carl Zigrosser, and Velonis to distinguish fine art use from commercial applications of the process. This term has come in and out of fashion, with some artists arguing that the terms silkscreen or screen printing are less pretentious and more suitably acknowledge the historical and commercial roots of the process.

With heightened appreciation, screen printing continued to gain respect as a serious print process for fine artists in the US and Europe. With the 1960s Pop Art movement, screen printing continued to gain popularity as many artists—including Americans Andy Warhol and Robert Rauschenberg, and Eduardo Paolozzi and Joe Tilson in the United Kingdom—employed screen printing as part of their artistic production. Chris Prater of Kelpra Studio in the United Kingdom is credited with introducing the process to some of the most influential artists of the time, including Paolozzi and Richard Hamilton. These artists were able to utilize the process to employ a collage strategy—combining photographic elements with hand-drawn autographic stencils.

Richard Hall, *Prints for the People*, 1937. Screen print, 22 × 14 in (55.9 × 35.6 cm). Library of Congress, Prints and Photographs Division, WPA Poster Collection, Washington, D.C.

This exhibition poster for a show of printworks produced under the Federal Art Project, an arm of the WPA, is an excellent example of simple, flat-color stencils.

Handprint, Roaring Creek Valley, Belize.

A negative handprint adorns the wall of an ancient Mayan cave in Belize.

Tools and Materials

The materials needed for screen printing are quite simple and can be set up almost anywhere. A screen, squeegee, printing table with hinges, stencil material, registration plastic, water-based screen-printing inks and paper, and a place with a good strong hose for screen cleaning is all that is needed to get started.

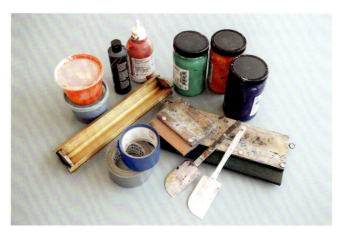

⌃ Basic screen-printing supplies: squeegee, scoop coater, waterproof tape, plastic spatulas and inks. Store them in clear plastic containers for easy color identification.

Screen Basics

Screens are available with wooden or aluminum frames. Although a basic wooden screen is relatively easy to make, professionally made screens are inexpensive and have the advantage of a very taut screen tension, which is very difficult to achieve in hand-built versions. Aluminum screens are also more durable. Even if damaged, it is a simple matter to send aluminum frames to be re-stretched with new mesh.

Choosing a screen

The most important factor of the screen is the mesh. Standard monofilament polyester mesh is measured by the number of threads per linear inch or centimeter. The decision of what mesh to choose depends on a couple of interdependent variables—the particle size of the ink and the kind of stencil being used. In general, professional-quality inks have the finest particle size and can be used with the finest mesh. It is this combination that can yield the most detail in an image. A tight mesh, 230 threads/inch (120 threads/cm) or higher, is recommended for general printing with water-based inks. The finest mesh, those over 305 threads/in (122 threads/cm), is best for photo-emulsion stencils with fine halftone detail. A more open mesh, from as low as 60 up to 180 threads/inch (43–90 threads/cm), allows a thicker deposit of ink and is suitable for printing large-particle (metallic) inks or bold imagery, or for printing on rougher surfaces or fabrics. Keep in mind that a coarser mesh allows more ink—and, consequently, moisture—through, which causes paper to buckle. Accommodate this by using a thicker, well-sized paper.

In addition to a standard white mesh, a yellow- or orange-dyed mesh is used for direct photo applications. The colored mesh reduces light refraction during the exposure process, yielding the sharpest detail.

The screen should be larger than the image by 4–6 in (10–15 cm) all around. This margin allows room for the ink to sit on the screen between pulls of the squeegee.

⌃ Tape the inside corners and the outside edge of the screen with waterproof tape to keep ink from seeping in between the frame and the mesh.

Screen care

With proper care, a screen can last through hundreds of printings. Immediately after printing, thoroughly clean off all ink. To remove water-soluble inks or fillers, spray the screen with very strong water pressure, preferably using a power sprayer. Stubborn areas may require a strong household cleaner/degreaser with a soft-scrub brush kept just for this purpose.

Remove photo emulsions as soon as possible (see page 73). Photo-stencils that have been allowed to remain in the screen are sometimes tenacious.

A final scrubbing with a detergent will degrease the screen in preparation for the next stencil. When water no longer beads up on the screen, rinse and blot dry.

Should the need arise for more aggressive reclamation due to dried ink or incomplete removal of photo stencils, there are several possible techniques:

- Liquid household bleach can break down old emulsion. Set the screen on a table in a well-ventilated area. Pour bleach on and soak for 20 minutes, then spray-clean with a power sprayer. Neutralize any remaining bleach with white vinegar.
- Use a more powerful gel emulsion remover. Paint the gel onto the screen and let it rest for a few minutes. Clean with a power sprayer.
- Sometimes photo emulsion is difficult to remove because inadequately cleaned old ink has dried on top of the emulsion. Try removing the old ink first with alcohol or a screen-cleaning solution. A caustic haze cleaner can be used if all else fails.

> ⊗ **Safety Watch!**
> Be sure to follow all safety recommendations when using tougher cleaning materials—protect skin and eyes and ensure that there is adequate ventilation.

The Squeegee

The squeegee is the functional companion tool to the screen-print frame. In the hands of the printer, it pulls the ink across the screen and through the stencil openings onto the paper. The flexibility of a squeegee is determined by durometer, a

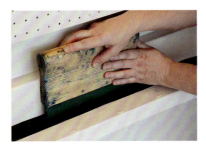

Squeegee blades for printing on paper should be kept square and sharp. A simple L-shaped sanding station keeps the blade at right angles to the sandpaper mounted to the surface. As an added precaution, sand the edge of the ends of the squeegee, so that a very sharply cut blade will not cut the screen.

measure describing the hardness of the blade. A midrange durometer (70–80) is suitable for most smooth paper or board surfaces. Softer blades (50–60 durometer) lay down much more ink and are good for printing on rough surfaces, such as fabric. Harder squeegees give a much thinner ink deposit. The very hardest blades (90 or more durometer) are used for printing fine detail work and halftones. The screen mesh is another factor that can determine the choice of squeegee blade. In general, use lower durometer blades with coarser mesh.

There are also different-shaped blades for different applications. The square-edge profile is the most common and is used for printing on paper. A round-edge or bull-nose blade is used to lay down an exceptionally thick layer of ink. Its most frequent application is in the printing of certain kinds of fabric. The single-beveled profile is widely used for printing on glass.

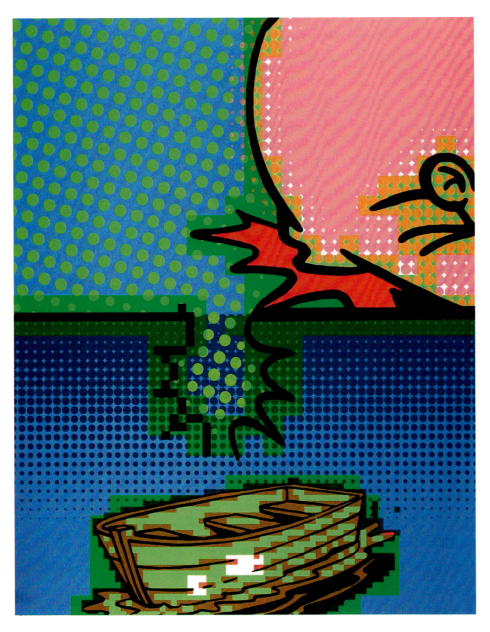

Tim Dooley, *The Ding-Dong-Daddy is Dead, Long Live. . .* , 2003. Screen print, five colors (three fluorescent), 20 × 16 in (50.8 × 40.6 cm). Courtesy of the artist.

This piece was produced in memory of Bill Walmsley, also known as Ding Dong Daddy, who was professor emeritus at Florida State University when the artist was an undergraduate. Dooley works with a collage strategy, collecting elements from coloring books and cartoons and digitally combining these elements to make a strange, hyper-familiar yet "not-quite" key image. He explores color strategies on the computer before finally realizing the image in screen printing.

Planning the Image

There are several approaches to conceptualizing a screen-print image. It is good practice to consider image making from different starting points—the various approaches often suggest alternative ways of resolving an idea. Those presented here can be used alone or in combination.

Key Image with Support (Spot) Color

A key image is a single color composition that controls all other aspects of a color print. Artists will sometimes print this image alone. It can be made initially in a variety of ways, such as a line drawing on paper, a collage, a computer-generated image, or a drawing made directly onto the screen. Layers of other color or textures "fill" the areas represented by the key image (rather like a coloring book).

Working in this manner requires accurate registration. The fill layers support the key image and are not typically made to stand alone. Sometimes, though, information generated in this process can prompt other images based on their abstract shapes.

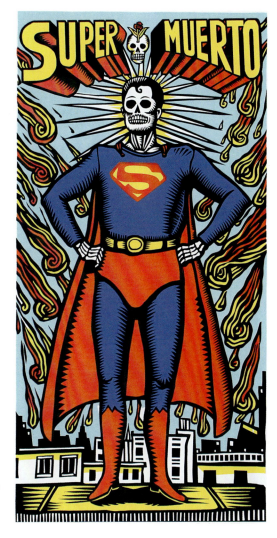

Artemio Rodriguez, *Super Muerto*, 2005. Screen print, four colors plus black, 24 × 12¼ in (60.9 × 31.1 cm). Courtesy of the artist.

Here the artist updates the traditional Day of the Dead imagery by using Superman as the subject. The key image is printed in black on top of red, yellow, and two blue layers.

Key image strategy

 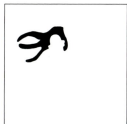 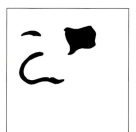 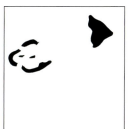 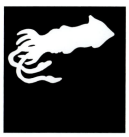

◓ High-contrast images, such as this line drawing of a squid, work best with the screen-printing process.

◓ Tracing from the key image, "fill" shapes that will be printed in the same color are identified and grouped for printing in layers. This can be done by hand or on the computer.

◓ Layers are printed on top of each other to build the image. In this example, the third layer and the background layer are printed with graded ink blends. To complete the print, the key image is printed on top, providing detail.

Relational layers

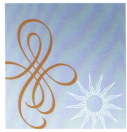

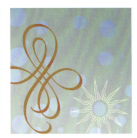

⏶ This exploratory idea begins with some typographic dingbats, a group of polka dots, and a graphic element from a dollar bill. Components are manipulated in many ways, including changing scale, orientation, position, amount of detail, and articulation.

⏶ Once the graphic element relationships are determined, layers are made into stencils for the screen.

Layer 1 Layers 1 & 2 Layers 1, 2 & 3 All layers Variation

⏶ Here, the sun symbol has been inverted so that the negative space holds the ink (layer 1). Next, the flourish symbol is printed in a darker orange (layers 1 & 2). The dot layer, also in reversal, has been positioned so that one of the circles aligns with the center of the sun shape (layers 1, 2 & 3). This layer is printed in a very translucent olive green, giving a subtle atmospheric field (all layers). The flourish and the dollar bill element are printed with more contrast, giving them the dominant presence in the final piece. The variation demonstrates the impact of these printing choices.

Reduction

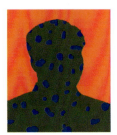

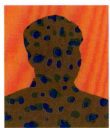

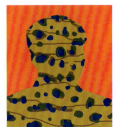

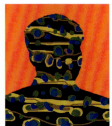

⏶ In this diagram, white areas represent areas of the screen that have been blocked out. Black represents the screen that is still open.

⏶ In this image, the field is printed as a solid first. The silhouette is established by blocking out the background, then printing in blue. Screen filler establishes a pattern of splotches in the silhouette field, which is printed next in green. The field is blocked out some more, and then printed in brown. This cycle continues with an ocher layer and, finally, a black layer.

Relational Layers

Working in relational layers begins with collecting elements that might be said to be "in conversation" with each other. The conversation might be between formal qualities of line, shape, value, color, and texture, but is most often thought of in terms of a conversation between images. A juxtaposition of images, text and or formal elements creates new associations and possible meanings as elements are brought together. In this way of working, while there may be a hierarchical articulation of images, it is the combination of elements that creates the idea.

The layered image is built from several screens, none of which exists as a finished image in its own right. As with a key image approach, elements are separated into layers that will be printed in the same color. Independent images exist in relation to each other rather than as images derived from a common source.

When conceptualizing the image, it is helpful to work in a layered format. A light table assists working with elements on paper. Seeing the layers is made even easier when images are photocopied or collaged on transparent Mylar. Scanning elements and developing layers digitally is an increasingly familiar workflow option.

The printing process demands another set of decisions. Color decisions, including degree of opacity or transparency and sequence of printing, can dramatically influence the final print.

Reductive Approach

A reduction print starts with a simple stencil. Rather than making multiple stencils existing in separate screens, successive layers in a reduction print are made by blocking (reducing) areas of the original stencil. This is traditionally done by using screen fillers or wax crayons, but can also be done with photo-emulsion stencils applied on top of an existing photo stencil.

Printing can start at any point. If there are white areas in an image, these would be established prior to a first printing. As the image is developed, less and less area is printed.

Color Separations

The color-separated image begins with a full-color image that is then digitally converted to four channels of cyan, magenta, yellow, and black (CMYK) (see pages 53–54). The four color layers are printed to re-create the color photograph.

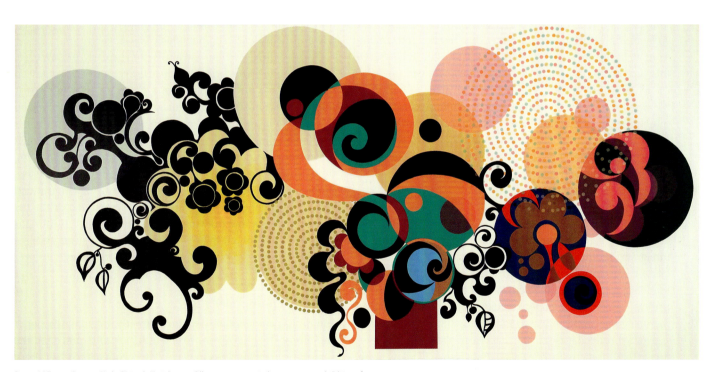

Beatriz Milhazes, *Summer Night (Noite de Verão)*, 2006. Silkscreen, 47 × 98 in (119.3 × 248.9 cm). Edition of 30, printed and published by Durham Press. Courtesy of the artist.

Milhazes' work combines an "adventurous fusion of influences, with undeniably Brazilian flavor." The print is composed of brightly colored elements relating to a string of popular Brazilian motifs, from carnival-inspired imagery to tropical flora and fauna. The print is composed of a large number of matrices, none of which exists independently, but each of which contributes to a tightly organized whole.

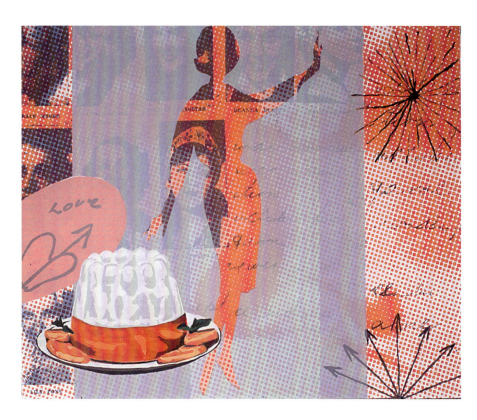

Melissa Harshman, *Orange Delight Salad*, 2004. Water-based screen print with 19 color runs, 15 × 19 in (38.1 × 48.2 cm).

All the layers in this image were created using photo-screenprinting techniques. These included digital printouts and hand-drawn elements that were exposed onto screens.

Registering Layers

Whatever approach is chosen, screen printing needs to register multiple layers. A guide sheet that records information from all of the layers can be very useful. The key image serves this purpose in the first case. The guide sheet can be drawn on a piece of newsprint, or on a regular piece of paper, cut *the same size* as the printing paper (including allowance for punch registration, if applicable). Use in combination with a Mylar to assist the accurate registration that takes place during image development and subsequent printing (see pages 27–29 for a detailed discussion of registration methods).

Basic Stencils

Stencils for screen printing fall into two broad categories: direct and indirect processes. Images made with direct stencils are developed right on the screen. Indirect stencils are made separately from the screen and put on the screen just prior to printing. The paper stencil and the photo-stencil are the two most commonly used indirect methods.

How you decide to create the screen may also influence image development (or vice versa). Photo-stencils allow for the most detail, but hand-drawn stencils created directly on the screen or cut paper stencils have their own characteristics, and may be just the right thing for your idea.

Direct Stencils

The most direct stencils are made by painting or drawing directly onto the screen with a block-out that can later be removed. The resulting printed image is a negative of the drawn mark. Screen filler and wax crayons will serve this process especially well and are most often used in the reductive approach described previously (see page 61).

Positive direct stencils are a two-step process. A drawing is initially made on the printing side of the screen with a medium that is soluble in water or solvent. Once the drawing is dry, the screen is covered with a thin layer of screen filler, blocking all open areas on the entire screen. When the screen filler is dry, the original soluble matter is removed with the appropriate solvent. Cold water quickly dissolves the screen drawing fluid, leaving the stencil filler. If grease-based media, such as a litho crayon, have been used, these are removed with mineral spirits. The result is an open area in the screen that prints the same as the original drawing on the screen. When printing is complete, the screen filler is removed using a strong household cleanser and a power sprayer with warm water.

Indirect Stencils: Paper

Hand-cut paper stencils are most directly linked to the paper stencils of the *pochoir* process that historically preceded the screen-printing process. A wax-coated paper, such as freezer paper is best suited for this purpose, as it will not be distorted by the water content of the ink. Freezer paper can be cut or torn into shapes that are laid under the screen. When the ink is pulled through the screen for the first time, these bits of paper adhere to the bottom of the screen, creating an effective stencil.

Adhesive materials are also acceptable stencil-making options. Polyester packaging tape or common frosted cellophane tape is especially good. Larger areas and shapes can

Direct stencils

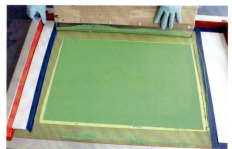

⊙ In this image, wax crayon is used to make a direct negative stencil. A reductive print is made by printing a layer, then adding more drawing, then another layer of printing. Eventually, the screen is mostly filled with drawn block-out material and very little ink is printed in later layers.

⊙ The most common drawing material is a screen drawing fluid (blue material in this image), which is rinsed out with cold water. Oil pastel crayons or soft litho crayons (black material in this image) also work with this method. They are removed with mineral spirits. Apply the screen filler with a stiff piece of cardboard over the image on the printing side of the screen. The layer of filler must be thin and smooth. Use rags with the appropriate solvent to gently remove the image from both sides of the screen. The screen drawing fluid makes a very solid mark, while the crayon retains some of the texture in the final print.

Indirect stencils: paper

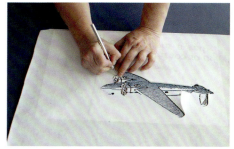

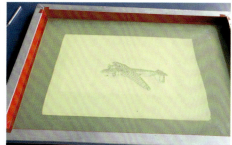

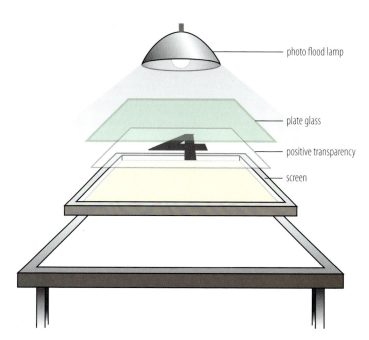

⊙ Tracing paper is positioned over an image to guide the cutting of a simple paper stencil. Once the stencil has been positioned, the screen is lowered and ink is pulled across it. The ink will hold the stencil in place, allowing the silhouette to print on the paper surface.

be made with adhesive shelf-lining paper. Cut shapes and develop the stencil on the back of the screen, being careful not to build up the thickness by overlapping elements, since this would cause too heavy an ink deposit when printed.

Indirect Stencils: Photo Emulsion

Photo-emulsion stencils are versatile and easy to make. The stencil is made by coating the screen with a light-sensitive liquid emulsion that is exposed to light through a positive transparency. The light hardens the emulsion everywhere except on the image, which rinses out with water, thus creating the stencil. Photo-stencils can mimic virtually any other stencil-making process and are, therefore, the most commonly used stencil-making method. Although it is necessary to have a darkroom and some means of exposing the photo-emulsion screen, it is possible to do this with a minimal set-up. Some photo emulsions can be handled in subdued light, making possible the use of a multifunctional space that can be temporarily used for this process.

⊙ In a do-it-yourself set-up, a photo-flood or halogen light shines through a positive transparency that sits on top of the screen coated with emulsion. Tight contact of the transparency with the screen is ensured by laying a piece of plate glass on top. During exposure, the emulsion hardens everywhere where light passes through the transparency. The opaque image in the transparency protects that area of the emulsion from hardening and ultimately rinses out with water to create the positive stencil.

Transparencies

A transparency is an image made with opaque materials on a clear or translucent surface. Transparencies can be prepared a variety of ways. In general, the image should be a "positive" transparency, i.e. it should look the way the final image is intended to look. The image must be dense and light-opaque to perform well. There are several basic approaches.

- Hand-drawn transparencies can be created using a variety of materials on frosted polyester film, drafting vellum, or similar surfaces. Experiment and see what works technically, to block the light, and aesthetically. Some materials may have to be sprayed with fixative to set them prior to using them as a stencil, and mixed materials may require some compromise during exposure time.

- A simple photocopy is an economical solution. It can be made sufficiently translucent for exposure by oiling the paper with vegetable oil. Copies on clear polyester save a little on the mess of oiling, but perform just about the same. Large-scale photocopies can be made at some service bureaus. They can be made on paper or clear polyester film. When doing this, be sure the toner in the photocopy machine is fresh so that the image will be dense.

- Translations of photographic or scanned imagery can be made digitally into a halftone (see pages 52–53).

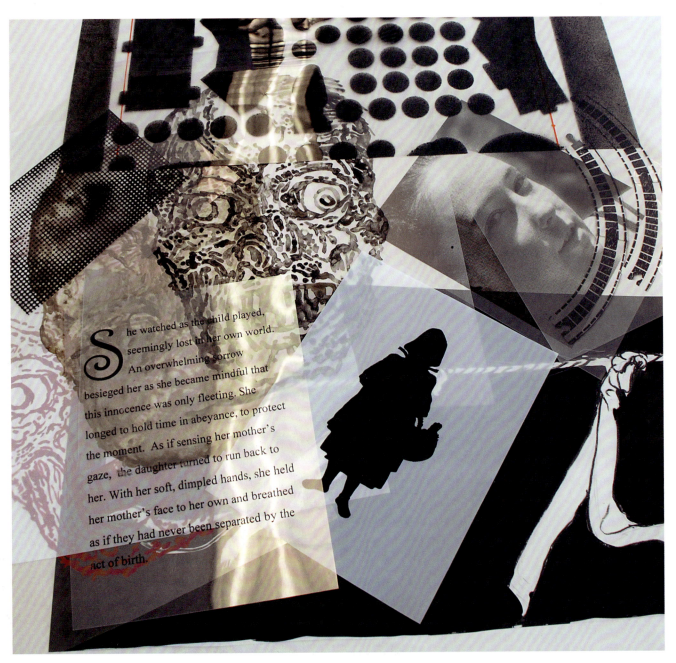

❖ Photo positives can be made in numerous ways: Some very reliable choices include a simple photocopy made translucent with vegetable oil, acrylic paint, pigment or metallic markers, good-quality felt pens that make dense marks, graphite (2B to, preferably, 6B), watercolor pencils, china wax pencils, litho crayons and pencils, India ink, Lascaux tusches, spray paint, or photocopy toner washes.

Transparencies: basic approaches

⌃ A transparency is created with India ink painted on Mylar or vellum.

⌃ Pour vegetable oil directly onto a photocopy. Rub it in on both sides, using a clean cloth. Blot off the excess between sheets of newsprint.

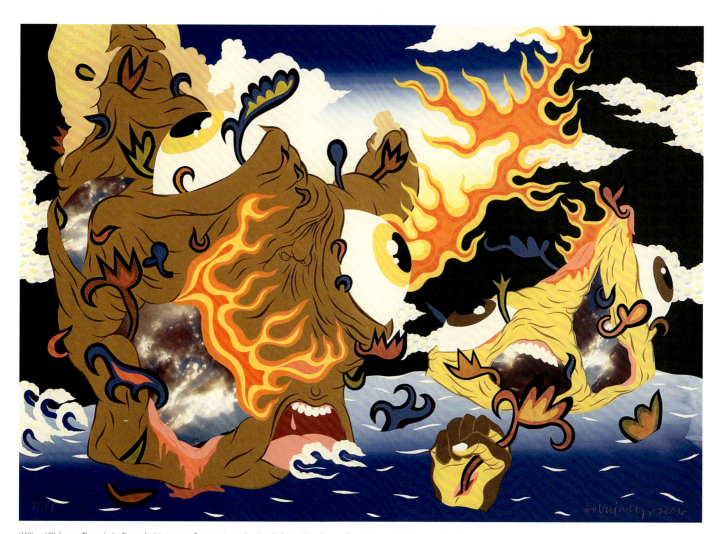

William Villalongo, *Through the Fire to the Limit*, 2006. Screen print and archival inkjet with velour appliqué, 28 × 39⅓ in (71.1 × 99.8 cm). Printed by James Miller, assisted by Dusica Kirjakovic and Doug Bennett, published by the Lower East Side Printshop. Courtesy of the artist.

Villalongo takes advantage of the flat, smooth quality of the ink layer that comes naturally to screen printing by contrasting it with digitally printed photographic elements and a physical velour appliqué.

65

David Sandlin

David Sandlin's artworks playfully and subversively address controversial issues, such as greed, racism, sexism, and the culture at large. His visceral imagery and bizarre narratives challenge clear distinctions of good and evil and, at times, provide a mirror to our own complicity in the state of the human condition.

> **Tell us about your creative process.**

Drawing was my first true love and I've made them as long as I can remember. As a kid, I loved comics. I would go back and forth between realistic-style drawings based on my *Children's Illustrated Bible* and cartoony monsters from my imagination. When I got to college, I had a great drawing teacher named John Dillon. He was also the printmaking teacher, so I took a class. In that first print class, I discovered that I had to think more about what I was doing—which of my images needed/deserved to be made into multiples.

Ever since then, printmaking has been integral to my working method. My work still begins with drawing, though. At first I sketch around, and from the sketches, I make larger drawings. The best of the finished drawings become prints. I use the printmaking process—making separations, deciding colors, and so forth, as a way of conceptualizing, editing, refining, and clarifying my art. If I want to keep thinking about it after I've made a print, it becomes a painting. After that, if I still haven't gotten the concept out of my system, it might become a book or installation—and once again, printmaking comes back into the picture.

I typically work with either books or groups of prints and I've found narrative to be a useful device. Of course, maybe it's the other way around—because I find narrative to be a useful structure for my content, I make books and prints, which lend themselves to narrative. Either way, my shows are usually themed, with the individual pieces working out various aspects of the narrative concept. I've always tried to make the shows fun and interactive by doing installations and stuff in the gallery windows. I also try to make inexpensive pieces like prints and bumper stickers, to keep the work accessible.

I get my ideas by simply living, observing, and thinking, and of course, by learning more about printmaking and its history. I have always used my family and friends as models in my paintings. Of course, this is practical—they model for free. More importantly, I find that depicting myself and people I know and care about helps me add an emotional aspect to the image, which I hope extends to the viewer. My work is often allegorical, and using models with personal connections has helped me create sympathy for what otherwise might appear to be two-dimensional mythological characters. More recently, still working in allegory, I've represented myself and my family in works of a more personal nature, dealing with the death of my father and my fears and hopes for my son.

Born Belfast, Northern Ireland

Education/training B.A., University of Alabama, Birmingham, Fine Arts, 1979

Current Position Instructor, School of Visual Arts, New York City

Awards and Exhibitions David Sandlin's paintings, prints, books, and installations have been exhibited extensively in New York and elsewhere across the US, Europe, Japan, and Australia. His comic art and illustrations have appeared in numerous publications such as *Blab!*, *Harpers*, MTV publications, *New Yorker* magazine, *Raw*, and *The Ganzfeld*. He is a recipient of grants from the Pollock–Krasner Foundation for the Arts, the Penny McCall Foundation, and the New York Foundation for the Arts, among others.

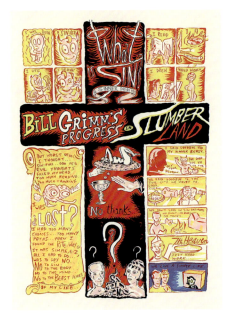

Bill Grimm's Progress in Slumberland, 1995. Screen print on paper, 22 × 15 in (55.8 × 38.1 cm). Courtesy of the artist.

The second page of *The Beast Years of My Life*, volume one of Sandlin's multibook epic, *A Sinner's Progress*.

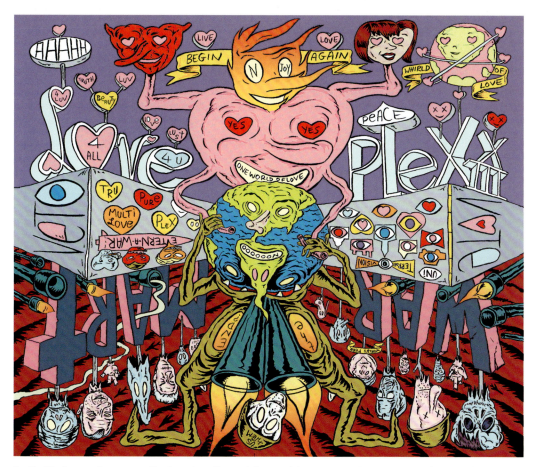

Love Plex/War Mart, 2005. Screen print on Plexiglass and wood frame with fluorescent light, 24 × 30 × 6 in (60.9 × 76.2 × 15.2 cm). Courtesy of the artist.

Sandlin's "sin sign," composed of a back-lit silkscreen-on-plexi image, which he describes as as a cross between a bar room sign and a stained-glass window.

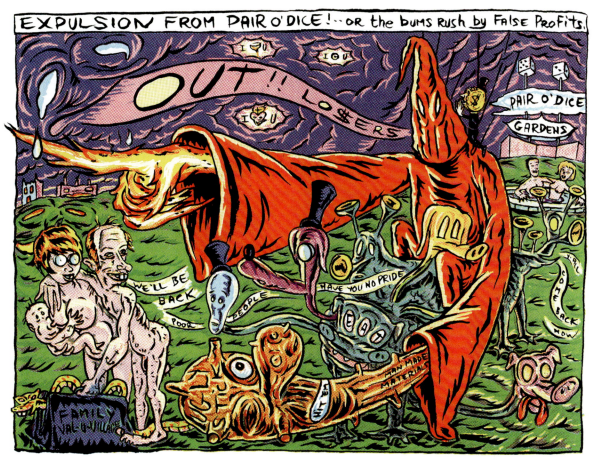

Expulsion from Pair o' Dice—Educational Screen No. 1, 2000. Screen print on canvas, 40 × 70 in (101.6 × 177.8 cm). Courtesy of the artist.

This "educational screen," one of Sandlin's Pur-Ton-o-Fun Co. products, was designed to "put the fun back in fundamental."

Emulsions

There are three basic categories of emulsions available: Diazo, dual cure, and pre-sensitized photopolymers. Diazo and dual-cure types are similar in that both use a diazo sensitizer that is mixed into the emulsion. Dual-cure types have a slightly different chemistry. Unlike straight diazo emulsions, the dual-cure benefits from a post-exposure, which continues to polymerize the emulsion, increasing its durability. Both these types of emulsion have a degree of latitude in the exposure time. Their main disadvantage is their relatively short shelf life. Once the sensitizer is mixed in, they will be good for only 6–8 weeks or up to three months if kept refrigerated. Purchase in quantities that will be used within this length of time.

Photopolymer emulsions employ a salt sensitizer (SBQ, or "stilbazol quaternized") that has a much longer shelf life. These pre-sensitized emulsions have a shorter exposure time, which requires more precision between the quality of transparency and the length of exposure. If working with the same kind of transparency all the time this can be determined and formalized in the workflow as a real timesaver. Otherwise, the greater latitude of the dual-cure or diazo sensitizers makes these better choices for a beginner.

When purchasing any kind of emulsion, look for those that are water-resistant and have high solids, and, for coarser-mesh screens, good bridging qualities.

Additional equipment

Photo-stencils are exposed with an ultraviolet light source. The transparency must be in tight contact with the screen for optimal exposure. Ideally, a vacuum frame designed for this purpose is used, however, a simple setup as described previously, can be employed effectively.

Applying the emulsion

1. Choose the screen—a dyed mesh at least 230 threads/inch.
2. Coat the screen with light-sensitive emulsion. This coating procedure must be carried out in a darkroom under yellow safelight conditions.
3. Dry the screen: While still in the darkroom, place it in front of the fan and dry for about 30 minutes. Check the edges to be sure that the emulsion is thoroughly dry before exposure—it is essential for it to be completely dry.

Exposing the screen

1. Set up for exposure. While the screen is drying, prepare the vacuum table. Check the glass on the table and clean with glass cleaner if necessary.
2. To encourage a sharp exposure, set the transparency on the exposure unit glass so that the image side will be in contact with the screen. This will be *image side up* in a vacuum fame where the lights are positioned below, as in this example. Then place the dry, emulsion-coated screen on top. Latch the vacuum frame closed.
3. Turn on the vacuum pump and wait until the suction has the screen and transparency held stable.
4. Expose: Set the timer for the required time and commence exposure. To determine exposure times, consult the emulsion manufacturer's recommendations. Timings will vary according to light source and emulsion type.
5. Wash out: Take the screen to the spray-out booth. First spray with the regular hose. Use a power sprayer only if the stencil does not clear easily and then only with a more gentle power spray. Check the screen against a backlight to see how well it has cleared.

> ⊗ **Safety Watch!**
> Wear hearing protection when using a power sprayer.

6. Dry the screen in front of the fan.
7. Once dry, check for pinholes. Use screen filler to cover any unwanted information.

Applying the emulsion

⌄ Fill the scoop coater with emulsion. Starting at the bottom of the screen on the back, put two layers on the back and then one on the front. Touch up the edges with a cardboard scrap.

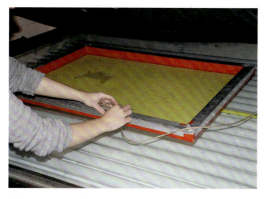

1. Transparencies are placed on the glass and the screen is positioned on top. A "bleeder" cord placed over the screen frame helps create a tight suction. This screen is being exposed with two layers of the image.

2. The exposed screen is rinsed in the backlit washout booth.

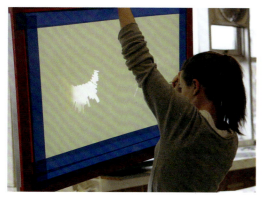

3. Hold the screen up to a light source to check for pinholes. Fill any pinholes with screen filler.

Printing

Printing can be a pleasure or a nightmare, depending on the setup of the printing situation. Take the time to understand an efficient sequence of steps so that printing proceeds in an orderly manner. Because inks tend to dry in the screen, it could be disastrous to stop in the middle of the printing process to attend to a necessary preparation.

Preparing to Print

1. Choose your registration method (see pages 27–29 for further details of each method described below):

- Mylar registration: To register layers accurately to one another, a Mylar is printed first. To do this, tape the polyester sheet to the edge of the printing table, beyond the position of the screen. Print the ink directly on the plastic. Dust a little bit of talc into the inked surface to set the ink and keep it from smearing. To register the printing paper, simply align it under the printed Mylar, flip the Mylar aside, then print the paper. This is an accurate method and can be used alone for small editions. The repeated handling of the Mylar can becomes tedious for editions larger than 15.

- Punch registration: All of the edition paper must be punched in advance. Used in combination with a Mylar, the punch system allows the position of the paper with the Mylar to be set first, after which the pin tabs can be positioned. Subsequent prints are just set on the pins and printed. This method can be very accurate.

- Tab registration: This is also used in combination with the Mylar. Simply figure out where the paper goes using the Mylar, then tape some tabs in place along the edges of the paper on two sides so that subsequent sheets are simply laid against the tabs.

2. Prepare the printing paper. Cut or tear paper to the desired size, leaving extra margins if using the punch registration system. It is sometimes helpful to mark the back of the paper with the correct orientation. Punch the paper for punch registration.

3. Mix the inks. To mix colors, add small amounts of darker color to lighter ones, a little at a time, until the desired color is achieved. Unless a very opaque ink is required, color should be mixed with about 30 percent transparent base. Very transparent inks can be made with up to 90 percent base. The ink should be as thick as heavy cream, but not too gloopy. Thin with alcohol (not water) if needed.

> ### Good Practice
> Store mixed inks in **clear** plastic containers so that the color can easily be seen. Mix inks in advance and store until ready to print. When printing is complete, put a few drops of glycerin in the ink to retard drying and save for future use. Be sure to clean up the ink mixing area before proceeding to printing.

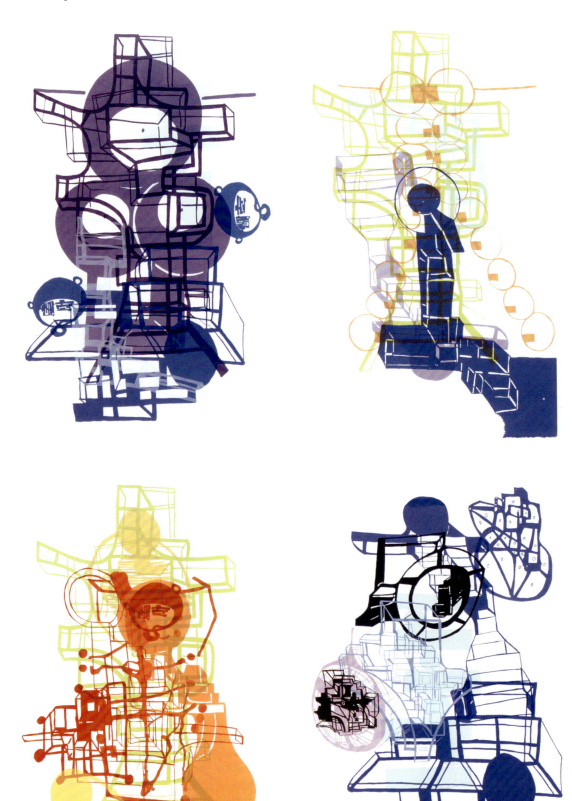

Joanne Greenbaum, *Untitled Outakes Nos. 2, 4, 5, and 6*, 2002. Screen print, 42½ × 30¾ in (107.9 × 78.1 cm) each. Printed by Courtney Healey, assisted by Dusica Kirjakovic and Justin Israels, published by the Lower East Side Printshop. Courtesy of the artist.

Greenbaum used several different screens to create compositional variations by registering the paper in a different location and printing layers with different colors for each image.

Setup

Many people disregard the importance of a proper setup. Take the time to get everything in place so that the printing experience will be more efficient and pleasant.

1. If there are multiple elements on the screen, cover the portion that will be printed later.
2. Clamp the screen to the table hinges.
3. Tape a double layer of mat board scrap at the corners of the screen opposite the hinges, so that the screen does not directly touch the table. The force of the squeegee will still push the screen into contact with the paper, but it will pop right back up, leaving no marks in the surface of the ink.
4. If the screen does not have a kickstand, find something that you can use to prop up the screen in between prints.
5. Choose a squeegee large enough to print the image. It should be at least 1 in (2.5 cm) wider than the area to be printed and small enough to fit the inside of the screen.
6. Decide where to set the ink, squeegee, tape, tools, rags, etc. so that work can proceed efficiently. Lay newsprint in these places to facilitate cleanup. Lay clean newsprint on the drying rack or area to collect the prints as they are made.
7. Tear off several sheets of newsprint to use for proofing during printing.

Setup

1. Use waterproof tape to mask areas of the screen to be printed later.

2. Hinges made especially for screen printing allow the screen to be securely clamped to the printing table.

3. Mat board taped to the corner of the screen will keep the screen from resting directly on the table.

4–6. A handy clamp-on kickstand, a stick screwed into a frame, or a simple wooden block will hold up the screen while the printed sheet is removed and the next sheet is placed in position for printing.

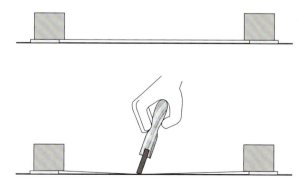

◗ Corner rises keep the screen from resting on the paper surface. A taut screen will come in to contact with the paper only as the squeegee is pulled across the surface, insuring an even deposit of ink.

The First Proof

1. Position the registration Mylar under the screen and tape it to the edge of the table (but not on the same side of the screen as the kickstand).
2. Put a generous amount of the ink onto the screen just above the image.
3. Flood the screen—with the screen lifted off the table a bit and applying only a little pressure, pull a layer of ink over the stencil.
4. Place the screen down and then, with increased pressure, pull the ink through.
5. Lift the screen gently.
6. thre will now be a print of the image is on the clear Mylar. Use the Mylar registration to position the printing paper under the Mylar.
7. Flood the screen in preparation for the next print.

The Final Print

1. Working quickly, position the paper either under the Mylar, against the tabs, or on the pins. Flip the Mylar out of the way.
2. Make sure there is a generous amount of ink on the screen just above the image. Add more ink, if needed.
3. Place the screen down and then, with increased pressure, pull the ink through.
4. Lift the screen, remove the print temporarily to the side while you flood the screen to keep the ink from drying out.
5. Move the finished print and allow it to dry.
6. Repeat the process.

> **Hint**
>
> If the paper sticks to the bottom of the screen after printing, try a light dusting of spray glue on the table surface, but keeping the nozzle away from the wet screen.

Making a screen print

1. A flood stroke puts a layer of ink in the screen.

2. With the image printed on the Mylar, paper can be aligned under the image in the proper location. Here, the punched transparency used to expose the screen is aligned under the printed Mylar so that a set of pins for punch registration can be taped into place. Subsequent sheets of punched paper are simply placed on the pins.

3. The paper is placed on a set of pins.

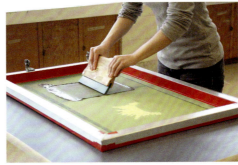

4. The layer is printed.

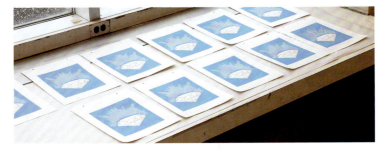

5. The prints are laid out to dry.

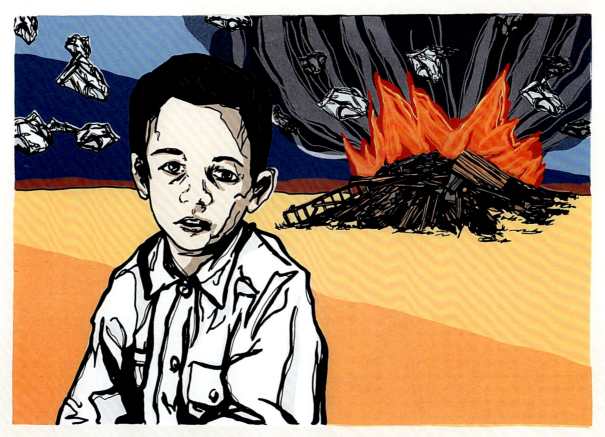

Hal had forgotten to account for the prairie winds.

Lany Devening, *Evidence*, 2005. Screen print, 16 × 20 in (41 × 51 cm). Courtesy of the artist.

Devening takes advantage of the graphic quality of screen printing to reference book illustration. Here, she employs a dark humor to create an absurd psychological drama.

Cleanup

1. Scoop any remaining ink back into the container and store.
2. Wash the ink out of the screen at the washout station. Use a biodegradable spray liquid detergent and a soft-scrub brush to help remove ink *thoroughly!* Ink haze residue can make removing photo-emulsion stencils very difficult.
3. If done with a photo-emulsion stencil, spray on emulsion remover. It is important to keep the emulsion remover moving and wet on the screen for at least two minutes, otherwise, if left to dry, the emulsion will be almost impossible to remove. Use a power sprayer to clean the screen *thoroughly*.
4. Wash the squeegee, ink spatula or spoons, and any other tools used.
5. Clean up the printing area: wash down the table, removing registration tapes, tabs, pins, etc. Wipe the table with bio-degradable cleanser. Remove any adhesive residue with a citrus-based cleaner.
6. Return all materials, tools, inks, and the screen to their proper homes.

Prints should be dry enough to print the next layer or to stack between newsprint within an hour or so. It is good practice to store prints as soon as they are dry enough so that they avoid possible damage in a shared studio.

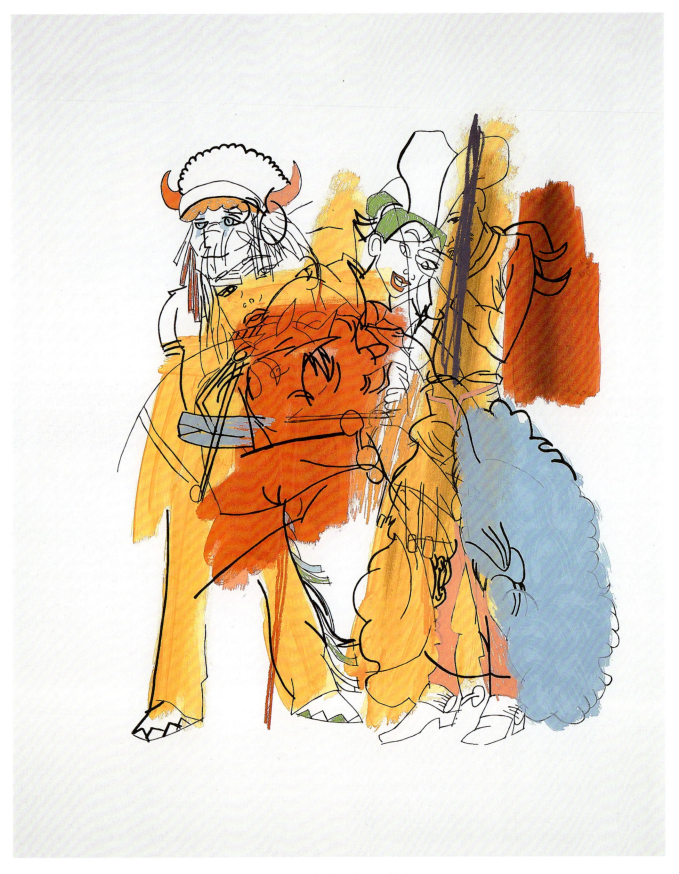

Ghada Amer, *The Cowboy*, 2002. Screen print with hand-painting, 28¾ × 22¼ in (73 × 57.1 cm). Edition of 30, printed by Courtney
Healey, assisted by Justin Israels, published by the Lower East Side Printshop. Courtesy of the artist and Gagosian Gallery.

The lines in this print replicate the artist's use of embroidery in her paintings to create abstract images that conceal tangled erotic scenes.
The painted brushstroke elements are used to color the images and add to the abstracted nature of the composition.

Chapter 4
Relief

Relief printing is one of the simplest and oldest forms of printmaking. The ocher earth hand-prints found in prehistoric caves are the first examples of relief prints. Simply described, the relief print is created by inking the top surface of a printing matrix, then printing onto a support. The prints made of a newborn's hands and feet, the "past due" rubber stamp on the face of an unpaid bill, or the potato-print wrapping paper made by the preschooler are all simple examples of the relief print. In fine art printmaking, the hand-carved matrix of the woodcut or linoleum cut (also known as linocut) are the most familiar approaches. Additionally, wood engraving—a specialized form of relief printing—utilizes very hard material, which allows for very fine detail. The image is made by carving into a block. The area that is left receives the ink and is then printed onto paper. Stone rubbings were the first expression of a relief matrix.

Woodblock printing had its early origins in ninth-century China. Following trade routes in the Islamic world, the technique spread throughout Asia and Europe. It wasn't until development of large-scale papermaking operations in the mid-fifteenth century that relief printing became economically viable as a means of printing for mass distribution of religious and informative imagery of all kinds.

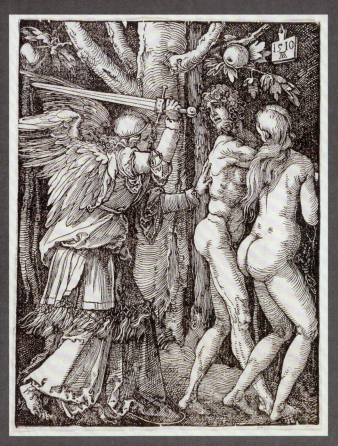

Albrecht Dürer, *Small Passion. The Expulsion from Paradise*, 1510. Woodcut, 5 × 3⅞ in (12.7 × 9.8 cm). Library of Congress, Prints and Photographs Division, Washington, D.C.

Dürer's exceptional skill helped to establish woodcut as a major art form.

Birth record footprints, 4 × 6 in (10 × 15 cm).

Any surface that carries an impression may be inked-up and made into a relief print.

Tools and Materials

There are many possibilities for creating a relief matrix. In addition to the familiar woodcut or linocut, artists have explored a variety of materials that can be carved, including plastics, rubber, cast plaster, Styrofoam, and composite boards. Essentially, any more-or-less flat surface that can be manipulated with hand or power tools is an option, as long as the material can safely pass through the printing press.

Additionally, matrices normally associated with intaglio printing, such as etched or engraved plates, can be conceived and printed as relief images. Relief prints can also be made from "found" surfaces that carry textured information, such as clothing, fabric, floor tiles, and other objects attractive for the imagery they carry. These materials are most commonly associated with the collagraph process and will be discussed in Chapter 6.

The choice of the most appropriate matrix material will be determined by factors such as the ease of cutting, preferred printing method (by hand or by press), and—perhaps most importantly—the contribution of the material to the interpretation of an idea.

Materials for Woodcut

There are many different kinds of wood suitable for woodcut. Although wood is generally classified into two categories, hard and soft, the actual hardness of any given type falls along a continuum. The choice of which wood to use will depend on

Käthe Kollwitz, *Self Portrait*, 1924. Woodcut, 8¼ × 11⅞ in (20.9 × 30.2 cm). Courtesy of the Ackland Art Museum, University of North Carolina at Chapel Hill. Burton Emmett Collection.

The type of wood and its grain can have a great impact on the strength of the directional movement in the image. In this self-portrait, Kollwitz established the image with clean cuts along the grain to create the strong silhouette. The cross-grain detail cuts add a raw tension to the somber, contemplative mood established by the predominance of black.

Tan Ping, *Untitled*, 2006. Color woodcut, 30 × 45 in (76.2 × 114.3 cm). Courtesy of the artist and Red Gate Gallery.

Cutting against the grain on softer woods with dull tools can leave a raggedy cut. This can be a problem or can be sought intentionally. Chinese artist Tan Ping takes advantage of this quality in his work.

balancing factors such as the grain, the ease of cutting and the ability of the wood to hold detail.

Since the cutting takes place on the grained, or plank, side of the wood, the coarseness and direction of the grain can be a factor in the overall aesthetic of the work. There is a tendency to cut with the grain, especially with softer and coarse-grained woods.

Softer woods that have a variety of hard and soft areas are best used when this kind of grain-dependent cutting is desired.

As a rule, the harder the wood and the more even the grain, the more detail it is capable of holding. It is also true, however, that the harder the wood, the more difficult it is to cut and the more frequently tools must be sharpened.

Materials for Carving

Attribute	Material	Advantages	Disadvantages
Soft and easy to cut	Soft woods: pine (white or sugar) Linoleum—softer grades now on market specifically for relief printing MDF (Medium Density Fiberboard)	Good for beginners	Require more care or, possibly, preparation to avoid dents Less durable and break down faster Pebbly texture of some softer linoleum which can also be crumbly if old
Moderately easy to cut	Poplar, a close-grained softwood excellent for medium detail Pear and linden (lime), two popular hardwoods Shina plywood, a specialty linden-faced product for woodcutting Linoleum—traditional "battleship" gray linoleum Plastics: Polyvinyl chloride foam board (PVC), HIPS (High-impact polystyrene)	Good for beginners Reasonable durability Linoleum is easier to cut if warmed slightly on a heated pad or warm hotplate	Shorter shelf life of linoleum, which can become dry and flaky with age
Hard and very durable	Solid hardwood: maple, oak	Most effective for finely detailed work Holds up for many printings	Usually more difficult to cut, requiring sufficient time and strength
Smooth	Cabinet-grade wood Linoleum MDF Plastics: PVC, HIPS	Little influence of grain or texture on the image Curved cutting is easier	Lacks the "character" provided by natural materials with more visible grain
Grainy or textured	Softwoods (pine) with varying grain densities that can be enhanced with a wire brush Oak Lauan plywood Linoleum with pebbly texture or burlap impression that can be sanded out	Texture can add an overall visual component to the image Strong wood grain that can dominate the directionality of the cut, adding movement and rhythm	Cutting across grain often difficult, causing splintering Varying pressure needed when hand cutting, due to inconsistent density of wood grain, resulting in tools "slipping" when moving from harder to softer grain Strongly grained wood unsuitable for curved cutting
Inexpensive (Note: More expensive materials are not always better)	Softwoods, PVC, HIPS, MDF	Less inhibiting, promoting experimentation (unlike more expensive materials which may encourage greater deliberation)	May encourage waste
Available in large sheets	Plywoood, up to 4 × 8 ft (1.2 × 2.4 m) Pieced solid boards Plastics: PVC, HIPS Linoleum, available in very large rolls MDF	Facilitates larger work Facilitates "on-the-block" registration (kentō and T and bar) and bleed prints Economical because several pieces are attainable from one block	May require assistance to handle Power saw required to cut block from large plywood sheets Curl in linoleum makes cutting more difficult
Thin	Linoleum PVC HIPS Thin lauan (door skin)	Good for jigsaw color or simple cutting to support background color Inexpensive	May warp (thin plywood or veneered boards) May be unable to hold up to vigorous cutting

Other Materials

In addition to the continuing love affair with wood, contemporary printmakers have expanded the range of matrix materials to include a myriad manufactured composite materials, rubber, and plastics. In contrast to wood, most of these materials are smooth and impose little of themselves on the final image, leading to a greater fluidity of cutting.

Linoleum, the most familiar of these materials, is made from ground cork and resin. MDF (medium-density fiberboard) is fast becoming a popular choice. Thin plastics with strong followings include HIPs (high-impact polystyrene) and PVC (polyvinyl chloride) foam board. Both come in a range of thicknesses and can be used in many ways. PVC is especially good because drawing directly into the surface with a ballpoint pen dents the material sufficiently to create a printable mark.

As with wood, the choice of the most suitable material depends on the function or effect that the material needs to deliver. The chart here (page 77) organizes material possibilities according to these attributes.

⊗ Safety Watch!

Because most MDF is made from compressed wood fiber dust and formaldehyde, the dust created when sanding or using motor tools can be dangerous to inhale. Under these conditions, a dust mask should be worn.

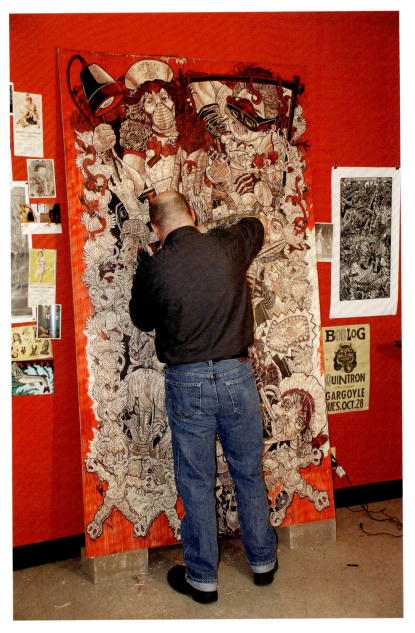

◀ American artist Tom Huck at work on the block for *The Transformation of Brandy Baghead*. Plywood allows work to be made at much larger scales. Tom's personal preference is very fine-grained marine-grade plywood. His unique style of carving the block in a vertical orientation is an ergonomic consideration, given that he will carve several hours each day for many weeks as he develops the image.

◖ Durability can be increased if the wood is prepared by rubbing a coat of shellac thinned with alcohol into the surface. Since the moisture from the solvent will raise the grain slightly, sand the surface back with very fine sandpaper before cutting.

Cutting Tools

The traditional woodcut involves the use of a knife and various U-shaped and V-shaped gouges for clearing. However, any tool that makes an impression in the surface will create a texture that can be printed. Even though linoleum can also be cut with the same tools as those used for wood cutting, there are special tools made for linocut. Tools with replaceable tips are handy so that cutting does not have to be interrupted by the need to sharpen tools.

Motor tools are another option. Small craft routers, sanders, and drills can make an interesting variety of marks. Motor tools make working with harder materials easier.

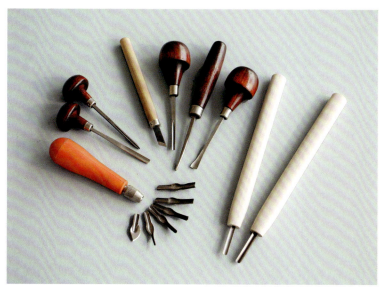

⊙ Choose tools made of good quality steel and the kind of handle that feels comfortable. Long-handled tools can be cut down to customize the fit to your hand.

Caring for Cutting Tools

Careless handling can cause nicks and chips that could require professional sharpening. Keep tools stored in a simple bamboo or canvas roll so that they do not bump against each other. Keep your tools sharp. You should never have to force a tool or "wiggle" it to cut a line. This puts stress on the blade and can quickly result in a broken tip.

Regular use of a leather honing block or razor strop with honing compound can delay the need for sharpening the tool on a stone. Should tools require significant sharpening, use an India stone with a drop of oil to do the major work of reclaiming the edge. Keep the angle of the blade flat on the stone and move it back and forth. With U- or V-shaped gouges, rock the tool on the cutting edge, keeping the angle of the blade flat on the stone. Finish the edge on a finer-grained Arkansas stone. Use a slip stone to remove any burr on the inside cutting edge of gouges.

Printing Tools

Handprinting is accomplished by placing the printing paper on the inked matrix and burnishing the paper from the back. The inexpensive tool for this is a hard, smooth object, such as a wooden spoon or a large wooden drawer pull.

The traditional tool for this task is the baren. A baren is handmade with a knotted coiled twine covered with a bamboo sheath. Professional-quality handmade barens can be very expensive. Some contemporary barens, designed with the goal of reducing the force needed to pull a print, are made of plastic or with a highly engineered system of ball-bearings.

⊙ Common burnishing tools: wooden knobs, Japanese Baren, wood spatula and wooden spoons.

Matrix-making Process

Putting the Image on the Block

There are several methods for establishing an image on the block to use as a cutting guide. The degree of information needed in such a guide depends on the artist's intention to work precisely or spontaneously. Even if a cutting guide is established on the block, do not overlook the possibility of interpreting information as the cutting progresses.

Preparing the surface

The degree to which the surface of any material is prepared to receive the drawing is sometimes a matter of aesthetic choice, but it is often important for facilitating the process of cutting.

With almost all surfaces, there might be some residue of the manufacture to consider. Sometimes these textures will be visible in the print. A light sanding with fine-grit (180 or finer) sandpaper or fine steel wool can remove this mechanical texture if it is deemed undesirable.

It is helpful to stain the block with a wash of acrylic paint, or printing ink thinned with mineral spirits. The stain makes it easy to see areas that have been cut. This is done *before* establishing an image with direct drawing and *after* any solvent transfer methods.

Alternately, if drawing on linoleum with India ink, a thin coat of gesso applied to the surface of the block will help the ink to adhere better. If the gessoed surface has undesirable brushstrokes or texture once it is dry, it can be smoothed with fine sandpaper or steel wool.

Direct drawing

The simplest method of establishing the image is obviously to draw directly on the block. Keep in mind that the printed image will be a mirror image of this drawing.

To avoid streaks, use a sponge brush to apply the gesso.

Tom Huck stains the surface of his uncut block with a red permanent marker. The red areas that remain to be cut are clearly visible.

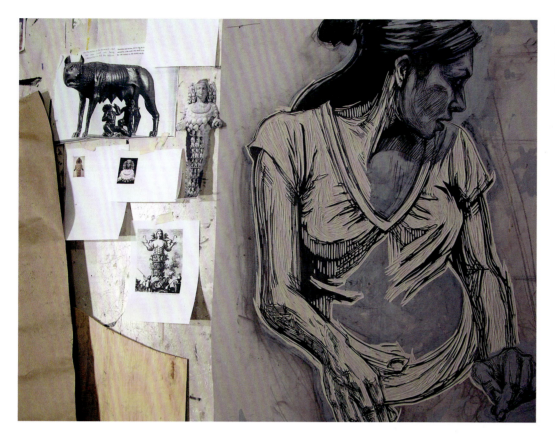

American artist Swoon draws directly on the surface of the block, then proceeds to "carve the drawing." She will interpret the drawing or add detail as she carves, using the carving tool as a drawing tool.

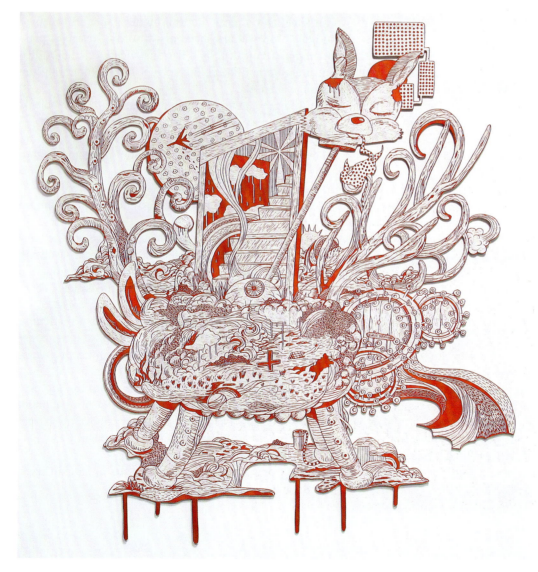

Kenichi Yokono, *Monster*, 2006. Spray-painted and inked woodblock, 71 × 65 in (180.3 × 165.1 cm). Collection of June Lee Contemporary Art. Courtesy of the artist.

Yokono takes the idea of drawing with carving tools to the next level. The blocks are carved, but rather than being printed, they are spray-painted white, then inked in red. The blocks stand alone as finished works.

Transfer methods

Transfer methods allow an image to be developed off the block where compositional considerations can be made in the same orientation of the final print. In most cases, the image transferred to the block will be a mirror of the original. Transferring can be done in several ways.

Drawing transfer

The first is to make the original drawing in a soft material such as charcoal, conté, or soft graphite, then place it face down on the block and transfer the drawing material by rubbing the back with a burnishing tool, such as a spoon or bone folder. Alternatively, transfer the material by running the assembly through an etching press at regular printing pressure.

Carbon transfer

The second method is to place a piece of carbon paper between the drawing and the wood or linoleum, and then trace the drawing, thereby transferring a layer of carbon to the block. If it is important to record a mirrored image onto the block, make initial drawings on tracing paper or make mirrored photocopies to trace from. Using a registration jig to keep the drawing and the block aligned, trace the information needed to guide cutting. Once the drawing is transferred, it can be strengthened on the block with a permanent marker or India ink for greater visibility.

Photocopy transfer

Another time-saving transfer process is photocopy transfer. It is especially helpful when working with text or photographic elements (begin with a clean, primed surface). The photocopy can be transferred either with heat or with solvent.

Heat transfers have the advantage of avoiding toxic solvents. While sometimes not as sharp as a solvent transfer, this method usually provides sufficient information to work as a cutting guide.

To transfer, place the photocopy face down on the uncut relief matrix. Using a household iron set on the highest dry heat possible, iron from the back to re-melt the copy toner and transfer it to the block.

> ⊗ **Safety Watch!**
> A hot iron can cause severe burns. When done, unplug and let the iron cool.

Solvent transfer can be done by hand or with the help of the press. Note that while the process is described here as a means to develop a block, the solvent transfer processes can be used for many purposes, including direct transfers to paper.

The advantage of this method is that it provides the most detail of all of the transfer methods. The drawback is the potential toxicity of the solvents used and the changing technology of photocopiers. Some newer photocopy machines use different plastic toners that may not easily dissolve with conventional solvents. As the technology of photocopy machines evolves, a certain degree of experimentation may be necessary to determine the most effective solvent for the different toner powders.

As of this writing, the most effective solvents are acetone and citrus solvent which is a d-limonene-based solvent and clearing agent that is marketed as a safe alternative to xylene and ethyl acetate. Check the MSDS of citrus solvent brands available locally to determine which products will work.

> ⊗ **Safety Watch!**
> The photocopy transfer uses a solvent to dissolve the toner powder and release it on to the printing matrix. Be sure to wear appropriate skin protection and use in a well-ventilated area or wear a respirator.

To transfer by hand, tape the photocopy to the top of the block. With a piece of cotton soaked in citrus solvent, rub the back of the photocopy to dissolve the toner. This may take a while. Be patient and let the solvent do the work. Rub the back with a spoon, pencil, or other hard tool to encourage the transfer and to create textural variations.

The press transfer is the quickest and generally affords a sharper, more detailed transfer. The process described here uses acetone. Collect the block, the photocopy, a newsprint sheet and a piece of clean blotter paper cut to cover the block. You will also need a stiff solvent-resistant plastic laminate (Formica) as a backing sheet. This helps give firm pressure and keeps the solvent from penetrating the printing blankets.

1. Set firm pressure on the etching press for the relief block, using all three felts and the backer.
2. Next, engage the blankets, then flip them out of the way. Keep the backing sheet and a newsprint protector sheet to the side.
3. Place your block on the press bed.
4. Trim the photocopy and lay it face down in position on the block.
5. Now you have to work somewhat quickly. Soak the blotter paper with acetone. Be efficient with the use of solvent, using only what is needed to soak an area big enough to cover the transfer area (not necessarily the entire sheet of blotter paper).
6. As soon as the acetone has flashed off so that the blotter paper is still wet but not shiny, *quickly* lay the blotter paper on top of the photocopy, then place the protective newsprint and then the plastic backer sheet on top.
7. Lay the blankets in place and crank the press through. Optionally, you may also go back and forth a couple of times to ensure a solid transfer. Then remove the blotter and photocopy to reveal the transferred image.

Once the drawing has been transferred to the block in black, stain the surface to facilitate the cutting process.

Drawing transfer

1. To transfer by hand, draw the image in a soft material.

2. Place the drawing face down on the block and transfer by rubbing with a wooden spoon.

3. Strengthen the image with a marker pen before cutting.

Carbon transfer

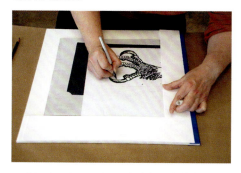

1–2. Using the registration jig gives the ability to check the progress of the tracing.

Photocopy transfer

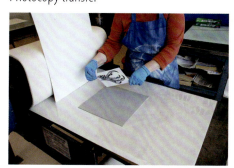

1. Lay the photocopy face down on the block.

2. Soak the blotter paper with acetone.

3. Lay the blotter paper on top of the photocopy.

4. Lay the backer and blankets, then crank through the press. Remove the photocopy and blotter.

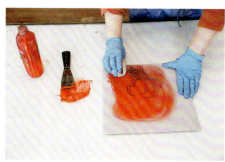

5. Stain the surface to aid cutting.

Cutting the Block

The relief artist has several choices when cutting the block. The choice of tool will impart its own characteristic to the work. In addition to choosing the cutting tool, aesthetic decisions must be made for interpreting every mark.

Characteristic features

Information can be interpreted as a white line on a black ground, a black line on a white ground, solid white or black shapes, or textured areas. White line is the most straightforward cutting, using the gouge or knife as a drawing tool. The classic "black-line" approach echoes the historical aim of woodcut to mimic the look of a drawn line. It is achieved by cutting both

sides of the line with the knife to establish linear elements, then clearing away the areas in between with the gouges.

Of course, not all edges are hard or linear. Textured cutting with gouges or other mark-making tools can create a variety of interesting marks that can read tonally. Patterned cutting allows for decorative interpretation of tonality.

> ### ✖ Safety Watch!
>
> It is very important to keep blades and gouges well-sharpened; dull tools resist the wood, requiring more force to use them. One slip can mean a quick trip to the hospital for a few stitches.

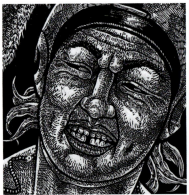

Black line textured cutting describes tonal values.

Black line cutting conforms to the line drawing.

High-contrast cutting interprets photographic information and lettering.

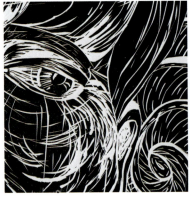

White line cutting describes form.

White lines with a variety of line weights. Wiggly lines have been made by rocking the U-gouge.

"Carving" with a belt sander expresses wood grain and creates soft edges.

Embossed and punched objects provide visual interest.

Stippling creates overall surface texture.

Decorative marks and patterns make for visual variety.

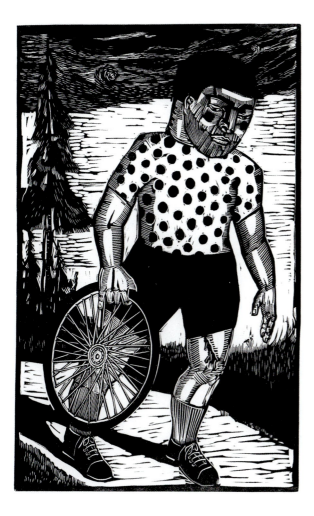

Marc Brunier-Mestas, *Maillot à Poids*, 2007. Linocut, 15¾ × 10 in (40 × 25.4 cm) . Courtesy of the artist.

Here the artist uses black- and white-line carving techniques to illustrate the scene of a disheartened Tour de France cyclist who has crashed and will no longer have the title of Best Climber, symbolized by the polka-dotted jersey.

Patsy Payne, *Cloudscreen 6*, 2002. Woodcut and linocut, 28 × 28 in (71.1 × 71.1 cm). Courtesy of the artist.

Australian Artist Patsy Payne utilizes a cutting strategy of small marks. The result is an undulating textural surface without the bold edges that are emblematic of black-line woodcut. Her organization of the landscape elements with multiple orientations in the diptych form accentuates the fact that the image has been constructed, compelling the viewer to consider the abstract notion of landscape and the difficulty of our human relationship to nature.

Using the knife

The knife is traditionally the most important tool of the woodcut artist, used to outline areas that will be cleared later with gouges or chisels. It can also be used repeatedly to scar the surface of the wood in a cross-hatching manner to create tonal areas.

Working with the gouge

Gouges are used for clearing and textural cutting. To clear a large area cleanly, C-shaped gouges are the most effective. The wood is shaved gradually and can be removed with little texture remaining. The U-shaped gouges cut a narrower path, leaving more texture in the cleared area. When working with wood, gouging is done as much as possible in the direction of the grain of the wood. Cutting in this direction lifts the wood cleanly without digging into the surface.

For a sharply defined edge, first score a line with a knife or flat chisel. Start gouging in the middle of the area to be cleared and cut toward the scored line. Ease up the pressure on the gouge as you approach the line, letting the wood lift out sharply. If you are establishing an edge without a preliminary knife line, start at the edge and cut into the area to be cleared.

> ### ⊗ Safety Watch!
> When cutting with gouges, always turn the block rather than the cutting tool so that cutting is directed away from the body. Use a bench hook to brace the block so that your hands can be kept behind the cutting tip.

Using the knife

⌃ Almost all cutting is done by pulling the knife toward the cutter. It is not necessary to cut very deep, and, the finer the detail, the less depth is required.

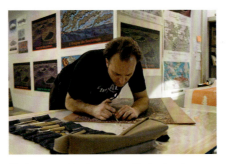

⌃ The artist stands and carves at a table. Comfort when working on large blocks is important so as to avoid fatigue and injury. Always keep your tools accessible.

When scoring a line in preparation for clearing operations with the gouging tool, cuts should be angled away from the printing area in order to create the most stable printing base.

Working with the gouge

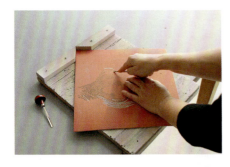

◀ The pressure of cutting pushes the bench hook up against the table and pushes the block up against a second stop on the bench hook. A notch in this second stop allows the block to be turned at an angle as well.

The scored or chiseled edge is established.

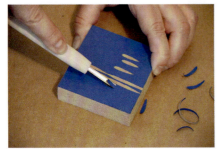

⌃ A U-shaped gouge clears a narrow path.

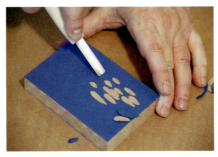

⌃ A C-shaped gouge can be used to cut a wider path or to clear large areas.

Cutting is directed toward the edge.

As the cuts meet, the wood is cleared.

Motor tools

Use of motor tools can provide a wholly different character of line and texture. Sanding tools can be used quite expressively and create soft tonal variations. Drills and routers can cut clean, mechanical marks.

Textural impressions

There are infinite ways to achieve textural impressions in the surface of wood or linoleum. Brushing the surface of softer woods with a steel brush can raise the grain. Distressing the surface by hammering nails, punches, found objects, or other items into it provides a variety of textures that translate to tonal values in the final print.

Since unmounted linoleum can be run through the press, textured materials that are not too thick, such as sandpaper, wire, metal washers, or watch parts can be impressed directly into the surface.

> **Good practice**
>
> Avoid potential damage to printing felts by using an old felt and a smooth piece of cardboard for this process.

Begin by setting the pressure of the etching press to accommodate the linoleum, felt, and cardboard. Lay the objects to be impressed on top of the block, place the cardboard and then the felt on top, and run them through the press. The impressions in the linoleum will be sharp and clear. (The cardboard will also be embossed with these textures and might possibly be developed further as a collagraph plate.)

Repairs

Once a part of the block is cut away, it is difficult to replace. It is a good idea, therefore, to be somewhat conservative when removing material at the beginning and take proofs at various stages during the cutting. Experience develops an understanding of the print that results from a certain amount of cutting.

If working with a detailed guide image, however, don't proof too soon. The inking process can cover up the guide image and make subsequent precision cutting more difficult.

Depending on the material being used, there are several approaches to repair work. Wood is relatively easy to repair. If you can retrieve the accidentally cut piece, simply glue it back in place with wood glue. If the piece is gone, fill the hole with wood putty, let it dry completely, then sand it smooth to the surface with a very fine sandpaper. Repeat this process as needed as the wood filler shrinks.

Linoleum is generally more difficult to repair, yielding mixed results depending on your craft. Mis-cut linoleum pieces can also be re-glued. Patches can be made with acrylic modeling paste, but it takes significantly longer than wood putty to dry.

Printing the Relief

While it might seem as if the work of making the relief print is in the development of the block, it is the ink-on-paper print that ultimately stands as the final measure of the work. Once the block cutting is complete, the artist has to consider paper type, size, and orientation, as well as ink color, all of which will interpret the information of the matrix into the final print.

Paper Considerations

Relief prints can be printed on a wide variety of papers. One of the main considerations has to do with whether you intend to print by hand or on a press.

Traditional handprinting is done on smooth, thinner, dry paper. With a thinner stock, the quality of the impression can be gauged by looking at the back of the print as the print is pulled. Asian papers from Japan, Thailand, China, and the Philippines offer a vast selection of suitable options.

When printing on the press, you can use thin or thick papers. Thicker papers printed on a press allow the image to have a degree of embossment, if desired. Smoother papers can be printed dry, while papers with textures can be dampened slightly in order to achieve solid, crisp printing.

Ink Considerations

The best ink for relief is a short ink with medium to high tack. It should also be relatively stiff. All of these qualities combine to allow the image to print sharply onto the paper.

Printing by hand requires a somewhat tackier ink. This helps keep the paper from slipping while burnishing.

Oil-based inks formulated especially for relief or lithography are more likely to be ready to use direct from the can. Some intaglio inks can be too runny for relief printing. Most printing inks, however, can be modified to make them suitable for relief printing.

In recent years, water-based inks have become much more viable options as slower drying formulas have given them similar working properties to the oil-based inks that they seek to replace. These are good options for situations that require simpler soap-and-water cleanup.

> **Good practice**
>
> Avoid using too much oil when modifying your ink. Excess oil will leach in to the paper causing a halo effect. Also, the ink may dry with a metallic-looking discoloration called "bronzing".

Karen Kunc

Karen Kunc's prints and artist's books stem from her contemplation of the forces of the natural world. Her works suggest ephemeral encounters and the immeasurability of time and distance. Her unique style of printing puts these notions into iconic images of creation and preservation, and allusions to human myth and metaphor.

❯❯ *Describe your creative process.*

My process begins by making spontaneous sketches on 8 x 5 in cardstock. I draw only in black pen, preferring to let the color develop in the printing process. I look everywhere; my eyes always searching for visual cues—in the landscape, in interesting graphic patterns of tree branches against the stark sky, the spaces between things, or in odd and surprising juxtapositions of materials. I look for the human trace in surroundings—the absence of presence and the wear of time. When traveling, I sketch from life to put what I see into my own hand-marks. When at home, I draw from memory and invention, and contemplate the visual symbols that suggest meanings. I continually refer to this ongoing stack of drawings. In the sketches, all of my influences come into a translation that carries my unique hand and sense of composition.

Working from a thumbnail sketch, I generate a full-size graphite drawing on Mylar. I then make a simple tracing of the main shapes and forms. I transfer this layout in reverse onto two birch veneer plywood blocks and then apply shellac to the surface to seal the wood and protect the tracing.

The blocks are carved as opposites; a "positive" and a "negative." I work with a reduction method, printing then carving further after each color run. I usually use paper stencils to roll color through the openings onto the block to apply ink in selective areas, enabling several colors to be printed at once. I try to print many colors against the white of the paper in the early stages, in order to insure a brilliance and variety of colors. I begin with transparent ink mixtures, with as much as 80–90 percent tint base, and use progressively stronger, less transparent colors as the image develops. To avoid embossment, I print on an etching press using a press board and no blankets. I use Japanese papers, which are very receptive to the ink. Some prints take as many as 8–12 runs to finish, with the later stages often handprinted. I work until the print feels finished and all my "questions" are resolved.

I do believe that there is a correspondence between my process and my content. Many ideas stem from thoughts of growth/evolution and how small things can affect the outcome or path of shaping of everything, from seemingly inconsequential acts to impacting the whole world! There is my core metaphor! My process is performative, as my understanding of the image develops while I am in "the making." My prints themselves record my process of destruction/creation, and I take on that omniscient role as I make my choices step by step toward the resolution of my image.

Born Omaha, Nebraska, USA

Education/training BFA, University of Nebraska-Lincoln, MFA, Ohio State University

Current Position Willa Cather Professor of Art, University of Nebraska-Lincoln

Awards and Exhibitions Karen Kunc's work has been shown extensively in the US, Europe, and Asia. She is represented in collections worldwide, including the Museum of Modern Art (NY), the National Art Library of the Victoria and Albert Museum, London, and the Machida City Museum of Graphic Arts, Tokyo, Japan. Among Kunc's many honors are a Fulbright Fellowship, two National Endowment for the Arts Fellowships, and the Southern Graphics Council Printmaker Emeritus award in 2007.

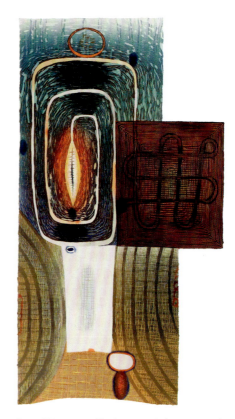

Primeval Message, 2001. Woodcut, 42 × 23 in (106.6 × 58.4 cm).

With this piece, the artist takes advantage of using a single sheet of shaped paper to achieve a collage-like effect. The print looks as if it was built from multiple elements to bring together seemingly unrelated forms, spaces, and colors. Kunc notes that she was referencing the fossil record, sedimentary accumulation, and the interpretation of meanings, when designing this image.

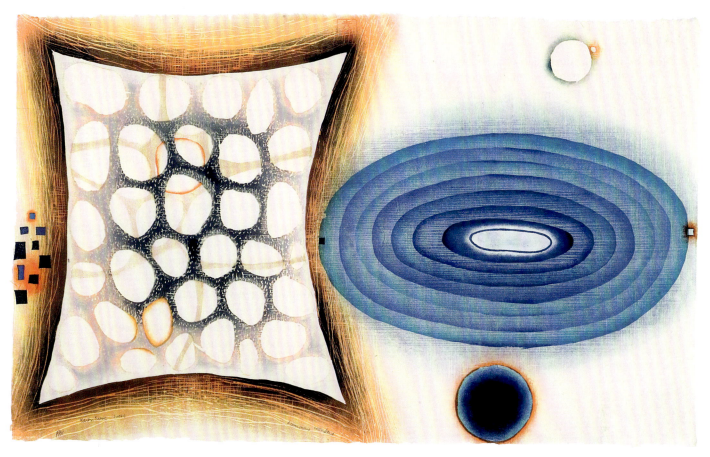

Luminous Wonders, 2006. Woodcut, 12 × 20 in (30.4 × 50 cm).

Here Kunc suggests a variety of dynamic themes ranging from the expanding universe to the birth cycle and cell division. With these images, she mixes a scientific illustrational style with a mysterious layering of cosmic spiritual symbols and orbiting celestial bodies.

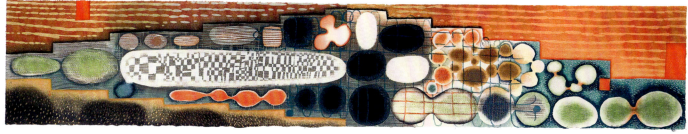

Treasure Trove, 2005. Woodcut, 14 × 80 in (35.5 × 203.2 cm).

With this image, the artist creates a scene reminiscent of an archeological dig—a place where ancient treasure and arifacts are scattered among colorful stones and rubble. The size of this piece allows the audience to experience the "artifacts" on a panoramic human scale.

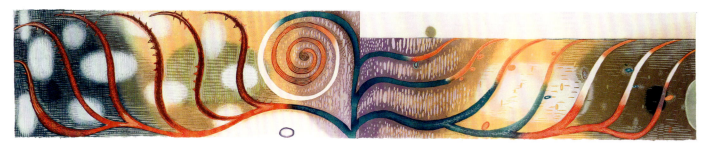

A Potent Embrace, 2005. Woodcut, 14 × 78 in (35.5 × 198.1 cm).

A beautifully exotic tree-like form unravels its dangerous tendril branches, reaching for its next embrace. Kunc takes advantage of the long narrow piece to accentuate the expanding nature of this primeval organic form.

Rolling Up

Roll the ink out onto a slab of glass or smooth stone using a medium rubber brayer. The layer of ink should be heavy enough to cover the printing slab, but not so thick that it develops an orange-peel texture. The surface should be smooth and velvety. Keep adding ink little by little and roll it out until a slight tacky sound is heard. Transfer the ink to the block with the brayer until the same sound is heard.

Depending on the surface area to be covered, you may have to add ink to the slab in order to maintain the ink film. Be careful, however, not to overload the surface of the block with ink. Aim to have the same velvety ink layer on your block as is on the inking slab. A heavy deposit of ink will spread during printing, sacrificing detail in the final image.

Rolling up

1. To add the ink to a glass slab or smooth stone, pick up a small amount with a brayer and begin to roll out.

2. Continue to add ink and roll it out in small quantities.

3. When all the ink is rolled out, the surface is smooth and velvety, and the ink makes a "tacky" sound, it is ready to transfer.

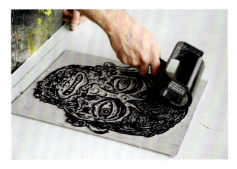

4. Use the brayer to transfer the ink to the block.

Printing the Block by Hand

Handprinting requires a simple registration method, especially if anticipating multiple colors. A registration guide combined with T and bar to align the paper, and block or kentō registration marks cut directly into the block are conventional registration systems for handprinting.

Alternatively, a system that holds the paper in place relative to the block in a fixed position can be very accurate. This can be accomplished with a punch registration, or simply by taping the paper down next to a block held in a fixed position.

Set up the paper and block in the registration guide of choice. Lay the printing paper over the inked block and rub the back of the paper with a burnisher—either a traditional Japanese baren, a wooden spoon, or some similar device. Wooden drawer pulls work nicely, too.

As the block is burnished, the ink will show through the back of thinner Asian papers, enabling you to gauge the quality of the printed image. The amount of pressure determines both the tone and sharpness of a print. In general, a sharper, more detailed image results from a relatively thin inking with heavier rubbing rather than lighter rubbing with a heavy ink deposit.

Sometimes, artists will purposefully vary the burnishing pressure to achieve additional tonal variety. A "kiss" impression is the term used to describe the even, light tone that the paper picks up when it is first put onto the inked block and rubbed lightly by hand. Darker areas can then be selectively developed with additional burnishing.

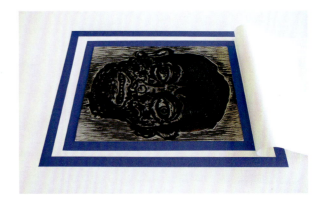

The paper is fixed into position with tape hinges. Tape is also used to define the border of the paper and the block position.

Printing the block by hand

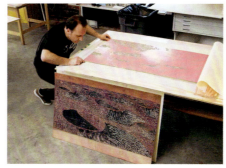

1. When inking the block make sure that the ink layer is consistent. Always avoid roller marks.

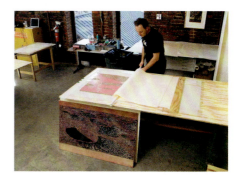

2. Here the artist Endi Poskovic uses a variation of the traditional system of registration. His printing papers are locked into place and successive blocks are placed in the exact position relative to the paper.

3. Placing the paper on the inked block should be done with care and precision. This will allow the paper to make full contact with the inked surface. Poskovic uses a long paper tube to help him roll out the paper.

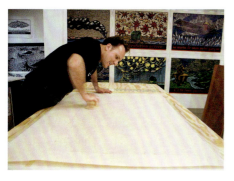

4. Burnishing a large print is a slow and physical process. Be methodical in knowing where you've burnished and pay special attention to the edges and corners. Once the image has been lightly burnished all over once by hand, select areas or the entire print can be darkened by continuing to burnish with heavier pressure. Place another sheet of paper over the print paper to protect thin papers from the direct action of the burnishing tool.

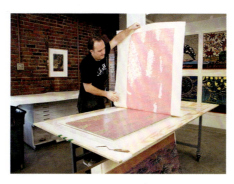

5. When lifting a large print after burnishing, make sure that the paper does not crease or fold in on itself. Hold it up high. Sometimes it helps to have another person assist.

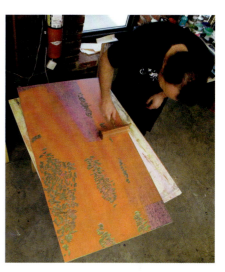

6. The block is inked with another color.

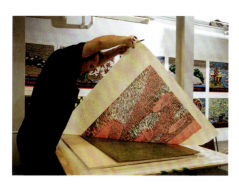

7. Another color is added.

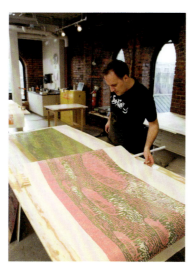

8. Poskovic reviews the image before continuing with more colors. In the end he will have printed ten different colors from five blocks.

Printing on the etching press

1. Tom Huck at work on his woodcut *Ultimate Cock Fight*. His press setup has running boards at either end of the block.

2. The block is inked.

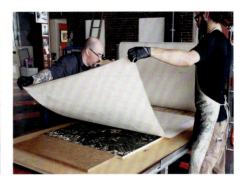

3. The paper is placed using a T and bar registration (located on running boards).

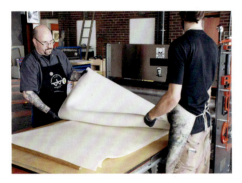

4. The blankets are added.

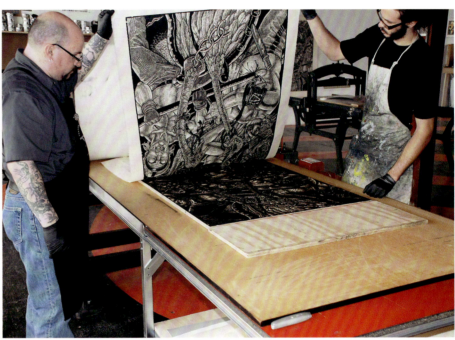

5. The finished print is removed.

Printing on the Etching Press

Methods for printing relief using the etching press will vary slightly depending on the material of your block. Because etching presses are designed to print thinner metal plates, mounted linoleum and blocks or boards greater than ¼ in (6 mm) thick require some accommodation for the thicker material. Extra wood or board, preferably slightly thinner, placed on the press at the leading edge of the block allows the blankets to be engaged off the printing block and keeps the block in position as it is run through the press. T and bar or kentō registration marks can be positioned on the block itself, or T and bar marks can be located on the surrounding running boards if the paper is larger than the block.

Other Presses

While the etching press is the more familiar and available means of printing the relief element, many artists still use vertical motion presses such as the Albion, Columbia, or Washington iron hand presses for relief printing. These platen presses are antiques that were used for printing type and relief images before the advent of lithography and digital process for mass printing. Their system of springs can transfer a great deal of pressure. Small iron "nipping" presses used for bookbinding have a similar vertical motion and can print small blocks too.

Letterpress proof presses are also favorites for many artists. These presses have a cylinder that travels over the inked block to make the print. Blocks must be "type-high" (.918 in/2.4 cm) to print in the proof press. Linoleum can be mounted on MDF and shimmed with thin cardboard to achieve this. The proof press is an excellent choice if making a large edition or if combining imagery with letterpress.

Printing on other presses

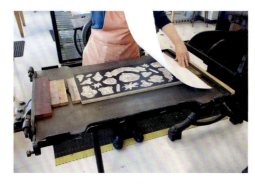

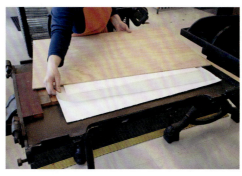

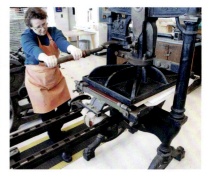

1. When using an iron hand press, the block is secured in the press bed and inked up by hand with a brayer. The paper is positioned.

2. Once the paper is positioned, packing is placed on top.

3. The bed is rolled underneath the platen and the lever is pulled to print.

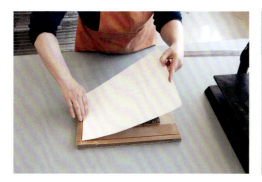

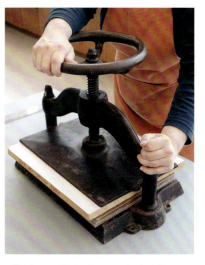

1. When using a nipping press, set the inked plate and paper on a carrier board. Registration guides can be marked directly on the carrier board.

2. Cover with a packing board.

3. Slip this assembly into the press and tighten the screw as far as it will go. Unscrew and carefully remove the assembly.

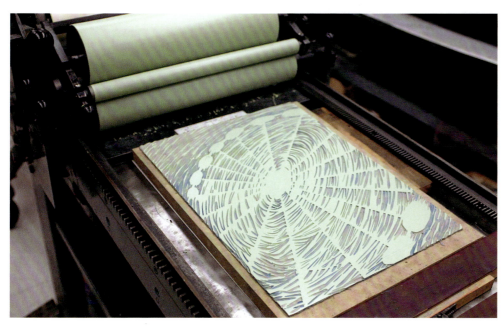

◗ When using a cylinder press, the relief element is secured in the press bed. Depending on the type of machine, inking is by hand or controlled by the machine. Paper rests on the cylinder, which travels over the inked block to make the impression.

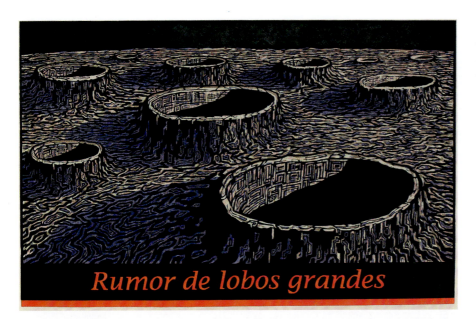

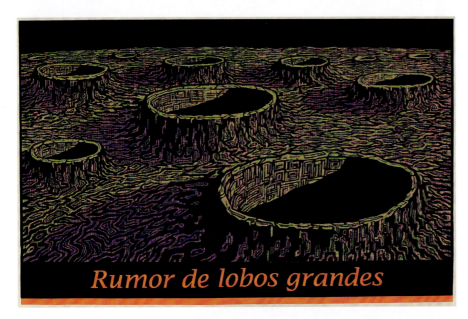

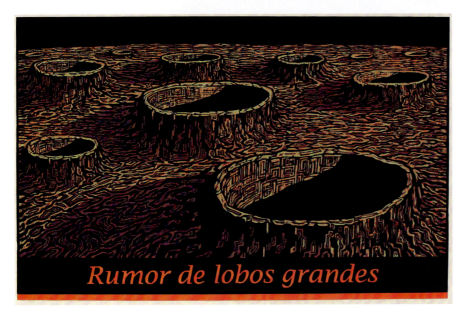

Endi Poskovic, *Night Studio Scene (Rumor de Lobos Grandes)*, 2007. Woodcut, 32 × 48 in (81.2 × 121.9 cm) each. Courtesy of the artist.

These images are different color versions or states. Creating separate color blocks allows Poskovic to explore different color combinations before editioning. Best known for his large-scale color woodcuts, Endi Poskovic's works have been exhibited all over the world. He works in series, developing a vocabulary of idiosyncratic images and text that portend ominous narratives. The works portray a dystopic vision of a contemporary world replete with conflict. The simultaneous seduction of color and surface in the prints becomes the metaphor for our own blindness to, and complicity in, the problems that exist in our world.

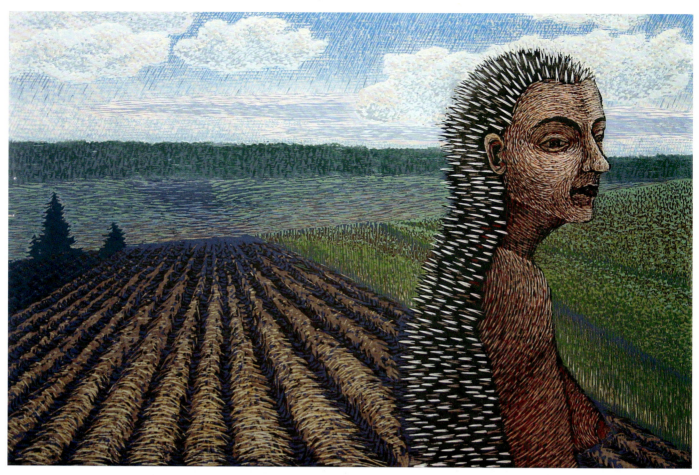

Jaana Paulus, *Eron Jälkeen (After Divorce)*, 2006. Reduction woodcut, 15¾ × 25 in (40 × 63.5 cm).

Jaana Paulus works with very complex color-reduction printing, often involving more than 15 layers of printing. This image is a view from the artist's country home where she sometimes feels transformed by nature. Standing in the foreground is a woman with hedgehog spines. If necessary, she will use them in her defense as she proceeds with a divorce.

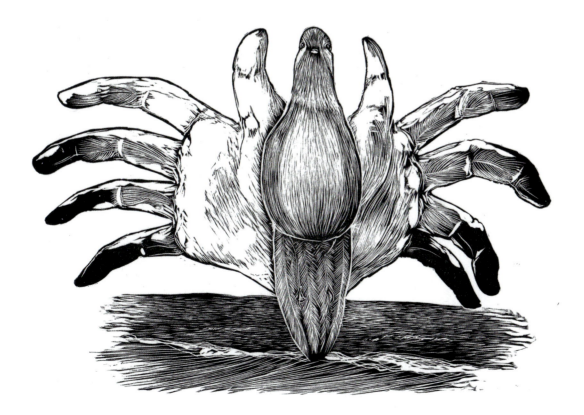

Andy Farkas, *New Wings*, 2004. Wood engraving, 5 × 7 in (12.7 × 17.8 cm). Courtesy of the artist.

Wood engraving is a traditional form for book illustration. Farkas continues that tradition in this work, an illustration for a short story entitled *The Bird and the Blind Man*. Developing his images in an improvisational manner, he loosely sketches an idea on the block, then finds the emotive detail as he carves. In this story the images take on a more surreal quality, the idea being that the imagery is from the blind man's point of view.

Color Relief Printing

There are two basic approaches to color image development in the relief print. A reductive approach builds an image with successive layers printed from the same printing element. Any printing after the first will layer with previous printings, creating color mixtures.

A multiple-block technique is essentially additive in approach. Color can be printed as a single layer or, when mixed with various proportions of transparency, layered for complex color mixtures. Of course, the experimental printer might use a combination of reductive and multiple-block techniques.

Reductive Approach

A traditional reductive approach begins with a color drawing to serve as a guide for the cutting and building of the image. Once the image is transferred to the block, the cutting proceeds by removing any areas of the image that are to remain white. The block is then inked with the first color and printed. Once the desired number of copies has been printed, the block is cleaned (with mineral spirits or water, depending on the type of ink) to prepare it for more cutting.

If it is necessary to work on the block right away, a little talc can be dusted into the surface to absorb excess solvent or moisture. This dusting, however, tends to fill in fine wood grain and should be avoided if it is important to maintain the grain.

The cutting that is now done may be viewed as "saving" the color just previously printed. Cut away the block in every place that this color is to exist in the final image. The second color may then be printed, overprinting the first one everywhere except where the block has been cut. The transparency or opacity of this second layer will determine the color mixture that results.

This cutting/printing, cutting/printing pattern continues until the majority of the block is cut away. The obvious drawback to this system is that the printing matrix is destroyed in the process of developing the image. Any mishaps along the way cannot be corrected.

Additive Approach

The multiple-block color relief is more versatile in that it enables all plates and blocks to be developed and proofed, then reworked if necessary. Since a separate block is made for each color, it can be more time-consuming, though.

Reductive approach

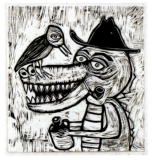
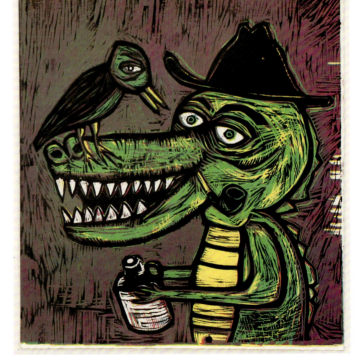

Sean Star Wars' print, *Country Croc*, combines reductive color with a key block. Here you see the sequence of color reductions printed separately, the key block and the final composite print.

Additive approach

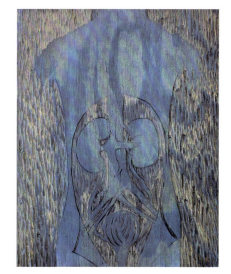

Key block

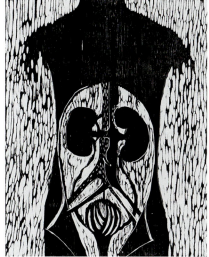

Key block proof

The key block

A key block is traditionally cut first, then used to generate color support blocks. The key image can often exist as a stand-alone print.

Background block

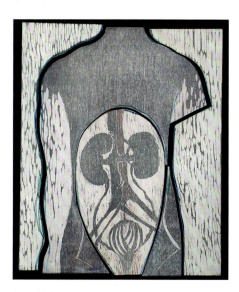

Jigsaw block

Support Blocks

Support blocks carry color and other information. The background block is used to print a wood grain texture, and the jigsaw block is made by offsetting the key image on to a thin piece of lauan, then cut apart. This allows for more complex color to be printed in a single pass through the press.

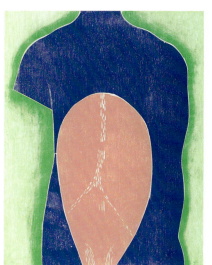

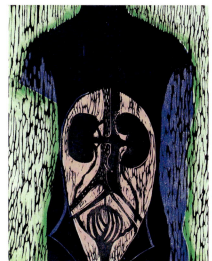

Sequence of printing: block 1, blocks 1 and 2, composite image

The multiple-block print can be approached in two ways. A common method is to develop a key image first. This image is then proofed and used to offset information onto other blocks to be developed for support color.

If the offset is made onto thin material, the image can be cut apart so that blocks of color can be inked up separately and reassembled in a jigsaw manner for printing. This allows several colors to be printed at once. Very thin (⅛in/3mm) lauan or HIPs are especially good choices for this process because they are relatively inexpensive and can be cut by hand with a utility knife.

Another approach is to transfer guide information to several blocks. The blocks are cut simultaneously with no block being dominant, each carrying detail important to the final image. When the cutting is complete, or nearly complete, the artist can proof the blocks, printing different color combinations and sequences.

Of course, these approaches are not absolutes. The continuum between them is certainly open for exploration.

Color Ink Considerations

Relief color printing is perhaps more flexible and forgiving than other color printing tasks. As mentioned earlier, the ink should be short, have medium to high tack, and be relatively stiff so that it can print accurate detail. This stiffness can be modified, since the level of detail is different in each color block.

When working with oil-based inks, it is ideal if prints can be air-dried for a day between printing successive layers. This drying makes the viscosity (oiliness) of the ink layer less of a factor in the quality of the printed surface. A dry ink will be rejected by an oily ink if printed too soon in succession. That being said, there are some occasions when printing successive layers directly after each other is necessary or preferable. When printing "wet into wet," avoid rejection problems by printing each successive layer with a slightly oilier ink.

As you mix color, consider its relative opacity or transparency. Adding more transparent base can create very pale tints, useful for subtle layers. Adding white and/or metallic pigments increases opacity. The sequence of printing can also affect the relative dominance of any color. Traditionally, the sequence runs from light to dark, warm to cool. With reductive printing especially, this sequence tends to build value contrasts that are important to compositional structure. But varying printing order or opacity can yield some fascinating variety of effects, such as veiling or editing. The nuances of layering can be a vital consideration in developing an image.

Printing Multiple Blocks (Etching Press)

A good registration guide and careful attention to precise placement is the key to obtaining accurate registration. Printing multiple blocks one right after the other allows even greater control. The following steps explain the procedure.

1. In order to use the press to help "hold" things in place, tear the paper so that it is at least 3–4in (8–10cm) longer than the final intended print size. Place the registration guide on the press.

Printing multiple blocks

1. The paper has been engaged under the roller and the first block is placed in position.

2. Here, the first layer is a background wood-grain texture printed in a pale green.

3. Once the first layer is printed, the block is removed and replaced with the jigsaw pieces for the second layer.

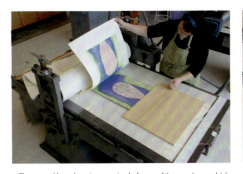

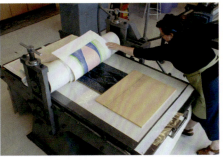

4. The second layer here is comprised of a set of jigsaw pieces which have been inked in three different colors. The outer shapes have been wiped so that just a halo of green ink remains.

5–6. The second layer block is removed and replaced with the final key block to generate the composite image.

2. Set the proper pressure for the material being used, accommodating running boards for thicker blocks if needed. In this example, running boards are in place to accommodate printing a series of wood blocks.

3. Lay the paper in place and cover the paper with a sheet of protective newsprint. Lay the printing blankets on top, then engage the blankets and the edge of the paper in the rollers. Flip blankets and paper over the roller, making sure they remain uncrumpled.

4. Place the inked block in place on the registration guide.

5. While holding the paper up, slowly crank the assembly through the press. As the press bed moves through, the paper will gently lower onto the block. Holding the paper up in this manner prevents ink "push" caused by any shifting of the paper on the plate.

6. Once the block is clear of the cylinder, crank just a couple of turns and leave one end of the paper engaged. Switch matrices and crank back through. Repeat for each successive color.

Sometimes this wet-into-wet printing is not possible, as would be the case with a reduction print. An option for successive colors in these situations would be to lay the printing paper with the printed surface face up and the block positioned on top. Positioning the smooth, flat sizing catcher under the paper for a little cushioning is also helpful sometimes.

Beyond the Press

The relief print is traditionally a human-scaled production. Many printmakers embrace the intimate scale of the activity as one of the reasons for making prints in the first place. Conversely, there exists a constant challenge for the printed image to compete with other forms of artistic production. Moving out of the conventional print contexts allows us to see the printed image in a new light.

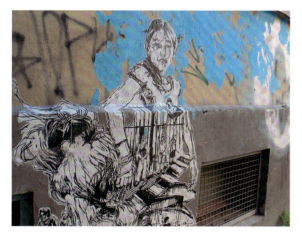

Swoon, *Buenos Aires*, Berlin, 2005. Linocut with hand-painting and cutting, approximately life-size. Courtesy of the artist.

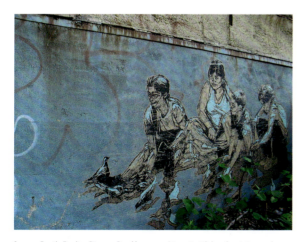

Swoon, *Family Feeding Pigeons*, Brooklyn, 2005. Linocut with hand-painting and cutting, approximately life-size. Courtesy of the artist.

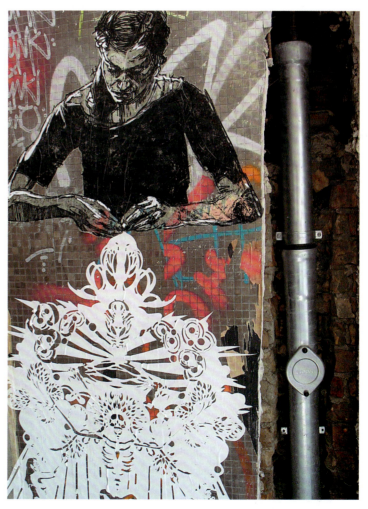

Swoon, *Allison the Lace Maker*, Berlin, 2005. Linocut with hand-painting and cutting, approximately life-size. Courtesy of the artist.

These prints by American artist Swoon are life-size portraits influenced by Indonesian shadow puppets, and by drawing on street posters and graffiti. The artist wheat-pastes the prints onto walls, doors, and other public spaces, allowing them to become a part of a community and take on a life of their own. As multiples, these prints are installed in different locations around the world, where they assume different lives, depending on the environment in which they are placed. They are not protected from the elements, allowing the process of decay to become an integral part of the prints.

Relief print installation

Thomas Kilpper, *Don't Look Back*, 1998. Site-related print installation.

The artist carved the floor of a basketball court to create a giant wood block that was then inked and printed on a variety of surfaces including fabric, paper, wallpaper and advertising posters. These prints tell the story of the abandoned site that was the central interrogation camp of the Luftwaffe during World War II and that was used after the war by the US Forces to interrogate some of the nazi-leaders, and to select who will be integrated into US-services and who will be brought to trial . . . The new West-German secret service was founded here under the control of the CIA. Like most of his staff members—its "new" director was the old director of the Nazi era, Reinhard Gehlen. Special anti-guerrilla warfare training was held here at Camp King near Frankfurt on Main during the Vietnam War. After printing the floor, the artist displayed the prints in the basketball court for the exhibition. The visitors—walking on the block—moved between "negative" and "positive". This way the prints and block worked together as an installation rather than existing as separate components. A 300 square meter banner print of the carved floor was sewn together and was displayed during the exhibition hanging from the town-hall's façade.

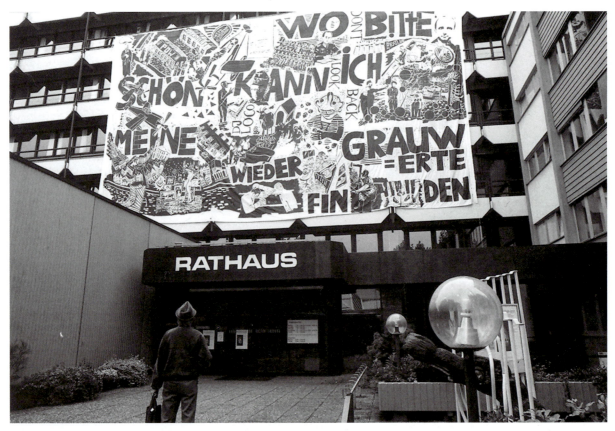

1. A banner, 984 sq ft (300 sq m), printed by Thomas Kilpper from a carved basketball court floor.

2. Visitors walk through the installation.

3. Images printed from the carved floor hang from a clothesline.

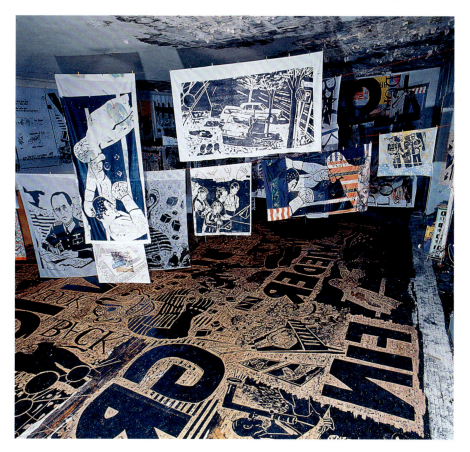

4. Some of the prints taken from the carved floor.

Relief print event

"Big Damn Prints," Pratt Institute, Brooklyn, New York, 2007. Courtesy of Dennis McNett.

Pratt Institute printmaking professor Dennis McNett has organized this event to allow his students and members of the art college's community to create large relief prints. Due to the scale of the blocks, a rented steamroller is used instead of a press. To save money and for ease of use, fabric (muslin) replaces paper. During the process, students learn to collaborate and assist one another, which are hallmarks of printmaking practice.

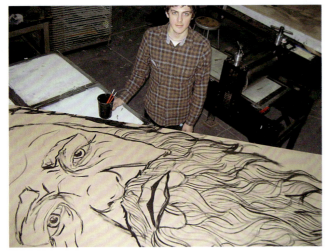

1. The image is drawn.

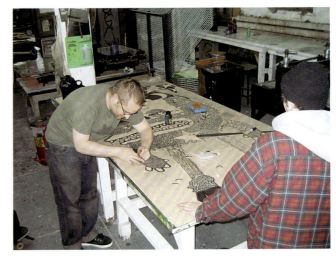

2. The block is carved.

3. The block is inked.

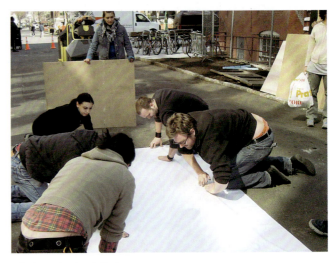

4. The sheet is placed on the block.

5. The steamroller is used for printing.

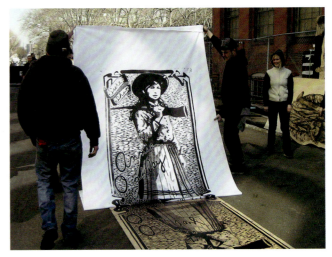

6. The print is removed.

Chapter 5
Intaglio

The word intaglio means to engrave or to cut into and describes the making of metal printing plates. Traditional platemaking processes fall into two categories, those where lines are inscribed directly by hand, such as engraving, and processes that employ acids to establish images on metal, known as etching. In contemporary usage, the term intaglio can refer to any printing matrix where the ink is held in recessed areas of the matrix. Collagraph printing, the subject of Chapter 6, is often encompassed in this broader definition.

Early examples of incised artworks date back to Paleolithic times. Carvings on stone, bone, and eventually on metals were the precursors of intaglio printing. Simple engraving was initially used to mark objects or to create seals to denote ownership. Later, more intricate engraved designs adorned armor, household items, and precious jewelry. The use of the engraved object as a printing element developed first as a means of documentation. Metalsmiths would take rubbings to record designs or establish inventory. The first known artist's engravings printed on paper were made in the mid-fifteenth century. The development of etching as an intaglio process also grew out of the metalsmithing trades. It emerged as a printing process in the sixteenth century but did not really flourish until the seventeenth century, when developments in chemistry

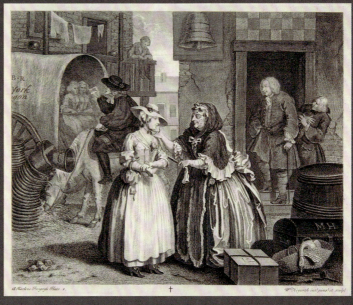

William Hogarth, *The Harlot's Progress*, Plate 1, 1732. Etching and engraving, 16⅞ × 23 in (42.9 × 58.4 cm). Ackland Art Museum, University of North Carolina at Chapel Hill, the William A. Whitaker Foundation Art Fund.

Many artists, including William Hogarth, used etching in combination with engraving as an expedient way to develop complex images.

and the use of copper allowed a fluidity of line more characteristic of the engraving process.

This chapter explores traditional metal platemaking processes with a particular focus on acid-based platemaking. Within the discipline, the term etching is used both generically to refer to all acid-based platemaking, and specifically to refer to line etching. Both uses of the term are employed here but appropriate modifiers and process-specific terms such as aquatint are employed when such distinction is important.

The Etching Process

The basic concept of etching involves the use of an acid-resist to protect the metal plate. This resist, called a ground, is either applied in a way that leaves some of the plate uncovered or applied to cover an entire plate, then removed with tools or solvents to expose the plate. The image is then etched by submerging the plate in an acid bath, where the acid "bites" the exposed metal, thereby establishing the image on the plate. A plate may go through several rounds of etching before the image is fully established.

Prints are made using an etching press, which pushes the paper into the etched recesses and lifts the ink out of the incised surface. The result is a mirror image of what was originally drawn on the plate.

Tools and Materials

As with all print processes, the characteristic features of intaglio printmaking are in part determined by the various tools and materials used. Developing a practical understanding of how tools and materials work can lead to informed experimentation as the ideas are translated through the etching process.

Tools

Fine, uniform, linear information is made with needling tools. Etching needles can be purchased from printmaking suppliers. Alternatives include scriber tools available at local hardware stores. An *echoppé*, also called a cat's tongue, is a specialized tool that makes lines with varied width by working the tool at different angles. Tools intended for direct marking (drypoint) are usually harder and made from steel or with a diamond point.

Mechanical or patterned qualities can be made with a ground-texturing punch, mezzotint rocker, or various roulettes. Motorized tools, such as rotary tools or hand-held drills, can be outfitted with various bits and sanding attachments to further expand mark-making possibilities. Wire brushes, steel wool, nails, sandpaper, needles, awls, and many other common items are also routinely used for intaglio platemaking. Indeed, a resourceful printmaker might press a variety of tools into service that can draw through a ground or directly onto a plate.

Two tools that are indispensable to the intaglio process are the scraper and burnisher. Both can be used to lighten or modify information that has been etched into a plate as well as make marks in their own right. For deletions, the scraper is used to remove unwanted information, and the burnisher, used with a little lubricating oil, polishes the metal so that new information can be added. Various grades of sandpaper are also helpful for lightening and polishing purposes.

The etching process

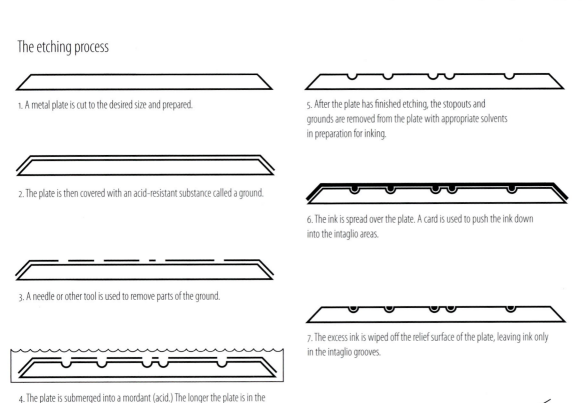

1. A metal plate is cut to the desired size and prepared.

2. The plate is then covered with an acid-resistant substance called a ground.

3. A needle or other tool is used to remove parts of the ground.

4. The plate is submerged into a mordant (acid.) The longer the plate is in the acid, the deeper the "bite" and the darker the resulting print.

At various stages in the etching process, the plate may be removed from the acid bath and "stopped out." In stopping out, parts of the already etched surface are covered with an acid resist, preventing further action of the mordant. This process of stage biting produces tonal variations in the final print.

5. After the plate has finished etching, the stopouts and grounds are removed from the plate with appropriate solvents in preparation for inking.

6. The ink is spread over the plate. A card is used to push the ink down into the intaglio areas.

7. The excess ink is wiped off the relief surface of the plate, leaving ink only in the intaglio grooves.

8. Dampened paper is placed over the plate and run through the press. The ink transfers to the paper and a print is made.

The etcher's toolkit

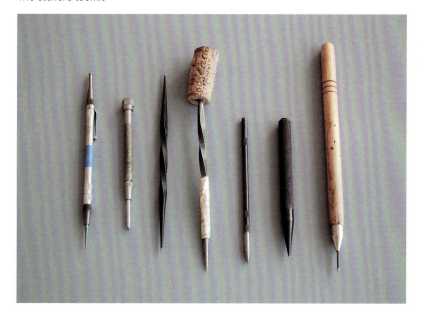

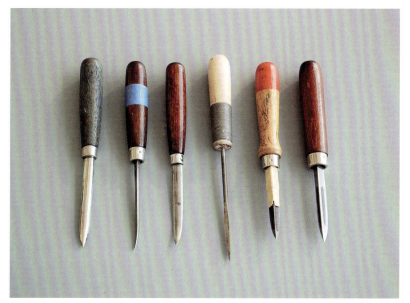

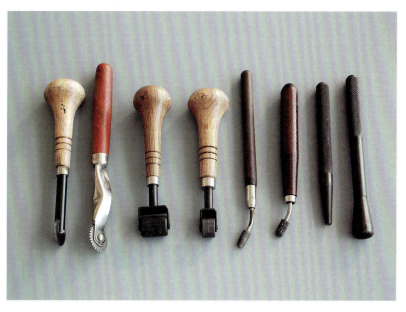

The main items of the etcher's toolkit are: needling tools (top), featuring pocket scribers, twisted scribers, diamond and carbide steel tipped points and *echoppé*; burnishers and scrapers (middle); and texturing tools (bottom), showing roulettes and ground texturing punches.

The names of these tools describe their function: the scraper (top) removes information; and the burnisher (bottom) is used to smooth and polish.

Metals

The choice of metal is governed by several factors:
- the ease of working the metal
- the length of time needed to etch the plate
- the durability of the etched plate

These factors are essentially functions of how hard the material is. Many metals have been used for intaglio printing, including zinc, copper, brass, and steel. Zinc and copper are by far the most common and are detailed here.

Zinc

Zinc has long been very popular for beginning printmaking. It is a soft metal, easily worked with direct physical platemaking techniques. This softness also makes for short etching times—definitely a benefit for the student printmaker with demanding time schedules. The downside of zinc's softness is reduced durability. When etched in nitric acid, the mordant action works in all directions, causing a lateral undercutting bite. This causes plates to break down quicker, especially with tonal work made with aquatint or soft-ground processes. Another drawback to zinc is that many colors oxidize with the metal, the most evident discoloration being seen with light inks.

The zinc commonly available is a polished plate made especially for fine art printmaking. It comes with an acid-resistant lacquer coating on one side, eliminating the need to protect the non-image face.

Copper

Copper is easily worked but sufficiently hard to retain fine detail. It is available in several grades from a harder, professional quality to industrial grade roofing copper. A 32-ounce roofing copper is slightly thinner than the familiar zinc plate, but holds up well to even the most aggressive platework. A thinner-gauge rolled copper is adequate for small plates up to about 12 in (30.4 cm) square. Both of these options may require some polishing, but are far less expensive than professional etcher's copper. Since industrial-grade copper is not backed, it is necessary to cover the non-image side of the plate with an acid-resistant coating. A durable enamel spray paint or contact paper can be used for this purpose.

Copper also has an oxidizing effect on inks, but the resulting discoloration is less pronounced than on zinc. It can be countered by steel facing, a process that deposits a thin layer of iron on the copper plate through electroplating. Most academic print studios do not perform steel facing, though; plates must be sent to a professional steel-facing service.

Etchants

The terms etchant and mordant encompass the variety of substances used to etch a plate. These include traditional acids such as nitric or hydrochloric acid. They also refer to safer corrosive salts, such as ferric chloride. While all etchants require careful handling, working with acid is one of the most dangerous procedures in the printmaking shop. It is especially important to understand the nature of acids and how to handle them safely.

⊗ Safety Watch!

When working with acids, follow these precautions:

1. To avoid extreme chemical reactions when preparing dilutions of acid, always add acid to water, never the reverse.

2. Etching in acid produces highly toxic fumes. Use only with proper exhaust ventilation.

3. Wear eye protection and acid-resistant nitrile or neoprene gloves when working with all types of mordants.

4. Neutralize spent mordants with sodium bicarbonate (baking soda) before disposal. Follow locally established safety guidelines for disposal.

5. If any etchant is spilled onto clothes or skin, flush immediately with water, then cover with sodium bicarbonate to neutralize the remaining solution.

6. For larger spills, use an absorbent material, such as cat litter (granulated bentonite clay), to contain the spill. Once the liquid is contained, it must still be neutralized with sodium bicarbonate. Contact emergency personnel in the event of severe spills.

7. After etchant solutions that generate a solid precipitant have been neutralized, let the surplus crystalline residues settle to the bottom of the container. After the liquid has been carefully siphoned and disposed of, collect these solid metal compounds for disposal as dry chemical waste, or recycling.

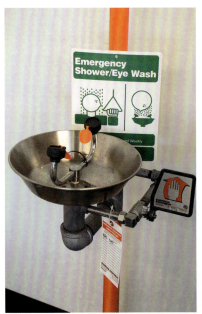
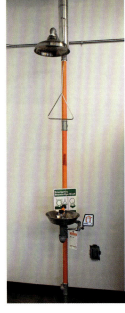

◆ All print facilities should be equipped with an eye wash and, ideally, an emergency shower located near the etching baths.

To use etchant solutions effectively, consider these facts:

1. Mordants are sensitive to temperature. The warmer the temperature, the faster the plate will bite. A corollary is that continued activity of the acid will increase the temperature of the bath. Therefore, a plate with more exposed area to be etched will etch faster.
2. Acids are sensitive to age. They will eventually weaken with use, but may show signs of strengthening if the water content has evaporated some because of heavy use.
3. Mordants that have been used with one metal should never be used with another metal. One drop of a copper acid into a zinc acid (and vice versa) will ruin it.

Traditional etchants include nitric acid for zinc or steel and solutions of hydrochloric and potassium chloride (Dutch mordant) for copper. Since these acids are very dangerous, a great deal of attention has been given to the research promoting safer alternatives. In particular, the work of Friedhard Kiekeben, Cedric Green, and Keith Howard continues to make alternatives viable for the general printmaker. Kiekeben's development of the Edinburgh Etch, using ferric chloride, and, more recently, the Saline Sulfate Etch, using copper sulfate, has especially contributed to reducing the hazards associated with etching. In fact, ferric chloride has essentially replaced all other mordants for copper. While etching zinc with nitric acid is still common practice, the copper sulfate and saline sulfate alternatives are gaining a foothold, particularly in educational settings.

Ferric chloride

Ferric chloride, or iron perchloride, is a corrosive salt. It etches slowly, but very accurately. The disadvantage is its opacity and the fact that sediment forms on the plate, necessitating all biting to be done upside-down or in vertical tanks.

Ferric dilutions are used primarily for copper. The chemical reaction between ferric chloride and zinc is more vigorous than with copper and steel and is not recommended. Ferric chloride dilutions for etching copper begin with a ready-mixed liquid form of the acid measuring 45° Baumé. The Baumé scale measures the specific gravity of liquids. A standard dilution is two parts water to one part ferric chloride. As water is added to ferric chloride, the mordant action initially becomes stronger because the viscosity of the liquid is thinner. So, while approximations of strength can be made by a water-to-acid ratio, the most accurate measure of the strength of a ferric chloride bath is made by taking a Baumé reading. Ferric chloride dilutions are strongest with a Baumé reading between 33° and 35°. Slower etches on copper are traditionally done with undiluted ferric chloride reading 45° Baumé.

When new ferric chloride baths are made, it is important to "prime" the bath with some old acid or a piece of copper. This tempers an initial erratic reaction of ferric, rendering a more stable bath. The ferric bath can last for a long time, requiring occasional additions of water to replace that lost to evaporation. Ferric chloride is brown when fresh and changes to a green color as it is used.

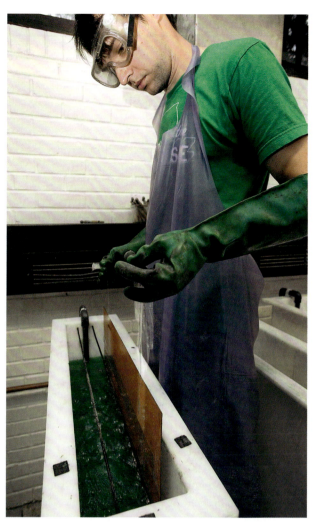

⌃ Vertical tanks in use at Louisiana State University. They allow precipitate to fall to the bottom of the tank rather than in the etched surface. Aeration in the tank helps the sediment fall out of the etched areas. Note the strapping-tape handles to help remove the plate from the vertical tray.

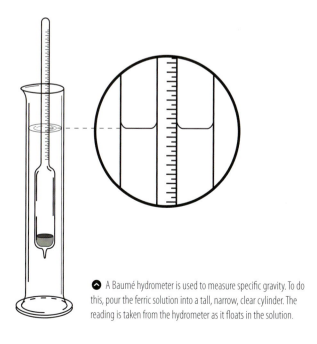

⌃ A Baumé hydrometer is used to measure specific gravity. To do this, pour the ferric solution into a tall, narrow, clear cylinder. The reading is taken from the hydrometer as it floats in the solution.

Edinburgh Etch for Copper

Large bath	Small bath
14 oz (400 g) anhydrous citric acid	7 oz (200 g) anhydrous citric acid
2½ pints (1.2 liters) water	20 fl oz (590 ml) water
12½ pints (6 liters) ferric chloride, 45° Baumé	101 fl oz (3 liters) ferric chloride, 45° Baumé

Edinburgh Etch for Zinc

Large Bath	Small Bath
10½–17½ oz (300–500 g) citric acid powder	5–9 oz (150–250 g) critic acid powder
14¾ pints (7 liters) water	13½ pints (6 liters) water
2 pints (1 liter) ferric chloride, 45° Baumé	17 oz (482 g) ferric chloride, 45° Baumé

Edinburgh Etch

The desire to retain the safety advantage of ferric chloride, while overcoming its sediment-forming disadvantage, has prompted the quest for ferric-based etch solutions. The Edinburgh Etch, developed by Friedhard Kiekeben at the Edinburgh Printmakers Workshop in Scotland, accomplishes just this purpose. A solution combining citric acid with the ferric eliminates the sediment problem while also making the acid faster and more controllable. Edinburgh Etch solutions of varying concentrations can be used for both copper and zinc.

To mix an Edinburgh Etch, begin by measuring anhydrous (powdered) citric acid on a gram scale. Heat the water so that it is warm and dissolve the citric acid in the water. Let this cool some, then add the ferric chloride last.

Nitric acid

Nitric acid is typically used to etch zinc. In general, biting zinc in nitric is fast but somewhat rough.

Different concentrations of water to nitric are used, depending on the kind of etching being done. Hard-ground line etching is bitten in a strong solution of 7–10 parts water to nitric. Soft ground and aquatint are bitten in slower acid of 15–20 parts water to nitric. Neutralize spent solutions with sodium bicarbonate and discard.

While copper can be etched with nitric, it is not recommended because dilutions must be quite strong, presenting an unacceptable hazard.

⌃ As zinc etches in nitric, bubbles of nitric oxide are created. Use a feather or soft brush to gently stroke the surface and remove the bubbles to prevent them from leaving their impression.

> ⊗ **Safety Watch!**
>
> Gases produced when etching zinc with nitric acid are dangerous to organic tissue. Use only in well-ventilated situations.

Copper sulfate

Copper sulfate ($CuSO_4$) diluted with water makes a relatively safe alternative for etching zinc. Developed initially by Cedric Green, it has also been called a Bordeaux Etch, the term stemming from the use of copper sulfate as a fungicide in wine vineyards. Like ferric chloride, copper sulfate is a corrosive salt. It is readily available in powder form at garden centers. To prepare a bath, mix 1¾–7 oz (50–200 g) copper sulfate powder to 2 pints (1 liter) water. When fully dissolved, the bath will initially be blue and will turn clear as it is used. As with other mordants, stronger solutions are used for linework (3½ oz/100 g $CuSO_4$ to 2 pints/1 liter H_2O), while weaker solutions are best for soft ground and aquatint (1 oz/25 g $CuSO_4$ to 2 pints/1 liter H_2O). The only byproduct of etching with copper sulfate is a harmless hydrogen gas.

> ⊗ **Safety Watch!**
>
> When inhaled or ingested, copper sulfate powder irritates the eyes and bare skin. Be sure to wear a dust mask and gloves when preparing new baths. Handle copper sulfate powder without running fans to avoid lifting dust into the air. Wipe up all spills or drips; if let dry, they will leave a zinc sulfate residue, which can also be harmful by inhalation.

Drawbacks to the Bordeaux Etch include the fact that it is exhausted faster than other mordants. It also produces a copper oxide sludge which must be feathered from the plate as it is etched. When the bath is spent, this sludge must be collected and disposed of according to local health and safety regulations. The copper sulfate also tends to break through grounds faster. It is best to apply thicker grounds to avoid unplanned mordant action.

Saline Sulfate Etch

Friedhard Kiekeben has developed an improved variant of the copper sulfate etch for zinc with the simple addition of sodium chloride (table salt). Dubbed the "Saline Sulfate Etch," it is three times more active than a straight copper sulfate solution, and produces a very crisp etch without the more settled sedimentation and surface roughness of the Bordeaux Etch. During biting, sediment of metal hydroxides and oxides continually floats to the surface, thus keeping the bitten work from clogging up. The solution works more effectively if floating solids are regularly skimmed off with a brush or a strainer and removed from the bath—this keeps the solution from turning alkaline and extends its useable life.

Saline Sulfate Etch

Metal	Etch
Zinc	2½ oz (75 g) copper sulfate
Aluminum	2½ oz (75 g) sodium chloride (salt)
Steel	2 pints (1 liter) water

The Saline Sulfate Etch is made up from copper sulfate and cooking salt crystals. Kiekeben recommends securing "production" or "industrial grade" anhydrous copper sulfate from a chemical dealer to avoid possible impurities found in copper sulfate available from agricultural supplies.

Neutralize spent solutions with sodium bicarbonate, diluted with plenty of water. Collect surplus crystalline residues for disposal or recycling.

Preparing the Plate

Metal is available in various degrees of finish and polish. Metals made for printmaking come protected with a polished smooth surface, almost ready for the artist's hand. Metals made for industrial purposes can be surprisingly smooth, but can have imperfections. The degree to which imperfections are accept-

able will determine the extent of preparation necessary before developing the plate. All plates must go through some preparation before they can be safely printed on the etching press. This includes beveling the edges, polishing, and degreasing.

Establishing the Bevel

To avoid damaging expensive printing felts, the edges of intaglio plates must be prepared with a 35–45° bevel. This can be done by hand with a scraper and a coarse file or with power assistance from a grinder attachment on a hand drill.

Polishing

Polishing is an optional step, depending on the initial condition of the plate and the desire (or not) to eliminate stray marks. Some artists invite these accidental marks while others' aesthetic demands a highly polished surface. Zinc or copper plates made especially for printmaking usually come pre-polished, but a slight further polishing is sometimes desirable. Other metals may have small scratches or milling marks that can be visible in the print.

Additional or selective polishing can be carried out at various points in the image development process and can be done after line etching without modifying the line. Polishing over aquatint or soft ground will lighten the etched work.

Establishing the bevel

1–2. With the plate firmly clamped to the table and overlapping the edge by at least ¼ in (6 mm), establish the 45° bevel by hand with a scraper or with a grinder attachment on a drill.

3. Smooth the beveled edge and round the pointed corners of the plate with a file.

4. Polish the bevel with the burnisher. A little lubricating oil facilitates the work.

Polishing

1. Progressive grades of emery paper or steel wool can remove subtle tonality due to manufacture or wear. Finish with a 400–600 grade sandpaper or extra-fine steel wool for a bright polish.

2. If bright contrasts are desired, use metal polish or jeweler's rouge applied with felt pads for an optional final polish.

3. Rub etcher's willow-charcoal blocks with light oil to polish the surface.

4. Use the scraper and/or burnisher with oil to polish out significant scratches or blemishes.

Degreasing the Plate

Degreasing is an essential step to insure a good adherence of grounds to the surface of the plate. The traditional use of whiting and ammonia for this purpose is discouraged due to the toxicity of ammonia. An eco-friendly alternative is an alkaline degreasing power. Alternatively, scouring powder (without bleach) may be used, its mild abrasives acting as a polisher for small blemishes.

❷ Sprinkle degreasing powder onto a plate. Spray water into the powder and work this into a paste with a square felt pad. Rinse the plate thoroughly until the water sheets off the plate. Wipe off any powder residue with a clean (oil-free) cloth. At this point, handle the plate carefully by the edges. It is now ready for a ground.

Non-acid Platemaking Techniques

Before discussing the various approaches to etching, it is useful to review some non-acid techniques. These techniques have legitimate histories and applications by themselves, but can also be used in combination with any other process for image development.

Anything that makes a mark in the metal plate will print. Direct techniques can be easy or difficult, depending on the sharpness of tools or the softness of the metal chosen. Copper tends to be the best metal for most direct non-acid techniques. It is soft enough to work relatively easily, yet it is strong enough to withstand many printings.

Non-acid platemaking techniques

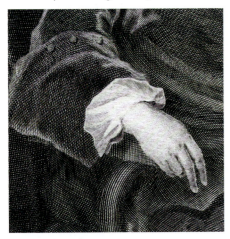

Engraving: where sharp tools (burins) are used to carve the intaglio line for a sharp, clean result.

Drypoint: where marks are created by scratching the plate with a sharp tool to yield a characteristically soft line.

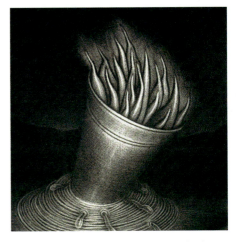

Mezzotint: where the plate is roughened with a special tool to hold ink, and the surface burnished to create a tonal range.

Motorized tools: these typically displace the metal (like drypoint or mezzotint) rather than remove it, yielding a soft mark.

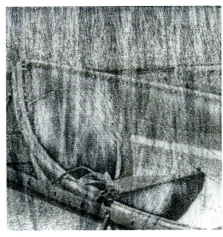

Corrective scraping: this removes stray marks or unwanted information or can modify the look of any previous etching.

Wallet art! Most paper currency employs classic engraving. The Chinese jiao is particularly beautiful.

Engraving

Evolving from the metalsmithing trades, the practice of printing from engraved plates emerged in the early fifteenth century. The technique was most often used to reproduce painted images for mass distribution. Familiarity with engraved images today is most likely through paper currency.

The primary tool for engraving metal is the burin. The tool is shaped so that it fits in the palm and bends to meet the plate. The lozenge shape of the point can vary; a broader shape is used for curved lines and a thinner lozenge for straight cuts. Cousins of the burin are called multiple tint tools. These tools make multiple lines that result in a tonal or textural mark. Tools must be kept sharp; otherwise, the work to cut a plate can be exhausting.

To work a plate, the tool is pushed across the soft metal to carve a shallow line. Darker lines are built with repeated carving rather than by attempting to carve a deep line to begin with. Curved cutting is made by rotating the plate rather than turning the tool. A leather sandbag facilitates this technique. With the plate positioned on the bag, the burin is placed on the plate and held steady while the plate is rotated, turned, and moved under the tool. The burin actually carves out the metal; any burr that is raised in the process is cleared away with a scraper. The resulting printed line is clean and sharp.

> ### ⊗ Safety Watch!
> Keep both hands behind the cutting direction of the burin.

⌃ Engraving tools must be kept sharp. A special jig is used to hold the face of a burin at the proper angle relative to a sharpening stone. Using a light oil on a smooth stone, first sharpen the sides, then the face of the tool.

⌃ As the tool pushes across the metal surface, the point carves out the metal.

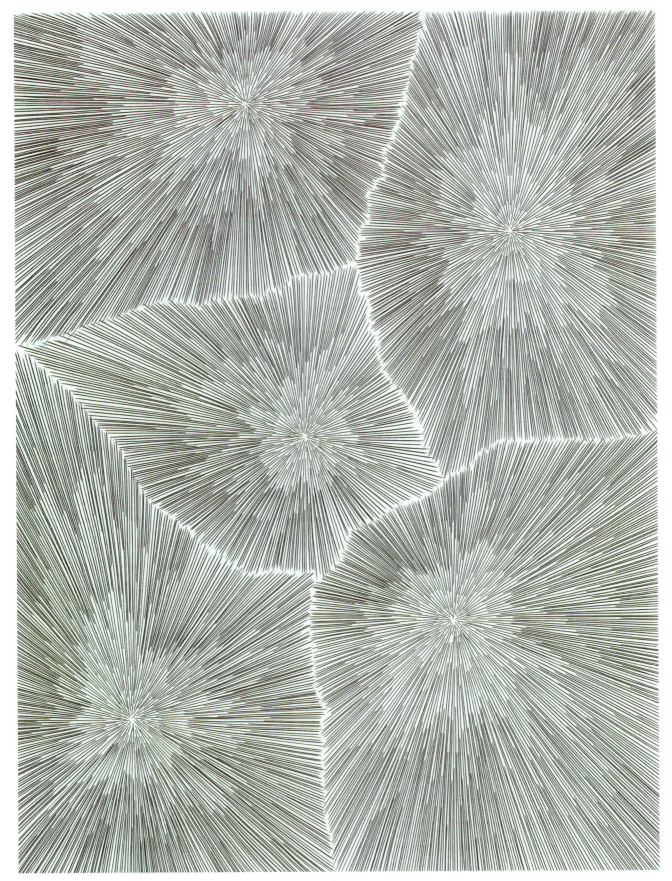

James Siena, *No Man's Land*, 2004. Engraving with *chine collé*, 11⅛ × 8¾ in (28.3 × 22.2 cm). Edition of 49, published by Harlan & Weaver, New York.

Siena's "hand-rendered procedural abstractions" are executed with great precision. The engraved line in this print is indexical to the crystalline quality of the image, creating a synthesis of means and end.

Drypoint

Drypoint is perhaps the most straightforward of the direct techniques. A drypoint plate is made by simply scratching into the surface of the plate with a sharp tool. As the tool is scratched across a plate, a burr is raised. In addition to the ink that is held in the incised line, this burr also traps ink, which accounts for the soft quality of the printed line.

Tools for drypoint need to be very sharp. Diamond-tipped points do not need sharpening but are expensive. A carbide-tipped steel point is a good alternative. It holds the point for a long time and is easily maintained with occasional freshening by sharpening the point on a smooth India stone. Other needling tools can be used with reasonable success as long as they are kept sharp.

Drypoint plates have a limited life. As the plate is printed, the burr gets flattened and holds less and less ink. Steel facing can extend the printing life of a drypoint made on copper.

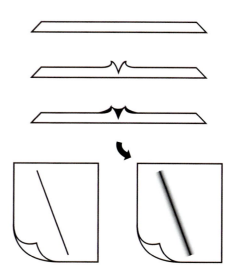

Scratching with a drypoint needle raises a burr, which also captures ink. This yields the characteristic soft, velvety line of the printed image.

Juli Haas, *Mother*, 2005. Drypoint with hand coloring, 17¾ × 13¾ in (45 × 34.9 cm). Courtesy of the artist.

Haas' line quality imparts an edgy mood to her drypoint work. Rich color is added by hand with watercolor.

Mezzotint

Mezzotint was invented in 1642 by amateur engraver Ludwig von Siegen (c.1609–80), The process is a *manière noire* or "black manner" process, where light areas are developed out of a black field. Like drypoint, mezzotint relies on a direct physical manipulation of the plate. First, a plate is made to print a solid black. This is done with a mezzotint rocker, a curved tool with a row of tiny, fine, sharp teeth. When worked over the plate many times at multiple angles, the tool raises a burr, producing a texture that prints solid black. It takes considerable time to prepare a mezzotint plate. A mechanical assist can help, but many artists prefer to purchase pre-mezzotinted plates.

The image is developed reductively by scraping and burnishing back tonalities from this black field. It is easy to see the image develop by rubbing a little bit of ink into the plate prior to burnishing. Mix the ink with some petroleum jelly or clove oil to retard drying. Remove and/or replace the ink after a few hours' work.

For detail work, it is sometimes necessary to work back into the burnished areas. A roulette is a tool made for this purpose because it can simulate the mezzotint surface somewhat. Roulettes come in a wide range of sizes and textures, from a single line roulette, to a 1 in (2.5 cm) wide lining roulette.

Preparing a mezzotint

 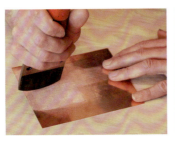 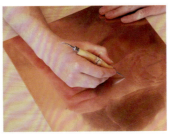 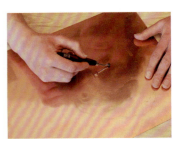

1. The mezzotint rocker is a hand tool and can be assisted by adding weights to the rocker.

2. The mezzotint rocker raises a burr just like the drypoint needle. Instead of a single line, however, the plate is rocked over an area or the whole surface, at least eight times at different angles, until the plate prints black.

3. Sean Caulfield develops small areas of his plate by burnishing areas of the roughened surface to create tonal variation.

4. An irregular roulette, which approximates the texture of the rocked plate, can re-establish darks if needed.

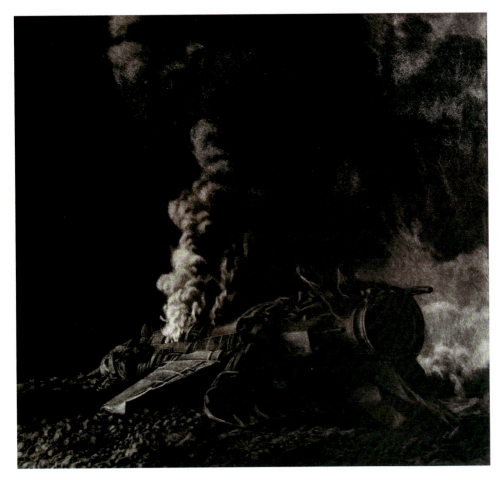

Antti Ratalahti, *Crash Landing*, 2007. Mezzotint, 11 × 12 in (27.9 × 30.4 cm).

Ratalahti's ominous black cloud imagery is the perfect subject for the mezzotint process.

Motor Tools

A variety of hand-held motor tools can make a vast array of marks and textures on the plate. When using motorized tools, metal hardness is less of a concern. Rotary tools or flexible shaft tools are available with a wide variety of attachments, such as router bits, steel brushes, sanding discs, cutting tips, and polishing tips. A hand-held drill is also a handy accessory in the print shop. Sanding discs and steel brush attachments are useful for imposing textures on large areas or for quickly removing or modifying information already established on a plate.

> ### ⊗ Safety Watch!
>
> As with all tools, it is important to keep motorized tools in good condition. Keep bits and attachments sharp. Keep moving parts well oiled. Replace worn or defective parts.
>
> To avoid electrical shock:
>
> • Wear proper eye protection when working with motorized tools.
>
> • Do not use a tool that has any exposed or damaged cords.
>
> • Keep electrical cords away from the working tool.
>
> • Do not use electrical tools near water.

Acid-based Platemaking Techniques

As previously stated, etching involves an acid-resistant ground to work in tandem with an etchant to establish the image. Simply put, the ground acts as a barrier to the corrosive action of the mordant, enabling the image to be etched into the metal. Different grounds have different visual characteristics. They may be used singly or successively in combination as is required by the image at hand.

At various points during plate development, stopout can be used to prevent further mordant action on specific areas of the image. If stopouts are used, they should always be considered as part of the image-making strategy. Stopouts can be any water-resistant material that blocks the plate. Traditional stopouts are shellac (alcohol-based) or stopout varnish, made with asphaltum thinned with mineral spirits. Less toxic acrylic stopouts are made by several manufacturers, although they may need alcohol, ammonia, or proprietary caustic stripping solutions to remove them, which somewhat compromises the nontoxic benefit. Silkscreen filler has also been successfully used for stopout, as has acrylic polymer medium. These are removed with a strong water spray or alcohol.

> ### ⊗ Safety Watch!
>
> Ammonia gas is very harmful, and may be fatal if inhaled. Ammonia dissolves readily in water, yielding a very corrosive solution. This solution can cause serious burns to the skin or eyes.

Hard Ground/Line Etching

Traditional hard ground is a mixture of beeswax, asphaltum, and rosin. It is available in both solid ball and liquid forms. Recent innovations in less toxic processes have generated a line of liquid acrylic grounds, which have essentially replaced the highly toxic liquid versions of the asphaltum-based grounds.

Hard ground can be used in a variety of ways. With traditional line etching, a ground covers the entire plate and the image is made by needling through the ground, thereby exposing the bare metal. The plate is then placed in acid to etch or bite the intaglio grooves. Tonal variations can be made by crosshatching, or stippling through the ground with the needle. Wire brushes, sandpaper, or steel wool can also remove parts of the ground to produce different kinds of marks in the etched surface.

◔ Needling through the ground.

The application of the ground depends on whether it is in solid or liquid form. The goal is to lay a ground that is thin enough to needle through easily, but sufficiently thick to protect the plate. False biting, also known as foul biting, is a term that applies to a random, unplanned mordant action on the plate where the acid has accidentally broken through a thin ground. It is characterized by multiple pinholes scattered all over the plate. If false biting takes place in a detailed area, it may be difficult or impossible to correct. Some artists, however, will intentionally lay a thin ground to make use of false biting for special effects.

Hard ground can also be used to create or modify an image using an open bite. Rather than needling through to establish the image, the ground can be used as a drawing material applied selectively to a clean, degreased plate, leaving broad areas of the plate "open." These areas will "bite" smoothly. While the etched areas may hold a little bit of plate tone, the printed open bite is characterized by the soft, linear quality of the ink as it catches at the edge of the mark made with the ground.

Ball ground

Traditional ball ground is a wax-based compound. Still favored by many professional printmakers, it is unparalleled in its ability to retain a smooth working consistency. To apply the ground, start with a degreased plate. On a hotplate set to about 150°F (65°C), warm the plate until the ball ground melts

Characteristic marks of various grounds and etching processes

Hard ground needled line

Spit bite

Open bite

Stage-bit line bite

Soft ground pencil line

Soft ground textures

Soft ground as tonal field with stage-biting

Aquatint stage biting

Aquatint with crayon stopout

Burnished aquatint

Ball ground

1. Place the ball on the plate until it begins to melt and spread.

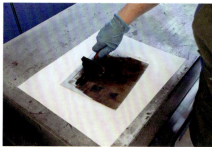

2. When approximately a third of the plate has been covered thickly with ground from the melting ball, spread it evenly over the entire surface with a brayer kept for this purpose.

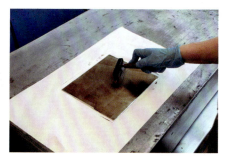

3. The plate is ready when the entire coating is an even, medium-dark tan color. If you find that the brayer slips or the ground is difficult to roll out evenly, remove the plate from the heat and give it a couple of passes as the ground begins to set up as it cools.

easily when touched to the surface. Cover about a third of the plate surface with melted ground. Then, using a brayer kept just for this purpose, roll the melted ground out to a smooth, even layer. If the brayer slides, the plate is too hot. Remove the plate from the hotplate to finish evening out the surface.

In order to make the hard ground darker so that the exposed metal will be seen more easily, it is a common practice to smoke the ground. The plate is positioned upside-down on smoking stands and smoked with a blackening candle, wax tapers, or an oil-lamp. The soot from the flame attaches to the ground and turns it black. The carbon soot can also help fill minute pinholes from the brayer action and prevent false-bite. As the carbon soot mixes with the ground, it also hardens it slightly.

⌃ Move the flame across the grounded surface. As the flame touches the surface, the ground will melt slightly and become shiny and dark. Be careful that the wick does not touch the plate for this will disturb the ground.

Liquid hard ground

Acrylic liquid grounds offer a quick, less toxic approach to line etching. It is important to apply acrylic grounds in a thin, even layer. Too thick a ground will drag against the etching needle when drawing, causing the ground to chip.

After etching, most acrylic resists are removed with a strong solution of sodium carbonate (also known as soda ash or washing soda). Mix 3½ oz (100 g) sodium carbonate to 2 pints (1 liter) water for a stripping solution. Let the plate soak for at least 5 minutes to soften the ground for removal. If the acrylic ground is left on the plate for more than a day, a stronger 10 percent ammonia solution may be required. Some newer products, however, have proprietary stripping agents. Be sure to check the specific requirements for the product you intend to use.

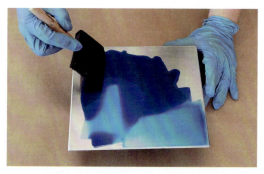

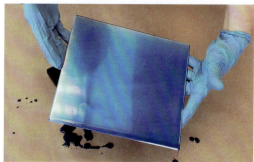

⌃ Begin with a clean, grease-free plate. Brush on the liquid acrylic ground with a soft, wide brush. Start at the top of the plate and gently stroke the ground back and forth without applying pressure. Alternatively, the ground can be poured over the plate. Allow the excess ground to drain off.

> ⊗ **Safety Watch!**
>
> Wear gloves when removing ground after etching.

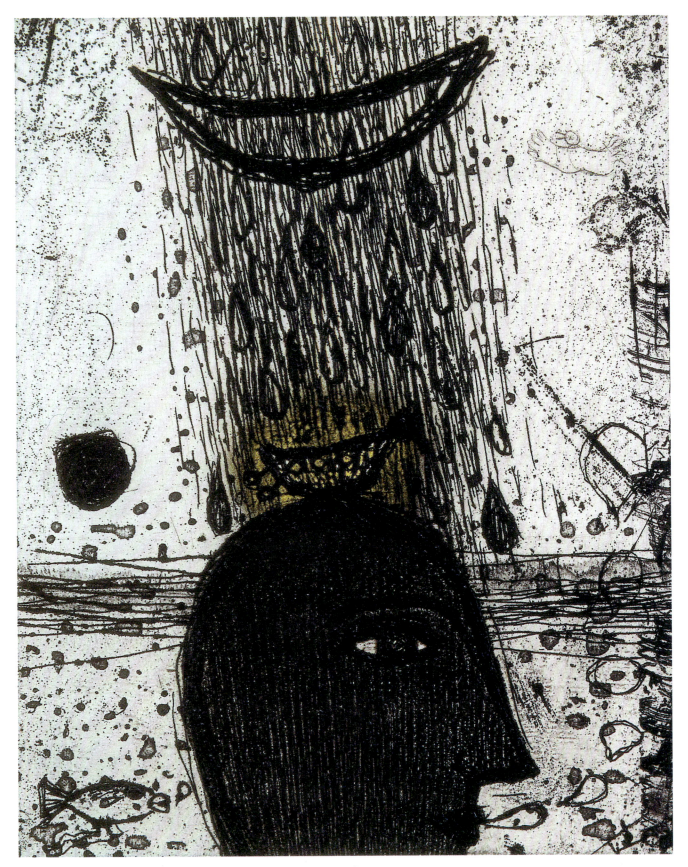

Akiko Taniguchi, *Mr. Ararat*, 1996. Etching, aquatint, drypoint, relief, 4¾ × 4 in (12 × 10.1 cm). Courtesy of the artist.

Taniguchi's work has a raw power that is a direct consequence of her platemaking process. By intentionally using a thin ground for her line etching, she allows the acid bite to create an overall pitted texture, known as false bite. Her linear work is similarly corroded, resulting in a physical richness in the printed work.

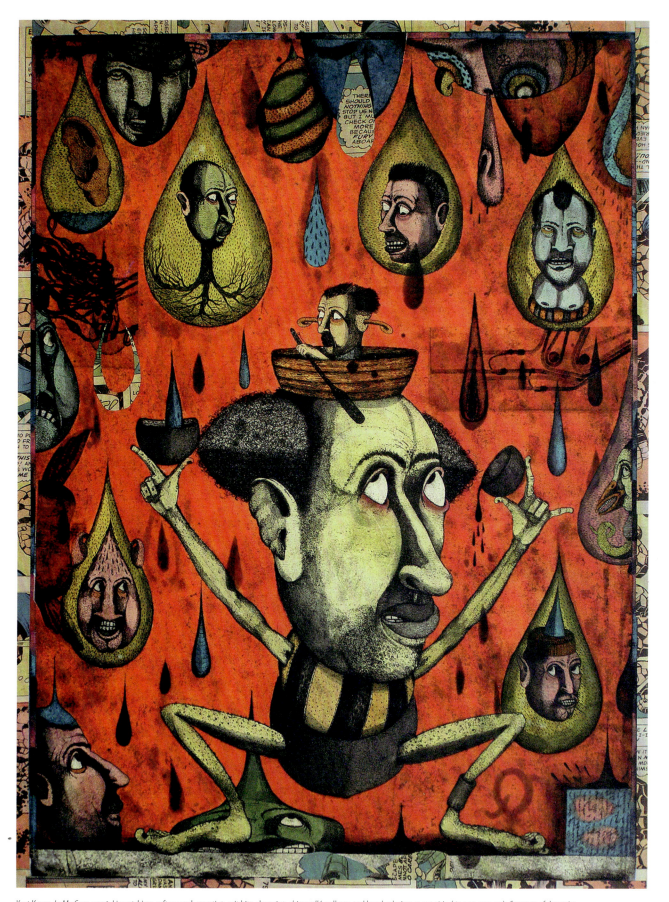

Kurt Kemp, *In My Cups*, 2006. Line etching, soft ground, aquatint, spit bite, drypoint, *chine collé*, collage, and hand coloring, 24 × 18 in (60.9 × 45.7 cm). Courtesy of the artist.

The title of this image refers to the state of indulging in too much drinking. In this case, the artist uses it to draw a parallel with the indulgent nature of artists who obsessively collect and develop imagery for narrative purposes. The use of many techniques enhances the obsessive aspect of the print.

Transferring a guide-drawing

1. Using an L-frame jig to align the image and grounded plate, place a piece of light-colored chalk paper or graphite paper between the image and the plate.

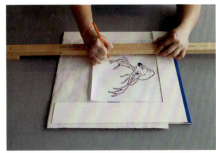

2. Trace the information needed to guide the drawing.

3. As the image is traced, the drawing may be flipped aside to allow inspection of the transfer.

Transferring a guide drawing

The manner of drawing on the plate depends on the results that the artist desires. Working directly on the plate without a guide drawing requires the confidence that generally comes through experience, but can also lead to a more spontaneous fluid image. However, the beginning printmaker usually finds that some guide information is helpful, if only to reverse an original sketch.

There are two methods for transferring an image onto the hard-ground plate:

- by hand, using carbon paper or direct transfer of graphite
- using the press to transfer a pencil drawing or tracing directly from a key image.

Remember that the print is a mirror image of the plate. Consider this before transferring an image; if necessary, reverse the drawing.

If you are using the etching press, not only is there no need to reverse the drawing, but this method also enables more information to be transferred accurately. The danger in this approach is the potential for some of the ground to lift off if it has not dried or cooled down sufficiently to become hard enough to withstand the pressure of the press. It is best to wait a day after putting on a hard ground to do a direct transfer.

Once the guide information is on the plate, the image is developed by needling through the ground.

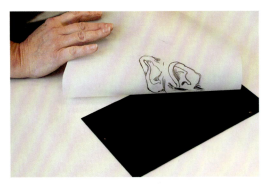

⌃ Make the preliminary drawing with a soft graphite (6B). Place the plate on the press bed and put the drawing face down on top of the plate. Run the plate through at slightly lighter than normal printing pressure. This will offset the graphite onto the plate.

Biting the plate

Up to this point, all of the image information is only in the layer of ground on the plate. To enable the plate to print this information, the plate must be etched. Hard-ground plates are bitten in a stronger acid.

The image may be etched in stages to achieve tonal variation. To work additively, information is added in the grounded surface after each time the plate is put in the acid. Stopping out information after each bite allows tonal variation to be achieved reductively.

Soft Ground

Soft ground is a resist that remains soft after being applied to a plate. The soft ground is probably the most versatile of the etching processes. Almost anything (including thumbprints) deliberately pressed into the plate will remove the ground, exposing the plate to the acid bath. Bold textural effects and quite subtle tonal effects can be achieved with ease.

Traditional soft ground is essentially a hard ball ground to which an amount of tallow or grease has been added, making a soft ball ground or paste. A paste soft ground is a good all-purpose choice. Commercial ball soft grounds are harder. They can vary in quality due to manufacture or age. It is best to buy small quantities that will be used within a year.

Research into alternatives for solvent-based soft grounds has led to the use of water-based relief inks as soft grounds, specifically Graphic Chemical's 1656 Carnation Red or 1659 Black. As the demand for this alternative has grown, products made specifically for this purpose have become available. But acrylic soft grounds do not come without limitations. They must be worked within about 20 minutes, after which they become stiff. This affords some durability, but is less desirable for images that take longer to develop. They must then dry completely for several hours before etching.

The various uses for soft ground require different degrees of softness. A more sensitive ground is usually preferable for impressing textures, while a stiffer soft ground that smudges less works better for line drawing. Experimentation and experience will determine personal preference.

Applying the soft ground

As with a traditional hard ground, the wax-based ball or paste soft ground is rolled onto a warmed plate. Dab the ground so that it covers about one-third of the plate, then roll the ground with a brayer to achieve an even layer. Usually the plate must come off the hotplate and cool a little before being given a final going over to even it out. Let the plate cool before working the surface.

Acrylic soft grounds are simply rolled onto the plate with a brayer.

> **Hint**
>
> Rub a little talc into the surface of the dry acrylic ground. This can help avoid any stickiness that might cause the ground to lift off.

Indirect drawing with soft ground

An indirect drawing approach brings the characteristic of pencil drawing to the soft ground. A sheet of paper placed on top of the grounded plate receives the drawing. The pressure of any drawing tool, including just finger pressure, will offset the ground onto the paper, thereby exposing the plate. The character of the mark is determined by the drawing tool, the pressure used to make the marks, and the texture of the paper being drawn through. Fabrics stretched between the plate and paper can introduce additional textures. Other direct disturbances of the soft ground, using fingers, brushes, rags, or other tools, can be quite painterly.

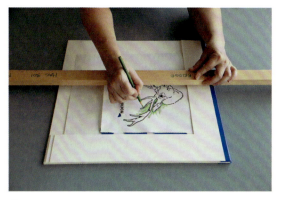

Use the L-hinged jig to hold the grounded plate and key drawing in register to each other. Use a drawing bridge to prevent your hand resting on the soft ground setup.

The guide drawing can be flipped back to allow examination of the plate condition as the image develops. The plate can even be removed, etched, regrounded, and then returned to the jig for further work.

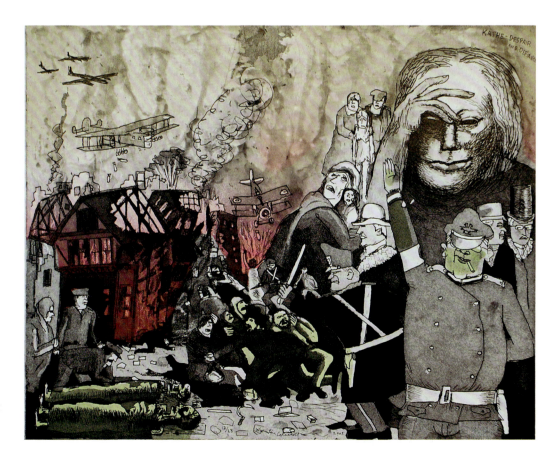

Warrington Colescott, *Käthe Despair and Defiance*, 2005. Intaglio, 14 × 18 in (35.5 × 45.7 cm). Courtesy of the artist.

Colescott utilizes the versatility of soft ground to create an overall tonal field that can be etched. This print was made in homage to Käthe Kollwitz on the sixtieth anniversary of her death. He states: "Kollwitz is one of my favorite print artists...Her prints are a testimonial to her great heart, clear eye and her strong, agile hands. I tried to transpose from her self portrait (in my hand) and reflect small bits of the dismal landscape of war and injustice that she defied."

Making textural impressions

1. Textures can be impressed into the soft ground by running the plate through the press with textured materials. Position the soft-ground plate on the press bed and arrange items on the plate.

2. Cover the plate with a piece of newsprint and an old blotter to protect the printing felts. Use extra foam or old felt cushioning if there are any thick items. Run them through the press under relatively light pressure. Carefully remove the textured elements after they have gone through the press.

3. Running the plate through the press removes some ground from the whole surface. Stopout should be applied in areas where no texture is desired.

Textural impressions

Any flat materials that will safely go through the press bed (fabrics, paper, threads, weeds, etc.) can be used to impress textures into the soft ground. Fascinating effects can be achieved with ease. Since their use can be quite seductive, however, it is good to keep in mind that these techniques should be considered subservient to the content of the work. Fine silk impressed over an entire plate is often used to imitate an aquatint; the tone is sturdy and will last many printings.

> ⊗ **Safety Watch!**
>
> Do not put sharp items or anything thicker than ⅛ in (3 mm) through the press!

Stopping out soft ground

Since anything that applies pressure to a soft-ground plate will lift off the ground, anything that is to remain white on the print must be stopped out; otherwise, the plate will have an overall gray tonality. Stopping out on the traditional soft ground is best done with acrylic or shellac so as not to disturb the excessively greasy ground. Shapes can be painted with stopout either prior to direct disturbance of the ground or at any time during or after the image making on the grounded plate. Take note, however—shapes made by stopout on a soft ground can be very prominent. Think of the stopout as part of the drawing strategy. Apply with deliberate consideration of the shapes being made with the brush.

Etching soft ground

Plates with a soft-ground are etched in a weaker acid bath (a 16–20:1 nitric solution for zinc, and 45° Baumé ferric or weaker Edinburgh Etch for copper). Because the surface remains soft, the plate must not be touched. When using nitric acid, lift the plate out of the bath to dislodge the gas bubbles that form during the etching process.

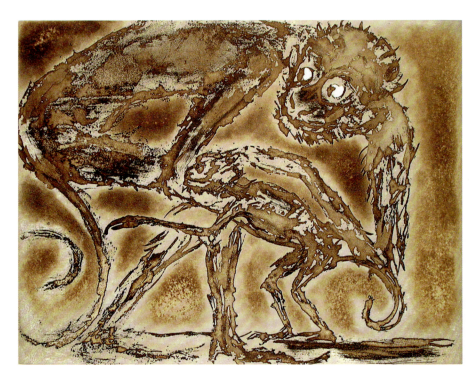

Francisco Toledo, *Chango con su Hija*, 2004–5. Mixed etching techniques, 11½ × 15½ in (29.2 × 39.3 cm). Courtesy of the artist/Davidson Galleries.

This piece displays an expressive quality that can be achieved by painting the grounds directly onto the plate and stage biting for different tonal effects.

Aquatint

The original goal of the aquatint technique was to mimic watercolor or ink washes. It is not unusual to see a historical print described solely as an aquatint, as opposed to an etching or the more generic intaglio. In contemporary uses, it is just as often used in tandem with other grounds as it is used alone toward the eventual development of an image. If planning to use aquatint with other grounds, it is advisable to use it last.

The effect of an aquatint is to produce areas of varying tonality. This is achieved by etching a very fine texture of varying depths into a plate. The deeper the etch, the darker the value. The image is established by stage-biting the various tonalities into the plate. Once a part of the image has reached the desired tonality, it is stopped out to prevent further action of the mordant.

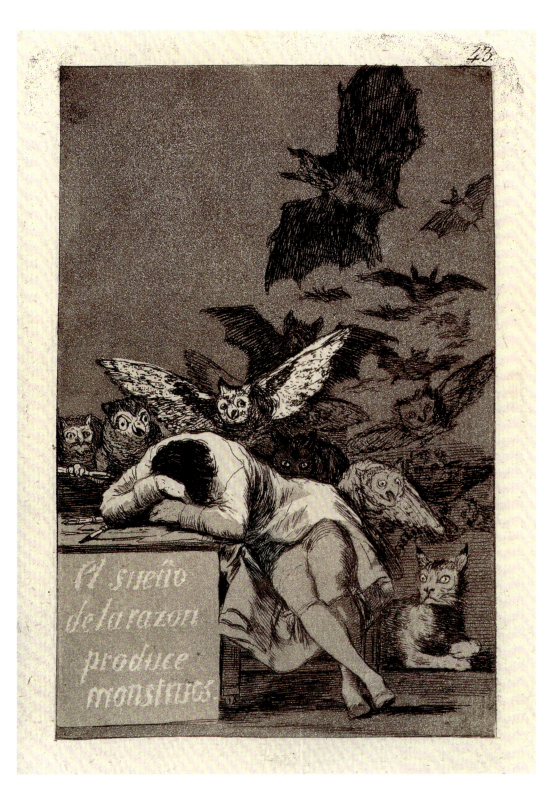

Francisco de Goya, *The Sleep of Reason Produces Monsters (El Sueño De La Razon Produce Monstruos)*, plate 43 of *Los Caprichos*, 1799. Etching with aquatint, 10¾ × 7½ in (27.3 × 19.5 cm). Ackland Art Museum, University of North Carolina at Chapel Hill, Ackland Fund.

Goya was a master of the aquatint process, a form of etching that is tonal, as opposed to linear.

Applying the aquatint ground

Aquatint requires the application of an acid-resistant material that covers the plate with a small random particle. Traditional methods use rosin power, which is fused to the plate with heat. Rosin is applied by hand or with an aquatint box. Spray paint or airbrushed liquid acrylic hard-ground can also be used with similar results.

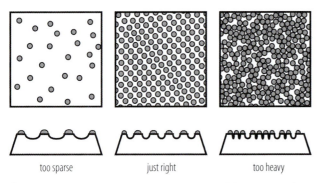

| too sparse | just right | too heavy |

The surface of the plate should be covered about 50 percent with the aquatint particle.

To apply an aquatint by hand, powdered rosin is dusted onto a clean, grease-free plate. Hand-dusted aquatints typically have a range in particle size. This character will be evident in the final print.

Powdered rosin or lump rosin that has been crushed is sifted onto the plate through a nylon stocking. The type of rosin used can affect the particle size of the aquatint.

For a fine, even aquatint, an aquatint box is used. This is a large air chamber, with a rosin container in the bottom and an agitating mechanism to throw a cloud of dust up into the space of the box. The plate is placed on a shelf inside the box and collects a very smooth layer of dust.

⊗ Safety Watch!

There is the possibility of explosion in every aquatint box if metal on metal produces sparks. Keep flammable solvents away from the aquatint box location. Wear a dust mask when using an aquatint box to avoid inhaling the dust particles.

Stirring up the aquatint

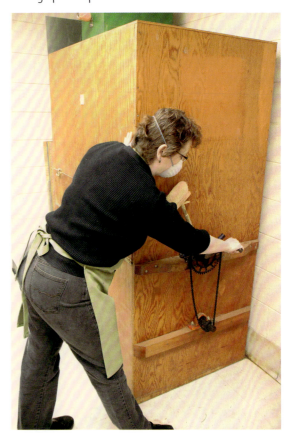

1. Stir up the dust in the aquatint box.

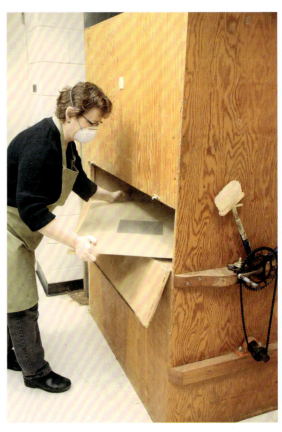

2. Place the plate on a board and put it in the aquatint box for about 5 minutes to collect an even layer of dust.

After the plate has been dusted by hand or with the box, the rosin aquatint ground is fixed by heating the plate. Once melted, check the aquatint with a photographer's loupe. If the particles are close, but still separated, the aquatint is good. If they are too sparse or too heavy, the operation will have to be repeated.

⌃ Set the dusted plate on a wire rack and heat the plate from below with a torch or heat gun. As the powder melts, each rosin particle becomes shiny and translucent. Keep the heat source moving to avoid overheating the plate and causing the particles to melt together. When completely fused, allow the plate to cool.

Sprayed aquatints can be made with enamel spray paint or air-brushed liquid ground. Choose an external-mix, siphon-feed airbrush with a tip to handle thick media. Spray the plate with a mist that covers 50 percent of the plate, as described above. Each dot of paint becomes an acid resist. Make sure the plate dries well before attempting to etch. Curing the aquatint by warming the plate on a hotplate can further strengthen the aquatint ground.

Stopping out

An aquatinted plate must be stopped out with care. Using a stopout that dissolves with a solvent different than the solvent used to remove the aquatint ground prevents the aquatint particles from dissolving and fusing. Rosin grounds use acrylic stopouts. Spray-painted aquatints use shellac or acrylic stopouts. Because the aquatint is tonal, stopped-out areas will be very prominent in the finished print. As with soft ground, carefully consider the shapes being made with the brush. Water-insoluble litho crayons can also be used to create a light, crayon-like line in a darker field.

Sprays used to establish the aquatint can also be used as a stopout. Subtle gradations can be made by alternately spraying and etching a number of times.

Biting the aquatint plate

The finished plate, with the areas that are to remain unbitten stopped out, is ready to be put into an acid bath to be etched. Aquatints are etched in a relatively weak acid bath (a 16–20:1 nitric solution for zinc, and 45° Baumé ferric or weaker Edinburgh Etch for copper). Although rough approximations can be made, strengths of acid will vary with use, especially in a communal shop. It is advisable to dust a test plate at the same time that the image plate is prepared in order to test times in the acid. Bite the test plate, stopping out in 30-second to 5-minute intervals, until the plate begins to deteriorate.

While the acid bites down into the aquatint, it may undercut just enough to etch out the delicate interstices of the dots, leaving a flat, etched space. This point of deterioration is known as *crevé*. *Crevé* happens most profoundly when etching zinc in nitric solutions, since the mordant action is in all directions.

To obtain very subtle value gradations, etch the plate with more stages of shorter duration in the acid. This allows the

Sprayed aquatints

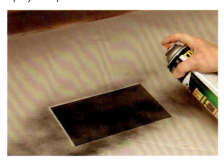

⌃ An aquatint made with enamel spray.

⌃ An inexpensive airbrush with an external mix makes particles that are not too fine.

⌃ An alternative is to splatter the liquid ground onto the plate. This would make a more variable dot, similar to a hand-dusted rosin aquatint.

Hint

Spray aquatints can also be used in conjunction with other grounds. A spray-aquatint applied over etched work before the ground has been removed will allow the plate to be etched just a bit longer. This might be useful to reinforce the ink-holding capacity of soft-ground textures, wide lines, or open-bite areas.

⊗ Safety Watch!

Always use sprays under an exhaust hood. Even "non-toxic" acrylics can cause respiratory problems if inhaled as a fine mist.

Wilson Shieh, *Swimmer*, 2005. Color soft-ground etching with aquatint and gampi paper *chine collé*, 20 × 16 in (50.8 × 40.6 cm). Published by Crown Point Press. Courtesy of the artist.

Wilson Shieh utilizes simple stage biting to make a subtle tonal range for this evocative print.

potential to have a wide range of value before reaching black, thereby making stopout brushwork less noticeable. Conversely, bold painterly marks can be made visible with fewer, longer intervals between the stopout sessions. To reinforce a deep, dark black, give the plate a light spray-paint aquatint, without removing the first aquatint, after it has been etched to a dark gray. This allows a slightly longer final bite past the point of *crevé* determined by a test plate.

Working the aquatint plate

After the plate has been etched, remove the ground and stop-out and proof the plate. If desired, aquatinted tones can be made lighter through scraping, burnishing, and sanding. Darker areas can be established by hand with roulettes or motor tools, or with a second aquatint. A second aquatint applied over the first has the potential to cancel the first one out (the dust particles won't fall in the same place, and may, essentially, cause *crevé*). Success is possible and more likely if the second aquatint coating has a different coarseness from the first. In fact, a coarse aquatint (hand-dusted, spray paint) used first, followed by a fine aquatint (aquatint box, fine airbrush) is much more predictable.

Biting the aquatint plate

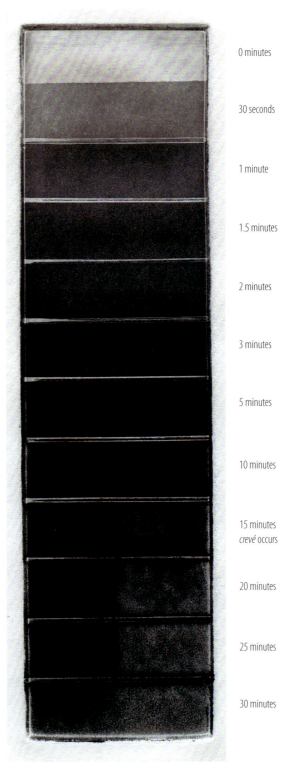

0 minutes

30 seconds

1 minute

1.5 minutes

2 minutes

3 minutes

5 minutes

10 minutes

15 minutes
crevé occurs

20 minutes

25 minutes

30 minutes

◐ A test plate for stage-biting aquatint in the acid helps to determine timing for value gradations and for when *crevé* occurs.

◔ The undercutting action of the acid causes *crevé*.

Mock mezzotint

A mezzotint is made by imposing a texture onto a plate until it prints black. Light areas are then burnished back by hand. To emulate this effect, a plate can be prepared with an aquatint and etched to black. Lights are burnished back or sanded out using a very fine garnet paper. Extremely soft forms are possible with this technique. Often a preliminary line etch is done before the aquatint is applied to provide a guide to the image.

Spit-bite aquatint

The term "spit bite" comes from the fact that originally saliva was used as a vehicle for the acid. Somewhat more viscous than water, the spit would brush well and hold its shape. Thankfully, we've found alternatives to spit. This technique offers an alternative to submerging a plate in an acid bath to etch an image. Rather than making a design in a ground for the acid to etch through, the design is made by painting acid

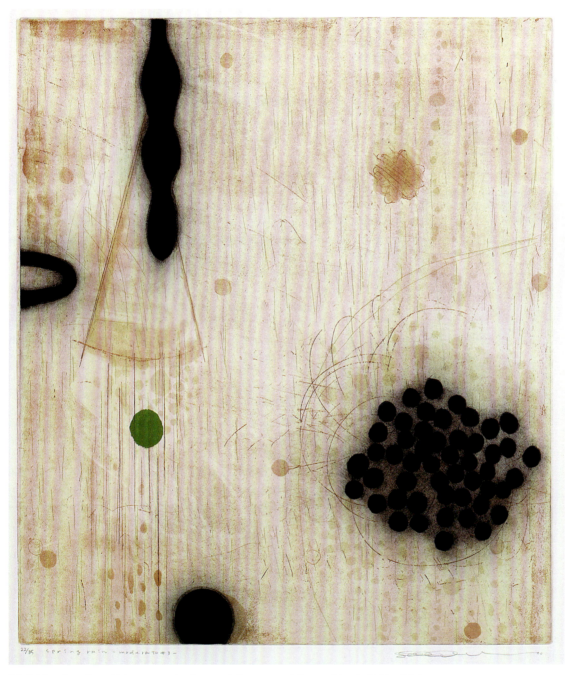

Seiko Tachibana, *Spring Rain—Moderato #3*, 2000. Intaglio, 18 × 16 in (45.7 × 40.6 cm). Courtesy of the artist/Davidson Galleries.

Tachibana employs etching, aquatint, and spit bite to create restrained and elegant images. She distills and refines information drawn from the world around her, expressing an essence found within. Like looking at a Japanese garden in the mist, forms shift and appear indistinct and partially revealed, allowing the viewer to imagine what is not obvious.

solutions in the desired pattern directly onto an aquatinted plate. The brushed acid creates smoky, soft-edged marks.

To set up for the spit-bite process, you need a durably aquatinted plate, a glass cup, acid, several small sponges, and various watercolor brushes, preferably without metal ferrules.

> ### ⊗ Safety Watch!
>
> Spit bite should always be undertaken with the same precautions observed for working with regular acids. Work in a ventilated area, wear gloves and eye protection. Keep a container of baking soda handy for accidental spills. Use brushes without metal ferrules so that they won't interact with the acid.

Spit bite can be done with straight ferric chloride on copper or with a 30–40 percent nitric acid solution for zinc. To make a nitric acid dilution, start with a 50/50 water and gum arabic mixture. Pour 1 fl oz (30 ml) or less into a glass cup. Use a dropper bottle to slowly add nitric acid into the water and gum mixture. Paint the acid solution directly onto the plate.

Spit-bite aquatint

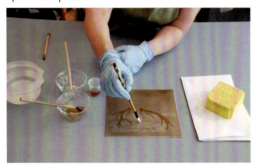

1. To develop the image, paint the acid solution directly onto the plate.

2. As the acid is spent, blot it up with the sponge.

There are three variables that can influence how dark the mark will be:
• the length of time that an acid sits on the plate
• the number of times that an area is brushed
• the strength of the acid solution.

The spit-bite technique is somewhat capricious as there is no way to preview how dark the ultimate mark will be. Nonetheless, the range of dark to delicate and smoky to atmospheric qualities has much potential.

Photo Intaglio

Photo intaglio is the process of using a light-sensitive film that acts as a ground. To make a photo intaglio plate, the film is attached to a plate, then exposed with a positive transparency. When developed, the positive image dissolves away, exposing the metal underneath. Once the film is developed and hardened, a print may be taken directly from the film surface or the plate can be further developed with conventional etching techniques.

Not only is the process useful for bringing a photographic voice to the intaglio process, but it can also be an expedient way to put nonphotographic information, such as text, onto a plate. Positives can be made by drawing directly onto Mylar, allowing translation of immediate kinds of imagery.

About Photopolymer Films

Photopolymer films were first developed for the printed circuit industry. Several innovators, most notably Keith Howard and Mark Zaffron, have developed the use of these films for the fine art printmaker. The film consists of a photosensitive polymer emulsion sandwiched between protective layers of acetate. Several photopolymer film products are on the market, the main difference being in the thickness of the film. Be sure to obtain technical notes as developing times vary according to different brands. In general, thicker films are preferred when the plate is not to be etched and printing takes place directly from the film surface. Thinner films are better if the plate is to be etched. Photopolymer film can be bonded to almost any flat, nongreasy surface, including copper, zinc, or aluminum plates, thin plastic, or any similar material.

Plate Preparation

Before the film can be applied, the receiving plate surface must be prepared. If the surface is not completely flat and dust free, the film will not adequately adhere to the surface.
1. Cut the plate to desired size. The bevel necessary for printing is not established at this point, but the edges must be lightly filed on both the front and the back to remove the sharpness, so as to protect the printing felts from being cut during the film-attaching process.
2. Using fine-grit sandpaper (320 or finer), sand the surface to create a fine tooth.
3. Degrease the plate as normal and rinse with a 5 percent acetic-acid solution (vinegar).
4. Once dry, wipe with a lint-free cloth.

Attaching the Film

The film is sandwiched between two layers of protective plastic. The film should be opened and prepared in a darkroom under yellow safelight conditions.

Exposing the Plate

The image is established by exposing a positive transparency to the light-sensitive film using an ultraviolet light source. The ideal exposure uses a vacuum and is as short as possible to prevent light from creeping underneath the black areas of the positive. Exposure times will vary, depending on the kind of exposure unit and the particular brand of film used. Make a series of test exposures to determine standards for the particular system in use. Once established, these times can be applied for all photopolymer film work.

Optional preliminary aquatint screen exposure

If the image contains a range of tones or areas of solid black, it is necessary to perform a pre-exposure of the film using an aquatint (or mezzotint) screen. The plate should be set up in an exposure frame so that light from the source passes

Attaching the film

1. Cut a piece of film that is slightly larger than the plate.

2. Identify and remove the thinner of the two plastic coverings. This is the inside of the curl of the film as it comes off the roll (gently "scratching" the film on the corner loosens this plastic layer).

3. Place the plate in a water bath and float the film (the side from which the covering has been removed face down) on the surface of the water. Lift the plate out and "float" it into position (this is especially helpful for large plates).

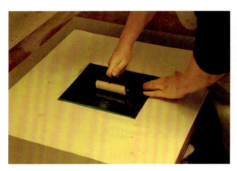

4. Using a clean, soft brayer, gently roll over the surface from the center outward to remove excess water and air bubbles.

5. Carefully flip the plate and film over, and trim any excess film with a sharp X-Acto (utility) knife.

6. To bond the film it is run it through the etching press. Before taking the plate from the darkroom, set the press pressure to accommodate ⅛ in (3 mm) acrylic sheet, and the thickness of the plate, protective cardboard, and extra old felt. The pressure should be firm, but not too tight. Place the plate between cardboard to minimize exposure to the light and take it to the ready press bed. It will not be harmed by brief exposure to the light in the room, but this should be kept to a minimum.

7. At the press, place the plate face down on the smooth acrylic sheet. Cover with protective cardboard and old felt. Run it through the press with a slow, steady pull. Return the plate to the darkroom. The plate is now ready to expose or store.

through the screen before reaching the emulsion on the plate. Following the general exposure procedure below, expose the plate with the aquatint screen first, and then expose the plate again with the positive.

1. Set the transparency on top of the plate and place in the exposure unit to face the light.
2. Turn on the vacuum pump to create a tight contact between the transparency and the plate.
3. Turn on the exposing lights and begin timing the exposure. With the ultraviolet light exposure unit, a 45-second exposure is good for more delicate tonal information and a 65-second exposure for dense, solid linework.
4. When the time is up and the exposure light is off, turn off the vacuum pump. Wait until the vacuum relaxes, then open the frame.

⌃ Place the plate in the exposure unit face down on top of the aquatint screen or positive transparency.

Developing the Plate

The photopolymer film is developed in a 1 percent solution of sodium carbonate. This is a commercial water softener, also called soda ash, and is available commercially as a pool conditioner. Make a stock solution in advance by mixing 3 oz (80 g) of sodium carbonate to 4 pints (2 liters) of water. Mix this stock solution with water in a 1:3 ratio to make the 1 percent working solution. Developing times vary somewhat due to temperature and length of exposure.

Once dry, give the emulsion layer a final hardening by post-exposing it to the UV light source for 1 minute. The plate is now ready to etch, or it can be printed directly from the film surface.

Photopolymer Flexographic Plates

Photopolymer plates, also known as flexographic plates, are light-sensitive plates that have been used for years as a relief element to print packaging materials for years. Initially adopted by the letterpress community, they were first developed for intaglio printmaking by Dan Welden, who calls his product Solarplate™. Because they develop in water, photopolymer plates have become a popular low-toxic alternative for intaglio and relief. Despite obvious advantages, the drawbacks are that they can be expensive and cannot be reworked.

Photopolymer plates are available in plastic-backed or steel-backed forms and have a smooth or mat surface. Some plates are also especially made with nylon to hold a fine "gravure" halftone. They also come in various thicknesses. In general, for intaglio printing, choose smooth and thinner plates. Plates come with a protective layer of plastic on the surface. Leave this in place until ready to expose. Cut steel-backed plates on a plate shear. Plastic-backed plates can be cut by hand with a mat knife. Handle plates in low light or yellow safe light conditions until exposed and developed.

The image is established in the same manner as other photosensitive matrices. An image on transparency is laid in contact with the plate and exposed to an ultraviolet light source. The transparency should be a positive for intaglio work and a negative for relief plates.

Processing Photopolymer Plates

Different manufacturers recommend slightly different exposure times and washout procedures. Consult the manufacturer's directions for specific details. Plates are also processed slightly differently depending on whether they will be printed relief or intaglio. Depending on the density of the transparency and amount of UV light (from sunlight or exposure unit), exposure times can range from 45 seconds to 10 minutes. It is important to make a test exposure to determine optimal exposure times for the particular combination of plate, transparency, exposure system and intended printing method.

1. Make text exposures using small scraps of plate. Some manufacturers recommend using a Stouffer 21-step gauge

Developing the plate

1. Important: Remove the top layer of protective plastic before developing the plate.

2. Place the plate in the developing solution for several minutes, according to the directions for the particular film that is used. If the plate is to be etched, developing must continue until the metal is clearly visible in all of the image areas.

3. Once the image is sufficiently developed, remove it from the developer and rinse it for 1 minute in a water bath or under gently flowing water. Spray the surface with vinegar to harden the film.

4. Set the plate on a hotplate to thoroughly dry and harden.

(a reusable piece of film with varying tonal densities) to help determine exposure times. An exposure time that hardens step 16 on the Stouffer gauge is about right for relief. Alternately, use a section of your transparency that has a good tonal range. Typically, optimal exposures fall between 45 and 90 seconds for intaglio plates. For intaglio purposes, use a double exposure method. Expose the entire plate to an aquatint screen first, then the transparency. Use the same amount of time for each. This puts a texture (similar to an aquatint) in dark areas, enabling them to print a rich solid.

2. Develop the exposed plate in a tray of cool (68°F/20°C) water. Gently scrub the plate with a soft brush. Unexposed areas will dissolve. For intaglio plates, develop for 30 seconds to one minute only. For relief plates, develop several minutes until a satisfactory relief is established, or until all of the unexposed polymer washes away.

3. Once developed according to intended purpose, blot with an almost dry sponge or lint-free paper towel. Finish drying thoroughly with a hairdryer. Be persistent and get rid of all moisture.

4. Return the dried plate to the exposure unit and post-expose for 5–10 minutes. This step will further harden the polymer.

5. Lightly file sharp plate edges to prepare for printing. Keep plates in sealed plastic bags to provide a constant, moderate humidity.

> ⊗ **Safety Watch!**
> Photopolymer may cause rashes or skin irritation in those who are acrylate-sensitive. Wear nitrile gloves when washing out plates.

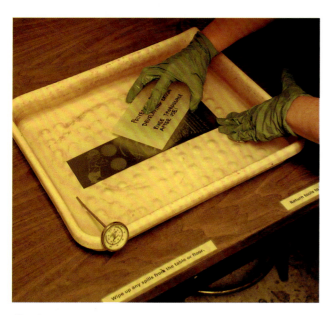

◓ Making a test exposure.

Photopolymer plates can be cleaned with most mild solvents. Keep in sealable plastic bags to provide a constant, moderate humidity and store in a cool, dark place.

Intaglio Printing

Once all the platemaking is completed, remove all grounds to prepare for printing. While a plate made with etching processes can be inked as a relief, intaglio printing is a different process— ink is carried in the incised lines of a plate rather than on the surface, essentially the opposite of relief printing. (For information on inks to use for intaglio printing, see chapter 1).

Printing is done with dampened paper on an etching press. Soaking paper removes excess sizing and makes the fibers pliable enough to press into the intaglio design. Waterleaf papers (papers without sizing) and thinner oriental papers should be sprayed with an atomizer to prevent them from becoming too fragile through soaking. Alternately, a damp pack can be made as an alternative to soaking and blotting each sheet individually. (For information on papers to use for intaglio printing, see Chapter 1.)

The damp pack method

1. Make a damp pack by lightly spraying each sheet of paper with water as it is placed in a stack.

2. Enclose the stack in a damp box or in a plastic bag.

3. Place under a light board for several hours or overnight until the moisture has been evenly distributed. As paper is taken from the damp pack, be sure to check the surface for stray particles, and brush if necessary. The damp pack method is most efficient when editioning.

Jo Ganter's prints are meditative works. Far from the concrete solidity of a room with walls, spaces defined by light and atmosphere deny specificity and offer only illusory stability. As if in a dream state, figurative elements hint of presence and specific identity, yet remain just out of reach.

❯❯ *Tell us about your creative process and interest in printmaking.*
I started out wanting to be a painter, having looked at lots of Old Master paintings in reproduction, but at art college my course scheduled a half day a week learning how to make etchings in the first year. The results I could get in etching suited the architectural subjects I was looking at and by the end of that year I was hooked, not on print as such, or the idea of multiples, but on the quality of mark and the slow process of making. The often accidental corrosion of the plate through the soft grounds I was using produced a richness of surface I couldn't produce in any other medium.

I continue to be interested in architectural spaces and have begun to create small "models" or model stage sets that I photograph. I print some of the photos digitally on high-quality paper that I can soak and print with deeply bitten aquatints. I also create bitmaps of the photos that allow me to transfer the images directly to the etching plates. For the series of Sets, I screen-print the negative of the image onto the steel plate with an acid-resistant "ink" so that I can etch the positive image. This process allows me to work on a much larger scale.

Working with photography is relatively new for me and I enjoy the framing device of my digital SLR camera. In some ways, the aquatinted surfaces I frame my photos with recreate the frame of the camera for the viewer. I continue to find the material presence of the etched surfaces essential to create the timeless quality I want to achieve in the images.

I always work in series and, once the idea for the series is clear to me, one image tends to generate another very quickly. Architectural space continues to be my inspiration although the figurative elements in the spaces is starting to predominate. The very figurative quality of the organic shapes in the photographs surprised me. I had wanted to suggest the figure but hadn't realized how strongly this would influence the work.

As a teacher, I enjoy sharing my discoveries with my students. We are beginning to teach a generation of students for whom etching, lithography, and screen printing are more exciting than digital because they don't experience these media until studying art in college. It is something they can't do at home. Digital technology is something they use without thinking, without being self-consciously fashionable, which I think is a good thing. I think there is a great future for the combination of digital and traditional media.

Born Yorkshire, England

Education/training MA (honors), University of Edinburgh, 1988; British School at Rome, 1989–90

Current Position Printmaking Coordinator, Edinburgh College of Art; Elected, Royal Scottish Academy, 2004

Awards and Exhibitions Jo Ganter's work has been exhibited widely in the UK, Europe, and the US. Her many accomplishments include a KALA Institute fellowship (1994) and a Sir William Gillies Award (2005). Collections holding her work include the Contemporary Art Society, London, The Museum of Fine Arts in Antwerp, The Jane Voorhees Zimmerli Art Museum, Rutgers, NJ, New York Public Library, and the Hunterian Art Gallery and Museum in Glasgow.

Set 1, 2005. Photo etching on steel plates, 36 × 43¼ in (91.4 × 109.8 cm). Courtesy of the artist.

Subtle figurative references imbue Ganter's work with a mysterious narrative.

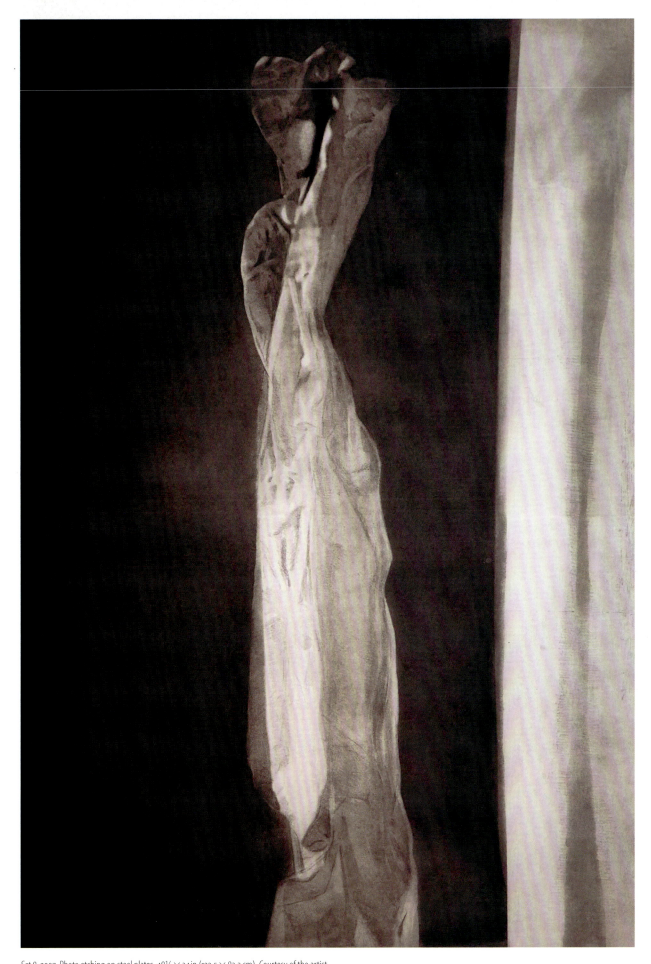

Set 8, 2007. Photo etching on steel plates, 48¼ × 34 in (122.5 × 83.3 cm). Courtesy of the artist.

Ganter's process includes a performative aspect of staging and photographing models. With the translation in to aquatint etchings, references to the actual scale are obscured, creating an enigmatic atmospheric space.

Basic Printing Procedure

1. Tear and dampen the paper.
2. Set up the press with a registration guide and the correct pressure.
3. Ink the plate.
4. Blot the paper and place on the press with a newsprint coversheet. Put blankets on top and engage the blankets, paper, and coversheet.
5. Place the inked plate in position.
6. Lay the blankets in place and pull the print. If running a second plate or making more prints, leave the blankets engaged while you repeat the inking and printing process.
7. Dry the print.
8. When done, remove all papers from the plate and press. Clean up the inking station.

Hint

While plates can be printed cold, warming the plate on a hotplate makes intaglio ink easier to wipe. The plate should never be too hot to handle; if it should become too warm, simply slide it off the hotplate and continue inking.

Basic printing procedure: setup

1. Tear paper to size and place the paper in the water bath. Most papers with sizing require at least an hour to soak adequately.

2. Prepare a registration guide to ensure uniform registration of the printing paper to the plate. Place it on a clean press bed.

3. Set the pressure on the press. Drypoint and relief plates generally require less pressure than a deeply-bitten etching.

4. Remove all grounds and stopouts and bevel the plate if this has not been done previously—unbeveled plates have sharp edges that will cut and ruin expensive felts.

Basic printing procedure: inking the plate

1. Put ink on the plate with an inking card or plastic scraper using a "squeegee" motion.

2. Card the ink in both directions to make sure it is in the intaglio crevices. Remove excess ink.

3. Wipe the plate. Using an inky tarlatan kneaded into a smooth-surfaced ball in your hand, wipe off the ink using long, circular movements on the plate. Change the surface of the tarlatan when it becomes saturated with ink. Remember to rotate the plate, to use long, circular passes over the plate without pressure. Gradually, with successively cleaned tarlatan pads, the excess ink is wiped off, leaving only the ink in the intaglio design.

4. Finally, polish the plate. Phonebook pages or newsprint are held flat in the hand and wiped over the surface (paper wipe).

5. Alternatively, polishing can be done by brushing the plate with the heel of the hand (hand wipe).

6. Finish by cleaning the edges with a rag.

Basic printing procedure: prepare the paper and print

1. To prepare for printing, drain the excess water from the sheet, then place the sheet between two blotters and roll with a rolling pin.

2. Finish by brushing the printing surface with the soft brush. The paper should be damp, not wet. Too wet a surface will reject the ink.

3. Bring the paper to the press, engage it and flip it out of the way. Then set the plate.

4. Lower paper and felts, then pull the print. Operate the press with a consistent, non-stop action until the papers and plate clear the cylinder. Flip blankets out of the way. Lift the sizing catcher carefully to prevent the printing paper shifting.

Basic printing procedure: drying the print

1. Dry your finished print. Place it in between clean, dry newsprint, making sure to cover the inked image, to prevent the fresh ink from offsetting onto the boards.

2. Place this newsprint sandwich between fiber boards in a drying stack. The weight of a couple of boards is sufficient to keep prints drying flat. Prints are dry in 1–2 days.

Good Practice

Although you should be able to feel the rollers passing over the plate when printing intaglio, the press should operate without difficulty. If there is any difficulty in turning the press, don't force it—turn the press back and loosen the screws until the plate passes through with a comfortable pressure. Make a note of this pressure setting for reference at subsequent printing sessions.

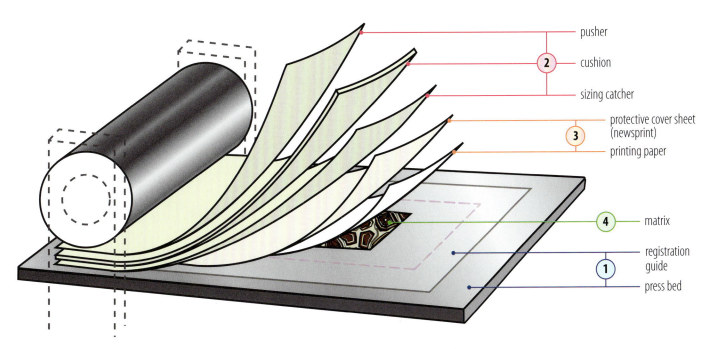

pusher
2 cushion
sizing catcher
protective cover sheet (newsprint)
3
printing paper
4 matrix
registration guide
1
press bed

⌃ Guide to the press setup: printing overview

1. First, set your registration guide on the press bed.
2. Next, set the blankets in order: sizing catcher, cushion, and pusher on top. Align them square with the press bed, engage under the cylinder, then flip them up out of the way over the cylinder.
3. Next, after blotting, set the printing paper in place on the registration guide and place a protective sheet of newsprint on top. Engage the leading edge and flip the paper up with the blankets.
4. Finally, place the matrix in position on the registration guide. Lower the paper, protective sheet, and felts, then crank through the press.

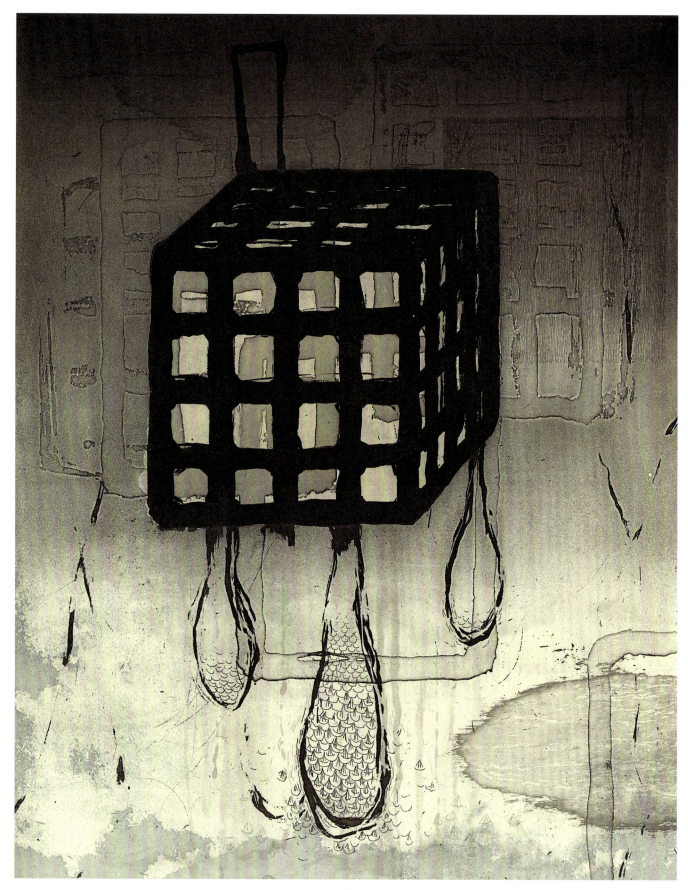

Akiko Taniguchi, *Cage III*, 2007. Etching, mezzotint, drypoint, *chine collé*, 15 × 12 in (38.1 × 30.4 cm). Courtesy of the artist.

Taniguchi explores human relationships to life and nature. Here, the cube cage shape references an apartment or office building. It simultaneously signals stress and captivity as well as a spiritual freedom as it floats in a nowhere sky.

Image Transfer for Multiple-plate Prints

To develop an image that utilizes multiple plates, it is necessary to record information from a first plate onto other unworked plates. This guides the development of subsequent color plates. It can be done in various ways, depending on the kinds of ground used to make the various plates.

Jig

An L-hinged jig, as described in Chapter 1, will hold the plates in the same position relative to a key image that can be moved and replaced. This provides several options for simultaneous plate development.

The image can be drawn on paper and traced with carbon or chalk paper to offset information to bare, hard-grounded or aquatinted plates. The carbon line will act as an acid resist on an aquatinted plate, so be aware of this when planning an aquatint plate.

Ink Transfer

To transfer very accurate information from one plate to another, the ink transfer is an ideal choice. To do this, ink up the first plate and print it. With the paper still engaged in the press, a second plate replaces the position of the first plate and is run back through the press, offsetting an ink layer onto the second plate. There are several ways that this offset can be of use.

If the information is transferred to clean, degreased plate, the plate can be put into weak acid for 10–20 seconds, until discoloration occurs. A light image will remain, even after degreasing. This ghost of the key image can be seen under a thin hard or soft ground or a rosin aquatint.

As a second option, the image can be transferred onto a plate covered with a clear adhesive masking paper or frisket. The frisket can be selectively cut away, exposing the plate. These areas can be open-bit and/or etched with a spray aquatint. Using clear contact paper allows transfer to a plate that is already partially developed. The existing image will be visible beneath.

A third option has the first plate inked and transferred to a plate coated with a hard ground. This is appropriate for doing linework on subsequent plates.

Ink transfer options

1. Ink is offset onto a clean plate.

2. It is dusted with talc.

3. After being etched for about 15 seconds, the ink is removed, leaving a ghost of the image.

⏷ Ink is offset onto a plate with a clear adhesive frisket. Openings cut from the frisket can be open-bit or etched with a spray aquatint.

⏷ The first image plate can also be replaced with a hard-grounded plate for subsequent plate development with line etching.

Procedure

1. For intaglio printing specifically, make sure all the plates that are being used together are accurately filed and the backs are marked for correct orientation. If plates of different sizes, shapes, or orientation are being printed together, trace all plates and note the correct orientation on the registration guide.
2. After the image is on the key plate and bitten, degrease the second (and third) plates.
3. Ink the first plate to prepare for proofing. The ink for the transfer should be very stiff and heavy, not too oily. It should be slightly difficult to wipe. A good mixture is:
 - 2 parts etching stiff black
 - 1 part ultramarine blue (very sticky)
 - 1 part lithographic black (stiff and tacky)
 - a small amount of oo burnt plate oil as needed
 Apply a generous amount of ink to the plate and wipe with tarlatan as usual. Try to underwipe the key plate, stopping the tarlatan wipe earlier than usual, then finishing with hand wiping until the excess ink is removed. The plate should be loaded with ink.
4. Proof the first plate, but do not remove the paper from the press bed. Leave the blankets engaged, with one end of the paper caught under the roller.
5. Remove the key plate and place the degreased second plate in the exact position on the registration guide. Pass the inked proof and plate through the press. A light ink image will be offset onto the second plate. Dust the ink with a little talc to stabilize it.
6. Repeat the process for the other plates.

> **Hint**
>
> It is good if some part of your key image actually goes off the very edge of the plate. This mark can be transferred to the subsequent plates and etched as well to give another registration reference.

Color Intaglio Printing

Once all of the platemaking has been completed, the process of color proofing commences. The plate can be inked in a variety of different manners, yielding quite different results.

À la Poupée

In French, *une poupée* means "a little doll." For intaglio printing, this refers to a small dauber and *à la poupée* describes the technique of color printing using these daubers to put several colors onto a plate at once. The technique was pioneered by French printmaker Manuel Robbe, in the late 1890s.

If it is important to have clean, sharp distinctions between the various colors being used, it is helpful if the plate is designed for this purpose by leaving spaces in between the different color areas. To ink *à la poupée,* wipe lighter, more easily corrupted colors first, followed by darker colors. Wipe each color carefully, using clean tarlatan and paper for each color.

Unsurprisingly, it is easier to achieve softer edges and transitions between colors because precision wiping is not as essential. The first color is put on but not wiped thoroughly. As the second color is wiped, some of the first color mixes across the edge between the two.

Double-drop

Any plate can be inked, printed, inked again, and printed on the same paper. This allows subtle tonal mixtures, wiping with different colors, and experimentation with plate tone. A common approach to double-drop is to ink and print the plate initially *à la poupée* with relatively pure colors. The plate is then treated as a key image and wiped entirely with a unifying, usually darker, color. Double-drop refers to the second printing of the same plate immediately on top of the first printing. The overall color of the key printing softens the edges of the *à la poupée* layer.

An accurate registration guide is essential to the success of this technique.

Relief Roller Inking

Plates may be inked with a relief roll, covering the entire plate with a large roller or specific areas with small brayers. If applying a relief roll on top of a plate that has an intaglio wipe, make the relief ink slightly oilier than the intaglio ink, so that the intaglio ink will not offset onto the roller.

Roller work can get quite fancy, blending several colors across the length of the roller and transferring them to the plate as a blended gradation. These blended rolls are also sometimes referred to as a split fountain or rainbow roll.

Another option is to roll the ink on through stencils. Stencils made of thin Mylar are particularly versatile; they resist curling and can be cleaned easily for repeated use.

Chine Collé

Chine collé is a process whereby collage elements can be added to an intaglio image during the printing process. The original purpose was to allow printing to take place on a much more sensitive surface to pull finer details from the plate. The toned papers placed behind the entire image carried an aesthetic function as well, introducing color to the image. Contemporary printmakers have expanded the idea to add shaped pieces to an image.

The best papers for *chine collé* are thin, unsized papers made from the inner or bast fibers of plants, such as gampi, kozo or mulberry. These papers are strong and soft, able to withstand handling yet very sensitive to recording subtle tonalities in the plate.

There are many approaches to *chine collé.* A very simple method employs a wheat or rice starch powder which is dusted onto slightly dampened collage elements. These are positioned

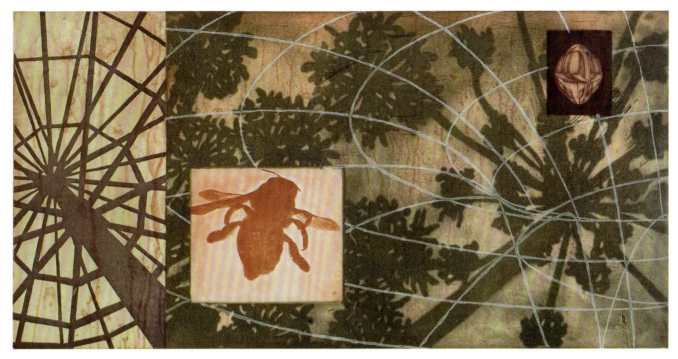

Tanja Softić, *Oculus*, 2006. Etching, drypoint, mezzotint, 15 × 30 in (38.1 × 76 .2 cm).

Softić's work explores ideas of memory. Intricately layered, composite images reflect the fragmented, complicated natures of both memory and contemporary living experience. Her intaglio prints employ drypoint mezzotint and a photogravure. These processes in particular lend a soft richness to the imagery.

on the inked plate, starch side up. When run through the press, the collage elements are glued and printed simultaneously.

A technique for adding a toned paper behind the entire image involves printing the image first onto the *collé* paper. After the image has dried, it is trimmed to the plate mark, then attached to a thicker paper. First, prepare a rice-starch paste by thinning it with water until it is lump-free and brushes easily. Next, cut a thin aluminum or plastic carrier sheet to the size of the image. Submerge this in a water bath and float the *collé* paper face-down above it. As the carrier sheet is lifted, float the *collé* paper in place on top of this sheet. Once in position, use a clean towel to blot off excess water. Next, brush the paste over the entire surface and, with another clean towel,

blot off any excess. Position the *collé* setup on the press that has been set for normal printing. The *chine collé* element will bond to the thicker print paper when run through.

Small elements can be individually collaged quite easily in a similar manner. The pieces to be collaged are dampened and placed face down on a clear plastic sheet and brushed with rice paste. Excess glue is blotted off with a clean towel and wiped from the surrounding plastic. If the receiving surface is very smooth, abrade it slightly with fine sandpaper. The moisture of the *collé* paper keeps it sticking to the plastic which is flipped over and positioned above the receiving surface. Once aligned accurately, contact the element to the print and press firmly into place.

A simple *chine collé* method

1. First trim the paper to size, then dampen using a spray bottle.

2. Gently blot excess water, then dust the pieces with a fine wheat-starch powder.

3. Carefully position the collage elements on the inked plate, glue side up. Set up the press and print as normal. The collage material adheres to the printing paper and the intaglio is printed over the entire surface, becoming a laminated collage print in one action.

Artist Sean Caulfield at work

1. Here, Sean Caulfield sands the surface of a print to open up fibers so that collage elements to be added later will adhere better.

2. The paper is dampened in the water bath, then floated face down on top of an aluminum carrier sheet cut to the same size as the paper.

3. Still floating on a thin layer of water, the paper is positioned precisely.

4. The excess water is drained off.

5. Air bubbles are smoothed away with a brush.

6. Excess water is removed by gently blotting with a clean towel.

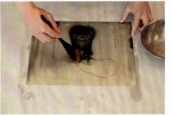

7. Rice-starch paste is brushed over the whole surface.

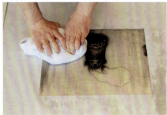

8. The excess paste is blotted with a clean towel.

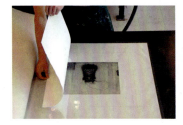

9. The plate with glued kozo paper is positioned on the press bed.

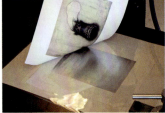

10. It is then laminated when run through the press.

11. Previously printed collage elements are glued.

12. With a protective newsprint in place, the collage element is rubbed down to affix it to the print.

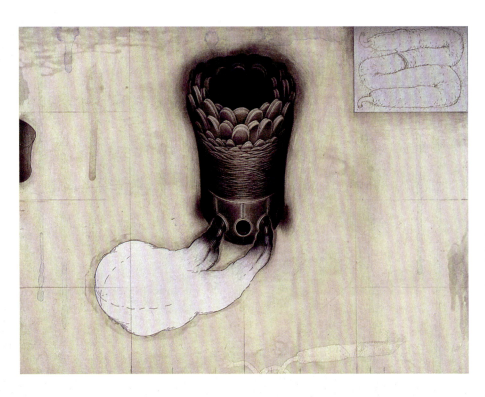

Sean Caulfield, *Black Wind* (from artists' book, *Darkfire*), 2005. Etching, mezzotint, *chine collé*, 12 × 16 in (30.4 × 40.6 cm). Courtesy of the artist.

Black Wind is inspired by the famous passage in Canto V of Dante's *Inferno*, in which Paolo and Francesca are tormented by a howling wind. The artist integrates etching, mezzotint, and *chine collé* to explore themes of mutation, metamorphosis, and biology/technology dichotomies.

Chapter 6
Collagraph

The word collagraph is an amalgamation of two words, *collage* and *graphic*, implying a connection between the method of construction and subsequent printing of an image, and reflecting the etymology of the word from the Greek *kolla*, glue, and *graphe*, writing. Some people spell the word with an "o"— collograph. We prefer the term collagraph, to avoid confusion with collotype—a very different photographic process. The term was coined in the 1950s by the artist Glen Alps, a printmaking professor at the University of Washington, Seattle. Traditionally, a collagraph "plate" is made in the manner of a collage: cutting and pasting paper and other textural elements onto a stiff cardboard support. Rather than existing as an end in itself, this plate is then printed in intaglio and/or relief methods. The term has expanded to include any intaglio printing plate that is not created on metal with traditional etching or engraving processes. Entering into a crossover category, collagraph plates are often printed relief.

There are as many different ways to create collagraph plates as there are people making them. This chapter introduces basic strategies that can be used alone or in combination with each other and other print processes.

Vatiswa Mtyalela, *Gabi Gabi*, 2006. Collagraph, 22 × 15 in (55.8 × 38.1 cm). Courtesy of the artist.

South African artist Vatiswa Mtyalela's print was inspired by the experience of women who have difficulty bearing children—something she also experienced. The materials and process used in the piece reflect the physical aspects of the medical procedure she endured and the bandages that healed her.

Collagraph Materials

There is an infinite number of materials that one can use for making a collagraph. Different base plate materials have various advantages and disadvantages. The following are important considerations:

Durability and stability

The material should be able to go through the press without distortion. Materials such as foam core or corrugated cardboard compress under pressure and are not typically considered. However, this could be exploited to make a plate with impressed textures; a material once compressed can be further developed.

Texture of the surface

When printing intaglio, a smooth surface will not hold ink while a textured surface will. This starting point will influence how the plate is further developed. Surface textures, such as woodgrain, or the variety of textures offered by mat board surfaces can contribute to the aesthetic of the printed image.

Thickness of the substrate

This is an important consideration if planning to work with multiple plates. Keeping plates close to the same thickness minimizes the need to adjust the pressure on the press.

Base Plate Materials

Material	Advantages	Disadvantages
Mat board, chipboard	Easy to work with knives and other tools. Comes with a variety of interesting surface textures. Easy to obtain—recycled forms can be used.	Can warp with water-based materials. Must be sealed with shellac before printing.
Hardboard or MDF	Very durable. Can be worked with motor tools and takes glues and acrylic media well.	Difficult to work reductively.
Whiteboard	Hardboard with a smooth enamel surface. Smooth surface scratches easily (drypoint). Works well with tapes and adhesive-backed plastic.	Difficult to work with wet media or glue.
Lauan	Stable when working with wet media. Carries wood grain texture. Thin type (⅛ in/3 mm thick "door skin") is especially good combined with multiple plates.	Can be made from environmentally sensitive products—check manufacture to avoid rainforest products.
PVC foam board (Sintra, Versacel)	Accepts water-based materials very well. Can be worked additively and reductively. Available with a mat or smooth surface.	More expensive. Not good for photo collagraph.
High-impact polystyrene (HIPS)	Least expensive of plastic options. Good for scratching. Comes in different thicknesses, up to a maximum of ¼ inch (6 mm). Very thin material can be easily shaped with scissors.	Not good for photo collagraph.
Clear acrylic sheets	Good for scratching (drypoint). Transparency aids multiple plate development.	Difficult to work with wet media or glue. Not good for photo collagraph.
Metal plates (aluminum, zinc, copper)	Durable, scratches hold up.	May resist polymer adhesives. More difficult to shape.
Found surfaces (fabrics, wallpaper, tiles, clothing, screens, paneling)	Varieties of preexisting textures extend imagery options and references.	Surfaces must be flat to go through the press. Check for sharp edges or items such as buttons or zippers that could cause damage to printing felt. Thickness variations are more difficult to print.

⊗ Safety Watch!

All materials used in constructing the collagraph must be able to pass safely through the press. Materials do not need to be thick to print a dense or interesting texture. Objects such as coins, buttons, and metal keys are too sharp and thick.

◀ Printing felts can be cut if thick or sharp objects are run through the press.

Collage-making Materials and Media

Dry Materials	Wet Media and Adhesives
Papers and thin boards with a variety of textures (glossy magazines to sandpapers).	White glue or carpenter's glue for drawing. This glue dries hard.
Tapes (try a variety of smooth and textured).	Acrylic media, gels and gesso.
Fabrics (a thinner fine-weave one such as silk will hold a dark ink without imposing too much of itself as a material; thicker fabrics may have to be partially filled with polymer or shellac to prevent them from holding too much ink).	Vinyl spackle.
	Latex paint.
	Iron-on adhesive.
Found surfaces or objects to print from directly (fabrics, string, thread, leaves etc.). See Safety Watch box, page 142.	Shellac (spray and liquid).
	Fine-grained materials (sand, 180 grit Carborundum) to dust into wet media. (avoid any that are too thick or coarse, such as coffee grounds).
	Objects to press into wet media.
	Adhesive options: spray glue, iron-on glue, glue stick or craft glue.

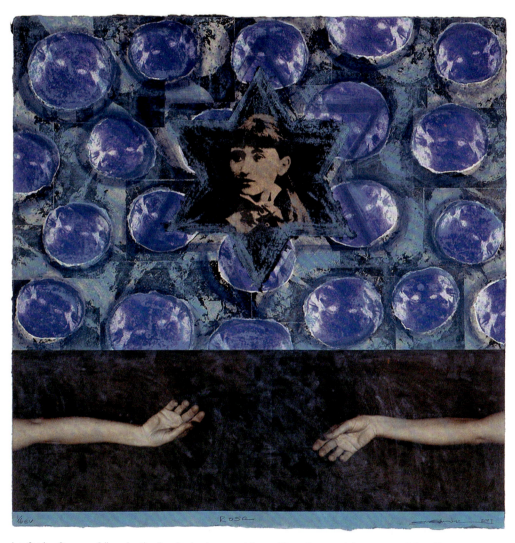

Artist Juan Sanchez uses a hand-held rotary drill to draw on the surface of a large plate of PVC foam board. This will create a variety of rough and smooth textures, ideal for holding ink.

Juan Sanchez, *Rosa*, 2007. Collagraph with collage, handmade paper and duotone lithograph, 48 × 48 in (121.9 × 121.9 cm). Printed by Maryanne Ellison Simmons and Amanda Verbeck, published by Wildwood Press. Courtesy of the artist and Wildwood Press.

This work is from a series about influential people who died young. Rosa Luxemburg was a Polish Jew living in Germany during World War I who, along with compatriot Karl Liebknecht and others, established the Spartakusbund, a left-wing Marxist revolutionary movement. She was a passionate pacifist who was imprisoned repeatedly for her outspoken opposition to the war. In the struggle for political power after the war, Luxemburg and Liebknecht were seen as threats to the newly established socialist government. They were captured and assassinated in Berlin on January 15, 1919; she was rifle-butted, then shot in the head, her body flung into Berlin's river Spree; Liebknecht, too, was killed in this fashion, then deposited at a mortuary as an anonymous cadaver. This print is implicitly in conversation with *Memorial to Karl Liebknecht*, a woodcut by Käthe Kollwitz done in 1919. Sanchez' print combines handmade paper, silkscreen and photolithography, united by an overall texture produced from a collagraph plate.

Approaches to Collagraph

The main idea governing the construction of a collagraph plate is to understand how the plate holds ink. For intaglio printing, tonal variations depend on principles of texture (rough or smooth). Relief printing, of course, depends on height variations of the plate surface. Most of the time, plates can be printed either intaglio or relief and offer a variety of potential outcomes. Sometimes, however, an image may require par-ticular tonal relationships and the plate construction must be deliberate, with a specific printing process in mind.

There are many ways to approach the collagraph plate. In addition to the classic collage approach, there are plates made with wet media or Carborundum, or a *manière noire* process that is similar in concept to an intaglio mezzotint. Plates can also be made using light-sensitive silkscreen emulsions, introducing the option of using a photo-process to establish information on a plate.

A classic collage plate, built with layers of cardboard and cut-out paper. Texture variations (smooth to rough) will hold ink differently.

Texture created in liquid acrylic or latex media from pressing elements into the surface when wet.

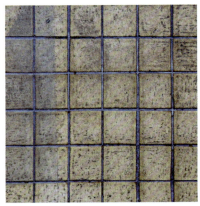

This plate has been made by incising lines into a cardboard plate that has been built up with painterly marks made with latex paint and Carborundum.

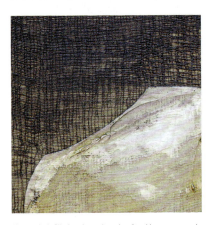

Cheesecloth filled with acrylic gel or Spackle creates tonal range in the print.

Carborundum flocked or painted onto a substrate.

Incised lines, attached stencil letters, paste, and gesso create visual content and textural contrast.

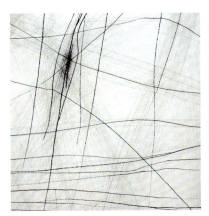

Similar to drypoint methods on metal plates, lines and textures made with sandpaper or steel wool are scratched into a smooth whiteboard.

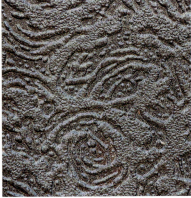

Textured wallpaper is an example of a "found" surface that can be used alone or collaged into a plate.

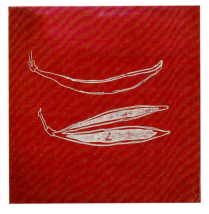

A photo-collagraph plate is made with a light-sensitive silkscreen photo-emulsion.

Collage Method

The collage approach is the most familiar of the collagraph methods. Simply, the plate is made by gluing materials to or otherwise physically manipulating a support board. The image is a result of the physical topography of the plate. These guidelines are given as a starting point.

1. First, cut the base plate material to the desired shape. Paper, thin plastic, or board options readily allow consideration of nonrectilinear shapes.

2. Create the collagraph plate in any number of ways: gluing down materials, cutting or scratching into the plate base, or peeling away layers of a paper board. Because the plates must endure a fair amount of physical stress for inking and printing, it is important to make sure that surfaces are glued tight—do not leave any air spaces—and that the glue extends to all edges of the collage shape.

3. Make textural areas by gluing down rough papers or thin fabric. When printing intaglio, rough textures will hold more ink, while smoother textures will hold less. The tonal range of the resulting print can be controlled to some extent by covering or filling textures with layers of polymer or thinned-down glue or gesso. Let each layer dry before adding subsequent layers. Some artists recommend applying a coat of polymer as the last step, filling the areas around the pasted forms. This would be important if the plate has more pronounced height changes; these areas would otherwise collect a lot of ink that would spread out when the plate is printed. If working with thinner materials, such as tape, a final sealant of shellac (described below) is sufficient.

4. Once the collage is finished, it must dry completely, and the longer it can be left the better—overnight if possible. If the plate is damp and subject to warping, dry it under a weight. Plate glass works well, as does an old etching plate. Just make sure not to use something that will glue itself to the wet collagraph plate. If an air-dried plate has warped, it can sometimes be flattened under a weight overnight.

Collage method

1. Tapes, stickers, vinyl lettering, or any adhesive-backed material can be used to develop a collagraph plate. Try materials with different textures to create tonal variation in the final print.

2. Score through layers of multiple-ply paper boards to create shapes. The peeled away area will be lower and have more texture. Edges can be defined with a knife or allowed to tear randomly, creating softer, less controlled edges. The cardboard surface can also be abraded or pierced with sharp tools.

3. Wet glue provides the strongest bond, but can be messy or unwieldy for large or thin shapes. Apply the glue with a brush before applying to the board.

4–5. Spray adhesive is useful for delicate materials like lace or papers with complex cuts. It also avoids warping that can be a problem with wet glues. Use in a well-ventilated area.

6. Iron-on adhesive allows even more complexity and stability when using delicate papers. The adhesive is first attached by ironing it to the material to be cut.

7. A shape, which can be very intricate, is then cut out—the glue layer gives some body, which facilitates handling. The pieces can be arranged before finally attaching them to the substrate.

8. The backing is peeled off.

9. Finally, the shape is ironed in place, face up, to attach it to the substrate.

145

5. When dry, check for sharp edges or areas where the materials are not firmly attached. If needed, sand the surface with a medium to fine sandpaper, especially in places where glues or sealants may have established unwanted textures.

6. Before sealing the plate, take a "blotter proof" by running the plate through the press without ink. But beware: the plate must be *completely* dry to do this! This uninked proof, or embossing, will give you an idea of what the print will look like. In addition, the pressure of the press will improve lamination and remove any air that is trapped between glued pieces. Corrections or additions can be made at this time. If necessary, recoat with polymer or shellac after any changes.

7. To finish the plate, it must be sealed so that it can be inked and cleaned with solvents. Sealant options include shellac, or water-based polyurethane varnish. Either of these give the plate a hard, durable surface that helps it stand up to the rigor of inking. Shellac has the advantage of a quick drying time and does not hold brush marks. It is also reversible with denatured alcohol should the plate need to be "opened up" for additions. A marine-grade polyurethane varnish is probably the most durable, although furniture grade gloss polyurethanes work well. Use water-based polyurethane products to avoid toxicity hazards. Apply a sealant of choice to both the front and back of the plate. Let this dry for another day before attempting to print.

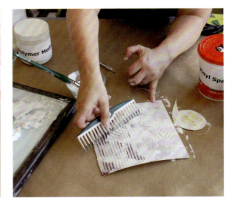

Keep the surface height variations to a minimum (as shown above). Extreme height changes are hard on the press and can damage printing felts (as shown below).

Wet Media Plates

Wet media plates rely on the texture made in media. Latex paint, liquid polymers, acrylic gel medium, gesso and vinyl spackle can be used separately or combined for a variety of effects. Gel medium and spackle will build impasto textures easily. Acrylic gel and medium or latex enamel dry with a glossy surface and wipe clean when printing intaglio. Mat mediums and spackle hold a bit of plate tone. Experiment with different mixtures to explore these combinations.

1. Prepare cardboard plates with a layer of spray shellac so that they won't warp. Lauan boards can either be worked with a steel brush to express the grain of the wood or filled with vinyl spackle and/or acrylic media to minimize the woodgrain texture.

2. Develop the image by painting media onto the plate. Develop textures by pressing shaped stencils into the wet media or simply brushing the thicker media on in an impasto-like manner. Drawing into the wet media with a pencil also produces intaglio lines that will print well.

3. Draw raised lines with white glue.

4. Dry the plates thoroughly. The amount of time needed depends on how thickly the wet media has been applied; minimally, it will be one to two hours for surfaces created with latex paint.

5. Textures can be modified by sanding back with fine sandpaper or filling with additional acrylic media or shellac.

6. Seal finished plates with spray or liquid shellac. Plates can be printed as soon as the shellac is dry.

Carborundum Plates

Carborundum is a common trade name for silicon carbide. It is a sand-like ceramic compound that is manufactured for use mainly as an abrasive. In printmaking, its primary use is for graining lithographic stones. In the collagraph process, plates are made that utilize the textural aspect of the Carborundum to hold ink.

Wet media plates

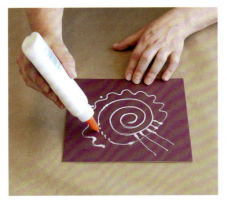
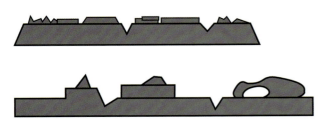
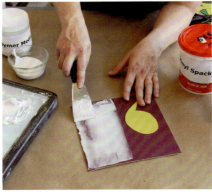

1. When doing a linear drawing with glue, be sure to use a glue that dries to a hard finish, such as a wood glue. Do not use polyvinyl adhesive (PVA) as it remains spongy after it is dry and can stick to the paper, even after sealing.

2–3. Gesso, latex paint, polymer media and gels, and household Spackle can be used alone or in combination to create a variety of effects. Thinner media can be painted to fill textures. Thicker media will hold textures made from various tools or from objects pressed into the media while still wet.

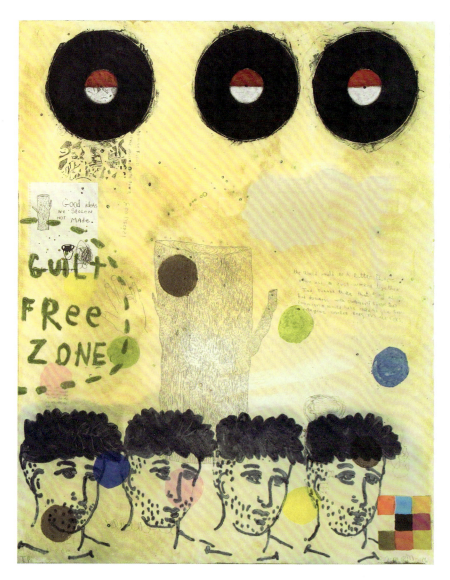

Squeak Carnwath, *Russian Etruscan*, 2007. Collagraph etching and *chine collé*, 60 × 48 in (152.4 × 121.9 cm). Printed by Tom Reed, published by Island Press at Washington University in St. Louis.

In many of her recent works, Carnwath uses an array of symbols that suggest loss and transience. The vinyl record becomes a metaphor for mortality; once powerful and a central cultural icon, it is now relegated to a nostalgic recollection. Its changed status reminds us that we have few chances and limited time to make a difference. The "guilt free zone" absolves us of that preoccupation as it suggests a "reprieve from that pesky emotion."

The plates can be made by simply painting with Carborundum suspended in shellac. Once these initial marks are dry, clear shellac can be added to fill the texture. This reduces the amount of ink it will hold, thereby modifying the printed value.

Alternatively, an image can be made by dusting Carborundum into ink or other wet media that has been printed or painted onto a board. Images screen-printed with a 50/50 mixture of ink and polymer medium, or a simple paper lithograph printed onto the base plate work well for this purpose. The dusted plate is fragile until it is sealed, so handle it carefully at this point. Once the dusted plate has had a chance to dry a little, remove any excess dust from the plate with compressed air and/or a soft brush. Carborundum areas can also be modified before the plate is sealed. This is a great way to introduce photographic information or text.

Fix the loose Carborundum with a coating of spray shellac. Once this is dry, further secure the Carborundum with two more coats of spray or liquid shellac.

Carborundum plates

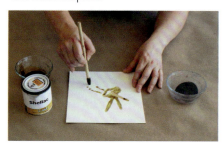

1. A wet material, such as shellac or polymer medium, can be painted directly onto the plate.

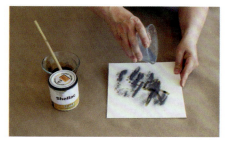

2. Carborundum is then dusted into the wet material.

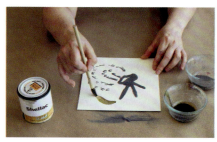

3. Alternatively, a mixture of Carborundum and shellac may be used to paint directly onto the substrate.

Manière Noire

A *manière noire* approach in collagraph is a reductive process. Rather than burnishing highlights into a roughened plate, lights are established by filling a collagraph texture with some kind of liquid medium.

1. Begin with a plate that would essentially print as a black. Starting plates can be created in a number of ways. The easiest is simply to glue a thin layer of fine-weave fabric or screen to the surface of a plate. This approach is commonly known as "silk collagraph". A fine grit wet-dry sandpaper, spray-mounted to a cardboard sheet, is also a quick way to begin. Alternatively, dust a fine layer of 180 or finer grit Carborundum onto a plate freshly coated with spray shellac or glue. Once dry, seal with a layer of spray shellac.

2. Tonal changes are made by filling the textured plate with wet media so that the texture holds less ink. Media that dry with a gloss surface, such as glue, latex paint, or polymer mediums are the most predictable for this process. Adding thicker media will quickly fill the texture and make stark contrasts. Thinned media added gradually can create a very subtle tonal range.

3. Once dry, finish the plate with a coating of shellac.

4. Print the plate in an intaglio manner.

> **Hint**
> Old silkscreen fabric saved from damaged screens is just about perfect for this purpose.

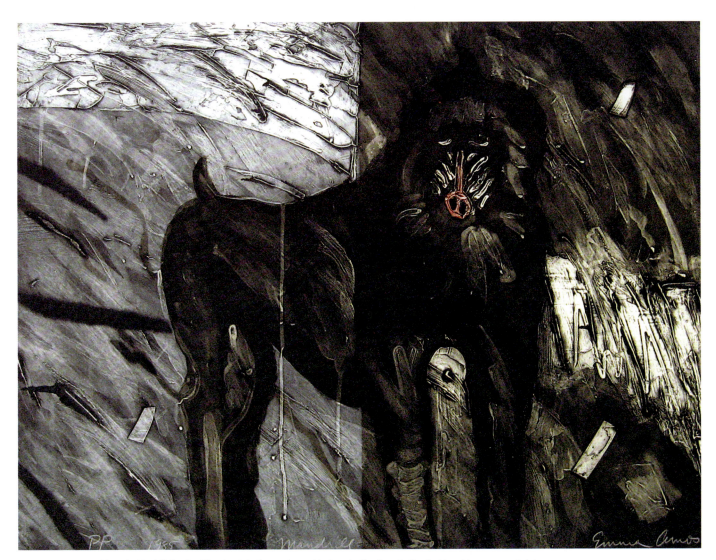

Emma Amos, *Creatures of the Night: Mandrill* (above) and *Josephine Baker* (opposite), 1985. *Manière noire* silk collagraph, diptych with each image 23 × 30 in (58.4 × 76.2 cm). Printed at K. Caraccio Printmaking Studio, New York.

This diptych is part of a seris called *Creatures of the Night*. In these works, Amos evokes the idea of strength, beauty, and grace in a hostile world. Through the diptych form, she draws a parallel to the position of black women in culture and a tendency to revere the exotic creature rather than attend to the individual who deserves honor and protection.

Photo Collagraph

Photo collagraph is a process that utilizes light-sensitive screen-printing emulsion to establish an image on a plate. Plates coated with photo emulsion are exposed with a positive transparency. When washed out, the image exists as physical recesses in the plate. The process can stop there or can continue with additional collagraph plate-development work of any sort.

Base plate material

As with other collagraph approaches, the base plate material can contribute a textural component to the image. Smoother support materials print with an "open bite" look, while a base texture will be visible in open areas and, to a lesser degree, in the surface under the emulsion. Functionally, the surface must be able to bond with the emulsion. For this reason, wood or composite boards tend to work best. The thickness provides stability for the water-based emulsion and the absorbent quality aids the adhesion of the emulsion.

⬆ Lauan or other thin plywood ("door skin" is a very thin Lauan, and especially nice) can be prepared to express the woodgrain texture to various degrees or not at all. This image shows several options: a board with texture made with wet media, a board with a layer of screen-printing fabric glued to the surface, a board coated with gesso, and a board with wood grain partly filled with vinyl spackle.

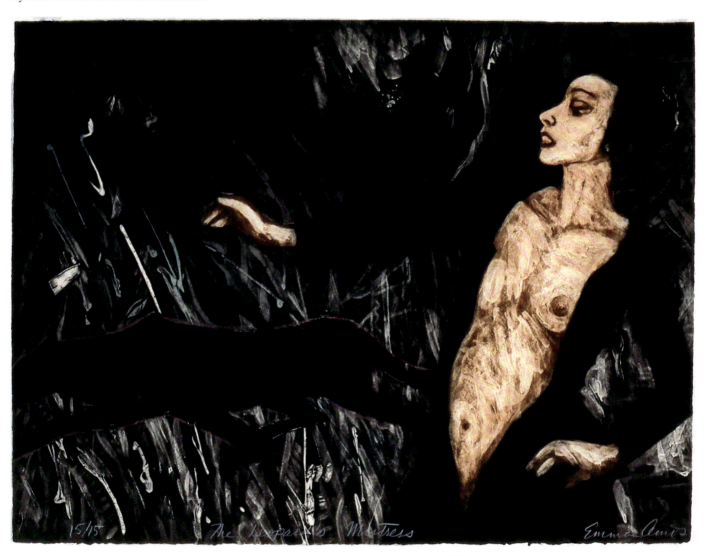

15/15 The Leopard's Mistress Emma Amos

Wael A. Sabour

Wael A. Sabour's work seduces the viewer with rich textural surfaces and saturated color. Pulled into the work with visual sensuality, the symbolic forms slowly work their way back to the analytic mind and remind us of the urgency of horrific realities. From abstraction emerges beauty and compassion.

>> *Tell us about your identity as an artist-printmaker and your creative process.*
My relationship with printmaking goes back to my childhood when I was watching my father, also a printmaker, working on his woodcut blocks. Since then I've been fascinated by this enchanting world of colors, tools, and papers and, of course, the resulting amazing images. Growing up in such a rich artistic atmosphere played a great role in forming my artistic consciousness and taste.

When making work, I start with simple ideas that I find interesting. My sources for ideas could be anything that I find visually interesting in the natural world around me or intellectually and emotionally provocative topics, such as political or social events, wars, and social injustice. Another source for my ideas is other artists' works, whatever the media are. For instance, I find old documentary films very inspiring. After all, art is a visual culture and others' creative works exist as an endless visual book that enriches the creative experience of any artist.

Once I choose an idea to work with, I draw several very simple sketches before deciding which of them best expresses my idea. Then I consider the techniques in which I'll execute my image, the colors I'll be using, and the format of the image. These decisions depend greatly on the original idea for the work. For instance, in my political prints [see opposite], I've chosen collagraph. I especially like its three-dimensional effects, which made the aerial scenes of crowded rooftops more convincing and more dramatic. I chose to print these images in black and white or in black and red to intensify the expressive nature of the subject. Printing these pieces in a large format was vital to make the viewer feel a part of the event rather than a viewer of an image.

Defining the relation between the technical process and the content is absolutely imperative for any artist and especially for a printmaking artist. I believe the success of any print as an artwork depends on an equation that integrates process and content. In my opinion, the technical process is just the vehicle that conveys the content. I always try to make the content rule that equation and choose to use the process that best conveys the idea. Sometimes, during the course of developing a print some "good" technical accidents may happen which can offer unexpected gifts in the form of unusual rich textures or forms. In such cases a good artist should be able to make use of that "happy accident" and to integrate it effectively within the context of his work without being distracted from the real core of his work, which is the content.

Born Cairo, Egypt

Education/training PhD, Philosophy of Art, Elmenia University, Egypt; M.F.A. Helwan University, Egypt; B.S.A. Elmenia University, Egypt

Current Position Assistant Professor of Art, Elmenia University, Egypt

Awards and Exhibitions Wael A. Sabour's work has been exhibited worldwide—extensively in Egypt, Europe, and Western Asia, as well as recent exhibitions in China and the US. Awards include: Grand Prize, 17th International Youth Salon, Egypt, and Certificate of Merit, 2005 Kochi International Print Triennial, Japan. Grants received: artist in residence, Alexandrian Bibliotheca in 2005 and the Egyptian governmental scholarship for work in the US. Sabour's curatorial work includes three internat-ional print exchanges: Meeting the Other, Open Expression, and Egypytian Printmakers Invitational at the University of Nebraska.

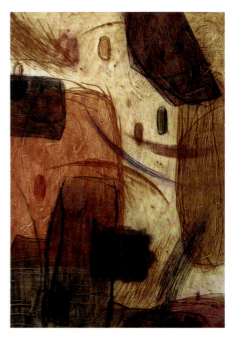

Ancient Structure 3, 2003. Collagraph, 27½ × 19½ in (70 × 50 cm). Courtesy of the artist.

This image is from a series of works in which the artist tries to capture the abstract nature of ancient structures that have documented the history of Egypt, witnessed major historical events, and influenced social progression. These structures are living, breathing objects for the artist, who uses the baked earthen colors, rough textures, and the organic shapes common to many ancient Egyptian structures.

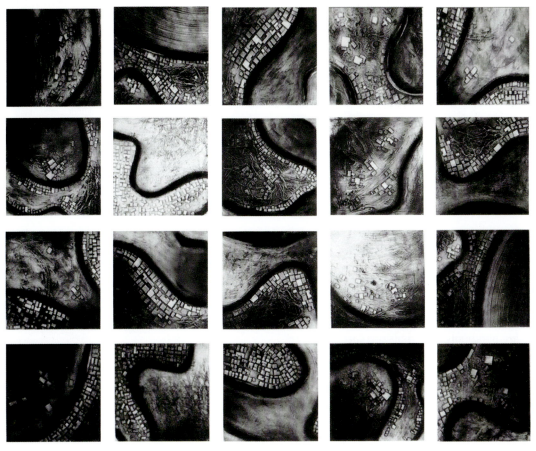

The Wall, 2004. Collagraph, 94½ × 110¼ in (240 × 280 cm). Courtesy of the artist.

This work is a protest by the artist against the highly controversial Israeli West Bank barrier. The wall "twists and turns like a snake" through the Palestinian lands, separating families and restricting the free movement of the Palestinian people. The image is meant to look like aerial photographs of different sections of the wall, represented by the thick black line. The rooftops of the Palestinain homes are massed together as dense geometric shapes.

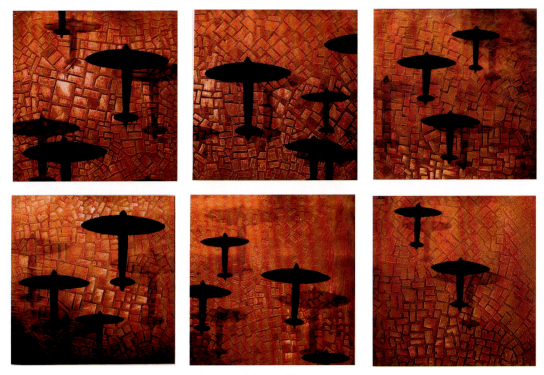

Shadows of Democracy, 2005. Collagraph, 82½ × 110¼ in (210 × 280 cm). Courtesy of the artist.

With this piece, A. Sabour chooses to highlight as he says, "the hypocrisy of nations that promote democracy while attacking other nations". The image represents the dark shadows cast by bombers over crowded city rooftops. The shape of the aircraft references the frightening silhouette of the German World War II warplanes that destroyed many cities and became a symbol of death and destructions. The artist feels this is now being repeated by the policies of "Democratic" nations.

Photo collagraphs: different plate preparations

1. A board with minimal preparation shows a woodgrain texture in the center of this printed image. The dots in this image are from bubbles created by brushing on the emulsion.

2. A plate prepared with a buildup of wet media textures shows these marks as soft brushstrokes in the negative spaces of this image.

3. A plate prepared by gluing a thin fine-weave fabric (in this case, reclaimed silkscreen material) provides a tooth that holds a solid ink in the center of this image.

Liquid emulsion

While almost any liquid silkscreen emulsions can be made to work, the most reliable are photopolymer emulsions (see chapter 3). When considering an emulsion for this purpose, look for good bridging qualities and solvent resistance. Different brands may behave slightly differently. It is beneficial to experiment with small quantities first. Some manufacturers will provide free or low-cost samples for such testing.

Positive transparency

Any transparency suitable for a silkscreen procedure can also work for the photo collagraph. The process works most predictably with bold, linear, and high-contrast information. Photographic information should be screened with a rather coarse halftone, with a linescreen of 35–55 lines per inch (see chapter 2 for a discussion of digitally generated halftones).

Plate preparation

Acrylic media, gels, gesso, vinyl spackle, or latex primer can be used alone or in combination. A mixture of vinyl spackle and some latex or gesso helps fill wood grain a little or to give a subtle impasto texture before the emulsion is applied. The plate preparation is finished with medium-grit (180) to fine-grit (400) sandpaper and spray shellac.

1. The amount of texture desired determines how much preparation is needed. Minimally, wood surfaces need a coat of spray shellac on both sides. To fill woodgrain, spread a mixture of latex or gesso and gel medium or vinyl spackle onto

Plate preparation options

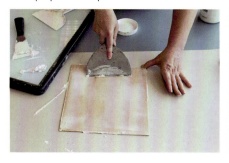

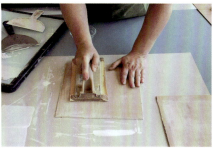

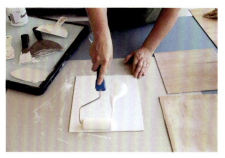

1. A wide spatula is used to spread a mixture of gel medium and gesso onto a board.

2. Once dry, the surface is sanded smooth. The process can be repeated to further eliminate the expression of grain.

3. Gesso applied with a roller will fill some grain and create a smooth surface.

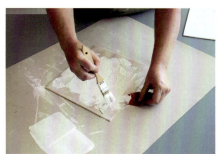

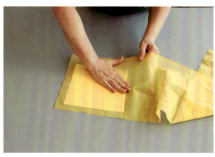

4. The plate can be left as it is or further developed with wet media to create subtle information under the photo-emulsion layer.

5. Silkscreen fabric is attached to the surface of the board with spray adhesive. For a tight bond, spray both the board and the fabric with adhesive.

the wood surface with a wide spatula. After this has dried, sand the surface and repeat the process to fill more grain, if desired. Finish by sanding with a fine sandpaper to even the surface.

2. An optional layer of secondary information can be introduced by developing texture or imagery with any wet collagraph media. Such additions will be visible in the final image as a softer layer of information.

3. Plates intended for images with large open areas that need to print solid should have a layer that will hold ink under the emulsion. Silkscreen fabric or similar material can be attached to the board with spray adhesive before applying the emulsion.

Applying the emulsion

Before coating, make sure the plate is dry and free of dust.

1. Screen-printing emulsion is quite thick. To adapt it for this process, thin it in a ratio of one third to one half distilled water to emulsion. Mix the water and emulsion thoroughly and let sit for an hour so that any bubbles created in the mixing process settle out. Dilute only the amount that will be used within a couple of weeks, and label the diluted emulsion clearly. The thinner the mixture, the smoother the surface it produces, but a thin mixture may require two coats.

2. Coat the plate in a darkroom. Yellow safelights are OK. Use a very soft bristle brush to apply the thinned emulsion. The brushstrokes generally will settle out to make a level surface. It is *very important* to use a clean brush—oil residue contaminates the emulsion, causing the surface to repel it. Alternatively, pour a puddle in the center of the plate and rock the plate to distribute the emulsion evenly. Let excess emulsion flow back into the container. Use a soft brush to help direct the emulsion flow and to pop any bubbles. The wet layer should be opaque. When the emulsion dries, it will seem thinner and translucent. Allow the plate to dry thoroughly and, if desired, give it a second coat. Once this second coat is dry, it is ready to expose. Practice and purpose will dictate how much emulsion to put on.

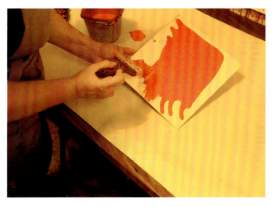

⏵ Using a clean brush or a puddle method, apply a smooth, even coat of emulsion to the base plate. Set the plate in a level, dust-free location to dry.

Exposing and rinsing the plate

Exposing photo collagraph plates is done in the same manner as photo intaglio, using an exposing unit or with a simple do-it-yourself setup.

1. Expose the plate following the manufacturer's instructions for exposure times for the particular emulsion being used. These can range from two minutes in a vacuum frame with fluorescent tubes, up to as much as 10 minutes with a photo flood bulb in a spotlamp.

2. Rinse the exposed plate carefully. Start with a firm spray of warm water. The image will emerge as a lighter color of emulsion; this is what will eventually rinse away. As the image washes out, keep an eye on delicate areas. Small halftone dots can pop off and delicate linear elements might want to come loose. As the image develops, adjust to a more gentle spray and a cooler water temperature. Be patient. It sometimes takes several minutes for an image to rinse out completely. It is OK to stop rinsing before the lighter emulsion is all gone, especially if delicate areas are in danger. The plate might look incompletely rinsed, but as long some of the image has been removed from the layer of emulsion, it will still print. (For optional extra steps at this stage, see "Modifying the photo-collage plate," below.)

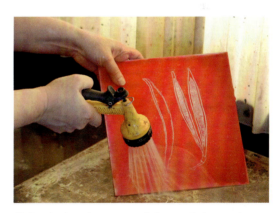

⏵ Rinse the plate with warm water and a firm spray. As the image clears, use less water pressure and cool water.

3. Dry the plate for a minimum of at least one hour.

4. Once it is completely dry, give the plate a coat of spray shellac. Let the shellac dry for at least two hours before printing—overnight is best, giving the surface a chance to cure.

Modifying the photo-collagraph plate

1. Dusted onto the plate just after washout, Carborundum will adhere to the still-soft emulsion at the edges of the washed-out areas. This adds darker articulation to the information and gives some crusty "noise" overall, for a more distressed look.

2. While the emulsion is still soft, it can be easily carved with linoleum tools. Linocut marks tend to print with a sharper edge, and if cut into the board, the deeper line will also print darker. Be sure to finish with spray shellac after any cutting.

3. After it is dry, the plate can also be further developed with other collagraph processes.

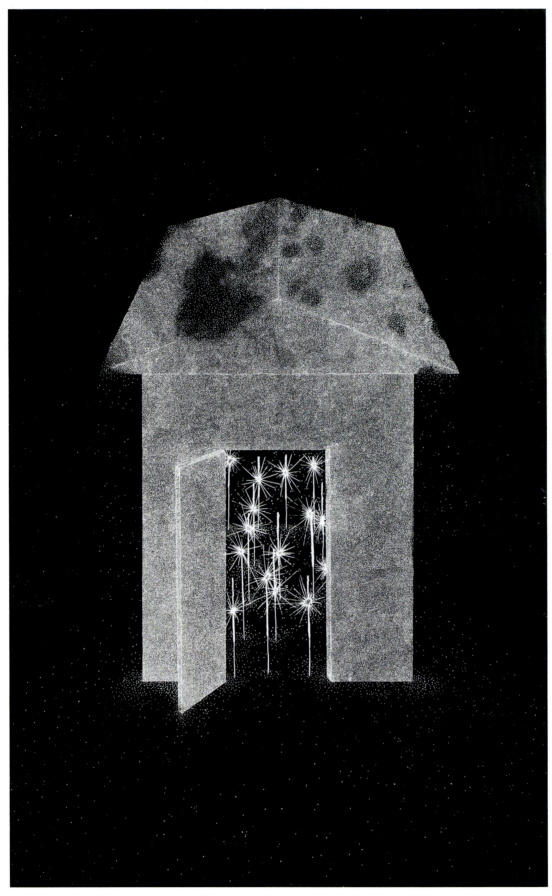

Holly Taggart-Koslowski, *Untitled*, 1999. Photo collagraph, 55 × 37 in (139.7 × 93.9cm). Courtesy of the artist.

Fiery sparklers burning inside a house made of sugar suggest domestic chaos in this relief-printed photo collagraph.

Printing the Collagraph Plate

Before embarking on making a print, certain checks and procedures should be followed:

Setting Up

1. Because individual plates will vary in actual height, the pressure of the press must be set for each plate (before inking!). Place the plate on the press bed without blankets in place. Push the plate between the press bed and roller. Turn the micrometers counterclockwise to loosen the pressure and raise the roller until the plate passes completely and freely under the roller.
2. Next, set protective newsprint, extra cushion, and blankets. Run the assembly through the press to check and adjust the pressure if needed. Do not force the press if there is any difficulty turning the press wheel.

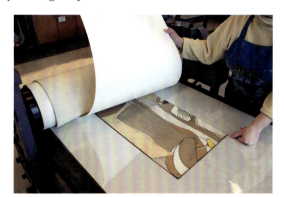
An extra cushion, blanket, or blotter paper is used to absorb the surface variations of the collagraph plate during printing.

⊗ Safety Watch!

If there is any difficulty in turning the press wheel, don't force it—turn the press back, loosen the micrometers until the plate passes through with a comfortable pressure.

Inking and Printing

Before inking the collagraph plate for the first time, it is helpful to "condition" the plate by spraying a light coat of anti-skin spray over the plate. Gently rub this in with a rag. Like spraying oil in a frying pan to keep food from sticking, this moderates any residual tackiness from the polymer or shellac that sometimes causes the paper to stick in an early print.

Inking

Relief inking is the same as for lino- or woodblocks. Unlike printing a metal plate, however, intaglio-wiped collagraph plates cannot be warmed on a hotplate. Heating can cause polymers to soften and become sticky, potentially causing the paper to stick during printing. With some glues, heating promotes excessive drying, which may lead to cracking when run through the press. Because plates must be printed cold, it is

helpful to use a reducing compound in the intaglio ink mixture: the compound should make up no more than 30 percent of the mixture. Plates without a great deal of physicality, such as photo-collagraph plates, are not as hard to wipe, and ink may need only slight modification, with reducing compound making up no more than one quarter of the mix.

Good Practice

Collagraph plates should be printed with foam or an extra cushioning blanket to protect expensive printing felts from possible damage. If there is significant surface variance in the plate, this should be reduced to more even levels; alternatively, protect the felts from possible damage by placing extra packing (blotters, foam rubber, or extra felt) to absorb these varying levels before placing remaining blankets in the usual sequence.

Depending on the physicality of the plate, apply ink with normal intaglio carding methods or, if the plate has a lot of surface variation, apply ink with a felt dauber to accommodate the varying levels. If necessary, use a toothbrush or (gloved) fingers to ink highly textural areas. Continue with normal intaglio wiping procedures: dirty tarlatan, clean tarlatan, paper wipe, hand wipe.

A felt dauber is a helpful tool for inking collagraph plates that have significant textures. The dauber is made from rolled scrap felt. The soft felt can push the ink into all of the nooks and crannies of the plate.

Printing

Except for the press setup that is needed to accommodate surface variations of the plate as previously described, collagraph printing is essentially the same as normal relief or intaglio printing.

Sometimes intaglio-inked collagraph prints hold a great deal of ink that must be air-dried. After the surface ink has cured for a couple of days, the print can be dampened with an atomizer and dried flat between drying boards, if desired. Otherwise, dry prints as normal intaglio prints.

Cleaning up

Clean excess oil-based ink from plates with vegetable oil or, if needed, mineral spirits. It is very important not to use alcohol or acetone, as this will dissolve the shellac or acrylic polyurethane sealants.

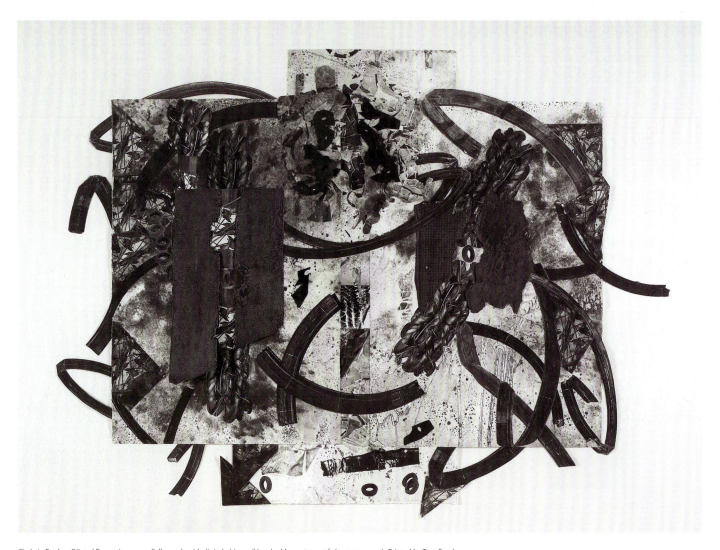

Chakaia Booker, *Dilated Perception*, 2007. Collagraph with digital *chine collé* and rubber, 48 × 96 ft (14.6 × 29.2 m). Printed by Tom Reed, published by Island Press at Washington University in St. Louis. Courtesy of the artist.

Chakaia Booker is known for her sculptural works using recycled tires. This image extends that motif into a two-dimensional space. The swirling black textured lines create a powerful energy.

Chapter 7
Lithography

Unlike other forms of printmaking, the history of the basic lithographic technique can be traced to the discovery of one man, Alois Senefelder. As the story goes, he came upon the discovery quite by accident in 1798. When asked to write down a laundry list one day, Senefelder hastily scribbled the list on a clean limestone with some homemade ground that he had been using for etching experiments.

Later, he wondered whether etching the limestone would make a suitable intaglio printing element and tried to etch the stone. He actually succeeded in creating a minimal relief. During attempts to print the stone as a relief he tried to wash the ground off the stone and saw how the water remained on the stone and was repelled by the drawn areas. Senefelder saw the potential in the discovery and lithography was born.

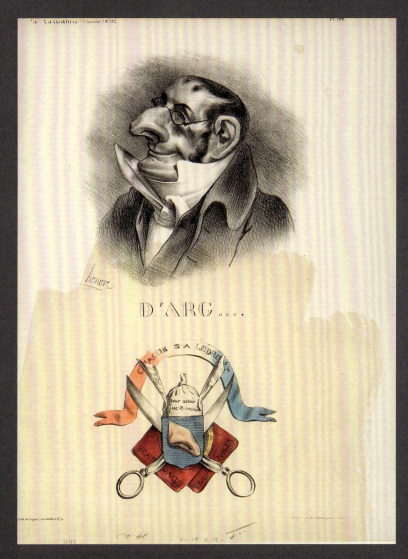

Honoré Daumier, *La Caricature, No. 92*, c. 1832. Lithograph, 13⅛ × 9⅞ in (33.3 × 25.1 cm). Ackland Art Museum at the University of North Carolina at Chapel Hill, Ackland Fund.

In the 1830s Honoré Daumier used lithography to provide journalistic illustration in the publications of Charles Philipon. Daumier produced over four thousand lithographs that took a satirical look at French politics and culture.

The lithographic process has been associated with commercial applications from its onset. Senefelder himself used it initially to make reproductions of musical scores and other printed matter for the theater. The income he made from these projects allowed him to further develop technical processes that attracted the interest of fine artists. Transfer paper, especially, allowed artists to draw directly on a paper support, enabling them to use familiar approaches to their work for printmaking purposes.

Although lithography was popular early in its history, interest declined in the early part of the twentieth century, when it was most often used for illustration and reproduction purposes. In the mid-1950s, several American printmakers sought to revive the interest in fine art lithography. The most prominent and influential of them was June Wayne. While living in Southern California, she started the Tamarind Workshop, dedicated to working collaboratively with artists in the lithographic process. Eventually the workshop moved to Albuquerque, New Mexico, and became the Tamarind Institute. To this day, it remains the preeminent research, training, and publishing center for lithography.

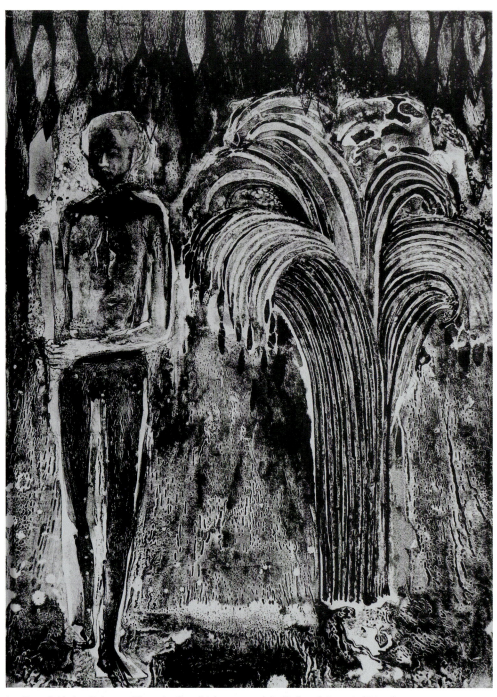

June Wayne, *Twickenham Garden*, 1958. Lithograph, 15⅛ × 11⅛ in (38.3 × 28.1 cm). Brodsky Center for Innovative Editions, Rutgers University.

This print is emblematic of the sensuous washes produced with lithographic tusches. June Wayne was a pivotal force in promoting lithographic printmaking in the US with the establishment of the Tamarind Workshop.

The Process in Brief

Lithography is a planographic process. This means that, unlike relief or intaglio processes, it does not rely on the physical characteristics of the matrix. Instead, the matrix is created chemically to form printing and nonprinting areas. Traditional lithography capitalizes on the principle that oil and water don't mix. The stone or plate surface is comprised of mutually exclusive hydrophilic (water-loving) and hydrophobic/oleophilic (water-rejecting/grease-loving) surfaces. To make a print, the surface of the matrix is alternately sponged with water and rolled with an oil-based ink, which adheres only to the grease-loving parts.

Technical developments in the past 20 years have expanded further on the concept of chemically defined printing and nonprinting surfaces, adding several additional approaches to the planographic print. Most promising has been the development of "waterless lithography," based on the ability of silicone to reject printing ink.

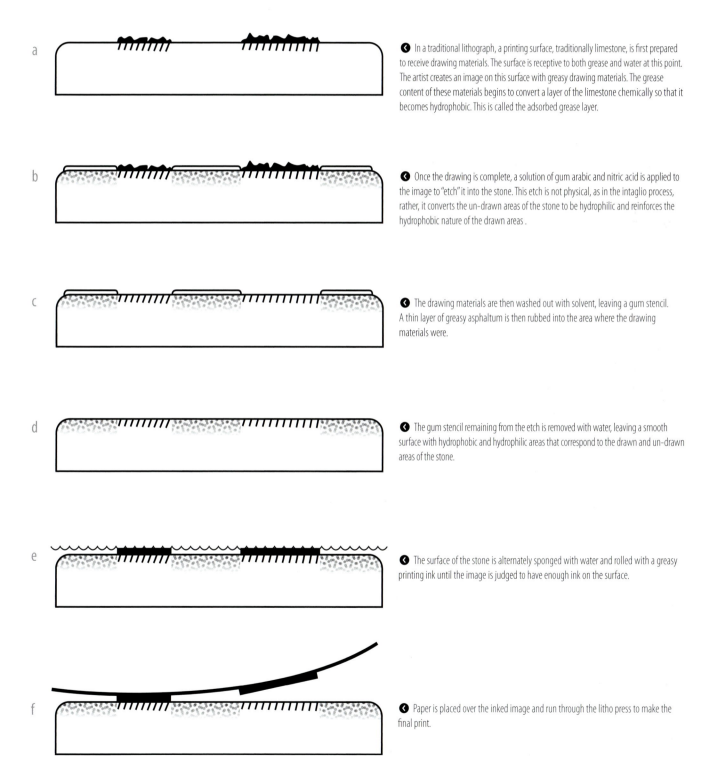

a ◀ In a traditional lithograph, a printing surface, traditionally limestone, is first prepared to receive drawing materials. The surface is receptive to both grease and water at this point. The artist creates an image on this surface with greasy drawing materials. The grease content of these materials begins to convert a layer of the limestone chemically so that it becomes hydrophobic. This is called the adsorbed grease layer.

b ◀ Once the drawing is complete, a solution of gum arabic and nitric acid is applied to the image to "etch" it into the stone. This etch is not physical, as in the intaglio process, rather, it converts the un-drawn areas of the stone to be hydrophilic and reinforces the hydrophobic nature of the drawn areas .

c ◀ The drawing materials are then washed out with solvent, leaving a gum stencil. A thin layer of greasy asphaltum is then rubbed into the area where the drawing materials were.

d ◀ The gum stencil remaining from the etch is removed with water, leaving a smooth surface with hydrophobic and hydrophilic areas that correspond to the drawn and un-drawn areas of the stone.

e ◀ The surface of the stone is alternately sponged with water and rolled with a greasy printing ink until the image is judged to have enough ink on the surface.

f ◀ Paper is placed over the inked image and run through the litho press to make the final print.

Traditional Stone and Plate Lithography

The printing element for traditional lithography must be capable of being chemically converted from a neutral surface to the hydrophilic and oleophilic surfaces just described. A variety of stone and metals have been used for lithography, but the materials most often used are limestone or aluminum. Limestone's particular qualities make it the most sensitive of these options. Metal plates have the advantages of portability and ease of use with some processes such as photographic techniques. Both zinc and aluminum have unique properties. Unfortunately, zinc is not widely used outside of the UK and is difficult to obtain elsewhere, hence the focus on aluminum plates in this section.

Properties of Limestone

Limestone is found in great quantities all over the Earth, but the best-quality stone for lithography is quarried in the Solnhofen region of Bavaria. A very porous stone, it is composed of about 97 percent carbonate of lime (calcium carbonate) and is almost completely soluble in nitric acid. Water sponged on the surface is retained in the grain for a considerable time—an important property for printing purposes. The stones range in color and hardness, from soft stones that are creamy buff or yellow, to harder and denser blue-gray stones. Gray stones are often preferred for their ability to hold a range of detail and to take stronger etches, affording more stable printing. Others favor the advantage of softer yellow stones to promote greater reticulation of lithographic washes. Lithographic stones have the advantage of repeated use. When the printing of an image is finished, the image is physically removed from the stone with a process called graining, which creates a brand-new surface ready for the next image.

Properties of Aluminum

Aluminum plates come with a grain imposed upon the surface. Unlike stone, aluminum plates are generally used only once. The properties of the metal are somewhat different from limestone, requiring different chemistry for processing the image. Either surface must be initially prepared to receive an image.

Preparing a Stone

Lithographic stones are very thick and have the potential to carry many images throughout their useful life. The purpose of graining the stone is threefold:

1. to remove the existing image and return the stone to a neutral chemical state
2. to make sure the stone is level and flat
3. to impart a grain on the surface suitable for the intended drawing materials to be used.

Carborundum grit is used to grain the stone. It is available in grades from very coarse to very fine. Sequential graining with increasingly fine grit gradually prepares the stone for a new image. Once the image is removed and the stone is flat, the main purpose of graining is to impose the preferred grain for drawing.

The stone must have uniform thickness to print correctly on a lithographic press. It must be level (not wedged) and the drawing surface must be completely flat (no dips), so that the image can print with uniform pressure from the press.

Stone-graining procedure

The process of graining simultaneously attends to all the requirements for preparing a stone (as outlined above), and consists of the following steps.

1. Begin by sponging off any gum arabic and removing as much as you can of any old image from the stone with solvent (odorless mineral spirits). Leaving excess old ink wastes Carborundum, not to mention time! Squeegee the stone and fan-dry.
2. File the edges of the stone being grained and the second graining stone or levigator to prevent scratches caused by chips of stone being pulled across the surface when graining.
3. When dry, check the level and thickness of the stone with a leveling straightedge and calipers. Discrepancies in the stone level and thickness will dictate the patterns of the first several graining cycles, since you will find yourself spending more time on high spots. If the stone is uneven, the first priority is to level the stone. Usually, the chemical "memory" of any old image is also removed in this process.
4. The first graining is done with a coarse (80–100 grit) Carborundum. Dampen (don't wet) the stone, then sprinkle grit evenly over the surface.
5. Graining can be done with a levigator or with a stone-to-stone method. Move the levigator, or the graining stone, in a regular pattern in a figure-eight motion, across the surface. As the limestone is ground, it mixes with the Carborundum and becomes a thick sludge. As the graining action becomes difficult to work, stop and rinse the stone. If grinding goes on for too long in this state, scratches will occur.
6. Dry the stone and check to confirm progress toward making the stone level and flat. Refine the graining pattern if needed.
7. Repeat the process. It may take several Carborundum renewals to remove the old image and level the surface. Continue until the old image reverses itself when wet (image areas seem lighter than the non-image areas). When that occurs, dry the stone and check the level once more.

Preparing a stone plate

1. First, clean any ink or gum arabic from the stone.

2. Round the stone's edges with a coarse file before graining. Also file the second graining stone or levigator.

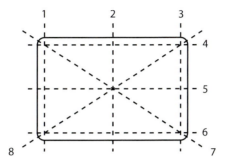

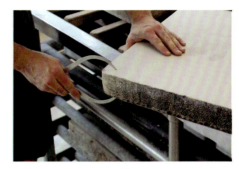

3–4. To check the level, place a level straightedge diagonally across the stone. Slip a piece of paper under the bar and test the resistance by attempting to pull it out from underneath at several points along the length of the bar. If the paper pulls out easily, the stone is low in that spot. Note these areas and grain less in those spots. Repeat this process over the entire stone: each diagonal, horizontal top, middle, and bottom; and vertical, left, middle, and right.

5. To check the thickness, take the calipers and adjust to one corner of the stone. Slide them off easily and compare to a measurement taken from the other corners to determine consistency. Grain more where the stone is thicker.

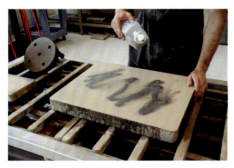

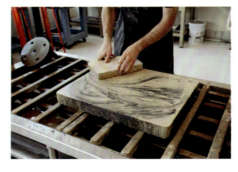

6. Physical graining not only takes off the old image, but also removes the layer of stone that holds any chemical memory of the previous image and returns the stone to a chemically neutral state. To begin, sprinkle Carborundum grit on the dampened stone. Do not overdo it; too much will just push over the edges during graining.

7–8. Graining is done with a levigator or stone-to-stone methods. When graining stone-to-stone, move the smaller graining stone in an overlapping figure-eight pattern.

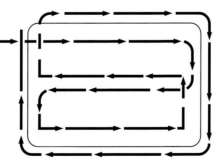

9–10. The graining pattern for the levigator spins along an overlapping zig-zag path, finishing with a pass around the outside edge.

Also check for any shadowy remains of the old drawing. Wash both stones or stone and levigator and your hands until all of the 80 grit is removed. Don't forget to rinse the sides of the stone as well.

8. If the stone is flat and clear, change to 100 or 120 grit and repeat the grinding process at least twice.

9. Rinse and switch to 180 and grind twice. Change to 220 and grind twice, but not as long as with the coarser grits. The finer grits fill up with sludge and tend to scratch more quickly. The 220 is a standard finishing grit, but surfaces can be grained finer or left coarser, depending on taste and purpose.

> **Hint**
>
> Substitute a citric acid counter etch in place of water for this graining. This will help neutralize any chemical memory of the previous image, discouraging reappearance of the old image during printing.

10. When the graining is completed and the stone is dry, check the level of the stone. If it is OK, file the edges using first a coarse, then a fine file. This prevents the edges from picking up ink during printing. The stone surface and edges are grease-sensitive at this time, so be careful about touching—fingerprints would ruin all of the graining work! Make a cover out of heavy craft paper and keep the stone covered when not in use.

⌃ Keep the stone covered to protect it between work sessions.

> **Good Practice**
>
> To keep the Carborundum powder flowing freely, do not get the containers wet! Move them away from the graining area once the Carborundum powder has been sprinkled onto the stone.

Preparing a Metal Plate

As plates are exposed to the air, they are subject to oxidation, in which a layer of aluminum oxide forms on the surface of the plate, caused by a chemical reaction between the aluminum and the oxygen in the air. This process happens continually, and is encouraged by moisture and acids in the air. It is undesirable because, when the image is drawn, it will attach itself only to the oxide, rather than to the plate, yielding unpredictable processing results. To avoid this, keep plates covered and stored in a dry place; plates that come straight from the factory are usually ready to be used.

> **Good Practice**
>
> Handle plates carefully by the edges to keep the surface clean. Grease from fingers will establish themselves just like the greasy drawing materials!

To determine whether plates have oxidized, simply wipe the surface gently with a damp, lint-free pad. If the pad shows a gray residue, then the plate should be counter-etched before drawing. Counter-etching is the term for any process that chemically returns the printing element to its original, neutral state. It is important to do this in the early stages of plate preparation. The simplest, least damaging, and chemically safest method is to use hot water. Just use tap water if it is sufficiently hot, otherwise, an electric kettle can heat up water quickly for this purpose.

A chemical counter-etch should be used only in extreme cases. Pour a 5 percent acetic acid solution over the plate and gently rub the surface with a lint-free cloth. Rinse thoroughly with water and blot dry.

Setting up the Matrix

Because of the way lithographs are printed, the entire area of the stone or plate is not available as image area. During printing, the scraper bar must come down on the printing element outside the image area, then travel beyond the length of the image and still remain on the printing element. To prevent damage to the scraper, it must not hang over the edge of the stone or plate.

The limits of the image can be established in two ways: one is to keep the paper being printed within the printing area

Preparing a metal plate

1. Flood the plate with near-boiling water.

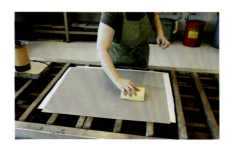

2. Gently wipe the plate with a lint-free pad or sponge, to loosen the oxidation.

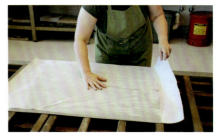

3. Rinse and blot dry the plate quickly, since the moisture from the rinsing begins the oxidation process anew.

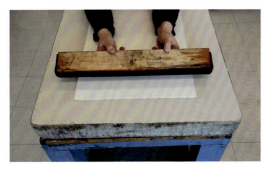

⬥ The image size is limited by variables: it must be no wider than the scraper bar, and the scraper bar must fit within the width of the stone. This is especially important for stones. The paper is always smaller than the printing element, regardless of whether the print will have borders or whether it is a "bleed" print.

by making a bleed print, the other is to establish borders on the print. In either case, you will need at least a 1-in (2.5-cm) margin around the perimeter of the printing element. To keep borders of the stone or plate clean, brush a thin coat of acidified gum arabic along them and let dry.

Creating an Image

The litho image is made by drawing with a greasy drawing material. If desired, lay out the drawing first with a nongreasy chalk, then go over it with the drawing material. If it is important to register information from a preliminary drawing, use a punch registration (see chapter 1) to align the drawing to the printing element.

Drawing Materials

Traditional lithographic materials have a grease content, necessary for the chemical reaction on limestone, and also some acid-resistant ingredient such as wax or shellac. Crayon compositions range from quite greasy, soft mixtures to less greasy with a higher component of wax or shellac, necessary for harder crayons. Variations on the proportions of these basic ingredients make materials suitable for different applications.

It is important to know the grease content of your drawing materials, since they will need to be etched accordingly.

Alternative drawing materials made from a plastic toner powder like that used in copy machines are in widespread use, especially with aluminum plates.

The drawing may be made with the following materials whose properties are listed only as a starting point:

Litho crayons are available in five grades, from very soft to very hard. Note the grading system when you purchase crayons. Different brands of litho crayon also have some different characteristics. Water-soluble brands enable crayon work to be softened with some brushwork. Crayons that are insoluble in water are less susceptible to smearing under water washes or etches and their composition enables stronger etches to be used. In addition to three sizes of sticks, they are also available in tablet form.

Lithographic Drawing Materials

⬥ Lithographic drawing materials can be applied with a variety of effects. Litho crayon is most often used in the manner of a pencil drawing and can be applied over masks made with gum arabic for white marks. Different grades are etched according to their grease content.

Crayon

Rubbing crayon

Rubbing crayon + variety of lines

Solid flat made with grease

Acid tint

Scraping

163

Mazosorbedae

Beauvais Lyons, *Association for Creative Zoology: Mazosorbedae*, 2006. Lithograph, 22 ×28 in (55.8 × 71.1 cm). Courtesy of the artist.

This work is part of a series of "academic parodies" that utilize lithographic prints to suggest authoritative documentation of research. Using crayon-drawing techniques, the print conjures associations with renderings by nineteenth-century naturalists. Posing as an official representative for the Association for Creative Zoology, Lyons extends his artistic identity in performance and presents these works as evidence of "zoomorphic juncture," God's design plan for creation on Earth. With masterful parody, Beauvais Lyons exposes our tendency to be persuaded by style and the authority of context.

Rubbing crayon comes in soft, medium, and hard grades. It can be used to produce a soft, smudged image and to reinforce light washes. Tones are built gradually by applying the rubbing crayon with a soft cloth or chamois. It is the greasiest of the drawing materials.

Tusche is available in liquid, stick, and paste versions. Solid paste and stick tusches are mixed with distilled water or solvent to create a liquid that, when painted on the matrix, makes solid areas or tonal washes, depending on the ratio of tusche to solvent. Solvent and water washes dry differently. Water-based washes have a characteristic reticulated drying pattern. It is the unique quality of these washes that is most emblematic of the lithographic process.

Solvent tusche solutions have different characteristic and etching requirements. Depending on the solvent used, the dispersion and deposit of the grease content can vary. Lithotine, for instance, adds grease to the mixture, while other solvents, such as alcohol, actually destroy grease content while simultaneously dissolving grease out of the pigment and creating invisible grease deposits.

Good Practice

Keep separate cans of paste tusche for use with distilled water and solvents. To prevent mold, keep the cover off of the can used with water.

Gum arabic is a liquid that is mildly acidic. It is the basis for lithographic etches and, when painted onto a prepared matrix, it will create white areas. It is used to establish borders on a printing matrix and can function as a mask when used in combination with crayons or solvent tusche. Once dry, it can be worked over with crayon, rubbing crayon, or a solvent tusche. As a drawing strategy, the gum acts as a stencil, blocking other drawing material from touching the matrix, thereby creating white shapes and textures.

Using toner powder as a drawing material for plate lithography is one of those fantastic discoveries that have entered into common practice quickly. In addition to toner made for laser printers, toner powders and specific products made especially for fine art use are now widely available. The powder can be used dry, in the manner of powdered charcoal or graphite, or it can be suspended in water or alcohol for wash-like effects.

Toner has many advantages over some conventional drawing materials. Until it is fused to the plate, the toner is infinitely movable. Because it is a plastic dust, it has no grease content and can be put on and taken off the plate or stone repeatedly without altering the surface properties of the printing element. Areas to be changed are simply wiped up with water.

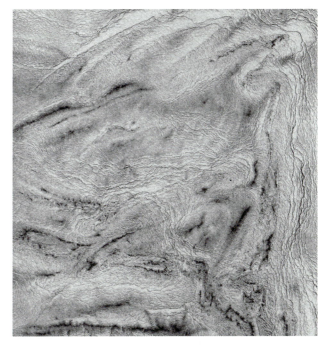

◉ The luscious reticulation pattern of tusche washes is a signifier for the lithographic process.

Lithographic Tusche

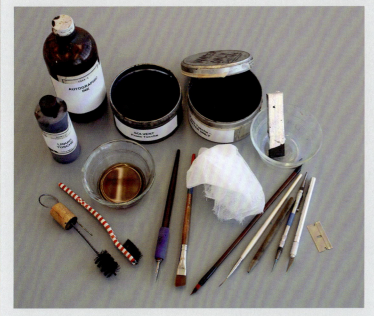

◉ Lithographic tusche is available in paste, stick, or liquid forms. Gum arabic can be used in a stencil-like manner under solvent tusches.

H₂O tusche

Solvent tusche

Solvent tusche with crayon

Splattered tusche

Tusche texture

Gum texture

Splatter (gum)

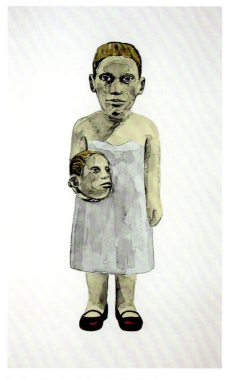 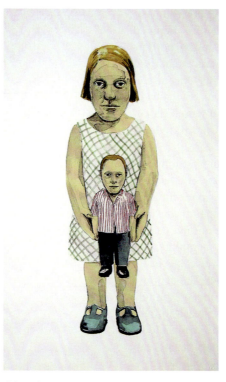 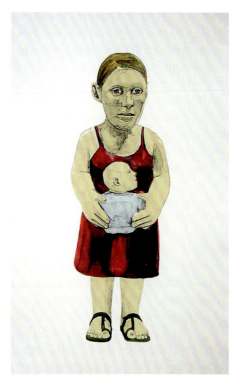

Claudette Schreuders, (left to right) *The Three Sisters I–III*, 2005. Five-color lithograph, 26 × 16 in (66 × 40.6 cm). Printed and published at The Artists' Press. Courtesy of the artist.

South African sculptor Claudette Schreuders is known for her wooden figure sculptures, exploring her personal family relationships and the complexities of race in contemporary South Africa. Working on stone with washes and crayon, these prints have become a way of recording the sculptures once they have been completed.

Once the image is complete, it is fused to the printing element with heat or with a solvent chamber. The heat method is carried out simply by heating the plate on a hotplate or using a paint-stripping heat gun held below the plate to fuse the toner powder. A solvent chamber is necessary when using toner powder on a stone, since the air flow from a heat gun could disturb the toner powder in the process of heating it.

> ## ⊗ Safety Watch!
> Because the solvents used in this process are toxic by inhalation and skin absorption, it is important to wear protective gear (respirator and gloves). Use only in well-ventilated areas.

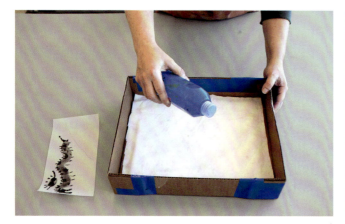

⏷ The solvent chamber is an efficient way to fuse toner powder to a stone or plate surface. To make a solvent chamber, staple absorbent cotton batting to the inside of a box that is larger than the image area. Soak the cotton with acetone and invert it over the area to be fused for 10–15 minutes. The solvent fumes will dissolve the toner and fuse it to the matrix. Check a small area of the image to confirm that it has been fused. Repeat the process if the toner has not completely fused.

Corrections

Due to the degrading of the printing element, corrections to the drawing should be kept to a minimum if at all possible. Chemical deletions can be made on stones or plates, but abrasive techniques are only suitable for stone.

⬥ Deletions can be made both physically and chemically. Abrasive deletions on stone include selective graining, work with rubber hones, and snake slip. Chemical deletions with degreasing solvents, such as acetone, must be done carefully and in a well-ventilated area.

Chemical deletions

Acetone, used with cotton swabs or rags, does a good job of grease removal and can act as an eraser while drawing. However, 100 percent of the grease may not be removed and a slight tone may still be present in the print, depending on the strength of the first etch.

> ⊗ **Safety Watch!**
>
> Work with acetone in a ventilated area, wear gloves, and use only a small amount at a time.

Physical abrasives

Abrasives can be used for corrections while initially drawing the image or, more commonly, after the image is inked. Anything that physically removes the drawing material or ink from the stone—such as razor blades, scrapers, or very hard rubber erasers—can be used as dry abrasives to completely remove grease or alter values.

Some deletion materials are used only when the image is in ink. Snake slip is used with a sponge and water as an eraser.

Be aware that in the process of working with abrasives, the stone's grained surface is mutilated, making it difficult to re-draw over that area. This may cause the image to take on unwanted ink, or "scum," in these worked areas, because of the poor grain structure and uneven surface. When the grain is disturbed by abrasion, a stronger etch will usually control the situation. These areas should be watched during the rollup, and subsequent etches may be required.

Processing the Stone

The next step is chemically to convert the remaining white areas of the image from a neutral state to a hydrophilic layer and complete the establishment of printing and nonprinting areas. This is known as etching.

The chemical reaction that makes lithography possible actually begins as soon as the greasy substance touches the plate or stone. When the fatty acid of the greasy lithographic drawing materials first come into contact with the stone, it penetrates the alkaline limestone, creating an oleomanganate of lime layer in the stone, which acts as a kind of grease reservoir.

At several points in processing—after the initial drawing and after each etch step—it is important to let the matrix "rest" in order to give time for the printing element to develop a chemical "memory." This enhances the stability of the printing element. Time the processing to include several hours for resting at these points, overnight if possible.

Etching the stone

A lithographic "etch" is really a misnomer, since the etch does not eat away any of the stone to the degree that a relief is produced. Nor does it incise lines as in the intaglio etching process. The process is more accurately described as a grease desensitizer, since it prepares the stone chemically so that greasy ink from the roller will not be attracted to the parts of the stone that have not been drawn upon.

Reaction of etch on stone

This so-called etch is made up of measured portions of gum arabic and drops of nitric acid. When the acidified gum solution is put on the stone, a thin layer of calcium nitrate forms in the stone in the following reaction:

$$CaCO_3 + 2HNO_3 \text{ yields } Ca(NO_3)2 + H_2CO_3 \uparrow$$

calcium carbonate plus nitric acid yields calcium nitrate plus carbonic gas (released)

This layer of calcium nitrate is called an adsorbed gum film, essentially having the properties of the gum transferred chemically into the stone. This establishes the white areas of the image, which will hold water and repel the greasy ink during printing.

A second function of the nitric acid is to increase the strength of the oleomanganate of lime layer created by the drawing materials. When the alkalis and fats of the drawing materials combine with the nitric acid, the fats are freed to penetrate the stone. This adsorbed grease reservoir is much like the adsorbed gum film. Together, they are the printing and nonprinting surfaces.

Etch solutions

Etches can be measured two ways; as a proportion of drops of nitric acid to an ounce of gum arabic, or by pH. Because of the variability of equipment and environmental conditions, pH tends to be somewhat more accurate. A general etch table (see page 170) provides a good point of departure for the inexperienced lithographer.

○ To make a general etch, measure one or two ounces of gum arabic into a glass cup. An acid dropper bottle controls the addition of nitric acid to the mixture. Consult the etch table to determine the number of acid drops needed to make the appropriate acidity for the image to be etched. Test the solution with pH papers for the most accurate measurement of acidity.

Several factors can mediate the effectiveness of the etch on the stone and thereby modify your assessment of how strong or weak to make your etch solution. Before etching, it is advisable to consider the following:

- Two interdependent variables influence the strength of an etch; the amount of acid in the gum arabic and the amount of time that it is allowed to react on the stone. For most medium and delicate work, a weak etch left on for a longer time is preferable to a strong etch allowed to work briefly. The weaker etch promotes the development of a stronger adsorbed gum film, greatly increasing the desensitization of the non-image areas. Stronger etches are necessary in darker passages, where grease particles are closer together. Because there is a tendency for the grease particles to spread slightly, there is a greater likelihood that these areas will want to fill in. The stronger etch, through its slight mordant action, removes any grease between close particles.

- Consider the materials used and quality of the application of the drawing materials. Pay particular attention as to whether the drawing particles are seated in or on top of the grain. In general, lightly drawn areas should receive a light etch and heavier, well-seated areas a stronger etch.

- If a drawing can sit longer on the stone before etching, the greasy materials will be more firmly absorbed into the surface. As a result, the stone can sustain a stronger etch (lower pH) and/or a longer time period for the etch to react.

- If the stone was exposed to a high heat during drawing, the grease will have penetrated the stone more and will require greater acid content in the etch. If the stone has been exposed to cold, it will have the reverse effect.

- Harder (gray) stones can withstand a stronger etch than softer (yellow) stones.

- As humidity rises and remains high, stones pick up moisture. Stones that have a high moisture content require stronger etches.

Stages of Processing

Processing the stone plate can be broken down into four main stages:

Stabilizing the drawing

Before etching the stone, coat the greasy drawing materials with rosin and talc so that the acidified gum will stick to their surface.

1. Dust the drawing with rosin, brushing the excess into the box.
2. Apply talc and buff in with clean cotton.

First etch

Prepare the etches. Use a soft brush without a metal ferrule to mix a general weak etch for the lightest work or solid areas (often straight gum arabic) and a stronger solution for spot etching. See the etch tables on pages 170–1 to determine the appropriate acidity for specific drawing conditions.

1. Apply the first etch. Begin by covering the stone with the weakest solution.
2. Spot-etch through this layer with the stronger etch for heavier work, being careful to avoid the more delicate areas. The solution should produce a slight effervescence through heavy work. Move the etch around for a few more minutes.
3. Remove excess gum with a dirty sponge.
4. Quickly buff down the gum layer with a clean cheesecloth for a thin, streak-free surface. This gum film is referred to as the "gum stencil." It remains in place, protecting the non-image areas as the drawing materials are removed in the next washout step.
5. Let the stone set (12–24 hours is preferable).

Washout/rollup

This step is usually referred to as the "rollup." It is the point where the drawing materials are replaced with ink.

1. Pour some straight gum arabic onto the stone and buff it down in the same manner as the first etch was applied. This replaces the acidified gum from the first etch with a less acidic layer in preparation for removing the drawing materials.
2. Wash out the surface grease (the drawing) with clean, dry rags and lithotine. Do not rub hard, but let the solvent do the work.
3. Rub up the image with asphaltum.
4. Remove the gum stencil with a wet rag or a gum sponge kept for dirty work only.
5. Dampen the stone with a fresh printing sponge and roll up with a stiff black ink.
6. Assess the image as you roll, rolling selectively if necessary. Blacks should be solid. When the image appears full, fan the stone dry.
7. Dust rosin and talc into the wet ink.

At this point minor reductive changes can be made. Remove undesirable areas of the image with abrasive deletion tools. Give particular attention to erased areas when the second etch is applied, since the grain has been disturbed. If more work is to be added to the image, the stone must be counter-etched to resensitize the surface to accept new grease.

Stabilizing the drawing

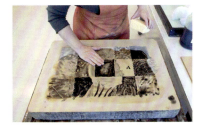
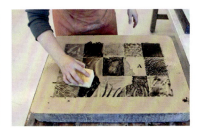

1–2. Dust with rosin and brush off the excess.

3. Buff in talc.

First etch

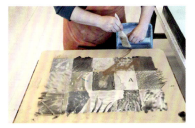
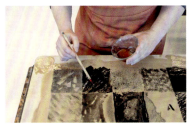

1. Pour on gum arabic.

2. Spot etch.

3. Remove the excess.

4. Buff tight.

5. Leave to rest.

> ### Good Practice
> Save any leftover etch in an "excess gum" bottle. This acidified gum arabic can be used to define borders on subsequent matrices.

Washout/rollup

1–2. Replace acidified gum stencil with fresh gum and buff tight.

3. Wash out the drawing.

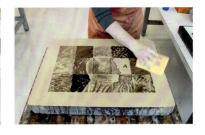

4. Rub in the asphaltum.

5. Wash off the gum stencil.

6. Sponge to dampen the stone.

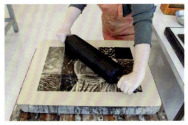

7–8. Alternate the rolling of the ink and sponging until the image is full, then fan dry.

9. Dust in rosin and talc.

Second etch

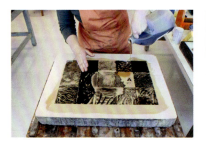
1. Apply weak overall etch.

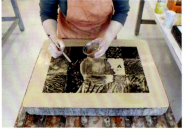
2. Spot etch.

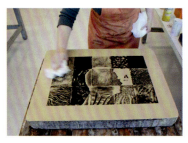
3. Buff tight.

Second etch

The second etch reinforces the "memory" of the stone and stabilizes the chemical conditions of the image in the inked state.

1. The ink layer is an even thin film compared to the drawing materials and is not as acid-resistant. Protect very delicate areas with straight gum.
2. Then, apply an overall etch of 2–6 drops for every 1 oz (28 g) gum or a pH of 2.5. Brush evenly for about 4 minutes.
3. Wipe down and buff with cheesecloth as in step 4 of the first etch (see page 169).
4. Allow the stone to sit for at least 10 minutes: an hour is better and overnight is preferable.
5. The stone is now ready to set up for printing.

Stone Etch Chart /pH / Crayon

Application	Soft	Medium	Hard
Light	pH 4 to pH 3	pH 4 to pH 3.5	pH 4 to pH 3.7
Medium	pH 2.8 to pH 2	pH 3.2 to pH 2.8	pH 3.5 to pH 3.2
Heavy	pH 1.9 to pH 1.5	pH 2.8 to pH 1.9	pH 3.2 to pH 2.8

Stone Etch Chart /pH / Tusche Materials

Application	Stick/H$_2$0	Stick/solvent	Paste/H$_2$0	Paste/solvent
Light*	pH 3–2.8	pH 3–2.7	pH 3–2.5	pH 2.9–2.5
Medium	pH 2.6–2.2	pH 2.3–1.4	pH 2.4–2.9	pH 1.8–1.2
Heavy	pH 1.8–1.2	pH 1.8–1.2	pH 1.7–.9	pH 1.2–.9

* for delicate, light applications, apply etch through an initial layer of gum arabic

Etching Guidelines for Toner Powder Drawings

When the particles have been fused to the plate or stone, give the printing element a medium etch, optimum for establishing an adsorbed gum film. On plates, this is a ⅓ TAPEM etch. On stones, a 2.3 to 2.5 pH is good.

Counter-etch Procedure

In order to add additional drawing to a stone that has already been etched, the adsorbed gum film (calcium nitrate layer) in the stone must be reversed, chemically reneutralizing the stone so that it can take grease again in the open areas. Also, if any work has been removed (scraping, selective graining, etc.), the re-exposed stone will be converted back to a neutral state as well.

1. Ink the image thoroughly to protect it from the mildly corrosive action of the counter-etch solution. Roll up with black if a color ink was being used.
2. Apply rosin and talc.
3. Mix the counter-etch solution in the ratio of ¼ teaspoon citric acid crystals to every 10 fl oz (280 ml) of water.
4. Pour the solution on a dry stone and manipulate with a clean sponge (kept exclusively for counter-etch purposes), either selectively or over the entire stone. Keep the solution moving and quite wet for 2–3 minutes, depending on the delicacy of the drawing. The longer the solution is on, the better it works, but the more damage it can do to the image.
5. Rinse the stone thoroughly with the hose, squeegee off excess water, and dry.
6. Repeat steps 4 and 5 two or three more times.

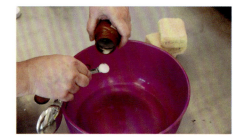
▲ Mix ¼ teaspoon citric acid crystals into 10 fl oz (300 ml) distilled water.

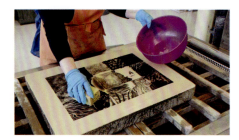
▲ Using a sponge kept only for counter-etch, sponge the solution over the stone for 2–3 minutes. Rinse, dry, and repeat.

The stone is now grease-receptive and can accept new drawing. The grain, however, has been reduced by previous etches and this counter-etch. Continued opening and closing of the stone may eventually make control of tones more difficult.

Stabilize and etch the fresh drawing, following the procedure for the first etch. A post-counter-etch etch is generally on the weaker side. Any remaining old image can just be re-gummed if it has not been disturbed. Continue processing in the normal fashion: buff down, wash out, roll up, second etch, and so on.

Processing the Aluminum Plate

The basic procedure for processing aluminum plates is similar to that used for stone. Because the image is not established on the plate with a grease reservoir as on the stone, the image is stabilized for printing with a slightly different chemistry.

Rather than using nitric acid, the aluminum plate responds best to a phosphoric and tannic acid mixture (TAPEM). Plate Etch, Tannic Acid type, is available commercially in the US, but can be difficult to find elsewhere. In this case, a phosphoric and gum arabic mixture in the ratio of 1:64 with a pH of 2.5 can substitute for TAPEM.

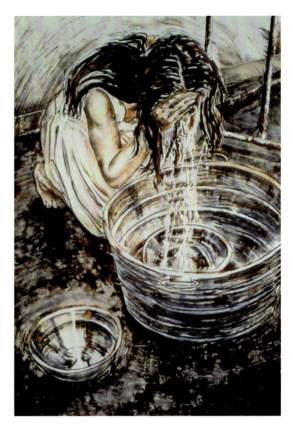

Ruth Weisberg, *Washing Away*, 1992. Color lithograph, 30⅛ × 22¼ in (76.5 × 56.5 cm). Courtesy of the artist.

Weisberg's work deals with experience, belief and personal history. Through her images she seeks to transport the viewer to a place where they can be transformed and create their own stories. In this piece, the artist shapes a rich narrative atmosphere through the use of expressive lithographic washes, textures and mark-making.

Crayon Etch Chart for Aluminum (proportions of TAPEM (or stock phosphoric/gum mixture) to gum arabic)

Lithographic Crayon

Application	Soft crayon	Medium crayon	Hard crayon
Light	⅔ TAPEM	¼ TAPEM Spot etch: ⅓ TAPEM	Gum arabic Spot: ⅓ TAPEM
Medium	⅓ to ½ TAPEM Spot: ½ TAPEM	⅓ TAPEM Spot: ½ TAPEM	¼ TAPEM Spot: ⅓ TAPEM *
Heavy	½ to ⅔ TAPEM Spot: TAPEM	⅓ to ½ TAPEM Spot: ½ to ⅔ TAPEM	⅓ TAPEM Spot: ⅓ to ½ TAPEM

Rubbing Crayon

Application	Soft crayon	Medium crayon	Hard crayon
Light	⅓ TAPEM	¼ TAPEM	Gum arabic
Medium	½ TAPEM	⅓ to ½ TAPEM	¼ TAPEM
Heavy	TAPEM to TAPEM *	⅔ TAPEM to TAPEM	⅓ to ½ TAPEM

* add 1 or 2 drops phosphoric acid

Wash Etch Chart for Aluminum Plates (proportions of TAPEM to gum arabic)

Tusche Materials – Water washes

Application	Paste Tusche	Stick Tusche
Light	⅓ to ½ TAPEM Spot: 50/50	⅓ TAPEM Spot: 50/50
Medium	⅓ to ½ TAPEM Spot: 50/50 to TAPEM	⅓ to ½ TAPEM Spot: 50/50
Heavy	TAPEM Spot: + pH 1.5–1.7	TAPEM Spot: + pH 1.7

Tusche Materials – Solvent washes

Application	Lithotine	Alcohol, Acetone
Light	½ TAPEM Spot: TAPEM	½ TAPEM
Medium	TAPEM* to pH 2	TAPEM
Heavy	TAPEM* to pH 1.5	TAPEM* to pH 1.7

* add 1 or 2 drops phosphoric acid to TAPEM to achieve lower-pH etches

Kevin Haas, *St Louis Window I*, 2006. Photolithograph on black mulberry paper, 27 × 40 in (68.5 × 101.6 cm). Courtesy of the artist.

Aging industrial edifices are obscured by the dust and marks accumulated in an abandoned storefront window. The montage of two images mimics reflections in windows. The dust and graffiti reaffirm the two-dimensional surface of the prints themselves and the separation between the viewer and the looming building, as well as the separation of the photograph from experience.

Unlike stone, aluminum is not helped by long durations of etch. Do not etch plates for more than 1 minute; longer than this damages the tooth, making solid areas more difficult to roll up.

The TAPEM (or stock phosphoric/gum mixture) is used straight, diluted with gum arabic, or strengthened with drops of phosphoric acid. The corresponding tables (see page 171) give proportions of TAPEM to gum arabic used to mix etches for various drawing conditions. Because aluminum is less sensitive than limestone, ingredient proportions are more general.

First etch

1. Before etching, establish registration marks on the plate.
2. Assess the drawing. Determine the grease content and a plan for etches and spot etches. Do this before talcing the image; you will not be able to see the drawing afterward.
3. Mix the etches. Consult the relevant tables to determine the etch strength required for your drawing.
4. Dust the drawing with talc. (Do not use rosin on aluminum plates.) There is no need to buff the talc tightly; doing so increases the risk of scratching the plate.
5. Spot-etch. First put straight gum arabic on all areas that will receive a stronger etch. Next, spot-etch the darker passages with the stronger etches. Etch the most delicate areas last with straight gum or whatever is left over from the other areas of the plate as the image is buffed down. Do not leave any etch on for more than 1 minute.

6. Wipe up any excess strong etch. Apply a small amount of gum arabic and sponge to a thin film. Using cheesecloth, buff it down smoothly, with no streaks, but not so much that it smears the drawing.
7. Let the plate set for a minimum of 1 hour.

Washout, rollup, and second etch

1. Scrape excess ink from the leather roller. Put out a medium-stiff black ink and work it well with a mixing knife. Roll out an even slab.
2. Apply a fresh coat of gum arabic buff tight, and fan dry.
3. Wearing gloves, wash out the image with lithotine in an adequately ventilated area. Do not rub too hard because doing so increases oxidation on the plate. Let the solvent do the work. Wash with lithotine until no trace of the drawing materials appears on clean rags.
4. Buff in a layer of asphaltum.
5. Wash off the gum stencil with a dirty rag, then sponge with clean water.
6. Roll up the image with a stiff ink, using quick, sharp horizontal and vertical passes to remove excess asphaltum film. Continue to roll up the image from the four corners in a fanning pattern until the image is fully inked.
7. Dust the image with talc.
8. Give the plate a second stabilizing etch of 50/50 TAPEM and gum arabic. Wait at least 15 minutes before proofing.

Corrections on Aluminum Plates

Just as with stone, aluminum plates require counter-etching to return the plate to a neutral state before additions can be made. Deletions can also be made chemically; however, unlike stone, subtle changes made with abrasive methods are not possible.

Counter-etching for additions

The simplest and least damaging counter-etch for plates (both to the plate and your health) is a hot water counter-etch. Before counter-etching, roll up the image and dust it with talc. Pour boiling water over the plate and move it around until the heat dissipates a little. Drain off the excess water, blot dry with newsprint, and fan any excess moisture off quickly to prevent oxidation (see page 162). Repeat this process three times.

A citric acid (¼ teaspoon citric acid crystals to 10 fl oz/ 300 ml water) counter-etch can also be used. First flood the plate with water. Never pour the counter-etch solution directly onto a dry plate. Wearing gloves, massage the plate gently with a lint-free cloth for about 1 minute. Rinse and dry. Repeat three times. The citric acid is potentially more damaging to the plate if allowed to dry on the surface. Be sure to rinse any residue well!

Additions can now be made with any drawing materials. When processing new information, etch according to the drawing materials. Image information that has previously been rolled up in ink needs only a 50/50 TAPEM/gum stabilizing etch.

Gum deletions

Because any abrasive action on the metal plate will destroy the grained surface, all deletions must be chemical. This is done easily by washing out the ink, then painting in the image areas with gum arabic or TAPEM. Begin by putting on a fresh gum stencil to replace any existing acidified gum and to make sure the gum stencil has not been disturbed by water. Wash out the image thoroughly with lithotine.

Once the image is thoroughly washed out, make deletions by painting gum arabic in the area where information is no longer desired. For fine gradations in the deletion, gum can be applied with an airbrush or otherwise splattered into the image area. When finished making deletions, let the gum dry thoroughly. Process the plates normally; roll the image up and give a stabilizing 50/50 TAPEM/gum etch.

Photolithography

Photolithography is the process of putting an image on a matrix with a photographic process. Here, positive working plates are used, necessitating a positive transparency to create the image.

Materials

In addition to normal lithographic materials, this process requires:
- Positive photo plates
- Image transparencies
- Universal Developer
- Plate finisher (commercial finisher, TAPEM, or gum arabic, and/or phosphoric mixtures)

Transparencies

The positive transparency, also called simply the "positive" or "photo-positive," is used to expose the image to a light-sensitive plate, which is your printing matrix. The positive can be made digitally or hand-drawn as described for screen printing, although positives for lithography can be made with a finer halftone or subtle textures.

Plate Handling

Photolitho plates are minimally light-sensitive, requiring yellow safelight conditions. Keep them in a light-safe container until ready to be used. Once in the darkroom, cut the plate to the desired size. The plate should have comfortable margins (3 in/8 cm larger than your image). Trim the sharp corners off the plate.

> **Hint**
> Keep litho plate trimmings in a separate container for aluminum recycling.

Photolitho plates are typically used with punch registration to enable exact alignment of the plate, the positive transparencies, and the printing paper. When punching the photo plate, be sure to protect the light-sensitive surface by covering it with a piece of cardboard.

Exposing the image

Photolitho plates need a strong light source, such as ultraviolet, tungsten, carbon arc, or xenon light. It is preferable to have a vacuum exposure unit, but if one is not available, a heavy piece of glass and flood lights will do the job (see DIY setup, page 63).

Making test exposures

Two factors influence the exposure time; the kind of light and the quality (density) of the transparency. To determine the optimal exposure time for each circumstance, cut several small plates and make test exposures at different times. Choose a part of the transparency that has both light and dark passages. It may be necessary to compromise for tonal range. Ultraviolet light sources typically expose between 30 seconds and 3 minutes, depending on the kind of transparency. Transparent films take from 30 seconds to 2 minutes, oiled photocopies up to 3 minutes. Carbon arc or xenon light sources typically have shorter exposure times.

Once the exposure time is determined, proceed to expose the printing plate.

Exposing the image on the plate

Orientation of plates and transparencies must be relative to the light source: light shines through a transparency that is in contact with the light-sensitive plate surface. These instructions are for an exposure unit where the light comes from below.

1. Open the vacuum frame on the exposure unit. Check that the glass is clean and free from debris. Use glass cleaner if necessary—avoid using razor scrapers to remove any debris such as tape or residue from other processes as this could scratch the glass and affect exposures.
2. Place the positive emulsion side up, right-reading (the way the final image should look) on the glass. Place the plate with the emulsion side down, contacting the positive. Alternatively, using punch registration, align the positive transparency and plate, emulsion sides together, and place in the vacuum frame. This may seem obvious, but make sure the light-sensitive surface faces the light!
3. Close and latch the vacuum frame.
4. Turn on the vacuum switch and wait until the vacuum makes a tight contact (a gauge reading of about 25 psi).
5. Set the timer for the time determined by the test exposure.
6. Turn on the light and start the timer (this may be automatic, depending on the equipment).
7. When the timing is done, turn off the exposure light (if it is not automatic), turn off the vacuum, and transfer the plate to the developing tray.

Developing

Plates are developed with a universal developer.

1. Cover the entire plate with developer. Using a felt developer pad or soft sponge, massage the plate using quick, circular movements. Keep the developer moving over the plate.
2. After about 2 minutes, squeeze the exhausted developer out of the pad or sponge and repeat the previous step. The entire process should take about 5 minutes. The image should be clearly visible at this point and there should not be any background tone or haze.

3. Rinse off the plate with cold water.
4. Blot off excess water with clean newsprint and fan-dry. Once developed, the plate can be handled in normal light, although prolonged storage should be in a UV-light-free environment.

Darkroom Cleanup

Be sure to remove all transparencies, tools, and personal belongings from the darkroom. Clean off the exposure unit glass if oiled transparencies were used. Rinse the developing tray and developing pad. Store the developing pad upright to dry. Wipe any spills off the counter surface.

Processing

1. First, in a ventilated area, remove any small patches of unwanted emulsion from the negative areas of the plate with a cotton swab or rag dipped in acetone or a commercial deletion fluid.
2. To finish the plate, pour a puddle of commercial plate finisher over the plate as recommended by the plate manufacturer. Using a clean sponge, quickly spread the finisher and buff it in tight with cheesecloth. Alternatively, straight gum arabic or a 50/50 TAPEM and gum mixture can be used. Buff down to a thin tight film.
3. At this point, the plate can be stored or printed.

Althea Murphy-Price, *Up Do No.8*, 2005. Lithograph, 27 × 19 in (68.5 × 48.2 cm). Courtesy of the artist.

In this work, Murphy-Price explores the close relationship of "hair culture" to religious culture. Often associated with pride, fashion, innovation, and assimilation, hair becomes the metaphoric medium evoking black community. Inspired by hairstyles and formal hats worn for church services, Murphy-Price uses synthetic hair to "draw" stylish hat forms. The synthetic hair drawing becomes a light-blocking photo stencil when placed directly on top of and exposed to a photolitho plate.

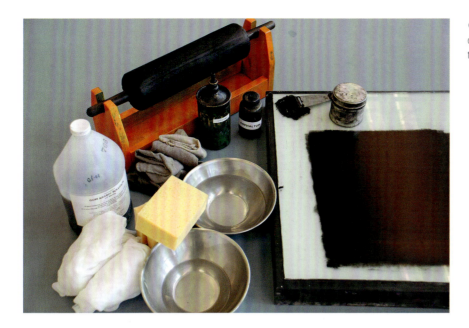

◀ For printing, you will need a leather roller, stiff black ink, clean and dirty water pans, printing sponges, cleanup rags, tympan, tympan grease, and masking tape.

Printing the Lithograph

As always, you should gather together all the materials you need prior to embarking on the actual printing process, then follow the sequence of work below.

Proofing the Image

Before printing the image color, it is advisable initially to proof the image in black. This is because color inks tend to be soupier and have less tack. The smooth composition rollers used for color printing also afford less image control. It is easier to assess inking requirements, both in terms of the amount of ink and the number of passes and cycles needed to roll it up fully, when using a napped leather roller and black ink.

Preparation for Printing

To ensure the most efficient printing process, it is important to set up properly at the press. There is a fine line between printing pleasure and printing distress, and much of it has to do with having the necessary supplies at hand to circumvent any possible problems. Before even touching the printing element with a roller, prepare the following:

Paper

- 10–15 sheets of newsprint cut a bit larger than the stone or plate to use for proofing
- Additional newsprint slightly larger than the printing paper for slip-sheets
- 2–3 sheets of inexpensive proofing paper, such as cover stock or the backs of old prints
- Edition paper, torn to size and marked with T and bar or punched for registration
- Backing paper for use between the printing paper and tympan (one sheet of cheap cover stock or newsprint will usually suffice).

Water, rags and sponges

- Two pans of clean water, one kept clean for printing and one for initial dirty work and to wring out printing sponges
- Two rags, one very wet and one damp for initial wash-off
- Two printing sponges made of fine pore cellulose: one a "dry" (slightly damp) sponge and the other a "wet" (soaked) sponge
- One small sponge for gum purposes and edge cleaning
- One old used sponge for general cleanup
- A half-dozen rags for washout and asphaltum rub-up, and for general cleanup later
- Tint solution and edge cleaner: 6 drops of phosphoric acid to 1 oz (28 g) of watery gum
- One small felt square to clean edges.

◢ Printing sponges are made of a fine-pore cellulose. To avoid having bits of sponge come off during printing, it is common practice to round the edges of the sponge so that they will not abrade as they go over a plate edge.

Jenny Schmid in her studio

1. Drawing on the Mylar.

2. Punch registration allows the key image to guide the development of Mylars for color layers.

3. Setting the registraton pins for Mylar and plate.

4. Plate and Mylar face down on exposure unit glass.

5. Closing the exposure unit.

6. Developing the plate.

7. Sponging the plate.

8. Beginning to ink the plate.

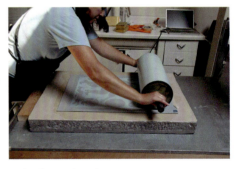

9. Inking from another angle.

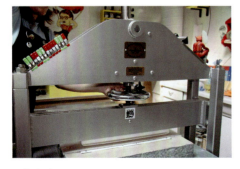

10. Setting the pressure.

11. Scraper bar in position.

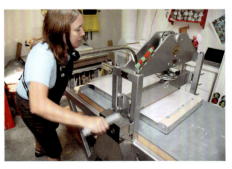

12. Running the plate through the press.

The layers and the finished print

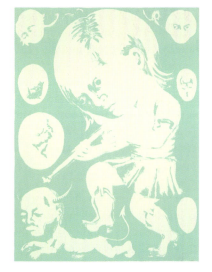

Blue layer.

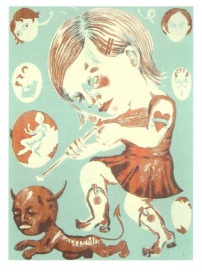

Blue, red layers.

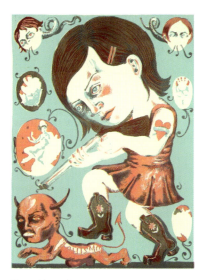

Blue, red, brown layers.

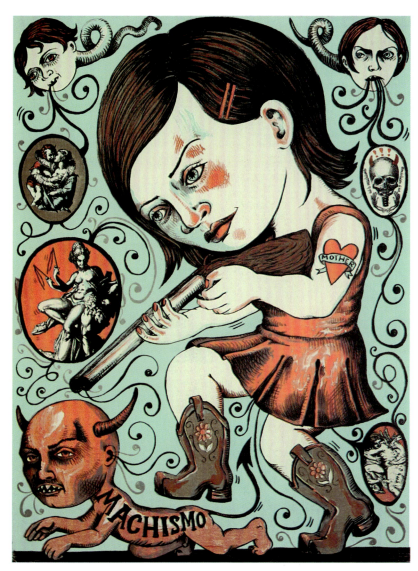

Blue, red, brown, black layers (finished print).

Jenny Schmid, *The Pathetic End of Machismo* (four color states), 2003. Photolithograph, 20 × 15 in (50.8 × 38.1 cm).

Jenny Schmid's satirical prints take a humorous punch at a variety of contemporary topics and issues. In this ornate scene, a pathetic devil, representing machismo, is kicked out of the picture by a shotgun-wielding lady, thus putting an end to distasteful male attitudes. Schmid's use of the photolithographic process allows her to take advantage of graphic mark-making and rich tonal washes. Punch registration aids in the creation of color separations.

Press setup

1. Choose a scraper bar that is longer than the width of the image area and shorter than the width of the stone or plate. Insert and lock it in the centered position on the press.

2. During printing, a tympan is positioned on top of the printing element and lubricated with grease so that the scraper bar can glide across the surface to make the print. Check the tympan for dents that would create uneven pressure. The side that comes into contact with the paper should be clean. Put a small amount of fresh grease on the side that contacts the scraper.

3. Clean the press bed and the back of the stone or plate base to remove foreign matter that could cause breakage.

4. Center the stone or plate base on the press bed and adjust to the centered scraper bar. Secure plates to the plate base with polyester tape.

5. Set up your preferred registration method on the printing element. Be sure to spot-etch newly scratched T and bar registration marks.

6. Set running marks to facilitate repeated positioning of the press bed during printing. To do this, first place a piece of tape on a stationary part of the press, next to the moving press bed. To determine a starting mark, push the press bed through until the printing element aligns where the scraper bar will come down. Mark this point by putting a piece of tape at the edge of the press bed so that it aligns with the tape on the stationary part of the press. Without lowering the scraper bar, push the stone through to line up the scraper bar with the bottom margin of the printing element to locate the end mark. Put another piece of tape on the press bed, again aligning with the stationary tape in this second position.

7. Begin with a light printing pressure. To set this pressure, place a sheet of newsprint and the tympan on the printing element. Align your starting running mark and bring down the pressure bar. Tighten the pressure until the scraper bar is firm, release the pressure bar, and then tighten the pressure screw a quarter turn more.

8. Use a leather hand roller for black and a composition roller for color. If the leather roller seems to have a buildup of ink, roll it out on a clean slab to strip off the excess ink. Repeat several times, scraping the ink slab between rolls. If the buildup is excessive or if the roller has been used with other oilier black inks, or for processing purposes, scrape excess ink off the roller with a long spatula.

9. For printing in black, start with moderately stiff ink, worked on the slab until it softens. Roll out just enough ink on a fresh slab to blacken the glass. Scratches should show through the ink. Start lean; you can always add more ink as necessary.

10. Prepare color ink appropriate to the image at hand. Images that have a tendency to fill in require an ink that is stiff and has tack. Conversely, stable images (crayon work or flats) can usually tolerate looser ink. If you are in doubt, start with a stiffer ink (see discussion of ink modifiers in chapter 1).

> ### Good Practice
> Never use a small scraper bar on a large stone; concentrated pressure may cause breakage.

Printing Procedure

Printing the lithograph is essentially the same for all kinds of printing matrices, with a few special considerations for working with photo plates as noted.

Press setup

1–2. Check to make sure the scraper bar is the right size for your printing element.

3. Grease lubricates the surface of the tympan so that the scraper bar can slide easily across the surface as the press bed runs through.

4. Pieces of tape placed on the moving press bed align with a stationary part of the press. The first piece locates the position of the press bed where the scraper bar aligns with the starting place.

5. The second mark tells the printer when to stop the press.

6. Prepare the roller by scraping off old, excess ink with a long spatula.

1. Apply a fresh gum stencil and buff it in tight. This is largely a preventive measure in case the stencil has been damaged by some errant water.
2. Except with photo plates, begin by washing out the image with lithotine. Next, buff in a coat of asphaltum, wash off the gum stencil and roll up the printing element. Note: If preparing to print with a colored ink, make a mixture of the ink with some lithotine to use in lieu of the asphaltum. Begin with 3–4 cycles for the first proof. A cycle refers to a number of passes over the stone with the charged roller. The roller is usually recharged with ink as the stone is sponged between each cycle. Through proofing, determine the needs of the printing element. The number of passes per cycle, recharging of the roller, speed of rolling, or adding ink to the slab are modified for the image at hand.
3. After the last cycle, wipe the edges of the printing element with a dry sponge to pick up fugitive roller marks and scum. Use an edge cleaner if necessary.
4. Lay the newsprint, backing sheet, and tympan on the press, lower the scraper bar, and then pull the first proof.
5. Remove the newsprint slowly. The first proof should be quite light.
6. Continue proofing, using a 3–4 cycle rollup, building up clarity and density to solids.
7. Add a small amount of ink to the slab after every 2–3 proofs. Be careful though; too much ink is the most common cause of filling-in problems. Larger, darker images will require more ink. It may take up to 7 or 8 proofs before understanding how much ink to add.
8. Increase the pressure slightly (one-eighth turn of the pressure screw) for each new proof until the image looks good. (Firm pressure is achieved after the third print or so.) Use this newsprint proof as a standard for comparing other prints.

> **Hint**
>
> Keep two printing sponges at hand—a "wet" one and a "dry" one. Use the wet sponge to lay down sufficient water to thoroughly wet the printing element. The dry sponge then follows and picks up excess water, leaving only a damp surface with no water streaks.

9. Don't rush! Watch for filling-in of darker passages. The goal is to print with the leanest slab and lightest pressure required for a solid print. Adjust ink additions (either to the slab or rolling pattern) and/or pressure if blacks come up too rapidly or fill-in occurs. Stop and etch again if problem filling persists.
10. After 3–4 consistent newsprint proofs in a row, move to printing papers. Moving from newsprint to better paper usually requires a slight increase in pressure and a bit more ink added to the slab. (Some prefer a less expensive proofing paper as a transition to more expensive edition papers.)
11. When a good proof occurs on the proofing paper, move to the print paper for the edition. Keep the pattern of cycles and ink additions consistent.

After Printing

1. Roll up the matrix to printing strength.
2. Dust with rosin and talc.
3. Proceed to counter-etch or buff down a layer of gum for short-term storage.
4. For storage longer than two weeks, wash out the printing ink with lithotine and rub up with asphaltum.

Cleanup

Follow normal cleanup procedures for oil-based inks, but remember that leather rollers are *never* cleaned with solvents. Specific litho tasks include:

1. Scrape the leather roller if the ink used was heavily modified. Cover with aluminum foil and store.
2. Clean grease from the scraper bar and tympan. Wipe with a dry rag and store.
3. Remove the stone or plates from the pressbed and store.
4. Wipe down the press bed, first with degreasing cleaner to remove the ink and gum residue. Use mineral spirits only if the ink residue is stubborn.
5. Rinse and snap dry any cheesecloth and hang to dry.
6. Clean water pans with cleanser.
7. Clean and store any shop materials used for drawing, etching, or printing (inks, knives, measuring and mixing cups, etc.).

Special Tips for Printing Photo Plates

To help the process operate as smoothly as possible, bear in mind the following tips:

- Because precoated photo plates have a very shallow grain, they do not hold much water. Adding 1 tablespoon of glycerin and 1 tablespoon of 50/50 gum/TAPEM to 2 quarts (2.2 litres) of sponging water helps to keep the plate wet longer.
- Photo plates roll up relatively quickly, so keep a lean slab.
- Rolling should be quick and crisp. If the plate is over-inked, the image may fill in. Photo plates require less proofing to roll up the image fully than is required to stabilize the image in stone printing. Because there is a permanent lacquer image on the plate, it is inherently stable. Sometimes it takes extra pressure from the roller in the beginning to get this lacquer to accept the ink from the roller everywhere (especially in the middle). Using a softer ink can promote this, but quickly switch to a stiffer ink once the plate begins to accept ink. Do not let ink build up on the edges. If it is not inking in the middle, use a small roller locally in the middle area to encourage the plate to accept ink.

Storing photo plates

1. When printing is complete, simply wash out the ink with lithotine and water (wet wash).
2. Remove excess lithotine with a rag and clean water.
3. Fan-dry.
4. Apply plate finisher or gum arabic with a sponge and buff in with cheesecloth.
5. Store in a light-safe place.

Ingrid Ledent

Ingrid Ledent's work is both a cerebral and poetic contemplation of the enigma of time. As remembered events collapse together, a refutation of measurability presents a qualitative experience of time. Experiencing Ledent's subtle yet complex images induce an extended lived *durée*; an encounter that lies outside of marked time.

Born Brasschaat, Belgium

Education/training Royal Academy of Fine Arts, Antwerp, Belgium; Academy of Applied Arts, Prague, Czech Republic

Current Position Professor, Royal Academy of Fine Arts, Antwerp

Awards and Exhibitions Ledent's works are in many public and private collections, including the National Museum of Fine Arts, Antwerp; Collection of the Frans Masereel Center; Museum of Modern Art, Armenia; Gasol Art Museum, South Africa; International Senefelder Foundation, Germany; and the collection of the Beijing International Art Biennale, China. Notable awards: Big Prize from International Print Biennial in Guanlan, China (2007); Grand Prix, 8th International Biennial of Drawing and Graphic Arts, Györ, Hungary (2006); Grand Prix, International Print Triennial 2006, Krakow, Poland (2006).

» *Describe your creative process.*

Process influences the content and the content influences the process. Content = process = content = process = content = process. As an artist, I prefer to make no separation between the print arts and the entire field of visual arts. An artist should challenge the boundaries of any medium. The use of prints in installations or three-dimensional works shows the flexibility of print media and how useful they are to all artists. In my own work, I augment the use of traditional printing techniques, combining them with computer print, video, and audio. Conceptually, the process of printmaking is quite significant and has become a part of the content of my work. I am mainly fascinated by one of the characteristic attributes of printing techniques, reproducibility. I use reproducibility not to make editions, but as a generating element. During the printing process, the "repetitions" get layered on one another, creating new visual forms.

I never make elaborate sketches; my work evolves on my press by printing layers on top of each other, in a fluent working process. I have my sources, of course. Time, as it is also in a process, is the basic theme in my work. I am strongly influenced by [Henri] Bergson's idea of time, especially his philosophical thinking about *durée*, the continuous living of a memory, which proceeds the past into the present. Emerging out of the manner in which I experience time, I highlight what cannot be interpreted as concrete, within measurable time, for the soul is not able to comprehend the experience as a phenomenon within the limits of time. This is a foundation for my images, a nontransparent, archaic tissue of frequently recurring forms. Also important in the content are processes of manipulation, the phenomenon of the matrix, and the controlled coincidence or serendipity. Time is also involved in the human body as well as in the actions it undertakes. Therefore, I often use my own skin and body parts to reference and translate time in more visual aspects.

This can be seen through the underlying dark grid of a lithographic print. Horizontal lines emerge, continued across the work, formed from the creases in a digital photographic close-up of my skin, or the recognizable elements of mouth or eye, which are derived from photographs of the surfaces of my body. In this manner, time taken to produce the lithographic print is mirrored in the passage of time evident in the creases in the skin, so that my physical presence, in a kind of self-portrait, becomes unified with the process I followed over a passage of time producing the work as a whole.

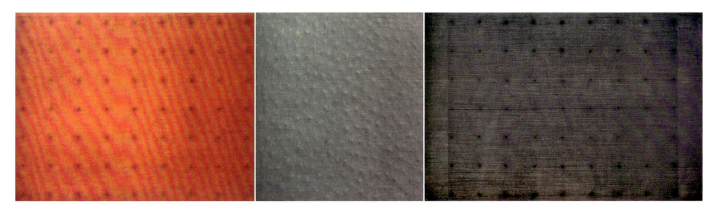

Inner duration IV 2005, 2005. (Left to right) lithograph on Zerkall paper, 25¾ × 35 in (65.5 × 89 cm), digital print and lithograph on Zerkall paper, 25¾ × 23½ in (65.5 × 60 cm), lithograph on Zerkall paper, 25¾ × 35 in (65.5 × 89 cm): overall 25¾ × 93¾ in (65.5 × 238 cm). Courtesy of the artist.

Using graphic similarity, Ledent sets up an echo between the grid of the mechanical marks and the surface bumps of the skin. The regular order compels us to count, marking time, perhaps as a measure of persistence.

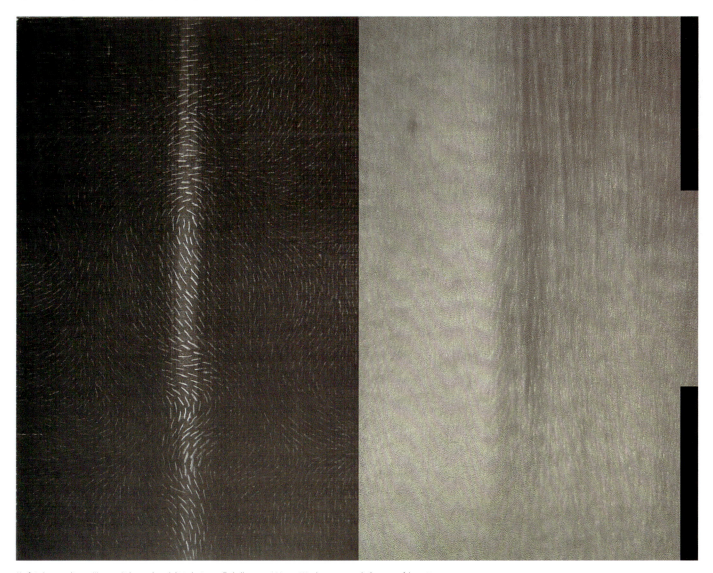

Un fait s' accomplissant III, 2006. Lithograph and digital print on Zerkall paper, 39⅓ × 51⅛ in (100 × 130 cm). Courtesy of the artist.

The graphic echo invites a poetic comparison between the two elements of this diptych. The swirling texture, illuminated in a narrow band of light, evokes the certain knowledge of a parallel swirl of fluid just beneath the fold of skin imaged on the right.

Color Lithography

There are many approaches to the color lithograph. As with other print processes, color images can be developed using multiple matrices that are printed together to create a final image, or a single matrix can be modified and printed multiple times.

In the first case, a familiar approach is to make a key printing element that carries the detailed information for the image. Color is printed first as simpler flats or textures, with the key image printed on top. Alternatively, a series of interdependent matrices, none of which exists as a complete image, combine sto create a composite final image. Either method allows the image to be proofed in advance.

In the second approach, the first layer of the image is printed in a chosen color. The printing element is then reduced or, with stones, grained back until there is just a ghost of the first image, then counter-etched, altered, and redrawn for the subsequent color. This system allows a reductive approach, but involves more risk, since the end product is an unknown.

Preparing for the Color Image

There are several preparations that are specific to working with multiple-color lithography. It is helpful to have an idea of how color prints; strategies for image development can be quite different, depending on the color to be printed.

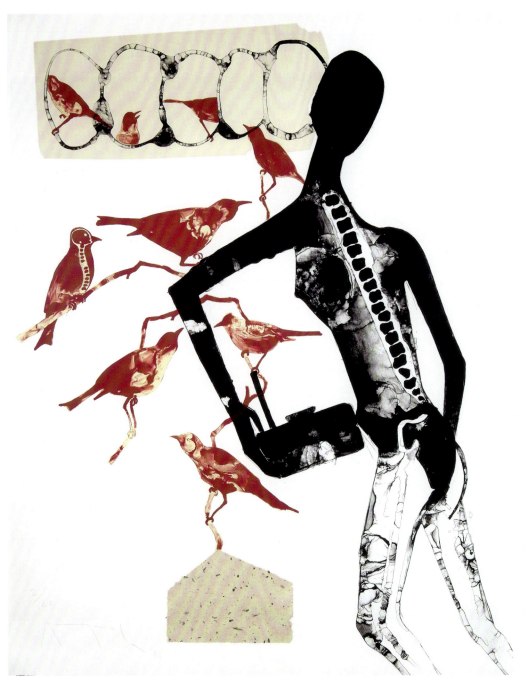

Atul Dodiya, *Sabari with her Birds*, 2005. Four-color lithograph and Chiri Bark paper collage on hand-made STPI cotton and linen paper, 50 × 40 in (127 × 101.6 cm). Ackland Art Museum, University of North Carolina at Chapel Hill, Ackland Fund. Courtesy of the artist and Bodhi Art, Inc.

In this work, Dodiya interprets a story from the Indian epic, The Ramayana: A tribal woman living in the forest as a hermit waits her whole life to be blessed by the crown-prince Rama, an incarnation of the deity Vishnu. The beautiful lithographic washes and striking red color emphasize Dodiya's non-traditional depiction of Sabari's youthful sensuality.

Drawing for color

Draw for a color image with the same materials as for black and white. A common misconception is that a matrix intended for a light color should be drawn lightly. Instead, think of the drawing as gradations of a solid as opposed to passages from dark to light. A solid field of light yellow should be drawn as a solid black and printed with a light yellow ink.

Calendaring paper

Paper should be calendared before being printed. Calendaring refers to running each sheet two to three times through the press on top of a clean plate or stone. This pre-stretches the paper, enabling accurate registration.

Registration

Accurate registration of one layer to the next is critical. Be sure to establish a T and bar or punch registration once the paper has been calendared.

Color Printing Considerations

When printing with colored ink, there are certain considerations to take into account for the most successful results.

Mixing and modifying color inks

The two most important characteristics of ink for lithography are the length and tack. Most lithographic printing requires a shorter ink with some degree of tack. It should have enough tack to print the image cleanly, yet it should release from the printing matrix without pulling fiber from the paper's surface. Flats and bold imagery with very little detail can usually handle a softer ink—long and loose. Delicate tusche passages and images that tend to fill need much stiffer inks—short and tacky. The most difficult printing arises when the image has both extremely fine detail and large flat areas. In this event, a balance must be reached between the ink's greasiness and tackiness. Large, solid areas will take a heavier deposit of ink, while lighter passages will require much less. Adjust the rolling pattern to apply more ink to solid areas.

Procedure considerations

Washout for color is the same as for black and white, except that instead of rubbing up with asphaltum, a mixture of the ink color and lithotine is used.

Working with the composition roller is also slightly different than working with the leather nap roller and black ink. Since there is no nap on the roller, the layer of ink is deposited on the stone or plate with the first few passes. It is therefore necessary to recharge the roller more frequently. Color images tend to roll up faster so fewer cycles are required to bring the image up to strength.

Changing colors

There are a few ways to change colors during printing. If moving from a light color to a darker color that is similar (analogous, maybe), the easiest approach is just to proof back the image (taking newsprint proofs until there is little of the image printing in color.) The next color is just rolled right on top.

If changing to a color of different character, roll the image up to just under printing strength with the first color, dust with rosin and talc, then give a tight coat of gum. Then wash out and roll up with the next color.

Another approach that is somewhat risky is to do a wet wash. The stone is flooded with water, then lithotine is sprinkled into the image. The old color is dissolved by the lithotine and wiped up with clean rags. The water protects the non-image areas. You must work quickly here, for the exposed image area is vulnerable to burnout from the water. Once the stone is clean, the new color is immediately rolled up, using the lithotine as a printing base.

When Printing is Complete

If the image is to be further processed (counter-etching, reducing, or etching), proof back the image then roll up in black and dust as usual. This is necessary because color inks do not have the grease content of black ink and are more vulnerable to the etches. Results of processing on top of color ink would be unpredictable.

Remove the stones or plates from the press bed. Clean the inking slab and tympan with oil and biodegradable cleaner. Remove the scraper bar and wipe off excess grease. Store all tools, equipment, and supplies. Wipe down the press and press station.

Innovations in Planographic Printing

The operative premise of planographic printing calls for chemically exclusive printing and non-printing surfaces. Applying this principle to different support materials has yielded some useful alternative lithographic options.

The most widely used variations on the lithographic concept are paper lithography and polyester plate lithography. The advantages of both include low cost and a greatly simplified technical process. Polyester plates are somewhat more versatile and durable.

While they cannot recreate the range of mark-making or the stability of traditional lithography, they are nonetheless valuable processes in their own right. Both processes afford quick ways to conceptualize an image that will be further developed in print or to add information to artworks that will be realized as drawings or paintings. Both paper litho and polyester plates can be printed on an etching press, simplifying mixed-process printing.

Paper Lithography

Paper lithography takes advantage of the common availability of photocopiers. The process uses the photocopy itself as the printing matrix. The toner powder that creates the image serves as a printing base for oil-based ink. To be able to print, the white areas of the paper simply need to be desensitized

with gum arabic so that ink applied to the surface will stick only to the black areas of the photocopy.

This process is not meant for refined work and long printing runs. Usually only a couple of prints can be made from a single photocopy.

Preparations

Begin with a good photocopy on regular bond paper. Different machines create copies with varying degrees of stability. Those that do not sufficiently fuse the toner will make copies that break down during the lithographic printing process. Experiment with different photocopy sources to find the most reliable.

While the process can be accomplished on the photocopy as is, it can be made more durable by spraying or brushing the back with shellac. This added durability allows for many additional printings from the same copy.

Compared to ink mixed for lithographic printing, the ink for paper litho needs to be somewhat loose. Tacky ink can sometimes pull the toner off of the copy, thus deteriorating the image faster. Add burnt plate oil or clove oil for an oily consistency. Extremely tacky inks can be softened with a little bit of reducing compound. Roll out the ink with a hand brayer until it is a smooth velvety consistency. Because black and transparent colors are difficult to gauge, it is easier to see when the copy is rolled up if you add just a little white to your ink mixture.

Because paper litho is printed with a softer ink, the negative spaces tend to hold a little bit of tone. You may wish to shape the paper to include this as part of the image strategy before inking.

Printing Procedure

1. In a bowl, mix a 1:3 solution of gum arabic and water.
2. Spread a little bit of gum arabic on a smooth surface and lay the photocopy face up on it. (The gum holds the photocopy in place.)
3. Spread gum across the surface of the photocopy image—sponge off the excess. As the paper expands, carefully reposition it to ease out any curls or bubbles.
4. With the paper expanded and the surface flat, sponge the surface of the photocopy with the water/gum solution.
5. Roll 4 or 5 passes ink on to the surface of the photocopy. Sponge frequently to avoid depositing ink in the white areas. Do not let the photocopy dry.
6. Continue alternating the sponging and rolling until the image seems fully charged with ink or until the paper begins to deteriorate.
7. Finish with a final sponging.
8. Place the inked-up photocopy face down on the paper, cover with newsprint, and roll through the press.

Polyester Plate Lithography

Polyester plates have been in use in the offset industry for many years. Introduced as an alternative to aluminum plates, they were initially designed for "direct to plate" imaging of high-resolution digital pictures. Polyester plates can be fed into a laser printer or photocopier for imaging. Plates may also be hand worked with a variety of materials, the most popular being permanent markers and toner powder.

Printing procedure

1. Apply the gum arabic.

2. Spread the gum and water mixture with a sponge.

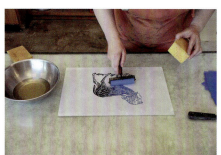

3. Roll on the ink.

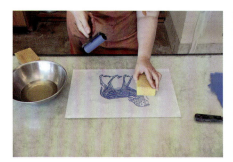

4. Sponge frequently.

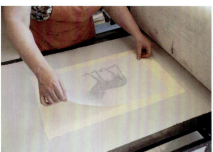

5. Place the inked copy face-down on the paper and cover with newsprint before rolling through the press.

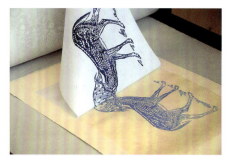

6. Carefully pull away the photocopy from the print.

Unlike paper litho, polyester plates can sustain longer runs, and can be used to develop multilayered prints. Because polyester plates are translucent, developing multiple layers is easy. Using a punch registration system or T and bar marks drawn on the back, plates can simply be developed one on top of the other, as one might do when making Mylar separations.

Imaging on polyester plates

As mentioned, polyester plates can be worked by hand or with toner powder techniques. In contrast to traditional litho, the materials are not washed out of the plate. Instead they exist as a printing base. For this reason, it is important that all imaging materials are well seated into the plate surface. Apply direct drawing materials with sufficient pressure. Liquid materials naturally flow into the pores of the plate. Toner powders are fused to the plate with heat or in a solvent chamber as previously described.

Processing and printing

While polyester plates are essentially ready to print once the drawing is complete, some recommend minimal processing by wiping a universal fountain solution. This can help the plate to absorb water and reduces scumming. Some polyester plate manufacturers provide a product-specific etch solution that performs the same function. Printing commences once this is dry.

Printing follows the normal lithographic process of sponging and inking. The main adjustment for polyester plates comes in the consistency of the ink. In contrast to the stiff and moderately short ink required for normal lithography, polyester plates print best with inks that are moderately stiff with a fair bit of length. Stiff black inks may require the addition of

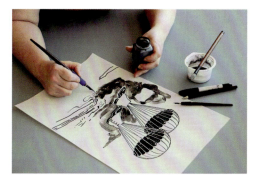

Polyester plates used with photocopy, toner powder, and drawing materials.

lighter litho varnish. Color inks are often suitable "as is," but may need some magnesium carbonate.

Sometimes, a capful of fountain solution added to the sponging water (the suggested ratio is 30:1, about 1 teaspoon per litre of water) can also help if scumming is a problem. Test the pH of the water—it should be between 4.5 and 5.5 for optimal printing. Use fountain solution sparingly or not at all when printing drawings, since it may remove drawing materials from the plate. Decide whether to use the fountain solution depending on how the plate behaves. If the plate won't accept ink, use less or no fountain solution. If the plate scums or over-inks too quickly, use more.

Polyester plates can be printed on an intaglio or lithographic press. As with paper lithography, it is possible to run the printing paper face up, with the plate positioned by eye face down on the print. This is especially expedient for printing multiple color layers. Registration is empirical.

Materials and Approaches for Polyester Plates

Imaging method	Materials	Process notes
Direct drawing	Ballpoint pen Permanent marker China marker Water insoluble litho crayons	These materials can also be worked reductively by scratching or erasing. Crayon and china marker performance is enhanced by heating briefly.
Washes and Textures	Acrylic floor polish—to aid visibility, color the polish with some India ink. Screen filler—dilute with water, 3:1 water to filler Waterproof India ink Carbon black acrylic paint	Apply these materials with brushes, airbrush, or with stamping or stenciling techniques.
Toner powder	Laser or copy machine print directly onto polyester plate Direct drawing (litho-coal sticks) Direct application of toner washes	Add 1–2 drops of photographic wetting agent to aid suspension toner powder in water washes. Directly applied toner must be fixed to the plate with heat or solvent.
Masking	Gum arabic Water-soluble pencils	Draw with these materials first. When dry, draw on top of them with any non-water soluble materials. When these are dry, remove the masking material with water to retain white areas.

Reworking the Print

One nice characteristic of a polyester plate is that it can be reworked during printing. Additional drawing or deleting can occur while the ink is still on the plate. Add marks to the plate using any of the drawing materials. Remove unwanted tonal areas by scraping them away with a razor blade or by using fountain solution or a pencil eraser. Since no etching or gum arabic is involved, it is not necessary to counter-etch or re-etch the plate. Once the modifications are finished, printing can continue immediately.

Cleanup

To clean the plate, proof the plate back by printing it on newsprint three times without inking it. Then clean it lightly with fountain solution and a sponge. If you are cleaning a drawing plate, dilute the fountain solution with water so it won't remove the drawing.

Litho press setup

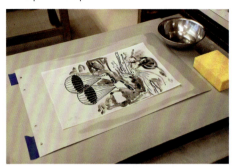

◀ If working on a litho press, set up the press bed with a plate base topped with an etched ball-grained litho plate. Set the polyester plate on top of the litho plate, holding it in place with a little water underneath. This allows the roller and scraper bar to run over the edge of the polyester plate, which is especially useful if the image goes to the edges of the plate. Tape registration pins in place on top of the litho plate. Alternatively, the plate can be rolled up off the press on a dampened glass slab. Then simply transfer the inked-up plate to your registration pins on the press bed and proceed to lay printing paper, cover paper, and tympan to run through the press.

Etching press setup

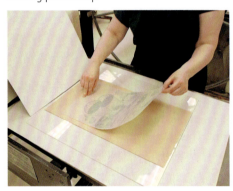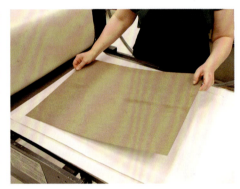

◀ When working on an intaglio press, setup is essentially the same as for any intaglio printing element. However, because there is no need for heavy pressure, the cushion blanket is removed and a stiff tympan, such as a Formica or acrylic sheet, is placed on top of the printing paper and cover sheet. Set the pressure so that it is firm, but not so firm that it is difficult to turn the handle.

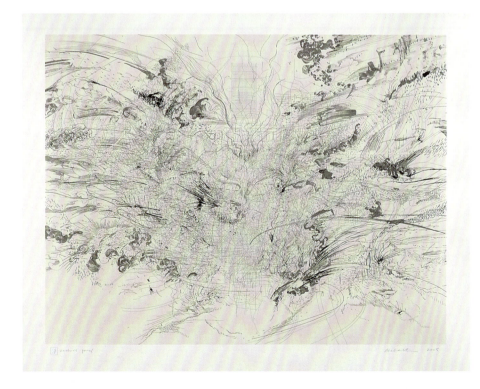

Julie Mehretu, *Entropia: Construction*, 2005. Lithograph with Gampi *chine collé* on Somerset Satin, 40 × 49¾ in (101.6 × 126.3 cm). Printed and published by Highpoint Center for Printmaking. Courtesy of the artist.

Mehretu deconstructs architectural plans of airport terminals, maps, and city grids, and reorganizes their elements into wholly new multi-dimensional, semi-abstract compositions. This print utilizes three layers from a previous print, combined with a fourth layer created for this image. Each layer is printed separately onto thin Gampi paper then layered and attached *chine collé* to the Somerset backing.

Chapter 8
Monoprint

Monoprints are one-of-a-kind, printed images. They have been called "the painterly print" or the "printer's painting." Indeed, making a monoprint brings together ideas from both practices, as well as concerns from drawing. Monoprints are also sometimes called monotypes. The two words are often used interchangeably, with monoprint being the more common and generic of the two. A useful distinction, favored by many, is that a monoprint employs some form of repeatable matrix used in the development of the image, whereas a monotype is not dependent on the ability to repeat information. In this chapter, the term "monoprint" is used both for the general class of prints and for the specific case of works employing repeatable matrices. The term "monotype" is used specifically for works without repeatable matrices.

Monotypes are probably the more familiar form. Working on an unarticulated plate, the artist develops an image much like a painting or drawing. When it is complete, the image is printed onto a paper or other support. Because the marks made to create the image are not physically established in a printing matrix, it is possible to print only one copy of the image. Ghost impressions are sometimes taken of the ink remaining after the original print has been taken, but the quality of the image is significantly different so as to constitute another monotype. It is common practice to "work

Giovanni Benedetto Castiglione, *David with the Head of Goliath*, c. 1655. Monotype in brown oil pigment on laid paper, 13¾ × 9¾ in (34.8 × 24.8 cm). Andrew W. Mellon Fund. Courtesy of the Board of Trustees, National Gallery of Art, Washington.

Castiglione's invention of monotype served to break down boundaries between printmaking, painting and drawing.

into the ghost," that is using the ink residue as a guide, to create related images.

The earliest known monotypes date from the mid-seventeenth century and were made by the Italian printmaker Giovanni Benedetto Castiglione (1609–64). Castiglione worked in a reductive manner by rolling a relief film

of etching ink onto a clean copper plate. He established the image by removing the ink with rags and brushes. Linear elements were made by drawing with a stick into the ink surface. To this day, these techniques are emblematic of the monotype.

Edgar Degas (1834–1917) is another artist who is well known for his use of the monotype process. Like Castiglione, he initially employed a reductive technique. Later works show painterly additions that expanded both the color and quality of mark-making in the work. Degas clearly enjoyed this manner of working, evidenced by the fact that many of his pastel drawings began as monotypes.

Paul Gauguin (1848–1903) further expanded monotype techniques. By drawing on a piece of paper that sat on top of an inked surface (sometimes another piece of paper with ink rolled on it), he made what is now called a trace monotype. These are characterized by a rich, soft line.

The monoprint probably has a longer history in that one-of-a-kind printing variations of any matrix essentially constitute a monoprint. Some of the most renowned monoprints were made by Rembrandt (1606–69), whose varied wiping on his etched plates created dramatic differences in lighting and mood in images made from the same plate. Similarly, William Blake (1757–1827) often took liberties with the idea of the edition. Information held in his plates often stood as a point of departure to explore variants through printing and hand-coloring.

The contemporary monoprint has built on the idea of variable articulation of the matrix. In addition to the painting and drawing manipulations characteristic of the monotype, a multitude of printmaking strategies can combine in many different ways to create the unique image.

Paul Gauguin, *The Consultation*, 1899/1900. Monotype, 11⅜ × 7¾ in (28.1 × 19.7cm). Ackland Art Museum, University of North Carolina at Chapel Hill. Burton Emmet Collection.

Note the rich, soft line of this trace monotype. Gauguin called his works "print-drawings."

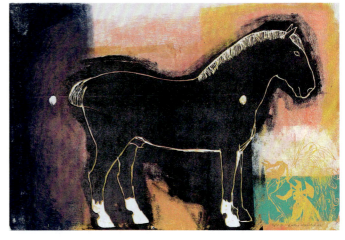

Riitta Uusitalo, *Cob (20−21)*, 2002. Woodcut monoprint, 24¼ × 36 in (61.5 × 91.4 cm).

Uusitalo uses a minimally cut woodblock to create a series of images. Using the brayer as her brush, she inks the block with multiple colors and adds stamped and stenciled elements. For Uusitalo, a work in progress is the most rewarding phase of the artmaking process. Monoprint allows her to remain in a state of discovery with the image.

Tools and Materials

The array of tools possible for monoprint pretty much encompasses all of the tools that exist in the printmaking studio. They are often adapted creatively for use with the monoprint or monotype. Brayers can be used to draw with, brushes can be employed to apply or modify ink films, and rags move beyond their typical cleanup role. Essentially anything that can apply ink or manipulate an ink film can be used.

Inks

Selection and modification of ink is somewhat dependent on how you intend to print. Any oil-based printing ink can be adapted for use. For reductive monotype, the ink should be modified to be a loose, yet buttery consistency, and not too tacky, or it will be hard to wipe. Adding a thin oil or up to a 30 percent proportion of reducing compound makes reductive work easier. If working additively by "drawing" with brayers, or if utilizing layering print strategies such as stencils, an ink suitable for relief work is good.

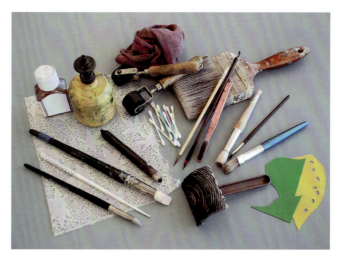

Tools for monoprint are typically quite ordinary, but used in different ways. Tools for reductive work include fingers, Q-tips, rags, brushes, and rubber-tipped marking tools. Textures can be made with tools adapted from other functions, such as this wood-graining tool. Lithotine is used to make washes. Stencils can modify and edit information.

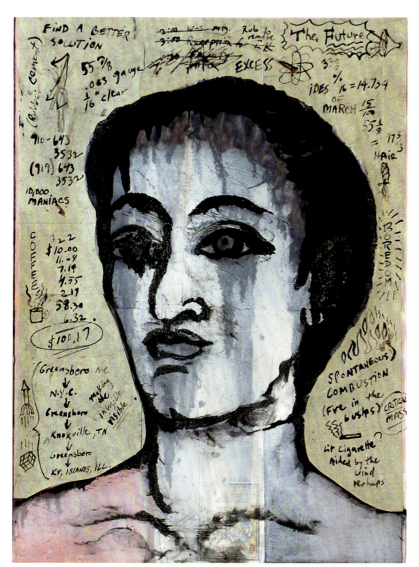

Roy Nydorf, *Heroic Head (Spontaneous Combustion)*, 1991. Monoprint with pen and ink, 24 × 18 in (60.9 × 45.7 cm).

Think like a printmaker! Visual texture is created by manipulating a thin ink film rather than painting thick impasto. A physical buildup of ink or puddles of solvent will spread out and streak as the plate is printed on a press. Used deliberately, this quality can create an interesting effect.

Image-making Strategies

Monoprints or monotypes can be as varied in approach as the artists working in the medium. The approaches presented here represent the possibilities. They do not have to be used in isolation.

Printing Surface Considerations

Different points of departure have various degrees of pre-planning and spontaneity. Style of working or intention for experimentation for the particular print at hand can influence decisions regarding surfaces to work on or paper choices. For instance, for prints that require multiple passes through the press to complete the image, the ability to register information can be critical. A transparent plastic plate might be preferable in this case.

Various surface materials have advantages and disadvantages for image development and printing concerns. It is

⬥ If the first layer of a multilayered print has been developed on an opaque printing element, subsequent layers of information can later be registered by printing from a transparent plate. To record information from the original printing for registration purposes, simply place a clean Plexiglas plate on top of the print (ink surfaces together). With a permanent marker, trace any essential information, including T and bar or other registration marks. The marker is removed later with alcohol. The plate is now ready to be developed for additional layers of information.

Plate Options for Monoprint

Attribute	Materials	Advantages	Disadvantages
Transparent	Acrylic glazing (Plexiglas, Perspex) Polycarbonate HIPS (High-Impact Polystyrene) Polyester drafting films	Aids multiple-color registration; guide drawing can be placed underneath or drawn onto the back of the plate Lets guide information be drawn on the plate at any point in the development of the print by tracing essential information with a permanent marker	Scratches easily, needing more frequent replacement
Opaque	Thin plastics (HIPS, countertop laminate, PVC foam board) Etching plate Cardboard Litho plate	On white surfaces, color can be seen more accurately	Makes it harder to develop multiple color without working into the ghost image If the surface is dark, there is less correlation between the color on the plate and the printed color
Smooth surface	Clear acrylic HIPS Etching plate	Facilitates reductive methods	Slick surface, so not as receptive for all additive methods, especially washes
Surface with fine texture	Textured laminate (Formica) Frosted plastics Ball-grained litho plate	Holds solvent washes nicely Slight tooth, which works better with oil sticks or watercolor crayons and pencils Soft and atmospheric plate tone when used with reductive methods	Muddy plate tone when used with reductive methods Harder to establish bright whites
Partially worked intaglio or relief plates and other textured surfaces	Any partially worked plate	Promote serial investigation	Restrict composition
Thin (2 mm or less)	HIPS Heavy polyester film Cardboard Litho plate	Easily shaped Can be utilized for textural effects or as stencils Allows for layering and printing together of multiple pieces	May become bent or collect unwanted dents Less durable for sustained use If cardboard or absorbent material, must be sealed

helpful to consider these properties prior to beginning a print; the printing element itself may contribute to your image-development strategy.

Remember that all plates must be sufficiently thin or beveled prior to image development—just as with intaglio plates, sharp edges can cut and ruin expensive printing felts.

Drawing and Painting Strategies for Monotype

Monotypes are most commonly generated using approaches based in drawing and painting. Information can be developed in both additive and reductive fashions, much in the same way as marks can be drawn or erased in a drawing.

Additive approach

Working additively implies the direct application of materials to a plate surface. Color can be applied in a painterly fash-ion, the only limitation being that an impasto surface is not possible if the image is to be printed on a press.

The most common approach to additive work is to paint ink directly onto a plate. The ink can be modified in a variety of ways to achieve different qualities of mark. A stiff ink has a dry-brush look. Modify with reducing oils or oil-painting media for a more fluid line. Ink can also be thinned with solvent for washes.

The potential to vary the viscosity of several inks is another factor to exploit. An image is initially painted with an oily ink. A second ink, much drier, is rolled over the surface of the image. The oily ink will reject the drier ink, allowing the first ink color to remain pure as the second ink fills the field around it. As the roller with the dry ink passes over the oily image, it will also pick up that image, having the potential to offset and redeposit the image again. This process can be used to repeat information painted directly or to pick up and transfer information from other printing elements.

Additive

Ink applied with a brush has a very painterly effect.

Washes are made by thinning ink with solvent.

Brayers of different widths create more mechanical marks.

An example of viscocity: An oily ink painted first rejects a drier ink that is rolled on top; the drier ink picks up the oily ink and redeposits it as the brayer continues to roll.

Reductive

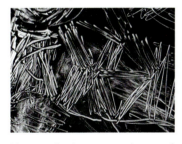

Ink is removed in a linear manner with a variety of tools, such as cotton swabs.

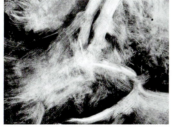

Ragwork can remove broader areas.

Solvent drops and splatter disturb ink film.

Printmaking strategies

Print approaches involve the use of simple matrices to make the image. Stamping can be used additively or reductively or in a modular fashion to build textures.

Stencils block printing in an ink layer, creating hard-edged shapes.

The residue left on a plate after printing a stencil also has a unique look.

The additive approach

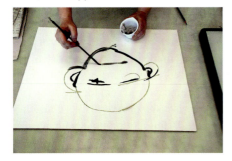 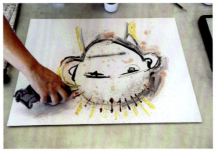 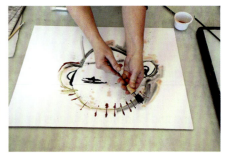

⬆ Ink can be applied with a myriad tools—brushes, rags, fingers. For ease of application, they can be thinned with a variety of modifiers, such as Lithotine or reducing oils. Oil painting media (such as Winsor & Newton's Liquin, which is particularly nice) are similar to reducing oils, but impart a slightly more appealing, velvety body to the ink.

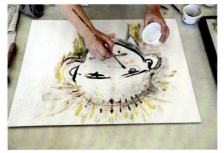 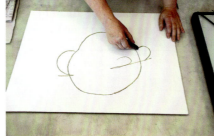 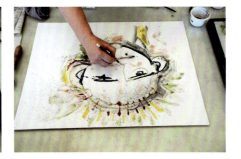

⬆ Use Lithotine to thin inks for wash-like effects or for splattering. Marks made with soft graphite will print when drawn into this kind of solvent wash. Add washes toward the end of the development of an image. If added early, they can sometimes dry so that they print poorly. Always print with a dampened paper when using washes. Formica, ball-grained litho plates, or frosted Plexiglas sheets have a tooth that holds washes nicely.

⬆ Oil-paint sticks allow the artist to create a crayon-like texture and mark. Both artist-quality paint sticks and livestock markers are useful. The cattle markers tend to print somewhat weaker (more transparent) and may be more fugitive in the color, but are an inexpensive alternative to artist-grade materials. Be careful not to leave large lumps: they will squish and streak when run through the press.

The reductive approach

⬆ The image is drawn on the back of the plate so that it can be visible through an inked layer. Although a transparent sheet allows an image simply to be placed underneath, the direct drawing eliminates the possibility of shifting and subsequent misalignment of multiple layers

⬆ Roll the surface of the plate, working from each corner (like the rolling pattern for a lithographic image). When the surface looks as if it has an even distribution of ink, begin to feather the rolling to minimize roller marks in the ink field. Roller marks tend to show more with transparent inks and if an area is to be printed as a solid. If the plate is to be developed significantly, this would be much less of a concern.

⬆ Stencils can create hard edges and textured information, and function editorially.

The reductive approach: tools for different effects

Rags Q-tips Brushes Rollers

Brayers and rollers come in many different sizes. They can be used as drawing tools to create an image rather than being used conventionally for laying down a smooth, even film of ink.

Some standard drawing materials will also print. Artist-grade oil sticks make crayon-like textures when used on a textured surface. Variations in the texture can be achieved when used in combination with washes. Similarly, very soft graphite (6B or ebony pencils) will print when drawn into a solvent wash.

Reductive approach

The reductive approach is essentially a *manière noire*—removing light tones from a solid ink film. A printing element is rolled with brayers or a large roller charged with ink. Transparency added to the ink allows a drawing guide to be seen through the ink when using clear plastic plates.

Trace monotypes

Another possibility for removing ink from the solid ink film is to directly offset the ink onto the printing paper, by drawing through the back or otherwise contacting the printing paper directly to the inked plate. To do this, a sheet of printing paper is placed on a surface that has been rolled up with a thin layer

○ A simple punch registration setup can allow viewing of the drawn image as it develops.

of ink. Then a newsprint layer placed over the back of the print paper receives the drawing. Different tools and varied pressure will create tonal variations. Open-weave fabrics or stencils placed between the print paper and inked plate can further modify the drawn image.

Once the direct offset image is complete, the residue ink on the plate can be printed on the press, generating a negative version of the direct offset image.

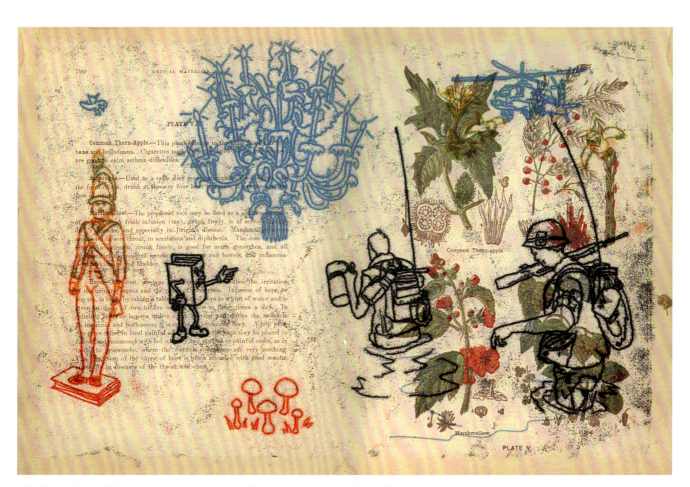

Michael Krueger, *Medicinal Soldiers No.6*, 2002. Monoprint with *chine collé*, 17 × 24 in (43.1 × 60.9 cm). Courtesy of the artist.

Much of the artist's work is based on spontaneous sketching and doodling. The trace monotype process allows him to take advantage of this impromptu style.

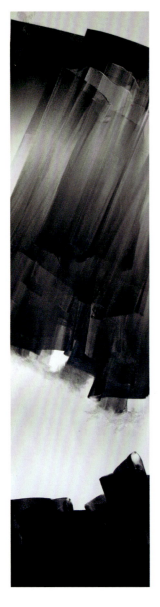
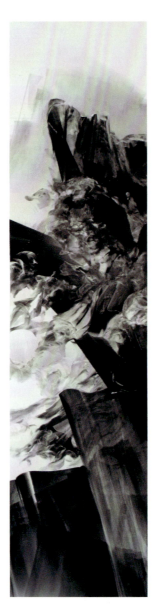
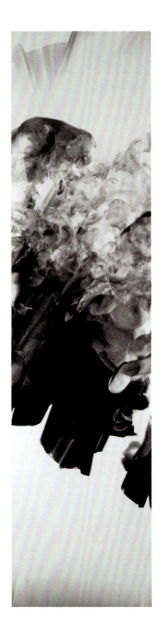
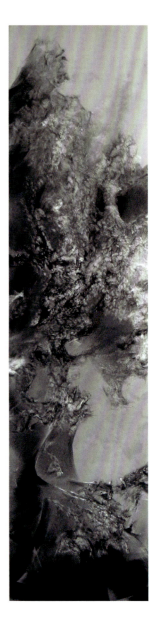

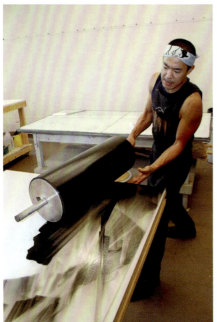

Koichi Yamamoto, (above left to right) *Ridatzu*, *Fusen*, *Fujyou* and *Chiri Nagare*, 2007. Monotypes, 72 × 18 in (182.8 × 45.7 cm) each. Courtesy of the artist.

Yamamoto works both additively and reductively with rollers, brushes, and rags. His prints evoke the landscape, not as a fixed terrain but as a dynamic and fluid state. Monumental land forms emerge from liquid atmospheres, defying gravity as elements float and sink through the long format.

◀ Rather than laying down a smooth, flat field of color, Yamamoto wields a large roller as a drawing tool to create tonal ribbons on his monoprint plate.

Marcin Kuligowski, *The Great American*, 2006. Monoprint with gumprint, 15 × 19 in (38 .1 × 48.2 cm). Published by Atelier Tom Blaess. Courtesy of the artist.

Kuligowski starts with color fields worked reductively. The image is developed with added drawing and monotype.

Martin Fivian, (left to right, top to bottom) *4 Fruit: Melon, Banana, Persimmon, Fig*, 2000. Offset monotype, 14 × 18 in (35.5 × 45.7 cm) each. Published by Atelier Tom Blaess. Courtesy of the artist.

The *4 Fruit* were made with an offset technique. The artist painted on a clear plastic sheet and a piece of acetate, registered by pins, was set on the wet ink and lightly rubbed, taking off a small layer. A second acetate was positioned and rolled with a hand brayer, taking off another layer. Three additional acetates were run through an etching press, with increasing pressure, separating the original painting into five layers. The image was "recombined" to make several variants by printing the acetates together with different pressure onto multiple sheets of paper. The backgrounds were printed in lithographically. The printing process introduced textural information, which made the images significantly different from a directly painted work.

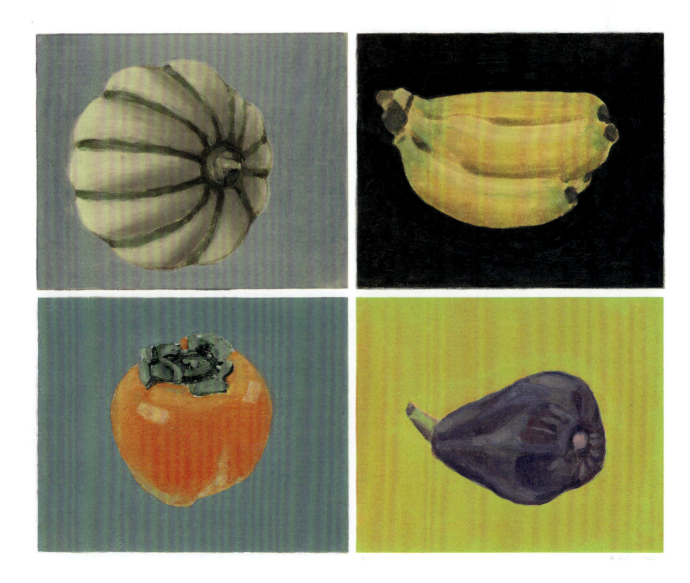

Printmaking Strategies

In addition to the drawing and painterly approaches most often associated with the monotype, a myriad printmaking concerns can expand the potential for the monotype or monoprint. Layering, stenciling, using parts of repeatable matrices, and repetition are all possibilities to explore with the multiple passes through the press.

Layering

One of the most basic aspects intrinsic to printmaking is that of layering. Complex color mixtures, layering textures, embossment, overlays of images, or editing of images can all be accomplished by successive printings of information on the monoprint. One can think of the press as the paintbrush; each time the paper is printed, the image can be built or modified.

Stencils are another image-modifying possibility. Used in a conventional way, they can block the printing element as ink is rolled or brushed through an opening. The stencil can also be used to prevent ink from being printed onto the final printing element. To do this, shaped paper, thin objects, or open-weave fabrics are placed on top of an inked plate before the printing paper is positioned.

Any given set of matrices can theoretically yield an infinite number of prints. Decisions about color, sequence, manner of inking, and number of layers can provide a lifetime of exploration. Although some monoprints are essentially color trial proofs that are inherently editionable, it is the attitude of improvisation and intentional exploration of the print as infinitely variable that governs this approach.

Modular and multiple

The idea of the multiple, most often associated with the editioning of a traditional print matrix, can be expanded to encompass the idea of a modular image. A large image can be built by repeated printings of any element.

An expansion of the idea of the modular matrix is the use of many separate printing elements that can be rearranged to create many variations.

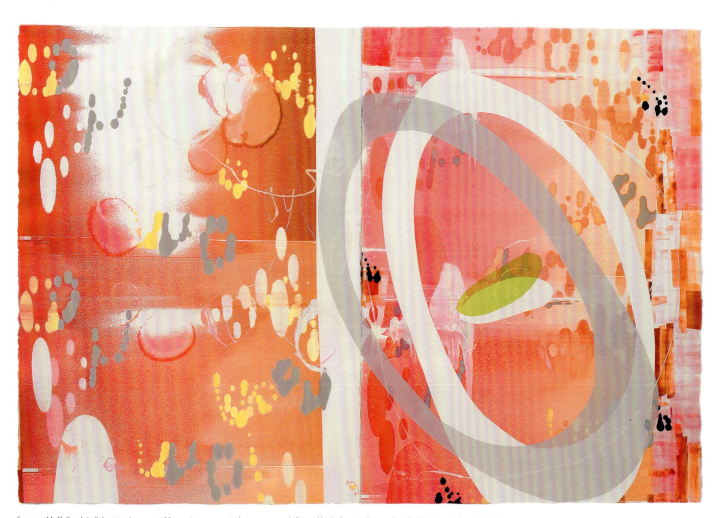

Suzanne McClelland, *Lullaby, #8, ohno*, 2006. Monoprint, 30 × 44 in (76.2 × 111.7 cm). Printed by K. Caraccio Printmaking Studio, New York, published by One Eye Pug. Courtesy of the artist.

McClelland has been interested in the intersection of form and language, specifically with ambiguity of the "O." Both a letter and a number, it also has sexual connotations and art historical references. Here she paints with an oily ink, then rolls a drier ink on top. The roller picks up this ink and redeposits it, creating repeated shape motifs in the image. Stencils placed during the first run create the sharp white open oval. This shape is reintroduced in the next layer in a more subtle gray.

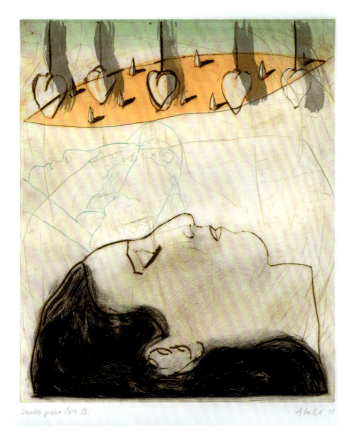

Ricardo Abella, *Sueño Para Eva IV*, 2001. Drypoint, monotype, 22⅕ × 18½ in (56.3 × 46.9 cm). Published by Atelier Tom Blaess. Courtesy of the artist.

Argentinian artist Ricardo Abella uses multiple layers of drypoint, monotype and drawing to create a dreamy narrative.

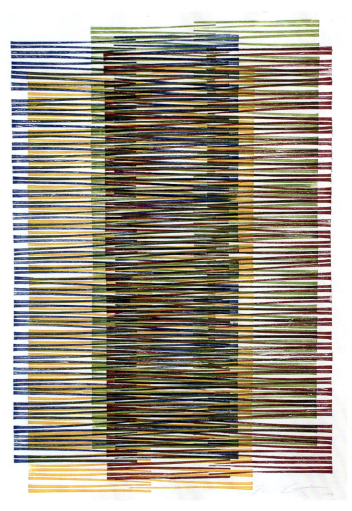

Michael Sonnichsen, *Chopstix*, 2003. Found-object relief monoprint, 30 × 22 in (76.2 × 55.8 cm). Courtesy of the artist.

The same matrix can be inked up and printed multiple times in a layered structure or in an overlapping repeated format. The plate for this print is made from chopsticks.

Printing the Monoprint

Monoprints and monotypes can be printed by hand or on a press. Etching presses are most commonly used, but a litho press can also be utilized for smooth-surface monotype plates.

Paper Considerations

Monotypes and monoprints can be printed on any good-quality printing paper. Paper may be printed dry or dampened, each having their own advantages and disadvantages. Smooth waterleaf papers, such as Arches 88, can print dry with good results. Because the paper does not expand and contract, dry paper makes subsequent registering for monoprints much easier.

Dry paper, however, is not suitable for intaglio information or dimensional plates. It also may not pick up delicate tonal passages made with solvent washes or graphite work. A dampened paper is much more sensitive to this kind of information. Dampened paper is also necessary for any embossment.

Many alternatives to conventional printing paper exist as possibilities for receiving the mono-image. Fabrics, industrial papers, wood veneer, thin metals, or plastic sheeting are but a few possibilities. Consider the support's impact on the image, both in terms of content and aesthetic.

Printing by Hand

Printing the monotype or monoprint by hand is essentially a relief-printing process. A dry printing paper is positioned on top of the printing element. A baren or similar tool is rubbed on the back of the paper to transfer the ink. One advantage of printing by hand is that an increased impasto is possible in the ink surface because the pressure of transferring the ink to the plate is controllable. Handprinting also affords an additional opportunity to modify the image through selective and variable printing pressure.

Printing on an Etching Press

If this method is chosen, printing normally follows the press setup for the material that is being used. Typically, this is a T and bar or pattern registration guide. If solvent washes have

Tom Blaess

"Sometimes you have to leave home to find yourself." So says master printer Tom Blaess. Armed with excellent technical knowledge and a streak of wanderlust, Tom Blaess left the US for Europe in 1987. In 1990, he established his own printmaking workshop near the Lake of Thun in Switzerland and relocated to Bern in 1999. His specialty in monoprint attracts artists from across Europe and the US for collaboration.

❯❯ *Please tell us about your atelier and work as a master printer.*
After years of printing lithographs in San Francisco with master printers Ernest de Soto and David Salgado I moved to Amsterdam in 1987. There I worked as a stone lithographer at Printshop under Piet Clement. I had the good fortune to work with the COBRA artists Constant and Lucebert, as well as the German artists A.R. Penck and Jörg Immendorf.

Moving to Switzerland in 1990 meant new challenges with language and culture, but limited possibilities for finding work as a printer, which brought me to the decision to start my own printmaking studio. So, for nine years I lived in a mountain village on Lake Thun, learning to speak German, making a living publishing Swiss artists and printing my own work. In 1999 I moved the shop to Bern, where I had found an ideal place down by the Aare River that circles the old town. In the years since, the atelier has grown steadily. Twice a year there is a special exhibition of a work project with an invited artist. On weekends, there are monotype workshops. The shop is represented at art fairs in Switzerland, with a mix of artists from Europe and abroad.

In my atelier I have the technology of the last three hundred years to work with. There is a large convertible hand press to print stone lithographs, monotypes, and drypoint, a flatbed offset press for Mylar lithographs and offset monotypes, and a full digital department with scanners and a large format Epson pigment printer. I like to experiment in mixed media, combining the limitations of analog printing with the limitless possibilities of digital imaging.

Whenever I am collaborating with an artist, whether it be a student, or professional, the first step is to establish their trust in me. I try to give the same level of respect and attention to each person I work with, regardless of their talent level. My years of living in a foreign land has helped my listening skills, I believe all those moments of trying to decipher what is going on around me has helped me be more sensitive to the artists I work with. I problem solve using intuition, logic, aesthetic taste, color sense, and humor.

Preferably, I publish artists who can draw, whether it be figurative or abstract. Content is also important—I want a strong statement, whether political, cultural, aesthetic, or in some other form that is compelling. I'm not necessarily looking for harmony and balance, I like edges. As for the future of printmaking, I believe that sharing information is the best way to keep it alive, so I try to pass on what I've learned.

Born Charleston, South Carolina, US

Education/training Michigan State University, Rhode Island School of Design, University of British Columbia, B.F.A. in Printmaking: Nova Scotia College of Art and Design, Halifax, N.S., Canada, 1978: Hand printer of lithographs for Ernest F. de Soto Workshop, Trillium Graphics, both in San Francisco, Ca, US, and Printshop, Amsterdam, Holland, 1979–89

Current Position Owner of printshop, Galerie Tom Blaess

Grants 1997, Department of Culture, Bern, Switzerland, monotype atelier; 1990, Department of Culture, Kanton Bern, Switzerland, litho stones; 1982, National Endowment for the Arts, US, Apprenticeship grant to work in lithography with master printer Ernest F. de Soto

Situated on the Aare River in Bern, Switzerland, the Tom Blaess gallery and workshop offers an idyllic location for sustained collaborative work.

Here, Blaess inspects a print coming off the FAG op 104, a Swiss flatbed offset press.

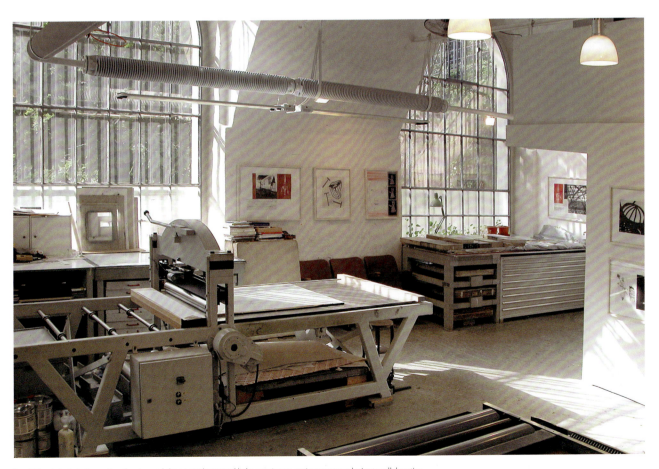
In addition to technical expertise, the airy workshop provides natural light, creating an environment conducive to collaboration.

Polly Apfelbaum monoprints made at Durham Press

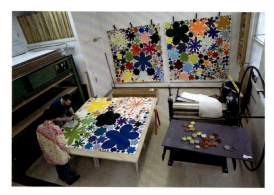 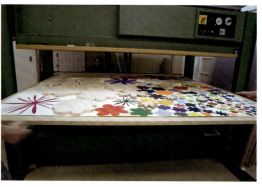

1. The artist supervises the production of a print in her *Love Park* series. Inked blocks are placed face-down on the huge sheet of handmade paper. This process is repeated several times until the image is completed.

2. Inked blocks are placed in the hydraulic press where they are printed with vertical pressure.

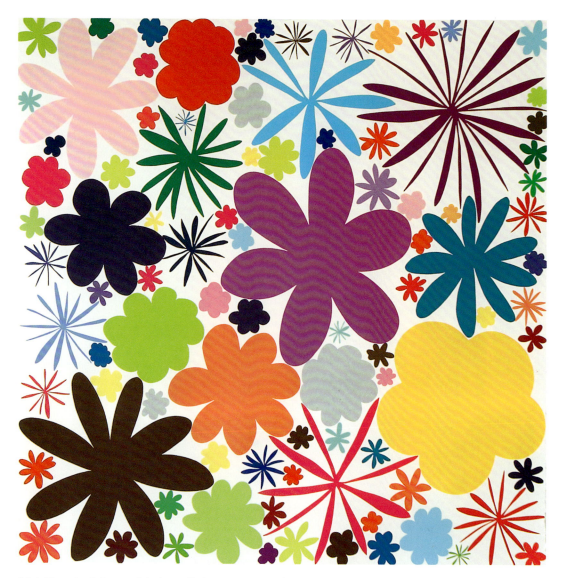

Polly Apfelbaum, *Love Park 12,* 2007. Multicolor woodblock monoprint, 79 × 79 in (200.6 × 200.6 cm). Printed and published by Durham Press.

Polly Apfelbaum creates huge prints using hundreds of shaped relief blocks. These large works are printed with a large hydraulic relief press—the contemporary version of the iron hand press.

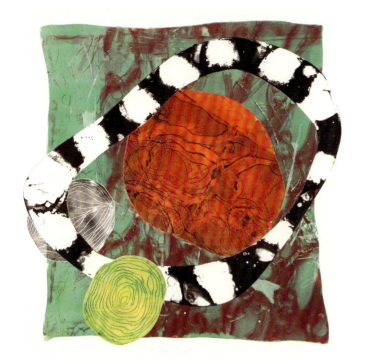

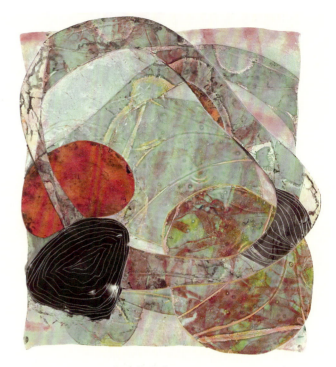

Marylyn Dintenfass, (left to right) *Sticks & Stones II: Jade* and *Little Ruby*, 2002. Monoprint, 31½ × 41 in (80 × 104.1 cm) each. Courtesy of the artist.

Dintenfass works with shaped plates made of thin plastic (HIPS) and thinner polyester drafting film. Thicker pieces have linear information carved in the surface, which can be inked intaglio. The elements are developed, and then arranged on top of one another to be printed in one run through the press. Taking advantage of the colors and textures left behind after the first print, Dintenfass creates a second print (*Little Ruby*) using the ghost. Elements are repositioned, some re-inked and some flipped over to get at the ink collected from the layered arrangement in the first print.

been used, be sure to put extra protective newsprint between the printing paper and the printing felts.

Once a plate has been printed, the artist is faced with some decisions. Sometimes ink that remains on the plate is sufficient to pull another print. This is called a ghost print or cognate proof. Once it is determined that there is not sufficient ink to make a good print, the residue left on the plate can provide a guide for subsequent layers on the same print or as a basis to make a new, related work. If using a transparent plate, information can be recorded by tracing marks onto the back of the plate. Alternatively, a new image can be developed directly in the ink residue by "working into the ghost."

Watercolor Monoprint

An alternative to monoprints made with oil-based inks is the watercolor monoprint. There are many advantages to working with watercolor. An important benefit is the avoidance of oil-based mediums and associated solvents. Also, because the watercolor must dry before it is printed, the time available to develop an image can expand indefinitely. This affords a great deal of flexibility; unlike the oil-based materials, a watercolor monoprint image can be developed over several days.

Aesthetically, the characteristic wash of the watercolor monoprint is a beautiful reticulated texture, much like lithographic washes. In contrast to watercolor applied directly to paper, the grain of the plate adds a subtle velvety texture to the surface.

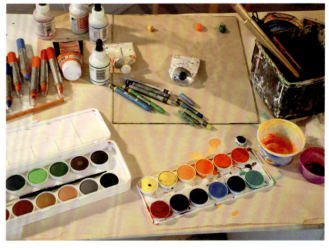

Conventional watercolors and watercolor pencils can both be used to develop the watercolor monoprint image.

Materials

Plates for watercolor monoprints must have a tooth to hold the washes. A transparent material allows a guide drawing to be placed underneath. Frosted plastic sheets or films serve this purpose especially well. Rigid sheets have an added advantage of allowing multiple plates to be stacked for a preview of the final image.

Plate Preparation and Setup

1. Plates may be purchased already frosted, or, if unavailable, a clear acrylic can have a grain imposed on its surface. This can be very simply done by sanding the surface with fine (320 grit) sandpaper, either by hand or with a palm sander. The edges of thicker plates should be beveled and filed smoothly. If the edges are to print as well, they should also be sanded with the fine sandpaper.
2. Clean and degrease the plate thoroughly with powdered cleanser.
3. The plate then needs to be conditioned so that the watercolor will flow smoothly onto the plate. Pour a small amount of gum arabic onto the plate and spread it evenly with a clean sponge. Buff the gum to a tight layer on the surface with cheesecloth. Because the gum arabic is water-soluble, it also helps the watercolor release onto the dampened printing paper during printing. This is not a critical step; the method will work without this preliminary conditioning, performing better as it is used.
4. A guide drawing can be made on the back of the plate or on a separate sheet to be placed underneath.

Developing the Image

The image can be developed in a variety of ways, being pushed and pulled on the plate a great deal before being printed. The ability to work reductively is a great advantage. Remember that the marks put down first will be on top in the print. Delicate accents applied over thick layers of paint may get lost in the final print.

By working two or three plates together, color can be kept separate and retain luminosity. Transparent layers of oil-based

ink may be also printed with the watercolor information when printed last.

If using rigid plates, the final image can be "previewed" to some degree by stacking the plates together on a light table or in front of a window. Look through the back of the plates to view the image reversed and to see the sequence of information. This preview can be a little misleading, as more opaque colors may appear darker when backlit during such a preview. They are usually more vibrant when printed.

Printing the Watercolor Monoprint

The setup for printing watercolor monoprint is the same as for standard intaglio printing. It is important for the paper to have soaked long enough so that it has sufficient moisture to release the watercolor from the plate onto the paper.

1. Tear the paper down to the desired size. Remember to leave an extra margin for multiple-plate prints.
2. Prepare the registration guide and setup on the press.
3. Soak sized print papers for at least an hour. Unlike printing with oil-based inks, it is important for the paper to have considerable moisture. Waterleaf papers need only to be dunked in the water bath until thoroughly moistened. Some artists prefer to prepare their paper in advance by making a damp pack.
4. Set the correct printing pressure and engage the blankets.
5. Place the plate in position.
6. Blot the paper. Brush the surface gently to remove any debris.
7. Lay the paper in position, cover with clean newsprint, and run through the press.
8. Leave the blankets and one edge of the paper caught if there are multiple plates to be printed. A limit of three watercolor monoprint plates can be printed in succession. After that, there is not enough moisture left in the paper to be able to release the watercolor layers. If at any time the paper seems to want to stick to the plate, spray the back with a mist of water until the paper releases. Be careful not to spray too much, however, as this may cause the colors to run.
9. If there is information left on any of the printing matrices, the ghost can be developed with additional watercolor and printed again.

Plate preparation and setup

1. Lisa Mackie uses a thin frosted Mylar for her watercolor monoprint. Gum arabic buffed into the surface helps the watercolor release during printing.

2. A drawing underneath the plate helps guide the development of the image.

Developing the image

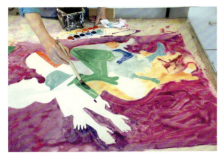

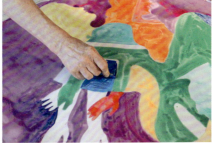

1–2. The image is developed with watercolors and watercolor pencils.

Printing

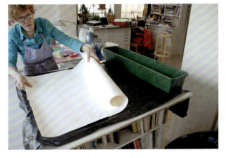

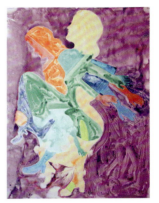

1. A deep trough is a spacesaver that allows Mackie to soak a large sheet of paper in a small space. Once wet, the paper is laid flat and kept damp between plastic sheets.

2. The print is lifted from the plate.

3. The finished first print.

Working into the ghost

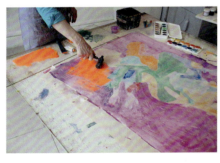

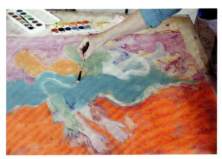

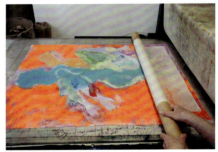

1. After the first print, Mackie works into the ghost to create a second print.

2. She continues to develop the image with reductive brushwork.

3. Mackie uses a cardboard tube to help her place a thin Asian paper at the press.

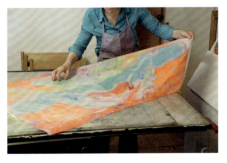

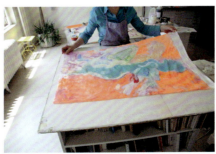

4. The plate is printed once again. The more delicate Asian paper must be gently peeled from the Mylar plate.

5. The print is laid out to air-dry.

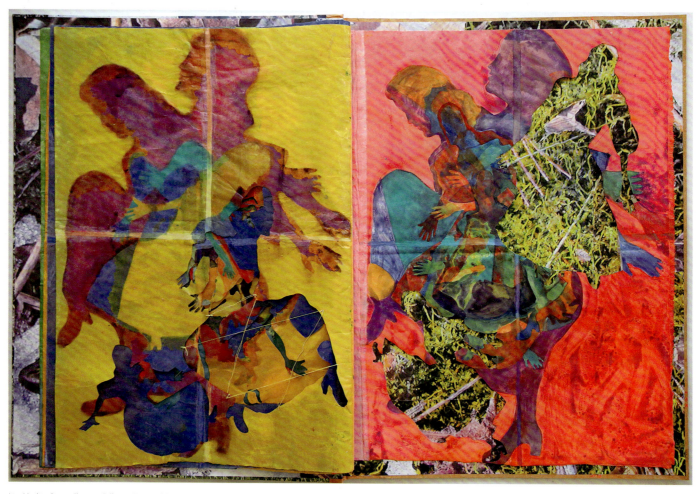

Lisa Mackie, *Rising, Floating, Falling in Perpetual Sequence*, 2007. Mixed media Japanese-style bound book (insides featured) watercolor monotype, some coated with wax encaustic, 36 × 29 in (91.4 × 73.6 cm) each page. Courtesy of the artist.

Mackie continued to create several more prints from this matrix. The individual prints were further manipulated and eventually became pages of an artists' book.

Chapter 9
Mixed Media

As indicated throughout this book, practices in contemporary printmaking vary widely. Many artists commit to individual technical processes, finding motivation in the aesthetic voice of the singular medium. For others, process decisions are guided by the project at hand. Particular choices may be related to desired image quality or simple expediency. This consideration alone often leads to combining printmaking processes. Still others find their motivation in the process and functions of printmaking, as outlined in the introduction to this book. A strategy that includes reframing, contextualizing, and making process or function visible is at the core of much postmodern practice. Such approaches can often lead to combining print processes with other means that cross disciplinary boundaries.

In his essay, "On the Manner of Addressing Clouds," Thomas McEvilley writes of the various ways that meaning is constructed in a work of art. He puts forth various concepts, one of which is the idea that materials and processes are themselves coded and contribute to the content of artwork. American printmaker Lisa Bulawsky encapsulates this idea in her artist's statement: "There is a strong metaphorical quality to the combination of

Francisco Souto, *El Otro III*, 2007. Mezzotint and digital print, 14 × 20 in (35.5 × 50.8 cm). Courtesy of the artist.

Souto combines digital elements with hand-worked mezzotint. Because the images are similar in subject, the contrast of process between the digital and the mezzotint heightens and questions the act of looking and recording. The digital element here is out of focus, while the mezzotint image of clouds is sharp. The two processes evoke a contrast of time; the photographic element is fast and hazy in its recollection while the mezzotint suggests a sustained engagement. Perhaps this is a commentary, even a lament, about the fast-paced quality of contemporary experience.

materials, images, and formal presentations where elements blend, then threaten to contradict each other, setting up a paradigm that's rich, human, tense, restricting, and liberating all at once. This is what is so appealing to me about mixed media. Every technique has its own mark, unique voice, and conceptual/historical territory. For me, it is the blending and/or contrast of techniques that drives the work and makes it successful or not."

The term mixed media is broad. It describes works that combine different print processes, yet remain within the sphere of printed works. The term is also important to works that utilize print processes as an important component of their creation, but perhaps elude any kind of strict classification by disci-

pline. Such works might be called prints, drawings, paintings, sculpture installation, or the all-encompassing "mixed-media." Some might contend that such labeling is immaterial to the art work. Yet, beyond understanding the process of making, such designations are important when they contribute to insights regarding the work's content.

This chapter addresses the range of approaches to mixing print media. In keeping with the technical aim of the book, we begin with some practical tips for combining print media in printed works, followed by a look at artworks that use print processes as a component of and in conversation with other non-print processes.

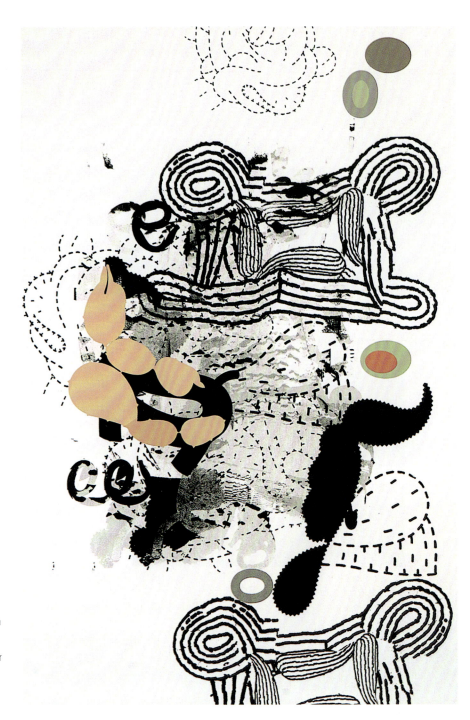

Laurie Sloan, *Untitled*, 2002. Screen print/cut paper, 30 × 20 in (76.2 × 50.8 cm).

Artist Laurie Sloan depicts organisms in a cartoon-like manner to counter the visceral rawness of the suggested biological events. The shapes reference comic-book graphic elements, inviting, but not delivering, a narrative.

Combining Processes

Whatever the motivation for mixing print processes, there are some practical considerations that might guide printing decisions. That being said, mixing processes is an invitation to experiment. Depending on how well the idea is formed, sometimes ignoring the "right" way of doing things can yield worthy results.

Much of the time, the choice of process relates to the desired image quality. In this case, it may be important to sustain the "voice" of a printing matrix, such as the graphic quality of woodcut, the soft, delicate quality of drypoint mark, or the flatness and luminosity of a lithograph. The following tips can be useful in achieving that goal.

Technical Tips

Mixing processes is not necessarily a new idea. For centuries, printmakers have hand-colored prints or used stenciling techniques with traditional intaglio or relief matrices. In contemporary practice, however, the mixing of process takes on a more unconventional strategy. Although one matrix might provide the primary information, often there is not a dominant printed character to the piece. Sequence is determined more by practical concerns.

- In general it is best first to print using processes that yield a flat surface. This assures clarity of image and, because the ink layer is better trapped in the fibers of the paper, it is less prone to offset during subsequent printings. These processes include lithography, photolithography, polyester plate lithography, or screen printing.

- Some water-based inks used for screen printing remain water-soluble when dry and therefore cannot be soaked in the usual manner for processes requiring dampened paper. It is best to choose acrylic inks that can withstand soaking if this will be a frequent practice. Otherwise, screen prints made with soluble inks can be dampened in a humid chamber. Using a box that is big enough to accommodate the size of the print paper, set a piece of blotter paper in it and dampen with a water sprayer. Set the dry print face up on top of this blotter and close the box. It will be damp enough to print an intaglio layer in about 20 minutes to 1 hour.

- Intaglio processes, especially those that create deep recesses, such as a deeply bit etching, generate a physical ink surface, which must dry before subsequent printing to avoid squishing. Print intaglio matrices last to retain this aspect of the ink layer.

- If other layers are required on top of a more physical layer, such as would be generated by an intaglio or relief process, it is helpful to "re-flatten" the print once the first layer of ink has dried some. Drying time can range from overnight to a few days, depending on the amount of ink and modifiers in the initial ink layer. To flatten, position the dried print face down onto a smooth support, such as an acrylic monoprint sheet and run through an etching press with firm pressure. Sometimes the flattening can be enhanced if the paper is slightly damp.

- If the print will undergo several cycles of dampening and printing, it is best to add *chine collé* during the last printing, because most archival glues will release when paper gets wet. Alternatively, print *collé* elements separately and add them later once the printed surface is dry. (See discussion of *chine collé* in chapter 5.)

- There are no rules regarding the sequence and timing of printing. Sometimes many layers are printed in a single day, printing "wet on wet"—that is, not allowing for drying time in between printed layers. Sometimes though, weeks or months go by between printing sessions. The potential consequence of waiting time between layers is for either "wet-rejection" or "dry-rejection." Wet rejection occurs when very oily layers resist subsequent "drier" or less oily layers if printed too soon. Similarly, dry rejection happens if very thick deposits of ink polymerize into an unreceptive surface if left too long. A partial remedy is to control drying time by accelerating or slowing drying. Air-drying can expedite curing a surface layer so that it can be printed sooner if physicality or oiliness is an issue. Conversely, to prevent dry rejection, drying can be slowed by keeping the print between boards, or between sheets of paper, so that there is less air circulation.

Exploring mixed processes with Lisa Bulawsky

1–3. Bulawsky prepares to print an intaglio matrix by spraying paper with water and enclosing it in a damp pack. Some papers have a layer already printed and some sheets are blank. In this way, she can explore the effect of the layering sequence. Once set up for printing, it is efficient to print the same matrix on several pieces of paper.

4–6. A PVC foam board plate is used for an early layer for this print. The intaglio line is shallow and the intaglio wipe of the PVC plate gives some plate tone atmosphere. Note that only the part of the plate that carries the image is inked. This is an aesthetic choice. In this printing, the atmospheric tone is confined to the bottom area of the print.

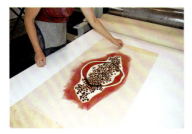
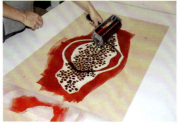

7–9. A relief block is the next element to be printed. To isolate a specific area of this block, a stencil is first positioned using T and bar registration. It is rolled aside while the block is inked up with a hand-brayer, then repositioned before the paper is placed.

10–12. To differentiate the inside of the mouth shape from the background, a solid cream tone is printed from an intaglio-wiped PVC plate. The cream is prevented from printing inside the mouth using a stencil. Because the printing is wet-in-wet, some of the red from the previous relief block is offset onto the plate.

13–15. A final layer is printed from a polyester litho plate. Since polyester plates can be used on both sides, this plate shows a second image that is not part of this print. The dots are rolled up with a white ink and printed on top of the red dots from the relief layer. Notice that the polyester plate is positioned on top of the print and run through the press. Since polyester plates are translucent, it is easy to register position by sight.

Bulawsky continued to develop the image after the printing session. After this proof was generated, further subsequent proofs were created using several of the same matrices, some of them modified (as was the final print below).

Lisa Bulawsky, *Irascible Deity*, 2007. Monotype with woodcut, drypoint, collagraph, lithography, 19 × 26 in (48.2 × 66.04 cm). Courtesy of the artist.

American printmaker Lisa Bulawsky employs a variety of printing matrices to generate her work. Although editionable, she tends to explore the variety possible in any given set of matrices.

Print Strategies

Artists take advantage of print strategies in mixed-media works with a variety of approaches. Many look to the attributes of the print discussed in the introduction to this book, such as the matrix, the multiple, or the module, to develop unique works that depend on these aspects of printed information.

The simplest extension of print into the realm of mixed media is the "enhanced" print. These are works that are essentially conceived as prints but are enhanced with hand-work. This can include hand-coloring prints made from a single matrix, or embellishment with collage elements. Other treatments to printed surfaces include distressing, staining, or coating the surface with a hand-applied material, such as a varnish or wax. These processes or treatments reintroduce or amplify the handmade aura of the work.

When considered in conjunction with drawing, we can think of prints and mixed media in several ways. Often prints act as a catalyst, providing a point of departure for a unique

work. It may be difficult to distinguish the printed and drawn elements one from the other.

Sometimes a combination of printing and drawing relies expressly on the difference between the printed element and the drawn element. The contrast of "voices" capitalizes on the associations made with each medium as part of the concept of the work. This approach often promotes working in a series or sequence, so that a variety of drawn elements can contrast with a common visual element across several pieces. Such repetitions of printed elements can create visual rhythms or narratives across a group of images.

Another take on the combination of print process and drawing is the "printed drawing," where a printing matrix is used as a drawing tool in a modular way to create a larger unique image. A printed element is repeated, but usually not with exact precision. Rather, variances in the articulation of the module allow for tonal variation in the final piece. Because the repeated element is visible, it announces its presence as a drawing tool. Consequently, the process loses anonymity and becomes a part of the work's content.

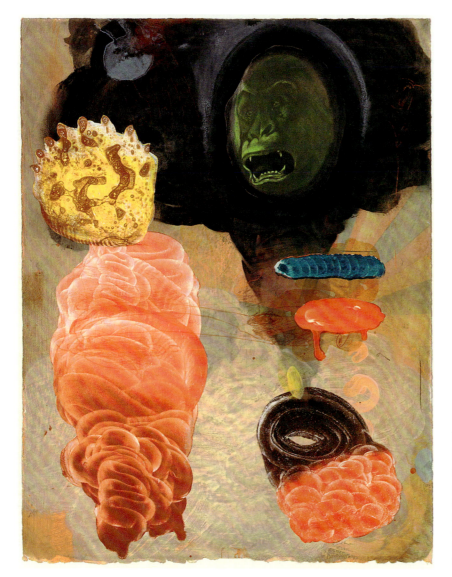

Tom Christison, *Bush Meat*, 2005. Lithograph, monotype, latex on paper, 19 × 15 in (48.2 × 38.1 cm).

Christison's images combine lithography, monotype, and latex paint. He paints latex "flats" on the print surface, which are dried and sanded. Key elements are registered using clear Mylar. On average, the prints go through the press 15 to 20 times, resulting in a very painterly appearance. This work explores simple narratives about life cycles, passages of time, regeneration, and the food chain.

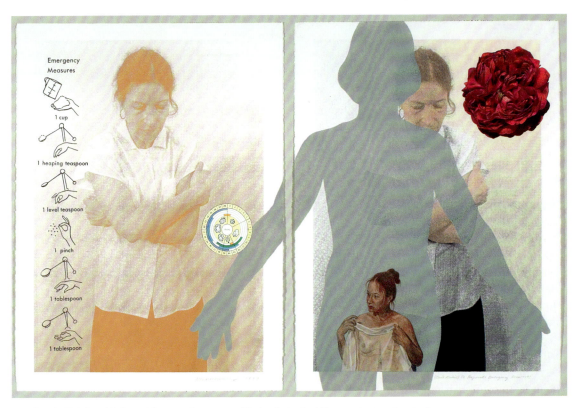

Minna Resnick, *(Can't Always) Be Prepared: Emergency Measures*, 1999. Mixed media drawing (silkscreen, solvent transfer, colored pencil, watercolor, acrylic, color photocopy), diptych, 30 × 45½ in (76.2 × 115.5 cm). Courtesy of the artist.

Resnick repeats an underlying figurative element across a series of works. The figure, with her arms folded, establishes a constant underlying mood of frustration or vulnerability.

Stacy-Lynn Waddell, *Get Down*, 2006. Branded and singed paper, 42 × 85 in (106.6 × 215.9 cm). Courtesy of the artist.

This work employs a handmade branding iron as modular drawing tool. As an African-American, Waddell explores issues of race and identity. The shape of the iron (full lips as a signifier of blackness) are burnt into the surface of a heavy, thick paper. Even though the image created relates to a garden, made lush and seductive by the golden-browns, the act of branding/burning recollects the insistent presence of slavery and contemporary discrimination.

Phyllis McGibbon

Described by the *Los Angeles Times* as "a tinderbox of ideas and allusions," McGibbon's art merges drawings, hand-pulled prints, print/collage constructions, and installations made in response to specific architectural settings. Drawing from historical images, her works reframe assumed narratives, offering agency through alternative readings.

❯❯ *Artist's statement.*

Much of my work is propelled by the notion of historical cycles and the way that images and ideas invert, layer, and reassert themselves over time. I'm interested in how the visual, procedural and cocnceptual processes of making prints relate to poetic, feminist and architectural ways of thinking.

Traveler is based up an etching by Albrecht Dürer, in which an angel holds St. Veronica's veil aloft while flying through the air. According to legend, Veronica offered her handkerchief to wipe the face of Jesus, and afterward her cloth revealed an impression of his features. The image on Veronica's veil was revered because it seemed not to have been made by human touch. While Veronica has been called the patron saint of photography, perhaps her story is more relevant to those who make prints using the instinct—the need—to touch. Countless artists have been inspired by the magical image on Veronica's cloth, but I'm motivated by Veronica's legendary gesture of compassion. *Traveler* carries an etched, Braille-like image that wraps around the cylinder. If rolled along a surface, it leaves a trace, extending Veronica's empathetic reach, endlessly.

I often imagine prints as travelers, tourists, guest workers, and exiles. They slip in and out of artistic categories over time, absorb multiple languages readily, and cross international boundaries with ease. They travel to multiple destinations and mark fleeting, transitory moments; their cultural implications shifting dramatically depending upon where and when they are encountered. If we think of printmaking as a constantly evolving set of transcultural conversations, it is an exciting field that links many forms of creative inquiry.

Learning how to make prints is not difficult. But the question of why we gravitate toward particular techniques or combine them in certain ways often depends on a broader set of assumptions about art and the significance of an artist's labor. Sometimes the physical effort or degree of complexity required by a project reinforces a sense of conviction in the artist or fosters a bond between collaborators. At a time when so many options are available, it is worth considering why we are drawn toward certain working methods, how they direct our attention in the studio, and whether they should be sustained or shifted as we travel between projects. Regardless of the tools at hand, graphic thinking often involves balancing a set of pauses and delays against unexpected possibilities, prompting us to rethink where an image might be headed next. By looking back through our proofs and matrices, we can retrace our path and find links to parallel projects in any media. In this sense, printmaking is a medium in which artists look back and forward at the same time.

Born Madison, Wisconsin, US

Education/training BFA, MFA, University of Wisconsin-Madison, US

Current Position Professor of Art, Wellesley College, US

Awards and Exhibitions McGibbon's works are included in over 30 public collections. She has created installations at the University of Northern Iowa; the John Michael Kohler Arts Center, Sushi Inc; The Orange County Center for Contemporary Art; and the Davison Art Center at Wesleyan University among others. Awards for her work include grants from the Elizabeth Greenshields Foundation, the National Endowment for the Arts, The Western States Arts Federation NEA, Art Matters, Inc., and the Howard Foundation at Brown University.

Veronica Vessel: after Dürer, 2007. Cobalt transfer decal on Porcelain, 7 × 6 in (17.7 × 15.2 cm). Courtesy of the artist.

Made in collaboration with traditional Chinese ceramic masters at the Sanbao Ceramics Institute in Jingdezhen, China.

Traveler: after Dürer, 2005. Etched copper tube, 2 × 16 in (5 × 40.6 cm). Courtesy of the artist.

The image was established onto the copper tube with a photocopy transfer, then reinforced with a Sharpie paint pen. It was then etched for eight hours in a ferric chloride solution.

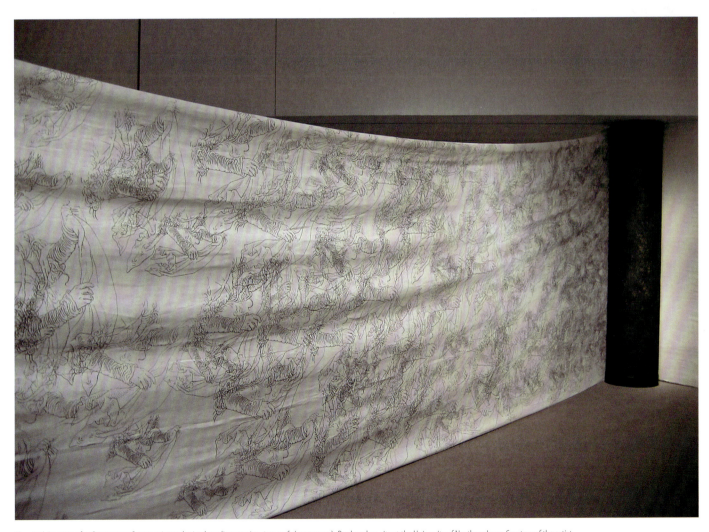

Veronica's Imprint: after Dürer, 2005. Screen print and mixed media on scrim, 8 × 40 ft (2.5 × 12 m). Produced on site at the University of Northern Iowa. Courtesy of the artist.

Using the screen in a modular fashion, the image of Veronica is repeated hundreds of times, metaphorically reenacting her gesture of compassion.

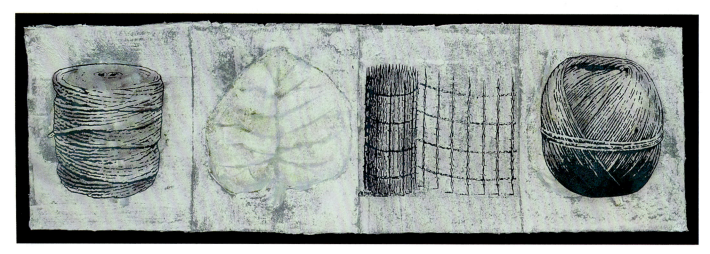

Georgia Deal, *Tethered*, 2007. Mixed print media (screen print, pulp transfers, and wax) on handmade paper, 12 × 40 in (30.4 × 101.6 cm). Courtesy of the artist.

The artist begins with a wet sheet of handmade paper that gets imbedded with finely beaten pulp transfer images. After the sheet has dried, detailed images are screen-printed onto the surface, followed by flocking with various materials. Finally, the sheet is rubbed with a cold-wax finish to bring up the color of the pigmented paper, giving a dull sheen to the finished work.

Crossing Other Boundaries

Of course, printed strategies can move into sculptural realms. Similar to the way in which it is used as a two-dimensional medium, printmaking can provide both the functional and conceptual components of sculptural works. An obvious strategy for taking prints into three dimensions is to create objects from printed material.

Thinking sculpturally also invites a reconsideration of substrate, or the surface that prints are made on. Materials such as glass, ceramics, metal, wood, or fabric assume a less anonymous role in the printed image than does a conventional paper support. Sometimes a change in substrate is sufficient, but often the printed elements are then arranged or combined in a larger sculptural form.

As well as converting printed elements into three-dimensional forms, artists working in a sculptural field often look to the matrix itself as a primary component of their work. Instead of assuming that the end product is contained in the progeny of the matrix, the matrix itself can assume a visible role as part of the end product. When a matrix is no longer flat, the concept of printing on a press must be revised.

Three-dimensional works are not only sculpture in the round, but also installation or site-specific works. Printed works operating in these cases impact not only the object but the space.

The production of the physical art object is typically considered the goal of an art-making endeavor. Looking beyond that traditional outcome, it is interesting to consider the performative nature of print strategies. In these works, the process is made visible as the primary concept of the work. The acts of making a matrix, of printing, or of viewing become amplified. In these examples, artists allow chance to contribute to the visual outcome of the work. Often collaborative, these conceptually motivated performative works are frequently played out in public spaces rather than galleries.

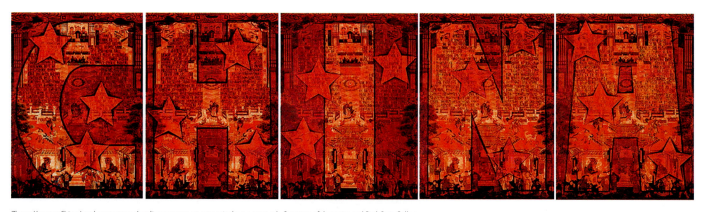

Zheng Xuewu, *China Landscape*, 2005. Acrylic on paper, 60 × 226 in (1.53 × 5.75 m). Courtesy of the artist and Red Gate Gallery.

Zheng Xuewu's works combine the traditional and the modern as they draw on a jumble of symbols that saturate Chinese urban visual vocabulary. Zheng prints Chinese and Arabic numerals and glyphs, newspaper types, stamps, and seal imprints, then paints back into the negative spaces in the images.

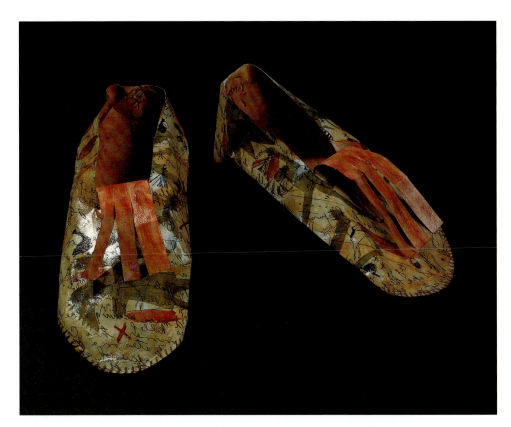

Lynne Allen, *Moccasin 4*, 2000. Handmade paper, intaglio, shellac, linen thread, 8¾ × 4 × 2½ in (22.2 × 10.1 × 6.3 cm). Courtesy of the artist.

Allen explores issues of the exploitation, colonization, and assimilation of Native American culture within the larger, dominant white European culture. Papers printed with journal entries, historical pictographic images, and decorative elements are further developed to mimic vellum or hide surfaces. These are then made into purses or moccasins. The elements function metaphorically, reminding the viewer that such issues continue to be relevant in the contemporary world.

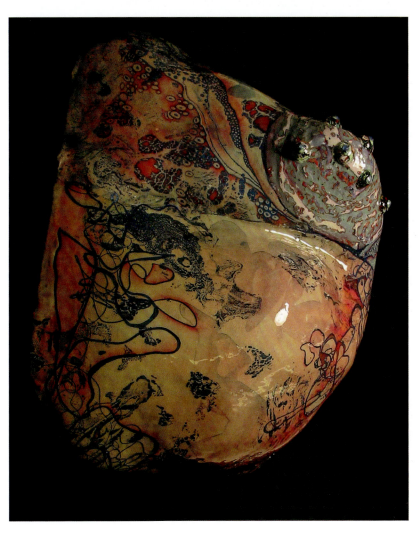

Margaret A. Craig, *Boil and Bubble*, 2006. Tar gel etching over plaster form with small glass inclusions and resin coating, 16 × 17 × 16 in (40.6 × 43.1 × 40.6 cm). Courtesy of the artist.

Craig prints conventional intaglio plates by painting a liquid polymer medium called tar gel onto her inked-up plates. Once the gel has dried, the polymer layer is peeled from the plate, creating a flexible, translucent skin with the image impregnated into the surface. This is then stretched over three-dimensional forms, resulting in dimensional prints.

Jill McKeown, *Jeu de mémoire*, 2006. Wall installation of intaglio prints and etched copper box, 59 × 197 in (1.49 × 5 m).

McKeown collects objects. In her works, image fragments collapse into a single surface, suggesting an accrual of experience that determines identity. In this piece, not only do the prints take their place on the wall but an etched copper plate also creates a storage box. This use of a printing matrix exists as a metaphor of individual perspective on any shared episodic event.

Anita Jung, *Cuentos de Hadas (Fairy Tales)*, 2005. Aluminum vinyl, gray vinyl, Plexiglas, projected light. Courtesy of the artist.

In this installation at Proyecto ACE in Buenos Aires, Jung explores the contradictions of the "American Dream" with the reality of the aftermath of hurricane Katrina, which hit the Gulf Coast of the US in 2005. In this piece, laser-cut images of middle-class suburban homes are combined with text that outlines the government response to the hurricane. Transparent plastic sheets, with imagery from the fairy tale Hansel and Gretel, hang in front. As the gallery spotlights shine through the plastic, they cast a shadowy image over the wall, taking the whole concept of the American dream into the realm of the fairy tale.

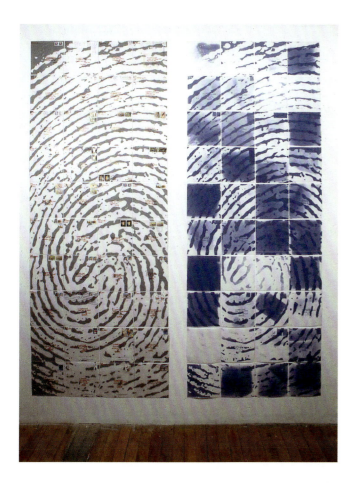

Elizabeth Dove, *Mailing Per Day*, 1999. Forty envelopes and photo-etched blueprint sheets, 6 × 8 ft (1.8 × 2.4 m).

In this piece, Dove sandwiched a photo-positive image of a section of her thumbprint with a piece of blueprint paper. For two days, she assembled these into translucent envelopes and mailed them to herself. The chance encounters with light and the "collaboration" with the postal system's canceling mechanisms document a relationship of time and distance.

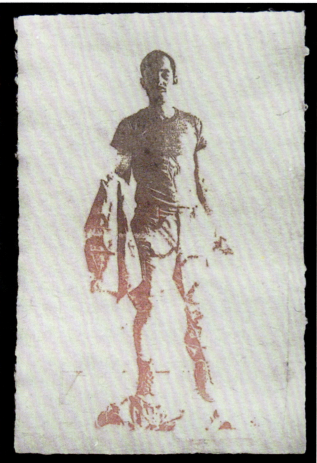

Drew Matott, Drew Cameron, and Jon Turner, *Combat Paper*, 2007. Volume I, edition of 5, six pulp paper prints in an envelope of pulp paper, 18 × 12 in (45.7 × 30.4 cm) each.

The creation of this work was coordinated by Matott, Cameron and Turner of the People's Republic of Paper at Green Door Studio. All the paper used was made from the shredded uniforms of members of Iraq War Veterans Against the War. The veterans destroyed their uniforms, which they had worn in combat, and turned them into sheets of paper. The paper was then printed with the images of the very same soldiers in the process of cutting up their uniforms, completing the arc from action to product.

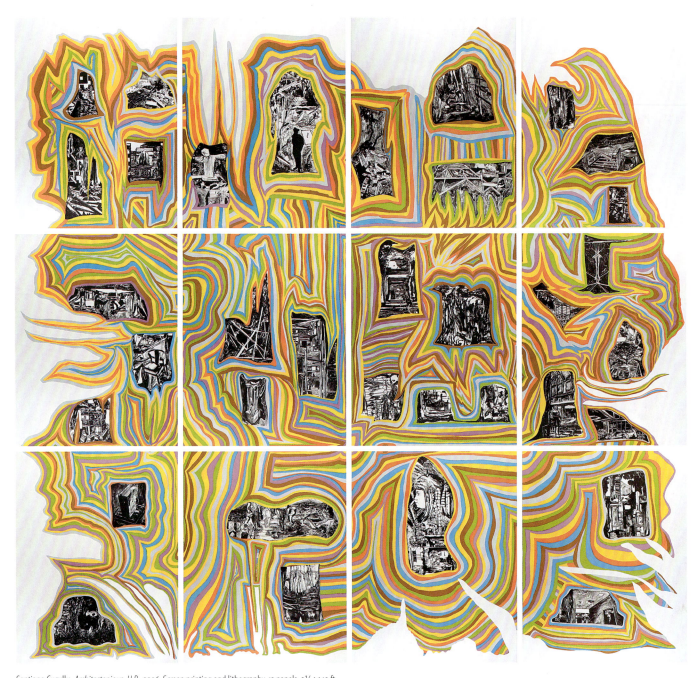

Santiago Cucullu, *Architectonic vs. H.R.*, 2006. Screen printing and lithography, 12 panels, 9¼ × 10 ft (2.8 × 3 m). Printed and published by Highpoint Center of Printmaking. Courtesy of the artist.

The presentation of this work includes an interactive opportunity for viewers to rearrange the prints in variable configurations.

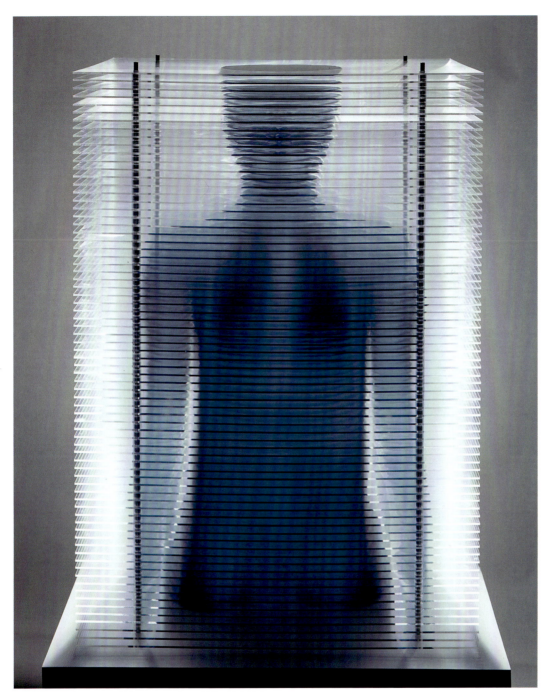

Marilène Oliver, *Radiant*, 2006. Inkjet on acrylic, 19 × 28 × 39 in (48.2 × 71.1 × 99 cm).

Oliver creates three-dimensional images by printing sections of MRI body-scans onto plastic sheets. When stacked, the ghostly presence of the figure reemerges from the analytic planar descriptions contained in the data sets of the medical scans. The work is a reassertion of wholeness despite contemporary pressures of fragmentation.

Troubleshooting

Chapter 2: Digital Processes

Making transparencies

Problem	Reasons	Remedies
My halftone dot is very coarse.	The pixels per inch (ppi) output resolution is too low.	Set the output ppi to 400 or larger.
My halftone has a moiré pattern.	There are interfering grid patterns between the halftone frequency (lines per inch, or, lpi) and the printer output resolution (dots per inch, or, dpi).	Adjust dpi resolution so that it is not a multiple of the lpi.
I need to make a transparency that is bigger than the printer I have.	Your printer is too small.	Print the image with a finer lpi (halftone) or ppi (diffusion dither), then enlarge at a service bureau. Or: Take the digital file to a service bureau for large-scale output. Or: Print the image in sections (tiling) and piece them together to create a large image.

Inkjet printing

Problem	Reasons	Remedies
The color of my inkjet print is fading.	The printer ink is low quality.	Use a printer that accepts pigment-based inks or high quality dye-based inks. Proprietary inks are more predictable. Use third-party inks with caution; some are not trustworthy, even though they may be less expensive.
My inkjet print looks very pixelly.	The image resolution is too low. The image is scaled up too much.	Image resolution (ppi) must be at least 150 ppi at the scale that it will be printed. The original input resolution must be large enough to print at the final output size. Images optimized for web viewing are 72 ppi and are too coarse for printed output.
My inkjet print looks fuzzy.	Non-digital paper absorbs ink and bleeds.	Use specialty coated inkjet papers. Prepare sized printmaking papers with a commercial digital ground.
The color on my inkjet print does not match what I see on my screen.	1. The monitor needs color calibration. 2. The printer settings are incorrect. 3. The printer, rather than the software, is managing the color.	1. Calibrate monitor with specialty equipment and software (weekly). Or: Adjust color output within the print dialog boxes. 2. Different types of paper have different printer profiles. Choose the printer profile associated with your type of paper. 3. Make sure the color management is being handled by the imaging software.

Chapter 3: Screen Printing

Problems with the stencil

Problem	Reasons	Remedies
The screen drawing fluid is repelled from the mesh.	The screen was not adequately degreased before making the stencil.	Prepare screen by scrubbing with grease-dissolving cleaning detergent. Rinse thoroughly.
The image won't wash out of the screen.	1. The exposure is too long. 2. The transparency is not opaque enough. 3. The emulsion too thin.	1. Test exposure times. 2. The image areas on the positive need to be dense and light opaque. This problem occurs most often with oiled photocopies. 3. Coat the screen with more layers of emulsion—one on the front and two on the back.
The image washes completely out of the screen.	1. The image is underexposed. 2. The rinse water too hot. 3. The emulsion is old.	1. Make sure the light in the exposure unit is working. 2. Use cold water to rinse. 3. Use fresh emulsion.
The photo emulsion has thick streaks.	There are nicks in the scoop-coater.	Recoat the screen with a smooth coater or squeegee.
The photo emulsion is uneven.	1. The screen is slack. 2. Technique is developing.	1. Choose a tight screen or restretch the existing screen. 2. Practice applying the emulsion. Using firm pressure, watch as you pull the scoop-coater up the screen, making sure it remains in contact with the mesh.

Problems in printing

Problem	Reasons	Remedies
There is a strange plaid-like or wavy pattern in a halftone photo stencil.	This is a moiré pattern. It is really a problem with the stencil, but it is not seen until the image is printed. The screen is interfering with the halftone pattern of the photo stencil.	Halftone rulings (lpi) should not be multiples of the screen mesh. Make sure to align the stencil to the screen carefully.
The ink bleeds under the stencil.	1. The ink is too thin. 2. The screen has shifted, causing misalignment.	1. Mix a new ink that is not so runny. 2. Make sure the screen is clamped tightly to the table.
The paper sticks to the screen after printing.	1. Printing large areas causes paper to cling to screen. 2. The screen is resting on the surface.	1. Spray a little bit of spray adhesive on to the table surface to hold paper down when screen is lifted. 2. Make sure screen does not rest flat on the surface. Tape 2-ply cardboard spacers at the corners.
There is a texture or pattern in the ink solid.	1. The screen mesh is not taut. 2. The screen is in contact with table.	1. Choose a screen with a tight mesh. 2. Tape board squares under corners to keep the screen off the print surface.
The ink dries in the screen.	1. There is too long between print and flood stroke. 2. Forgotten flood stroke. 3. The ink is drying too fast.	1. Flood the screen immediately after pulling a print so that the screen is not exposed to air. 2. It may be necessary to clean the screen before proceeding with printing the edition. Try cleaning with a water sprayer and rags with the screen in place first. For stubborn problems, proceed to a full wash-out. 3. Add drying retarder to the ink (propylene glycol or glycerin).
The ink deposit is thick and the image is not crisp.	1. There is excessive pressure in the flood stroke. 2. The squeegee is not sharp. 3. The squeegee is not held at the correct angle during the printing stroke.	1. Do not push ink through on the flood stroke; use a gentle stroke to just cover the opening with ink. 2. Make sure the squeegee blade is sharp for paper printing. Freshen the edge on fine sand paper. 3. Hold the squeegee at a 60-degree angle and print with a firm, quick stroke.
The layers don't align properly.	1. The screen is not clamped firmly and has shifted. 2. The registration has become misaligned.	1. Make sure the screen is firmly clamped in place. 2. Reestablish registration pins or tabs to align the print paper to the Mylar. It may be necessary to check each print with the Mylar in case the misalignment is inconsistent in the edition.

Chapter 4: Relief

Problems with the material

Problem	Reasons	Remedies
My linoleum is curled and won't stay flat.	Linoleum cut from a roll has a "memory" and wants to retain the curl.	*As you cut, the linoleum will relax, but if you want a flat piece from the beginning try these remedies:* Roll the piece in the opposite direction, tie the roll, and let it remain in that position for a few days before using. Cut your piece to size and put it under a heavy weight for a couple of weeks. Dampen the back of the linoleum to expand the burlap and dry it under weight to "restretch" the burlap. This can be done on the hotplate with a low setting to expedite drying. Be careful to let the burlap dry thoroughly before removing from pressure, otherwise it will shrink and exacerbate the curl. Once a few cuts have been made, you can mount your linoleum onto a piece of board. To do this, spray lightly with a spray adhesive, then stick to a piece of plywood. Tap a couple of small brads into the cut recesses. This will hold the piece in place while you continue cutting. You can proof by hand from this setup or simply peel the linoleum up when you want to print on a press. Having the linoleum mounted can facilitate using a bench hook as well.
My linoleum is hard and difficult to cut.	With age, linoleum can dry out and become difficult to cut or may crumble or flake while carving.	Make sure your tools are sharp. Warm* the linoleum to aid cutting; possible heat sources are a hair dryer, heating pad, hotplate, or warming tray, set at low temperature. *Be careful: too much heat can further dry the linoleum rather than just softening it, making your problem worse. Never put the entire piece in an oven—you will cause moisture in the linoleum to expand, make bubbles, and crack.
The wood that I am using is warped and difficult to print.	1. Inattention to selection of boards can result in the purchase of wood that is too "green" and is continuing to dry, or is already curled. 2. Old cuts will curl from being stored vertically.	1. Make sure you pay attention to the flatness when purchasing wood. Buy pieces that are kiln-dried and flat to begin with. 2. Store printing blocks flat so that gravity works with you. a. Print by hand—this is the typical remedy. b. If the warp is slight you can sometimes print effectively on the press by positioning the curl parallel to the press cylinder.
My cuts are jagged and tear the wood.	1. The tools are dull. 2. You're cutting across different grain densities.	1. Keep tools sharp. 2. When working with wood with pronounced grain variations, cut with the direction of the grain. For curved lines, establish an edge with the knife, then clear with gouges in the grain direction.
Oops! I cut away an area that I did not want to cut!	1. Your tools are slipping. 2. The image has not been adequately planned.* *Note: This is not to imply that working spontaneously is bad. As you gain experience, you can determine what level of preparation suits your style.	*Carving mistakes can be difficult to correct. Avoiding them in the first place is best:* 1. Keep your tools sharp! 2. Draw as much info as you need to see where you are going. If you have a lot of detail that is important, make sure it is transferred to the block before you begin. *But if you make a mistake:* Try to incorporate the mistake into the design. Replace the cut piece with wood glue (wood) or a flexible adhesive such as epoxy (linoleum), and sand to smooth the repair. If you don't have the mistakenly cut piece, try filling the cut with wood putty (wood) or a flexible filler (linoleum). You can also try to make a paste of ground-up linoleum and epoxy.

Problems in printing

Problem	Reasons	Remedies
My image is not sharp and lacks detail.	1. Too much ink on the block squishes over the edges and can cause blurry shapes or filled-in detail.	1. The ink should have a smooth, velvety surface.
	2. The ink is too soft.	2. Add a bit of magnesium carbonate to stiffen the ink. Be careful to retain appropriate stickiness ("tack"). Add a little #7 or #8 varnish if needed.
	3. The paper shifts during printing.	3. See the remedies for paper shifting (page 90).
The paper shifts during printing causing a blurry, double-vision quality in the print.	1. As you print by hand, the ink is transferred to the paper and has less ability to stay in place.	1. When hand printing, use a bit of lightly sticky artist's tape to keep the edges paper in position. Don't peek too soon, as replacing the paper in the exact position can be difficult, especially with big paper.
	2. The ink is too slippery.	2. Try a slightly tackier ink.
	3. When using an etching press, the paper can shift in the direction of the press as the paper and block meet the cylinder, causing the whole image to print twice—once when it is first laid on the block (lighter), then as it goes through the press. Alternatively, the paper can stretch as it moves across the surface of the block, creating a characteristic rippled texture called "push."	3a. Set up the press so that you can engage the paper before placing the block. Lower the paper slowly as you crank the press so that it touches the ink layer as it is printed.
		b. Lay down a piece of board (book board, thin plywood, or Formica laminate) after you have placed the paper. This layer absorbs the bump from the press and helps to keep the paper from moving.
The image is grainy.	1. There is not enough ink.	1. Determine the amount of ink needed through proofing on newsprint. You might need to add another pass or two for a softer, thicker paper.
	2. There is not enough pressure when printing.	2. Make sure the press is set at the proper pressure before printing. This should be determined in advance by running the un-inked block through the press with a piece of newsprint. Check the embossment.
	3. The ink is too stiff.	3. For stiff ink, add some oil or a small bit of reducing compound.
	4. The paper is too textured or hard.	4. Choose softer papers. Smooth, waterleaf (unsized) papers are easiest.
		If your aesthetic demands a harder or textured paper, try printing with a slightly dampened paper (using a damp-box).
The image has an undesirable texture.	1. The block was not prepared adequately.	1. If you want a very smooth flat surface, be sure to prepare the block material before cutting. Coat linoleum with gesso or wood with shellac and smooth with a fine steel wool or sandpaper.
	2. The ink is too thick.	2. Make sure the ink layer is velvety and smooth.
	3. There is too much pressure.	3. Adjust pressure settings to accommodate the combination of felts, backing boards, paper, and block thickness for your print. This can vary from print to print!
	4. The block has not been adequately cleaned from previous printing.	4. Clean blocks after printing to avoid build-up of ink.
	5. The paper has shifted across the surface of the block during printing, leaving the "push" texture.	5. See the remedy for paper shifting above.
I can't see the hue of my dark color.	The color is too opaque or dark.	Add transparent base or white ink to the ink mixture until the hue is satisfactory.
My second color is not registering to my first color.	1. The first color was printed incorrectly.	1. Check the registration marks for correct orientation of the paper. If you printed everything upside-down, for instance, correct your markings for subsequent printings.
	2. The second color registration guides are not correct.	2. Revise your registration guide marks, using a proof on Mylar to locate the correct positions of the registration guides.
	3. The punch registration holes may have stretched.	3. Re-attach new punch tabs using a Mylar proof to position the print to the tabs.
I printed a sheet crooked.	The paper slipped or was placed haphazardly.	Take care when placing paper to avoid mis-registration.
		Establish a revised registration as described above.

Chapter 5: Intaglio

Platemaking

Problem	Reasons	Remedies
There is an overall gray tone on the plate after line etching.	The ground is too thin, creating false biting.	Once the plate has been etched, this tone has been established in the plate. It can be modified with scraping and burnishing, but is difficult to remove entirely. Begin with a fresh plate and use a thicker application of hard or soft ground. Or. . . work with it. . . Consider this kind of incidental "noise" as part of the process.
The ground pulls away from the plate.	The plate is not thoroughly degreased.	Clean the ground off the plate and begin again. Be sure to degrease until water sheets off the plate.
The soft ground did not work —the textures/drawing did not etch.	1. The ground is too thick. 2. The ground is too hard. 3. The ground is too dry. 4. There was insufficient pressure to remove the soft ground.	1. Apply a thin, even ground. It should be quite translucent. 2. Soften traditional paste ground by adding tallow or petroleum jelly. 3. Work with water-based grounds immediately after applying. 4. Hand-drawn textures usually require a softer ground compared to textures established on the press. When working on the press, check the pressure before modifying the ground mixture.
The soft ground image etched unevenly.	1. The ground was applied unevenly. 2. If materials used to remove soft ground were used before, they may reapply ground rather than taking it off.	1. Take care to apply an even ground. 2. Use clean, non-greasy materials to impress textures.
There is an unwanted gray tonality all over my soft ground plate.	Ground can be removed by protective sheets when establishing textures with the press, or by resting your hand on the plate while creating a drawn soft-ground plate.	Use stopout to protect areas of the plate that should not be etched. However, since soft ground creates a tonal field, stopout shapes are visible. Take this into account by carefully applying stopout or incorporating stopout in the drawing process.
The printed aquatint tone is undesirably uneven.	1. The plate was not sufficiently degreased. 2. The aquatint was applied by hand unevenly.	1. Areas can be sanded or scraped and burnished to reclaim the area. Degrease thoroughly, then re-aquatint. 2. Hand-dusted rosin aquatints are the most difficult to control. Spray aquatints (airbrush or spray enamel) are hand-applied alternatives that might be easier. An aquatint box creates a uniform dusting of rosin.
The printed aquatint is a splotchy gray.	*Crevé* occurred because. . . 1. The aquatint was applied too thinly. 2. The plate was etched for too long. 3. The aquatint was not sufficiently fused to the plate, so it came off in the acid bath.	1. Check coverage of the aquatint ground with a magnifier. 2. Make a test plate to determine accurate etching times. 3. Before putting the plate in the acid, check a small area with a cotton swab to make sure the aquatint is durable. If the aquatint seems to be lifting off or *crevé* is apparent once in the acid bath, you may be able to salvage some of the work. Remove the plate, dry it, apply a spray paint aquatint on top of the existing one, and continue to etch.
The printed aquatint shows almost nothing.	1. The acid was weak. 2. The aquatint was applied too thickly. 3. The rosin aquatint got too hot, becoming liquid and fusing together.	1. Check the strength of the acid bath with a test plate. 2. Aquatint particles should cover the plate about 50 percent. Check aquatint coverage with a magnifier before etching. 3. Heat just until the dust melts, but no more.

Printing

Problem	Reasons	Remedies
The print has too much or not enough value contrast.	1. The plate itself does not contain the desired contrast. 2. Under-wiping leaves an overall plate tone, wiping clean delivers a higher contrast image. 3. Printing the plate warm or cold can affect how the ink prints. 4. Paper choice can affect the range of tone printed.	1. Continue plate development to achieve the desired tonal range. 2. Tonal ranges inherent in the plate can be enhanced or minimized with selective hand-wiping. To enhance brightness, wipe until the white areas on the plate are shiny for high contrast. To soften information, pull some ink back out of the lines with *retroussage*. 3. Warm plates soften the ink and print more tone. Ink will stiffen on a cool plate and print with more contrast. 4. Papers with more sizing tend to print with higher contrast, while minimally sized or waterleaf papers are more sensitive.

Problem	Cause	Remedy
The plate was very difficult to wipe.	1. The ink is too sticky. 2. The plate was inked too cold.	1. Try adding a reducing oil or a reducing compound, such as Easy Wipe. 2. Use the hotplate to warm the plate during inking.
The ink appears dull.	There is too much modifier in the ink.	Use less oil or reducing compound.
The lines are not printing sharply.	Ink that is too oily oozes out of deep lines.	Use a stiffer ink. Wipe deeply etched areas thoroughly.
There is a ripple texture in the relief-rolled ink surface.	This texture is called "push." It is caused by the paper shifting across the plate as it is being printed.	Lay the dampened paper on the registration guide first. Place the cover sheet, then the blankets, engage them in the roller, then flip them out of the way. Place the plate on the registration guide. Hold the paper and blankets up and lower them onto the plate as the press is cranked through.
There are scratches in the plate that were not present before printing.	The inking cardboard, squeegee, dauber, tarlatan (scrim), or the ink itself has some dried, hard matter that is scratching the plate when ink is applied.	Make sure the ink mixture is smooth. Remove any bits of dried ink from the can or cartridge to ensure a smooth ink mixture. Replace old ink if the problem is in the ink container. Check the ink spreaders and wiping materials and discard contaminated pieces. Burnish the plate to remove unwanted scratches.
Ink has squished out of some of the lines.	The ink may be too loose.	Use a stiffer ink or add mag to stiffen an ink.
There are white areas in the lines of the print.	1. There is insufficient inking. 2. There is insufficient press pressure. 3. There are very deep lines. 4. The paper is too stiff. 5. Wet paper rejects ink.	1. Use more ink. 2. Increase pressure by tightening pressure screws or use extra packing. 3. Rub a little burnt plate oil into the plate before inking. 4. Soak sized papers for at least 1 hour. 5. Make sure to blot and brush the paper sufficiently before printing to remove surface moisture.
There are little specks on the print after printing.	Stray bits of paper in the water bath or on blotters stick to the paper and act as tiny stencils, blocking the ink from adhering to the print paper.	Check the paper-soaking bath for flotsam. Refresh the water if needed. Replace blotters if necessary. Brush the paper surface thoroughly before printing.
There are little specks on the print after drying.	There is dust between the drying boards or on the protective newsprint.	Use clean newsprint only to interleave wet prints in drying stacks. Dry with open-air system.
There are splotchy light areas in the print.	The paper is not evenly dampened or blotted.	Soak the paper for the required minimum period. Blot and brush thoroughly—leave no shiny damp water spots; or use a damp pack instead.
There are unwanted light shapes or areas in the print.	This is caused by uneven pressure due to embossment, uneven wear, or cuts* in the printing felts. *If the blankets are cut, they must be replaced (although you may be able to salvage some smaller blankets out of a bigger piece). Save old felts to use for extra cushioning with collagraph and deeply etched plates.	Check the pressure settings—they should be the same on both micrometers. Check the felts for possible damage. If the felts are embossed, they can be soaked to re-expand and then fluffed. Once they are partly dry, run them through the press to flatten them again. It is good to have an extra set of felts in case you need to pursue this remedy.
There are pressed fold marks in the print.	The blankets were crumpled or folded during printing, creating extra pressure in the fold area.	Pull blankets taut before pulling the print. If you have creased the blankets, dampen and flatten them as described above.
The print is cut at the plate mark.	1. There was insufficient plate bevel or degradation of the bevel during the etching process. 2. There was too much pressure on the press.	1. Check for a proper 45-degree bevel. Freshen the bevel if needed. 2. Ease up on the printing pressure.
There is ink around the plate mark.	1. Ink from the back of the plate has squished out. 2. The plate has shifted during placement, leaving ink on the registration Mylar or pressbed.	1. Wipe the back of the plate before printing. 2. Clean around the plate before placing the paper.
The borders are messy.	The registration Mylar was dirty.	Wipe the registration Mylar clean before each print—use spray cleanser or alcohol, mineral spirits if needed.
The print is not square to the paper.	1. The registration guide was inaccurate. 2. The paper was placed inaccurately. 3. The plate or paper shifted.	1. Check the registration measurements. 2. Be careful when placing paper. 3. Engage the blankets and paper before placing plates. Lower the blankets and paper into position.

Chapter 6: Collagraph

Problems with the plate

Problem	Reasons	Remedies
The cardboard plate is curled from using wet media.	The cardboard isn't thick enough to handle the amount of moisture. The plate wasn't dried under a weight.	Atomize the back of the plate with water to relax the plate and redry under a board. Spray-mount the cardboard to a second, thicker/stable board (paper, wood, or thin aluminum). Use plastic, metal, or wood base.
The plate is falling apart during printing.	1. The items were not adequately glued in place. 2. The cardboard plate is too thin or has been weakened by reductive processes.	1. Re-glue dislodged pieces, being sure to get glue on all surfaces. Dry under a weight. 2. Mount to a second board.
The photo-collagraph emulsion is pulling away from the plate.	Contaminated prep materials, emulsion, brush or base-plate have been used.	Use fresh plate-prep materials. Make sure the brush is clean. Use fresh emulsion. Sometimes oils leach from the manufactured wood plate. Seal the plate with shellac before attempting to re-coat.
The photo-collagraph won't rinse out.	1. The plate was overexposed. 2. The transparency is too thin. 3. The exposure unit was not set up properly.	1. Check the timing; make test-plates to determine correct exposure for the equipment in use. 2. The transparency must be light-opaque. 3. Make sure the transparency is on top of the emulsion and faces the exposure light (this problem occurs when the setup is upside-down).

Problems in printing

Problem	Reasons	Remedies
The paper stuck to the plate.	1. The plate was not sufficiently dry. 2. The plate wasn't conditioned prior to first printing.	1. Spray the back of the stuck paper with water to help remove it from the plate. Remove the ink with mineral spirits and let the plate continue to dry. 2. Condition the plate with anti-skin spray before attempting to print.
There are ink squishes from heavy textures.	The textures hold too much ink.	Reduce the capacity of the texture to hold ink by sanding it down or filling it with wet media or shellac.
Some areas don't print.	1. The height changes in the plate are too acute, and the paper cannot bend to pick up ink. 2. The paper is not sufficiently soft.	1. Reduce the surface height on the plate. Or: Create individualized packing to push the paper into the physical recesses of the plate. 2. Soak the sized paper for at least 1 hour.
The printing paper tears during printing.	Too much surface variation and/or sharp edges.	Reduce by sanding.

Chapter 7: Lithography

Successful lithographic printing is perhaps the least forgiving of the various printing processes. It requires a stable image to be maintained through a complex choreography of etching, ink modifications, and the printer's skill of roller work on the printing element.

Knowledge about the chemistry of the process and sensitivity to the physical components of the printing process are key to problem solving.

Problem	Reasons	Remedies
Darkening image; the image rolls up too fast.		*These remedies all require bringing detail and clarity back to the image by proofing back, gum massage, or, if serious, wet wash. These procedures are described on page 228. Once the image is recovered, follow these guidelines to prevent recurrence:*
	1. The matrix is not etched properly.	1. Give the element a stabilizing etch after image recovery.
	2. There is too much ink.	2. Reduce the slab or rollup matrix with fewer cycles or passes per cycle. Use quick passes, since sluggish rolling can deposit more ink.
	3. The ink is too soft.	3. Stiffen ink with mag and maybe #7 varnish.
	4. Not enough ink was removed during printing.	4. Increase the pressure on the press slightly to remove more ink.
	5. The printing environment is warm, causing the ink to soften and fill.	5. If the printing environment is hot, try sponging with cold water to help keep ink stiff.
Scumming, coarsening.	1. The printing element loses chemical balance over the course of a long printing session, because the buffering agents of paper attack adsorbed gum film.	1. Loose-gum the image periodically to restore adsorbed gum film.
		a. Add a small amount of gum arabic to the sponging water (fountain solution). The slightly acidic sponging water reinforces the adsorbed gum layer. Caution: too much gum can burn delicate areas.
		b. Add a small amount of mag to the sponging water to gently clean the image when sponging.
	2. There is too much mag in ink mixture.	2. Add #3 varnish to increase the grease content of the ink.
	3. Some color inks become waterlogged (flocculation) during long printing sessions.	3. For waterlogged ink, clean the roller and replace the slab with fresh ink. Proof back the printing element and resume printing with new ink.
Fading.	1. There is not enough ink.	1. More cycles of ink will bring it up full.
	2. The grease reservoirs of the stone need replenishing.	2. Use a greasier ink (add #3 litho varnish). If it's severe, roll up with greasier black and give a stabilizing etch.
Mis-registration.	1. Paper stretching causes the first printed layer to distort.	1. Pre-stretch the paper before printing (calendaring).
	2. The registration is inaccurate.	2. Print a Mylar of the current color, being sure to mark position of the registration marks. Align the Mylar to subsequent prints and correct the registration if needed.
Tinting out.	Water-soluble pigments have leached into the printing water.	Add mag to the sponging water.
Streaking.	Caused by excess water left on the stone or plate from sponging.	Don't sponge after the last roll.
		Add a few drops of glycerin to the sponging water.
Push—an unwanted rippled texture in a flat area.	1. The ink is too soft.	1. Stiffen the ink with mag.
	2. The paper is stretching or moving.	2. Pre-stretch (calendar) the paper. Lower the paper to the matrix as it goes through the press.
Offset—the ink from a previous layer of printing comes off on the matrix during subsequent printing.	1. The ink is not sufficiently dry.	1. Sponge thoroughly before laying paper, or wait longer before printing next layer.
	2. The matrix dried out before laying the paper.	2. Increase the humidity to keep the printing element from drying too quickly.
Marking—unwanted roller marks, usually seen in transparent inks.	1. The ink is transparent or soft.	1. Feather the rolling pattern to distribute ink more evenly.
	2. The roller has picked up information from slab or image.	2. Use a larger roller and ink without spinning.

Chapter 7: Lithography cont.

Litho Image Recovery Procedures

To correct filling problems, the image must be reclaimed before attempting to stabilize the matrix for further printing; otherwise, stabilizing measures will reinforce the darkened state. These procedures are presented in an increasing order of risk. Try the simplest and potentially least damaging remedy before resorting to solutions that are more aggressive.

● **Proofing Back**
Take several proofs of the image on newsprint without inking it up in between. Continue to proof back until most of the ink has been stripped off the image. Resume quick, sharp inking passes until the image is rolled up. Assess the filled-in areas of the image. If they have been cleared, loose-gum (see below) or give a stabilizing etch to the image.

● **Loose Gumming**
This is essentially a mild etch without having to go through the standard washout and rollup. Simply sponge some gum arabic over the inked-up image and pull down to a thin film. Let it rest for 15 minutes or so. When ready to resume printing, take off the gum with a clean sponge and pull a proof. Resume normal printing.

● **Gum Massage**
After pulling a darkened proof, massage a small amount of gum into the filled-in area. Sometimes it is necessary to force gum into the filled area more aggressively by patting or beating gum into the affected area with a sponge. The gum should lift excess ink particles, making the gum solution look dirty. As this happens, wipe off the gum with a sponge and ink up the image with sharp, lean passes. Continue to alternate the gum-massaging or beating with the cleaning passes. If details return in the image, stop when the image is rolled up to printing strength, dust, and give a stabilizing etch. Be careful not to over-etch any delicately rolled areas. Any parts of the image that were working before will probably only need straight gum arabic or the mildest of stabilizing etches.

● **Wet Wash**
A wet wash is a last-resort remedy for regaining areas lost to filling-in. It is somewhat risky, because all areas of the printing element become exposed and vulnerable. However, when done right, it often seems to be the miracle cure. After the last unsuccessful proof, sponge a generous amount of water onto the image. Pour lithotine directly into the water on the printing element. Wash the image with a rag until all traces of ink are gone. It is important to work quickly; if water stays on open areas for too long, it may burn the image. Once the image is clear, dampen it with a clean sponge and roll up rapidly with a lean roller. Assess the problem areas. Dust and give a stabilizing etch. Rest the matrix for at least 20 minutes to let this etch work, then wash out and roll up normally. As proofing commences, keep an eye on the problem areas so that a repeat wet wash is not necessary.

Chapter 8: Monoprint

Oil-based monoprint

Problem	Reasons	Remedies
There are roller marks in the field.	1. This is most noticeable with transparent inks. 2. A small roller or brayer was used to apply ink to a larger surface.	1. Use a more opaque ink mixture. 2. Feather the roller strokes to minimize marking or incorporate roller marks into the image idea.
There is ink squish.	Ink applied too thickly squishes when run through the press.	Apply ink with the idea of visual rather than physical textures. Before running a plate through the press, blot excessively thick deposits of ink.
The washes I made did not print.	Plate development took too long and the wash has dried.	Add clove oil to the wash mixture. Print wash layers within a half hour of application.
The flat color areas printed "salty."	1. The paper is textured or dry. 2. There was insufficient pressure on the press. 3. The plate surface has a texture.	1. Use a smooth, soft paper (waterleaf) if dry printing. Or: Dampen sized paper as for normal intaglio printing to increase receptivity. 2. Make sure the press settings are accurate. 3. Choose a very smooth surface for solid color.
Unwanted marker lines have printed on my monotype!	The guide marks were inadvertently drawn on the wrong side of the acrylic sheet.	Clearly mark the BACK of the plate to avoid confusion.
I expected a soft line, but the line of my trace monotype is too blurry.	The quality of the line is dependent on the tool and the paper that are being used. The ink surface was too thick.	Hard, pointed tools will make a sharper line. A thinner smooth paper also yields more detail. Experiment with various tools and paper to get the degree of clarity desired. Roll a very lean slab for a trace monotype.

Watercolor monoprint

Problem	Reasons	Remedies
The color became a big puddle when I printed.	1. The watercolor was not dry. 2. The paper was too wet.	1. Be sure to wait until the watercolor has dried completely. 2. Paper needs minimal soaking and must be blotted and brushed. The surface should not have any wet puddles. Prepare the paper as for normal intaglio printing.
The watercolor beads up on my plate.	The plate was not thoroughly degreased or prepared with gum arabic.	Clean the plate surface with cleanser . Buff in a thin layer of gum arabic.
Some of my crayon marks did not print.	1. The crayons were not water soluble. 2. The crayons were old or of insufficient quality. 3. The paper was not sufficiently damp to release the watercolor crayon.	1. Keep watercolor crayons separate from wax or oil-based crayons to avoid confusion. 2. Purchase better quality supplies for reliable printing. 3. Dampen paper as for normal intaglio printing.

Glossary

À la poupée A manner of inking intaglio plates where many colors are put on at the same time, using a small dauber (French, *une poupée*, a doll).

Acetic acid (CH3COOH) A degreasing agent, used in a 5% solution. White vinegar is a substitute.

Acetone (CH3COCH3) Dimethyl ketone. A colorless solvent used for degreasing and photocopy transfer.

Adsorbed grease reservoir An oleophilic character of the lithographic stone, caused by a reaction of the stone with acidified gum arabic when alkalis and fats are released into the stone surface.

Adsorbed gum film The layer of calcium nitrate that forms in the surface of the limestone during the lithographic etch process.

Albion press A variation of a platen-type iron hand press, used for relief printing.

AP Artist's proof. A designation on prints that conform to the edition, but kept by the artist, usually numbering no more than 10 percent of the total edition.

Aquatint A specialized etching process that yields tonal variations.

Asphaltum A solution made from tar that is used to cover or stop out plates when making an etching.

Ball ground A traditional wax-based ground for intaglio line etching.

Baren A hand-held tool used to burnish paper that has been placed on an inked block.

BAT (*bon à tirer*) The designation on the proof that becomes the standard for an edition of prints (French "good to pull").

Baumé The measure of specific gravity of liquids; used when checking the strength of ferric chloride.

Bench hook A device used to increase safety when carving a relief block. When the block pushes against the rail of the bench hook, it is held steady so that hands can stay out of the way of cutting tools.

Bevel A 45-degree angle established on the edge of a metal intaglio plate to prevent damage to printing felts.

Bit Smallest unit of data.

Biting the plate The process by which a metal plate is etched in a diluted bath of acid or other etchant solution.

Bitmap An image mode, which reduces all information to either white or black Bitmap images. It can be made in two basic forms, diffusion dither or halftone, each of which has several variables that can alter the appearance of the image.

Black line A relief print technique where the image is defined by the lines that remain after carving the block; if printing with black ink these are the black lines that remain.

Blankets Felt blankets are used when running an etching plate through the press. Typically, three different blankets are used. The top blanket is called the pusher felt and receives the most abuse from the press cylinder. It is made of a woven felt so that it can withstand the wear and tear. The next blanket is called the cushion blanket or the forming blanket. This is the thickest blanket of the three and is used as a cushion so that the paper can form around the plate as it passes through the press. The bottom blanket is called the sizing catcher. This is a thin blanket that is used to absorb the excess water and sizing that comes off the paper as it runs through the press.

Blotter Heavyweight absorbent paper sheet used to remove excess water from soaked paper.

Brayer Also known as a roller and used to apply a relief layer of ink on to a matrix.

Burin A pointed engraving tool that comes in many different profiles.

Burnisher A hard tool that is used to smooth rough or scratched areas of a metal plate.

Burnt plate oil A partially polymerized linseed oil used as a vehicle for oil-based intaglio inks and as an ink modifier.

Carborundum Silicon carbide (SiC). Carborundum grit is a very hard abrasive used to grind lithographic stones. It is also used with glue or shellac to make collagraph plates.

Chemical deletions Removing information from a lithographic printing matrix with solvents as opposed to physically abrading information away. Chemical deletions are most often used with plate lithography.

Chine collé A French term describing a collage element, usually made of thin Asian paper, that is printed and glued to the print at the same time.

Citric acid Used in lithographic counter-etches. Also an ingredient with ferric chloride for the Edinburgh Etch for copper intaglio plates.

CMYK Cyan (C), Magenta (M), Yellow (Y), and Black (K) are known as process colors for printing.

Collagraph A combination of the words "collage" and "graphic" to describe a print made from a matrix built with collage materials. Also encompasses intaglio matrices made with photo-sensitive films or emulsions applied to non-metal substrates.

Color separation To make a multiple color print, an image must be divided into layers of separate color. Sometimes the colors are printed as solids that stand on their own (spot colors) and are printed with a unifying layer (key image). Another approach is to convert an image into process colors, which are printed in halftoned layers.

Copper Sulfite Etch (Bordeaux Etch) An etching solution made by using copper sulfate, a corrosive salt that can be found in garden centers and commonly used as a fungicide.

Counter-etch To re-sensitize a lithographic printing element.

Crevé The point during etching of an aquatint when the undercut biting of the acid causes a breakdown of the plate to the point where it no longer holds an even tone of ink.

CTP (color trial proof) A color state proof.

Damp pack A system of dampening paper in lieu of soaking; esed for delicate or waterleaf papers and as an efficiency measure when editioning.

Degreasing Cleaning a metal etching plate with cleansers to prepare it to receive a ground.

Diazo A light-sensitive substance used in screen-printing photo-emulsions.

Diffusion dither The digital translation of tonal information into a bitmap system of black or white pixel dots arranged in various densities (frequency) dots to simulate a continuous gradation of value.

Digital print A print produced and output through digital means.

Digital workflow The use of the digital technology, (computers and software, cameras, scanners, laser- or computer-driven cutting machines, and printers) at various stages of image production including image input, processing, matrix-making, or output.

Double drop A color-intaglio printing option where the same plate, inked differently, is printed twice in register on the same print.

dpi dots per inch.

Duotone A two-color print employing halftones of the same image made with varying tonal range. Usually printed in black and one color.

Draw-down A small sample of ink scraped across a clean sheet of paper for testing ink properties, such as hue or opacity.

Drypoint An intaglio technique where the image is created by direct drawing into the plate using a sharp tool. The darkness of the line varies depending on the depth of the mark.

Drypoint burr Scratching with a drypoint needle raises a burr that also captures ink. This yields the characteristic soft black velvety line of the printed image.

Durometer A measurement of the stiffness of rubber used to make squeegees, brayers and rollers. The term "shore" is used in the UK.

Dutch mordant A corrosive solution made of hydrochloric acid and potassium chloride used to etch copper plates.

Echoppé A specialized intaglio tool that makes lines with varied width by working the tool at different angles. Also called a cat's tongue.

Edinburgh Etch A ferric-based etching solution developed by Friedhard Kiekeben at the Edinburgh workshop, which eliminates the sediment problem inherent in the basic ferric solution.

Edition A number of identical copies made from a matrix or set of matrices.

Embossing A physical impression of the matrix in to the printing paper. Most often seen in deeply bitten intaglio, collagraph, or relief matrices. Also used to refer to prints without ink, also called "blind" embossing.

Emulsion A light-sensitive liquid for coating screens for photo-processes in screen printing.

Etch solutions In lithography, etch solutions are made with gum arabic and acid. Mixtures are made with varying strengths of acidity to correspond to the strength of the drawn image. Different acids are used, depending on whether the litho is made on a stone or plate.

Etchants A general term referring to the acids or corrosive salts used in etching.

Etching needles Any sharp pointed drawing tool that can be used to scratch through a ground to expose the metal plate, which will be etched in an acid bath.

Etching press A wringer-style press action for printing intaglio plates.

Feathering 1. As zinc etches in nitric, bubbles of nitric oxide are created. Feathering means to gently stroke the plate surface dislodging the bubbles in order to prevent them from leaving their impression. 2. An inking technique where a roller is lifted from the matrix as the ink is applied to minimize roller marks.

Felt dauber A rolled up strip of felt used to ink collagraph plates; works best for very physical plates.

Ferric chloride Also known as iron perchloride, is a corrosive salt. It is a less toxic etchant for copper.

File format When working with digital images, files are stored in a particular digital arrangement, called a format. TIFF (Tagged image file format) and JPEG or JPG (Joint Photographic Expert's Group) are the most common for raster images.

Flexographic plates Photo-sensitive polyester plates used for relief or intaglio printing. Plates come in varying thicknesses and with different backing materials, marketed for different purposes.

Flood stroke In silkscreen, the ink is gently pulled across the screen in order to fill the stencil opening with ink.

Gel medium A thick acrylic gel used to coat and texture collagraph plates.

Generative matrix The concept of the capacity of any plate, block, screen or stone to generate a variety of printed results.

Gesso A heavily pigmented acrylic primer. A thin layer can be used to prime a linoleum block to aid visibility of a guide drawing.

Giclée A fine art inkjet print (French *gicler*, "to spray").

Gouge A hand-held carving tool that is used to remove material such as wood or linoleum when making a relief block. These tools come in many shapes and sizes primarily U-shaped and V-shaped.

Grayscale A digital image without color, but representing a full range of gray tones.

Grease content An important consideration for lithographic drawing materials and inks.

Ground texturing punch A hardened metal tool used to hammer patterned marks into a ground or directly on etching plates.

Guide pattern A registration method that locates the relative position of printing matrix and paper.

Gum arabic A substance from the acacia tree, used for lithographic etches and often as a binder in water-based pigments.

Halftone The translation of tonal information into a bitmap system of various sized (amplitude) dots to simulate a continuous gradation of value.

Hand wipe A final wiping stage of intaglio printing where the hand is dusted with French chalk and gently wiped across the surface of the plate to fine-tune highlights of an image.

Hard ground A hard-drying protective coating made of wax, asphaltum, and rosin. The ground is applied to a metal plate and scratched through with a needle to expose the metal so that it can be etched in the acid bath.

HIPS (High Impact Polystyrene) A lightweight plastic that comes in sheets and can be cut to shape with scissors or a mat knife. These shapes can then be inked as a relief surface and/or used as stencils.

Hydrometer Device used to measure the specific gravity of the ferric chloride solution used for etching.

Hydrophilic Water-loving.

Hydrophobic Water-hating.

Ink slab Ink rolled to a thin, even film on a glass or otherwise smooth surface for relief or lithographic printing.

Inkjet print A print made with an inkjet printer, which sprays minute droplets of ink onto the printing surface.

Intaglio The word intaglio means to engrave or to cut into and describes the making of metal printing plates. Traditional platemaking processes fall into two categories, those where lines are inscribed directly by hand, such as engraving, and processes that employ acids to establish images on metal, known as etching. In contemporary usage, the term intaglio can refer to any printing matrix where the ink is held in recessed areas of the matrix.

Jig (for tool sharpening) A device used to hold the face of an engraving burin at the proper angle relative to a sharpening stone.

Jig A simple registration device made of mat board or heavy card stock that holds a plate or block in a fixed position relative to a cover sheet that can be moved and returned to the same position.

JPEG A file format for raster images; useful for internet transfer as the files are compressed and can be small.

Kentō A traditional Japanese registration system for woodcut where registration guides, or stops, are cut directly into the block. Paper is positioned at a corner stop *(kag)* then aligned along a side stop *(hikitsuke)*.

Laid lines A visible pattern of lines running the length of a sheet of paper created by the distribution of pulp on brass wires of the papermaking mold.

Lauan A thin, construction-grade plywood used for relief prints.

Leather roller Leather-covered roller used for lithography. The nap of the leather helps maintain image quality.

Letterpress A field of printing that incorporates hand-set metal type; the presses used to print type and other relief elements.

Levigator A tool used to grind lithographic stones.

Lift ground An intaglio technique that uses a water-soluble lift solution (sugar, tempera paint) to establish an image on the plate. Once dry, the lift solution is covered with a liquid hard ground. Once the liquid ground is dry, the lift solution is dissolved with water, leaving an open area on the plate. The plate is etched as an open-bite or further processed with aquatint.

Limited edition A fixed number of identical copies from one printing matrix. Sometimes the limit is determined by the wear and tear of the matrix. Sometimes the limit is an arbitrary determination, based on market concerns.

Linescreen Sometimes used to refer to the various patterns used to make a halftone, such as round, square, or elliptical dots, linear or other patterns.

Linocut A relief printing technique that uses linoleum as the matrix from which the image is printed. Linoleum does not have a grain so it is generally easier to carve than wood. It can be purchased mounted or unmounted.

Litho crayon A grease-based drawing material for lithography, graded according to softness and grease content. Litho crayons come in a variety of stick, pencil, and tablet forms. Rubbing crayon is a specialized form of crayon meant to be applied with a soft cloth or rag for subtle tonal effects.

Litho press A press for printing lithographic matrices; uses a scraping motion.

Lithography A planographic form of printmaking that relies on mutually exclusive printing and on-printing surfaces of the matrix. Traditional lithography depends on the antipathy of grease and water to create the limestone or metal plate (aluminium or zinc) matrix.

lpi lines per inch. The number of lines of variable-sized halftone dots per inch in a halftone screen.

Manière noire Also known as silk collagraph. A collagraph process by which a textured surface is selectively filled with a smooth, hard drying medium. The more the plate is filled, the less ink it will hold, creating highlights and tonal variations. (French "dark manner").

Matrix The plate, block, screen, stone, or other surface that carries the information for the print.

MDF Medium-density fiberboard is a commercial grade compressed fiberboard that is used as an alternative to wood or linoleum for relief printing. It is easy to cut and does not have a grain. It also comes in many different thicknesses and sizes and can be purchased at most lumber yards.

Mesh The fabric stretched across a frame for screen printing. Typically a monofilament polyester, it is measured in threads per inch or threads per centimeter.

Mezzotint An intaglio process in which the surface of a metal plate is roughened with a serrated tool to produce a fine, overall texture that, when printed, produces a rich solid. The image is established by scraping and burnishing into this texture.

Mezzotint rocker A curved fine-toothed tool that is rocked across a plate to create a textured surface.

Mock mezzotint Establishing a texture in a plate with soft ground or other means of roughening a plate surface. Highlights are created by burnishing the metal back.

Modifiers Substances added to printing inks to enhance printing performance.

Moiré An interference pattern caused by two overlapping regular grid or patterns. Moiré problems are seen in screen printing if the grid of the screen mesh is misaligned with halftones. The effect can also be seen in a print that layers several halftone layers. To avoid moiré, halftone screens should be rotated at 15-degree intervals.

Monoprint One-of-a-kind printed image. The general use of the term includes monotypes and prints that may involve a printing matrix with repeatable information. Used specifically, the term refers to one-of-a-kind images created with a repeatable matrix.

Monotype One-of-a-kind printed image made on an unarticulated surface.

Motorized tools Any tool that is powered by a motor. In printmaking, they are used to speed up the mark-making process or to remove large surface areas using abrasive pads or belts.

MSDS Material Safety Data Sheets. These provide information of chemical contents and known safety hazards and health effects.

Multiple An inherent capacity of prints to exist in duplication. Conventionally understood as the edition, the term is also relevant to the use of the matrix in a modular form or conceptually to enable mass distribution of printed information.

Mylar A generically used trade name for clear polyester film used for registration purposes.

Negative A particular kind of transparency used for photo-processes. The image is in reverse (black and white values are flipped). Used with processes that yield a positive when exposed to the matrix.

Nipping press A small press with a fixed base and a moveable upper platen. It is used for gluing operations in book binding and has been adapted for simple small-scale relief printing.

Nitric acid Very corrosive acid used for etching zinc plates.

Offset Ink transferred from a fresh print onto another surface, usually to aid development of multiple color plates.

Offset lithography A commercial form of lithography where the image is initially printed from a plate to a rubber blanket, then onto a final substrate.

Oleomanganate of lime A deposit of fatty acids from greasy drawing materials in the surface of the lithographic stone, creating a "grease reservoir" in the stone.

Oleophilic Grease-loving.

Output resolution The resolution of a digital image at the scale that it will be printed.

Oxidation A chemical reaction of metal to oxygen in the air. Oxidation can be a problem with lithographic plates and must be removed by counter-etching prior to working.

Paper wipe A step in wiping intaglio plates where paper is used to polish highlights and increase overall contrast.

pH scale A measurement of acidity and alkalinity. The scale ranges from 0—14. A reading of 7 is neutral, while below 7 is acidic and above is alkaline.

Photopolymer film A light-sensitive polyester film used for photo intaglio.

Pixel An abbreviation of picture element. The smallest level of detail in a rasterized digital image.

Planographic Prints from a flat surface. All forms of lithography, some monotype.

Pochoir A hand-stencil technique.

Polymerization A chemical reaction during drying of oils where the molecular structure of the oil changes, converting from a liquid to a solid.

Positive A transparency used for photo-printmaking. The image as it appears on the transparency yields the same image on a light-sensitive matrix.

ppi pixels per inch. A measurement of digital resolution. A high ppi yields more detail.

Process colors (CMYK) Cyan, Magenta, Yellow, Black.

Proofing The process of exploring inking and/or sequencing variations of a matrix or group of matrices.

Punch registration A registration system where a set of holes is punched in the edge of the paper. The holes are fitted over a set of pins so that each sheet of paper to be printed aligns to the matrix in exactly the same way.

PVC Polyvinyl chloride is a thermoplastic polymer that is used to make a wide variety of products. In sheet form, it can be carved, scratched, or cut.

Rag content The amount of cotton fiber in a paper, usually represented as a percentage. Paper made from cotton rag is more archival due to its neutral pH.

Raster image An image made up as an array of pixels, as it is typically used for the representation of tonal images. A raster image is scale dependent; that is, it cannot be enlarged without loss of clarity.

Reduction print A print made from a single matrix printed multiple times. The matrix is altered between printings so that less and less of the information prints each time.

Registration To align paper to printing matrices so that colors print in correct position. Systems include kentō, T and bar, Mylar, punch or pin, guide sheets, and various combinations.

Relief Printing that takes ink from the top of the matrix. Woodcut, wood engraving, and linocut are traditional relief methods, although intaglio matrices can also be inked in a relief fashion.

Relief roll Applying ink to the relief surface of a relief or intaglio matrix.

Resolution A general term that refers to the amount of information in a digital image. Most commonly, it refers to the number of pixels per inch (ppi) of a digital image. Another resolution measurement is the lines per inch (lpi) of a halftone screen.

Retroussage The process of gently stroking a wiped intaglio plate with a soft cloth in order to pull a little bit of ink out of the line, yielding a softer printed line.

Rosin Solid residue created when turpentine is distilled. Powdered rosin is used for aquatints in intaglio and to prepare drawings for etching in lithography.

Roulettes Tools that can be rolled over the surface of a plate to create an irregular or mechanical pattern. They are ideal for creating values and textured effects.

Run-up blocks Boards that are used to engage the cylinder of an etching press when printing a relief block.

Saline Sulfite Etch Developed by Friedhard Kiekeben, this is an improved variant of the Copper Sulfate Etch for zinc. The addition of sodium chloride (table salt) creates a mordant that is three times more active than a straight copper sulfate solution. It produces a very crisp etch without the more settled sedimentation and surface roughness of the Bordeaux Etch.

Scoop-coater A tool for applying photosensitive emulsion to a silkscreen.

Scraper A rigid tool with a sharp point and edges that is used to remove marks on a metal intaglio plate.

Scraper bar The part of the lithographic press that exerts pressure through the tympan on to the stone or plate with printing paper as it is run through the press.

Screen 1. A frame with a stretched mesh to which stencils are adhered for screenprinting; 2. A term that refers to converting an image to a halftone.

Screen printing A stencil process utilizing a fine mesh stretched over a frame. Stencils are attached to the screen and can be made in a variety of ways. Ink is forced through openings in the screen.

Serigraphy Another term for screen printing.

Shellac A natural resin that can be liquefied using alcohol and used as a sealant and hardening agent for relief print wood blocks. The shellac can be applied before or after the carving. Also used as a stopout for etching.

Silkscreen *see* screen printing, also called serigraphy.

Smoking the ground With a hard- or soft-grounded plate held upside-down, lit wax tapers are moved underneath so that soot combines with the ground to make a darker surface.

Soft ground Similar to a hard ground, with added tallow so that the ground remains soft and can record information by pulling ground off with pressure.

Solvent lift ground A solvent solution used in combination with hard ground. When painted on the plate covered with hard ground, the solvent dissolves the ground, which is wiped up, leaving the painterly brush mark.

Spackle A smooth acrylic based construction paste used to patch cracks and small holes; can be used to create textures on collagraph plates.

Spit bite Applying acid directly to an aquatinted plate to create subtle smoky tonal information.

Spot color A single color.

Squeegee A tool with a flexible rubber or plastic blade used in screen printing to push ink through the stencil opening.

State proof A proof taken of a matrix or matrices during the development of the print.

Stencil A mask that blocks printing ink; most often associated with screen printing. Stencils can be made directly with paper, thin plastic, or block-out liquid applied to the screen, or with photographic emulsions. Simple paper stencils can also be used in combination with other forms of printing.

Stone graining The act of removing an old image from a litho stone with Carborundum grit. Graining also flattens and levels the litho stone.

Stopout Used during the development of an etched image, a substance painted on an etching plate to close off that area to further mordant action.

Stouffer gauge A small piece of film with step wedges used to evaluate the exposure and processing times for photolithographic and flexographic plates.

Substrate The surface on which a print is made. Usually paper, substrates can be any flat surface such as wood, plastic, or fabric.

Sugar lift *see* lift ground.

T and bar registration A system of registration that aligns markings on the back of the printing paper with corresponding markings on the matrix or registration guide.

Tack The stickiness of ink.

TAPEM Tannic Acid Plate Etch Mix. A solution of tannic acid and gum arabic used for processing aluminum plates. A mixture of phosphoric acid and gum arabic can substitute for TAPEM.

Tap-out A system to test the value range of color ink.

Tarlatan A loosely-woven starched cheesecloth used to wipe intaglio plates.

Thixotropic The property of ink that describes a change in viscosity as an ink is worked.

TIFF Tagged Image File Format (also TIF). A widely used digital file storage format. Good for storage of large raster images uncompressed.

Toner powder Plastic dust particles used in photocopiers.

TP Trial proof. A proof to test color, paper, or registration.

Transparencies Opaque (light-blocking) images on clear or translucent materials used to expose photo-sensitive printing matrices. *See* positives or negatives.

Tusche A lithographic drawing material used to make washes. It is available in paste and stick forms for both water-based and solvent-based washes.

Tympan A sheet of high-density plastic or fiber board used in lithographic printing. The tympan is placed between the paper and the scraper bar slides across the surface as the pressbed moves underneath.

Universal developer Chemical developer for photolithographic plates.

Variable The capacity of a matrix or set of matrices to be articulated differently, creating variations of the image. Changes include color, order of printing, cropping, location, or repeated printings of any element.

Varnish A polymerized oil used to modify tack of lithographic inks.

Vector image A form of digital imaging whereby information is represented by mathematical equations. Vector images are resolution independent, meaning that they can be scaled to any size without loss of detail.

Vehicle The substance used to suspend pigment particles to make an ink. Water is the vehicle for water-based inks; burnt-plate oil or varnish is used for oil-based inks.

Vertical etching tank A tank that is used when etching copper plates. The upright nature of the tank allows precipitate to fall to the bottom of the tank rather than remain on the etched surface. Aeration of the tank helps the sediment fall out of the etched areas.

Viscosity The relative fluidity of a printing ink.

Viscosity printing An intaglio color inking method that relies on different viscosities of ink to build layers of relief-rolled color on a single plate.

Washout booth A contained location for rinsing exposed photo emulsion from screens or photo collagraph plates. Some washout booths have back lighting to aid observation of the washout.

Washout/rollup A step in the lithographic process when the original drawn image is removed (washout) and replaced with ink (rollup).

Water-based ink Inks made with water as the vehicle. Screenprinting inks are the most common water-based inks in printmaking, although some water-based formulas are available for intaglio and relief printing.

Waterleaf A paper without any added sizing.

Watermark A design, often a company logo or name, in a sheet of paper. The design is a physical part of the mold that made the sheet of paper, resulting in a thinner deposit of fibers on the design. It is visible when the paper is held up to light.

White line A relief print technique where the image is defined by the carved white (the area that is not printed) lines.

Wood engraving The process by which a very dense piece of end-grain wood is carved using engraving tools (burins and gravers) that make fine detailed marks and lines.

Working proof *see* state proof or trial proof.

Suppliers

General Suppliers

Daniel Smith
P.O. Box 84268, Seattle,
WA 98124–5568, USA
Tel: +1 800 426 7923 (USA)
Tel: +1 206 223 9599 (non-USA)
www.danielsmith.com
In addition to general supplies, they carry their own brand of ink favored by many.

Dick Blick Art Materials
P.O. Box 1267, Galesburg,
IL 61402–1267, USA
Tel: +1 800 828-4548 (US orders)
Tel: +1 309 343-6181 (International)
www.dickblick.com
Good prices on linoleum and screen printing inks.

Edinburgh Printmakers
23 Union Street, Edinburgh, EH1 3LR,
Scotland, UK
Tel: +44 131 557 2479
www.edinburgh-printmakers.co.uk
Range of printmaking materials, Photec Photo-polymer Film, Random Dot Digital Screen.

Graphic Chemical and Ink Company
732 North Yale Avenue, Villa Park,
IL 60181, USA
Tel: +1 800 465 7382
www.graphicchemical.com
Wide selection of all printmaking materials —inks are widely used and distributed. A long-serving reputable company.

Hawthorn Printmaker Supplies
Hawthorn House, Appleton Roebuck, York,
North Yorkshire, YO23 7DA, UK
Tel: +44 7855 621 841
www.hawthornprintmaker.co.uk
Carries general supplies. Specialty: Non-skinning Etching Inks.

Intaglio Printmaker
62 Southwark Bridge Road, London,
SE1 0AS, UK
Tel: +44 20 7928 2633
www.intaglioprintmaker.co.uk
General printmaking materials and supplies for Acrylic-Resist Etching.

Joop Stoop
12 Rue Le Brun, Paris, 75013, France
Tel: +33 1 55 43 89 95
www.joopstoop.com

Lascaux Colours & Restauro
Barbara Diethelm AG, Zürichstrasse 42,
CH-8306, Brüttisellen, Switzerland
Tel: +41 44 807 4141
www.lascaux.ch
Eco-friendly acrylic-resist etching system, tusches and professional grade water-based screenprinting inks. Distributed worldwide.

Lawrence Art Materials
T N Lawrence & Son Ltd, 208 Portland
Road, Hove, East Sussex, BN3 5QT, UK
Tel: +44 1209 313181
www.lawrence.co.uk
Comprehensive selection of general printmaking supplies.

McClain's
15685 SW 116th Avenue PMB 202,
King City, OR 97224–2695, USA
Tel: +1 800 832 4264
www.imcclains.com
Specializing in woodcut supplies.

Melbourne Etching Supplies
33A St David Street, P.O. Box 188,
Fitzroy 3065, Australia
Tel: +61 3 9419 5666
www.mes.net.au

Neil Wallace Printmaking Supplies
44–46 Greeves Street, Fitzroy 3065,
Australia
Tel: +61 3 9419 5949
www.e-artstore.net

Parkers Sydney Fine Art Supplies
3 Cambridge Street, The Rocks, Sydney,
NSW 2000, Australia
Tel: +61 2 9247 9979
www.parkersartsupplies.com

Renaissance Graphic Arts, Inc
69 Steamwhistle Drive, Ivyland,
PA 18974, USA
Tel: +1 888 833 3398
www.printmaking-materials.com
Full range of supplies for the professional and student printmaker. Quality products.

Speedball
www.speedballart.com
Student-grade products, especially good for relief printing tools and materials and screen printing inks. Global distribution.

Takach Press
3207 Morningside NE, Albuquerque,
NM 87110, USA
Tel: +1 800 248 3460
www.takachpress.com
Top-quality supplier. Specialties include big equipment: presses, hotplates, hand inking rollers and brayers and ball-grained litho plates. Many products developed and tested with the Tamarind Institute.

Valley Litho
1047 Haugen Avenue, Rice Lake,
WI 54868, USA
Tel: +1 800 826 6781
www.valleylitho.com
Excellent source for Ulano QTX screen printing emulsion for photo collagraph.

Screen Printing Suppliers

Lawson
www.lawsonsp.com

Atlas Screen Supply Company
www.atlasscreensupply.com

Silk Screening Supply
www.silkscreeningsupplies.com

Presses

Conrad Machine
1525 South Warner Street, Whitehall,
MI 49461, USA
Tel: +1 231 893 7455
www.conradmachine.com

Harry F Rochat
15a Moxon St, High Barnet, Herts,
EN5 5TS, UK
Tel: +44 20 8449 0023
www.harryrochat.com/home.htm
UK-based press manufacturer.

Takach Press
www.takachpress.com
Gold standard litho and intaglio presses.

Safety Materials

Franmar Chemical
www.franmar.com
Specializing in environmentally friendly products. Silkscreen emulsion removers.

Lab Safety
Tel: +1 800 356 0783
www.labsafety.com
Safety gear, containers and supplies. Good for color-coded solvent dispensers and non-skid mats for the press.

SoySolvents.com
www.soysolvents.com
Soy-based substitutes for petroleum-based solvents.

Specialty Equipment & Services

Cape Fear Press
www.capefearpress.com
Sells Puretch photopolymer film— a thinner film, good when intending to etch photo intaglio plates.

Richards of Hull
Unit 1, Acorn Estate, Bontoft Avenue, Hull,
HU5 4HF, UK
Tel: +44 1482 44 24 22
www.richards.uk.com
Specialist suppliers of Vertical Etching/ Stripping Tanks, Platemaking Sinks, Ventilated Acid Units, and more.

Stones Crayons
www.stonescrayons.com
Specialty water insoluble litho crayons and technical tips.

Z Acryl
The Crate Inc, P.O. Box 3661, Oakland,
CA 94609, USA
Tel: +1 800 651 7975
www.zacryl.com
Specializing in reduced toxicity etching supplies. Vertical etching tanks, Z-Acryl photopolymer supplies: film, stopout and grounds.

Inks

Caligo Inks
www.caligoinks.com
Oil-based inks for etching, relief and lithography. Offers a new product, Safe-Wash inks, which are oil-based but clean up with water. Caligo's contacts page lists distributors worldwide.

Daniel Smith
www.danielsmith.com
Daniel Smith inks are a popular brand. Their Miracle Gel modifier is good for monotype.

Graphic Chemical and Ink Company
www.graphicchemical.com
Graphic Chemical inks are excellent quality with a large palette of colors. Handy cartridge tubes for relief and intaglio inks reduce waste. Graphic also carries Handschy brand inks.

Hawthorn Printmaker Supplies
www.hawthornprintmaker.co.uk
Specialty: Non-skinning etching inks.

Rostow & Jung
219 East 4th Street, New York, NY 10009, USA
Tel: +1 888 473 4670
www.waterbasedinks.com
Makers of Akua Kolor and Akua Intaglio—a line of water-based inks for monotype and intaglio.

Rudolph Faust, Inc
542 South Ave East, Cranford, NJ 07016, USA
Tel: +1 908 276 6555
www.store.faustink.com
Excellent intaglio and relief inks. They also have a new line of water-soluble inks for intaglio and relief. They also carry dry pigments and etching blankets.

For Silkscreen Inks:
TW Graphics
Tel: +1 800 901 3051
www.twgraphics.com

Golden Paints
www.goldenpaints.com
Silkscreen medium mixes with their line of high-quality acrylic paints. Makers of Tar-gel.

Lascaux
www.lascaux.ch
Professional grade water-based screen printing inks.

Speedball
www.speedballart.com
Student-grade products, especially for screen printing and relief.

Daler-Rowney
www.daler-rowney.com
UK company with offices in the US and Europe (Belgium). System 3 acrylics for screen printing are good. Distributed worldwide (Graphic Chemical, TN Lawrence).

Paper Suppliers

Artpaper
Tel: +1 866 296 0404
www.artpaper.com

Dolphin Papers
Murphy Art Center, 1043 Virginia Ave, Suite 2, Indianapolis, IN 46203, USA
Tel: +1 877 868 000
www.homepage.mac.com/dolphinpapers
A wide variety of papers from one of our favorite companies.

Hiromi Paper International
2525 Michigan Ave, Unit G-9, Santa Monica, CA 90404, USA
Tel: +1 866 479 2744
www.hiromipaper.com

Japanese Paper Place
77 Brock Avenue, Toronto, Ontario, M6K 2L3, Canada
Tel: +1 416 538 9669
www.japanesepaperplace.com

Stephen Kinsella
8352 Olive Blvd, St. Louis, MO 63132, USA
Tel: +1 800 445 8865
www.kinsellaartpapers.com

Paper Connection International
166 Doyle Avenue, Providence, RI 0290–1645, USA
Tel: +1 877 434 1234
www.paperconnection.com
paperwoman@paperconnection.com
Specializing in Asian papers.

John Purcell Paper
15 Rumsey Road, London SW9 0TR, UK
Tel: +44 20 7737 5199
www.johnpurcell.net
True-Grain Polyester Drawing Film (Sheet: 80 ×122cm / Roll 123cm × 10m). Also True-Grain Ink Jet. Extensive range.

Matrix-making Materials

For Plastics:
PVC board is available under the trade names Sintra™ and Versacel™ (USA), and Foamalux (UK). HIPS (High Impact Polystyrene) is available up to ½ in thick. Very thin (.5 mm) is great for stencils.

Engineering and Design Plastics
84 High Street, Cherry Hinton, Cambridge, CB19HZ, UK
Tel: +44 1223 249431
www.edplastics.co.uk/Products.htm

Professional Plastics
Tel: +1 888 995 7767
www.professionalplastics.com
14 locations in the USA & Singapore. Serving customers in Canada, UK, France, Germany, Belgium, Netherlands, Australia, New Zealand, South Africa, Mexico, Brazil.

For Linoleum:
Bangor Cork
William & Savercool Streets, Pen Argyl, PA 18072–0125, USA
Tel: +1 610 863 9041
www.bangorcork.com
Great prices on bulk linoleum.

For Polyester Flexographic Plates:
Boxcar Press
501 W Fayette St, Studio 222, Syracuse, NY 13204, USA
Tel: +1 315 473 0930
info@boxcarpress.com
Supplies Polyester (Flexographic) plates.

Nicoll Graphics
Openshaw International Ltd, Woodhouse Rd., Todmorden, Lancashire OL14 5TP, UK
Tel: +44 1706 811 408
gold@openshaw.com
Bulk suppliers of Toyobo KM95R Water Washable Plates.

Polymetaal
P.O. Box 694, Leiden, 2300 AR, The Netherlands
Tel: +31 71 522 2681
www.polymetaal.nl
info@polymetaal.nl
A Dutch supplier of printmaking materials specializing in photopolymer and acrylic etch products.

Solarplate
P.O. Box 520, Sag Harbor, NY 11963, USA
Tel: +1 631 725 3990
www.solarplate.com
solarplate4@aol.com

Other Useful Links

Bill Fisher's Site
www.billfisher.dreamhost.com
Links to many artists' art departments and suppliers.

Center for Fine Print Research
University of the West of England, Bristol, UK
http://amd.uwe.ac.uk/cfpr

Edinburgh Printmakers
www.edinburgh-printmakers.co.uk

Green Art
www.greenart.info
Information and links to non-toxic printmaking.

International Print Center New York
www.ipcny.org/links.htm
Many useful links to print workshops, publishers and artists.

Tamarind Institute
www.unm.edu/~tamarind
World renowned center for education, research and creative projects in lithography.

Index

Page numbers in *italics* refer to illustrations.

Credits

The publishers would like to thank all the artists and the following contributors for providing photographic or other visual material for this book:

P2: photo by Atelier Tom Blaess; p7: photo by Beth Grabowski; p8: photo by Art Werger; p9 top: © 2006 the artist/author, Marshall Weber/binding, cover design, Shon Schooler and Alice Yeates/photo by Marshall Weber; p9 bottom: photo by Judy Tobar; p10: photo by John Hodgkiss/Courtesy David Krut Fine Art; p11: © 2003, Adriane Herman/Slop Art, photo by Adriane Herman; p12 top: © Jim Hollander /epa/Corbus; p14–15: photos by Ackland Art Museum; p17: photo © 2003 Paul Croft; p20 left: photos by Bryan Baker; p29: courtesy of Jeanne Hearn; p32 left: Courtesy of The Art and Creative Materials Institute, Inc. (ACMI); p35: Creative Commons license; p36: photo by Randy Bolton; p37: photos by Shaurya Kumar; p38: photo © David Tinapple; p39: photo by Tim Dooley; p41 top: photos by Donika Wiley; p41: photo by Michael Krueger; p42 bottom left: photo by Ryan Burkhart; p42 bottom right: Brian Reeves and Adriane Herman; p43 top: © Jennifer Yorke 2005, photo by Aaron Wilson; p43 bottom: Courtesy of ShopBot; p44 top: © Carl Fudge, photo by Judy Tobar; p44 bottom: photo by Lauren Rosenthal; p45: photo © Alicia Candiani 2007; p46: photo © 2004 Manuel Castro Cobos; p47: © Pixelstate/Dreamstime. com/photo Chris Sargent; p48: photo by Beth Grabowski; p49: © Pixelstate/Dreamstime.com/photo Chris Sargent; pp50–1: photos by Robert Hensleigh; p53: © Pixelstate/Dreamstime.com/photo Chris Sargent; p54: photo © 2001 Melissa Harshman; p55: photo by Special Collections Research Center, North Carolina State University Libraries, Raleigh, North Carolina; p56 left: photo by Library of Congress; p56 right: Getty Images/National Geographic/Stephen Alvarez; p58 bottom: photo by Tim Dooley; p61: © Noite de Verão (Summer Night), Beatriz Milhazes, photo by Durham Press; p62: photo © 2004 Melissa Harshman; p65 bottom: photo by Hiro Ihara; pp66–7: photos by David Sandlin; p70: © 2002 Joanne Greenbaum, photo by Hiro Ihara; p73: © 2005, Lany Devening; p74: © ADAGP, Paris and DACS, London 2008/ © Ghada Amer, photo by Rob McKeever/Gagosian Gallery; p75 top: photo by Library of Congress; p76 top: © DACS 2008, photo by Ackland Art Museum; p76 bottom: photo by Red Gate Gallery; p81 top: photo by Swoon; p81 bottom: Collection of June Lee, June Lee Contemporary Art, photo by Eric Mellencamp/Mark Moore Gallery; p85 top: photo © 2007 Marc Brunier-Mestas; p85 bottom: photo by Stuart Hay; p86 top right: photo by Endi Poskovic working in his studio by Mitchell Kearney; pp88–9: © Karen Kunc, photos by John Nellendorfs: p91: photos by Mitchell Kearney; p94: photos by Larry Ferguson Studio; p95 top: photo © 2006 Jaana Paulus; p95 bottom: photo by Andy Farkas; p96: © Sean Stars Wars; p99: photos by Swoon; p100–1: photos ©1998/99, Thomas Kilpper; p102: photos by Dennis McNett; p103: photo by Ackland Art Museum; p107 top: Courtesy of Leslie Koptcho/Louisiana State University School of Art; p110 middle right, mezzotint): Courtesy of Sean Caulfield; p112: photo by Harlan & Weaver, New York; p114 bottom: © 2007 Antti Ratalahti, photo by Jaana Paulus: p116 top middle, spit bite: Courtesy of Louis-Pierre Bougie; p118: photo by Akiko Taniguchi; p119: photo by Kurt Kemp; p122 bottom: photo by Shaun Kardinal/ Davidson Galleries; p123: photo by Ackland Art Museum; p126 left: photo by Ira Schrank; p127: photo by Shaun Kardinal/Davidson Galleries; p132–3: photos by Jo Ganter; p136: photo by Akiko Tanguchi; p139 top: © Tanja Softić, photo by Katherine Wetzel; p140 bottom: photo by Sean Caulfield; p143 left: photo by Casey Rae; p143 right: photo by Amanda Verbeck; p147 top: © DACS, London/VAGA, New York 2008, photo by Richard Sprengeler; p148–9 bottom: © DACS, London/VAGA, New York 2008, photo (p148) by Amy Rinaldi, photo (p149) by Becket Logan; pp150–1: photos by Wael A. Sabour; p156: photo by Richard Sprengeler; p157: photo by Ackland Art Museum; p158: © DACS, London/VAGA, New York 2008, photo by Jack Abraham; p164: photo by Beauvais Lyons; p166: © Claudette Schreuders, photo by Mark Attwood; p171: photo by Ruth Weisberg; p172: photo by Kevin Haas; p174: photo by Althea Murphy-Price; p176: photos by Rebekah Champ; p177: photo © 2008 Jenny Schmid; p181: photos by Ivan Willemyns; p182: photo by Ackland Art Museum; p186: photos by David Kern Photography, LLC; p187: 1977.30.1.(B-29154)/PR: Castiglione, Giovanni Benedetto; p188 top: photo by Ackland Art Museum; p188 bottom: © Riitta Uusitalo, photo by Shaun Kardinal/Davidson Galleries; p189 bottom: © Roy Nydorf; p193 bottom: photo by Michael Krueger; p194: photos by Koichi Yamamoto; p185: photos by Atelier Tom Blaess; p196: photo by One Eye Pug; p197 left, 198–9: photo by Atelier Tom Blaess; p200: ©2007 Durham Press, Inc./Polly Apfelbaum, photos by Durham Press; p201 top: photo by Marylyn Dintenfass; p204: photo by Curtis Eberhardt; p205: photo by Francisco Souto; p206: photo © 2002 Laurie Sloan; p209: Lisa Bulawsky; p210: photo © 2005 Tom Christison; p211 bottom: photo by Chris Ciccione; pp212–13: photos by Phyllis McGibbon, (p213 bottom) produced with assistance from students, faculty and staff at the University of Northern Iowa; p214 top: photo by Mark Gulezian, Quicksilver Photography; p214 bottom: photo by Red Gate Gallery; p215 top: photo by Jack Abraham; p215 bottom: photo by Margaret Craig; p216 top: photo © 2006 Jill McKeown; p216 bottom: photo by Anita Jung; p217 top: photo © 1999 Elizabeth Dove; p217 bottom: © 2008, Drew Cameron, Drew Matott, Jon Turner, People's Republic of Paper, photo by Drew Cameron; p218: photo by David Kern Photography, LLC; p219: Radiant 2006 © The artist and Beaux Arts Gallery, photo by Nicholas Moss.

The following photographs were provided courtesy of Bill Fick: pp12 bottom, 19, 20 right, 21–31, 34, 42 top, 43 bottom, 57–8, 59 top, 63–5, 65 top, 68–9, 71–2, 73, 75 bottom, 78–80, 83–4, 86 top left and bottom, 90, 92–3, 96, 97–8, 105–6, 108, 110 (except middle right, mezzotint), 111, 113 bottom, 114 top, 115, 116 (except top middle, spit bite) 117, 120–1, 122 top, 124–5, 126 top right, 128–31, 134–5, 137, 139 bottom, 140 top, 141–2, 144–6, 147 bottom, 149 top, 152–5, 161–3, 165, 166–70, 175, 178, 184–5, 189–92, 193 top, 197 right, 201 bottom, 202–3, 208.

The following illustrations were provided courtesy of Beth Grabowski: pp59–60, 97 (prints and blocks), and Brittain Peck: pp18, 21, 28–9, 40, 63, 71, 86, 104, 107, 113, 124, 126, 135, 146, 159–61.

Acknowledgments

The authors would like to thank the publishers, studios, and their staff that generously contributed images, contact with artists, feedback, and technical expertise for this book. They include: Kathan Brown and Sasha Baguskas of Crown Point Press; Dick Solomon, Kristin Heming, Judy Tobar at Pace Prints, and Ruth Lingen at Pace Editions Ink; Bronwyn Law-Viljoen of David Krut Publishing and Susan White of David Krut Arts Resource; Sei Young Kim, Dusica Kirjakovic, and James Miller of the Lower East Side Printshop; Cole Rogers at Highpoint Center for Printmaking; Ann Marshall and Nick Larsen of Durham Press; Maggie Wright of Harlan & Weaver; Kathy Caraccio of K. Caraccio Printmaking Studio; Sue Scott and Rachelle Agundes of One Eye Pug; Tom Reed of Island Press at Washington University, St. Louis; Mark Attwood of The Artists' Press; Maryanne Ellison Simmons and Amanda Verbeck at Wildwood Press; Amy Lebo of the Brodsky Center for Innovative Editions; Clare Chapman of Anish Kapoor Studio; and Adam Ewing of Yee-Haw Industries.

A great deal of thanks to Cara Forrier of Davidson Galleries for supplying us with so many images and information by the artists she represents.

We would also like to thank the following galleries and staff for allowing us to use work by the artists they represent. They include: Catharine Clark and Rhiannon MacFadyen at Catharine Clark Gallery; Karen Stone Talwar at Bodhi Art, Inc; Brian Wallace of Red Gate Gallery; Max Presneill of Mark Moore Gallery; Cathy Serrano at Ronald Feldman Gallery; and James McKee of Gagosian Gallery.

Special thanks to Scott Hankins, Timothy Riggs, and Barbara Matilsky of the Ackland Art Museum, University of North Carolina at Chapel Hill. Without them we would not have had access to the many wonderful historical images that have been used in the book.

Beyond providing images, the following artists have contributed to the book in many ways, including traveling to North Carolina to shoot demos, allowing us to shoot demos of them working in their studio, referring us to other artists, answering countless emails, reviewing rough drafts and making work specially for this book. They are: Tom Blaess, Kevin Haas, Jenny Schmid, Michael Krueger, Lisa Bulawsky, Tom Huck, Endi Poskovic, Lisa Mackie, Thomas Kilpper, Swoon, Dennis McNett, Sean Star Wars, Tanja Softić, Sean Caulfield, Akiko Taniguchi, Randy Bolton, Wael A. Sabour, David Sandlin, Jo Ganter, Ingrid Ledent, Karen Kunc, Phyllis McGibbon, June Wayne, Emma Amos, Zheng Xuewu, Minna Resnick, Marylyn Dintenfass, Tim Dooley, Juli Haas, Patsy Payne, John Gall, Mike Sonnichsen, Lany Devening, Gretchen Huffman, Jody Cedzidlo, Jeanne Hearn, and Ann Gratch.

We would also like to thank Deborah Fanning at The Art and Creative Materials Institute (ACMI).

Thanks to Takach Press for supplying us with two of their excellent brayers, which were used during many of the demonstrations.

We would also like the thank the following reviewers of this book: in the US, Kevin Harris (Sinclair Community College), EJ Herczyk (Philadelphia University), Richard Wohlfeiler (University of California Santa Cruz); and in the UK, Paul Croft (Aberystwyth University), Graham Firth (Doncaster University) and Allison Neal (Hereford College of Arts).